Ava

A LIFE IN MOVIES

KENDRA BEAN *and*
ANTHONY UZAROWSKI

RUNNING PRESS
PHILADELPHIA

For Robbie, with love. — KENDRA

For my grandfather, Zbigniew Uzarowski,
who loved Ava Gardner. — ANTHONY

Books published by Running Press are available at special discounts for bulk purchases in
the United States by corporations, institutions, and other organizations. For more information,
please contact the Special Markets Department at Perseus Books, 2300 Chestnut Street,
Suite 200, Philadelphia, PA 19103, or call (800) 810-4145, ext. 5000, or e-mail
special.markets@perseusbooks.com.

ISBN 978-0-7624-5994-0
Library of Congress Control Number: 2017930766

E-book ISBN 978-0-7624-6043-4

9 8 7 6 5 4 3 2 1
Digit on the right indicates the number of this printing

Designed by Susan Van Horn
Edited by Cindy De La Hoz
Typography: Verlag, Filosofia, Blend, Hillda, and Cervo

background art credits: *pages 16, 69, 129:* billnoll; *pages 114, 236:* naqiewei; *pages 6, 189, 244:* Kannaa;
pages 97, 150, 223, 256, 257: Atypeek; *pages 43, 86:* jcrosemann; *pages 21, 58, 109, 212:* lm-kseniabond;
pages 13, 66, 79, 138, 166, 228, cover spine, endpapers: luanateutzi; *pages 106, 148, 230, endpapers:*
IndigoBetta; *pages 35, 100, 173:* AnnaSivak

Running Press Book Publishers
2300 Chestnut Street
Philadelphia, PA 19103-4371

Visit us on the web!
www.runningpress.com

CONTENTS

INTRODUCTION

TENNESSEE WILLIAMS ONCE SAID OF AVA GARDNER, "When I think of her, I think of a sort of poem or koan: Laughter through tears. Sex and sweetness. Hugs and second helpings. A steady shoulder. My beautiful, ballsy friend." During her own lifetime and beyond, the pervasive narrative, both factual and mythologized, has largely focused on Ava's private life—the men, the booze, the restless and at times self-destructive attitude that made her the subject of global tabloid scrutiny. In truth, there were many Avas: the public Ava, the "love goddess," the glamorous film star; the private Ava, shy, independent, impulsive; Ava, the loyal, discreet, and giving friend.

Ava was more than a movie star—she became a legend in her own lifetime, known the world over for her earthy sensuality that sizzled on movie screens. She had an alluring magnetism that seduced many famous men, leading to short-lived marriages to Mickey Rooney, Artie Shaw, and Frank Sinatra, with whom she carried on a turbulent lifelong romance.

Beyond the legend, she was a very real person. To many people around the world, she was a dear friend who is cherished and remembered with great love to this day. Fame came relatively easy to the green-eyed daughter of a tobacco planter from North Carolina. At age nineteen she secured a contract with Hollywood's biggest studio, getting her big break a few years later playing the sultry femme fatale in Robert Siodmak's 1946 film noir classic *The Killers*. But as a true product of the Hollywood star system, she was given little credit for her abilities and even less encouragement to grow as an actress. When MGM's hold on her became too oppressive, she fled to Europe, becoming much like the free-spirited, glamorous, Hemingwayesque expats she portrayed in films such as *The Snows of Kilimanjaro* and *The Sun Also Rises*.

Ava never believed in her talent, and she never gave her career in movies much thought. Yet for someone who remarked, "I was never really an actress. None of us kids who came from M-G-M were. We were just good to look at," she left a rich and often underrated screen legacy. In a career that spanned nearly half a century she worked with many now-legendary directors and traversed film genres, appearing in noir, westerns, costume dramas, romantic comedies, musicals, and, later, even blockbuster disaster films and horror.

Although Ava blazed through life, leaving an indelible mark on film history, few items remain in the way of personal papers, save for a post-humous ghostwritten autobiography. In order to piece together the rich tapestry of her life, we consulted archives, libraries, and museums in countries around the world. What emerged was a chorus of different voices, each illuminating a different aspect of her complex persona. Scattered throughout various collections were also snippets of Ava's own voice. Letters to author Henry Miller at UCLA; to her friend Robert Graves in Oxford, England; to George Cukor at the Academy of Motion Picture Arts and Sciences in Los Angeles revealed a curious, intelligent woman of varied interests and a ribald sense of humor. "It's too bad that the silent pictures went out," Cukor wrote in one of his letters to Ava. "You'd have had a great career as a title writer. Not 'Came the Dawn . . .' but real comical stuff. Why did you keep this special talent of yours hidden from me?"

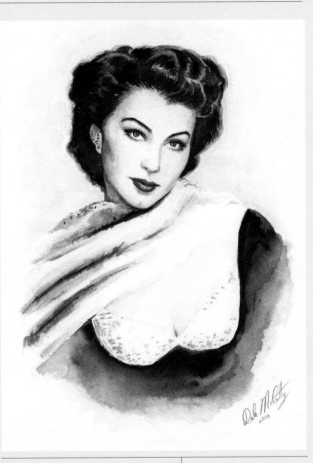

It was not our goal to write a definitive biography. Rather, our book aims to challenge the well-worn perception of her life and work by bringing together a new narrative perspective with the largest collection of photographs ever assembled in an Ava biography. "As an actress, she was much better than she thought she was. She had no vanity about her talent," said her dear friend Gregory Peck. "The Edna St. Vincent Millay verse might have been written about Ava—'Her candle burns at both ends. It will not last the night. But oh my friends and ah my foes, it sheds a lovely light.'"

—KENDRA BEAN and ANTHONY UZAROWSKI,
London, May 2016

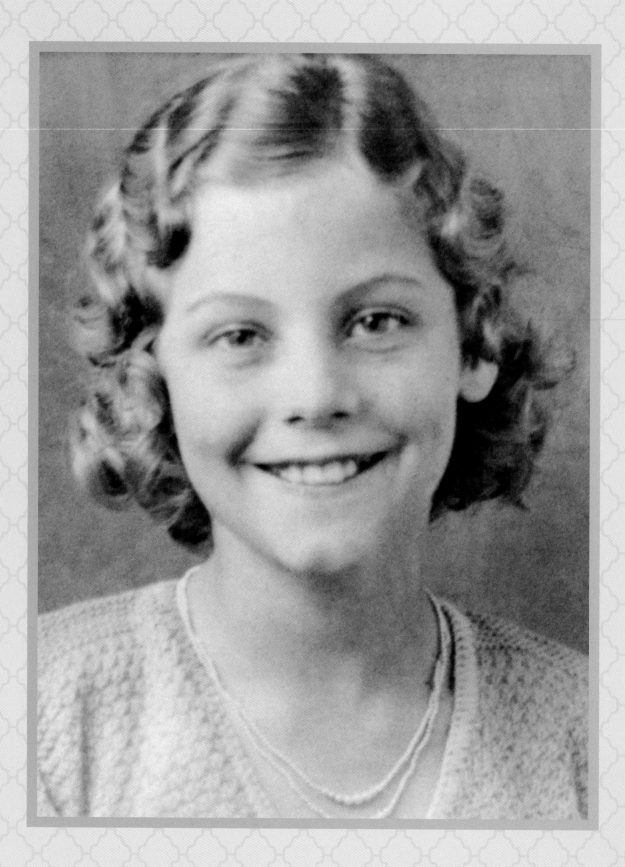

CHAPTER **ONE**:

Daughter of the South

T HE TOWN OF LIPHOOK, NEAR PORTSMOUTH IN THE SOUTH of England, was teeming with people from London's film world in early June 1955. In residence were the cast and crew of *Bhowani Junction*, MGM's lavish Eastmancolor film set in India. The company had taken over a stretch of the Longmoor Military Railway in order to stage one of the film's key scenes. At the bottom of an incline, a group of train carriages was carefully arranged and set on fire to look like a horrific accident—the product of eight weeks' worth of preparation from the art department. Director George Cukor was busy setting up a shot, yelling his commands over a loudspeaker to two hundred extras strewn about on the ground, covered in fake blood, bandages, and prosthetic wounds. Lunch would be announced soon, but one more take had to be completed first.

Thomas Wiseman observed the action. The Austria-born British journalist was young but already had ample experience dealing with high-profile film people as author of the showbiz column for Lord Beaverbrook's *Evening Standard*. When reflecting recently on how different it was speaking with celebrities over a half century ago, he said, "I can tell you that in the fifties major stars were much more accessible than they are now. I would ring up someone I wanted to interview, without going through a PR person, and arrange for us to have lunch."

At the top of the incline stood the film's lead actress, surrounded by makeup department personnel, awaiting her cue. One of the makeup women used a large silver can to douse the star with glycerin—"Only stuff that shows up like sweat on screen. Terrible stuff," the actress said. A male colleague dirtied her already filthy

opposite: Ava at age 12, Brogden, North Carolina. Getty Images/John Springer Collection.

7

sari in blood "correctly pigmented for Eastmancolor." Wiseman noted the actress's beauty and the stick of chewing gum in her mouth—a gift from her older sister in America—that hinted at her detachment from the controlled chaos surrounding her.

This was Ava Gardner, at that time known in the press as "the world's most beautiful animal," or in Wiseman's words, "the Aphrodite of the atom-age." After fourteen years under contract to Hollywood's largest movie studio, she had forty-two short and feature-length screen appearances under her belt (*Bhowani Junction* would be the forty-third) and was now reportedly earning six figures per film. The salary alone spoke volumes about her position on the roster at Metro-Goldwyn-Mayer. But one didn't need to know the specifics of Ava's contract to understand her popularity with filmgoers around the world. Her films were often well received by audiences, if not always by critics, and since the early 1940s her personal life had provided titillating copy for publications ranging from the *Los Angeles Times* to *Esquire* magazine.

Ava Gardner epitomized international celebrity, but as many journalists already knew—and as Wiseman would discover during their interview—she wasn't a typical film star. For one thing, she didn't exactly *like* her job. Whereas many of her peers may have been happy to bend and yield under the iron fists of studio bosses in exchange for a shot at fame, Ava had been in the business long enough—and had become successful enough—to bluntly voice her opinions on the trappings of the film world. She wasn't in it for the craft, she admitted. Acting talent was one thing she was sure she didn't possess. "I don't enjoy making films," she told Wiseman. "I just enjoy making money." Nor did she find other actors particularly appealing on an intellectual level, instead preferring to associate with writers, musicians, bullfighters, directors—men who could stimulate her brain, if not her body.

She counted the likes of Ernest Hemingway, Robert Graves, Tennessee Williams, George Hoyningen-Huene, and John Huston as friends. Still, she never could understand why other people found *her* fascinating.

"Perhaps we're not so interesting to ourselves," Wiseman noted Ava as saying. "I'm a simple girl, a farmer's daughter. I can't think where I got the bad blood—the bad blood that got me into this business."

AVA LAVINIA GARDNER, A SELF-PROCLAIMED "WAY AFTER thought" that her parents needed "like a hole in the head," was born in a two-story, five-bedroom clapboard house in Johnston County, North Carolina, on Christmas Eve, 1922. Studio publicity would later claim she was from the town of Smithfield, as her true birthplace, the community of Grabtown, was so small and rural that state mapmakers didn't bother to include it. Her parents, Jonas Bailey Gardner and Mary Elizabeth Baker (known to friends and family as Molly), were both approaching middle age when their youngest came along. They

had already experienced their fair share of tragedy and hardship, having borne six previous children and burying a baby son, Raymond, after a freak home accident in 1911 that involved a dynamite cap and a blazing fireplace.

Although there was nothing at the outset to suggest that Ava would one day become one of the most famous women in the world, a look into the Gardners' past reveals some interesting characters. Her family had been in the United States since before the country's foundation, with more than one member playing some type of role in the broader context of shaping the nation. Several branches of Gardners (sometimes spelled "Gardiner") sailed over from England in the mid-seventeenth century and settled in the New England area, including the branch to which belonged George Gardiner, a pastor's son who entered into a common-law marriage and fathered seven children with divorced mother of two Herodias Long-Hicks. Herodias was a Quaker convert whose outspoken, dissident religiosity led to trouble. She and her first husband, John Hicks, had been denied a place in the Puritan church at Weymouth, Massachusetts. On May 11, 1658, Herodias, accompanied by friend Mary Stanton, carried her baby sixty miles on foot from Newport, Rhode Island, to deliver a religious speech in her former town of Weymouth. There they were seized, brought in front of Governor John Endicott in Boston, and whipped before being thrown in jail for two weeks. The incident did little to curb Herodias's unconventional ways. Unhappy with her choice of partners, she entered into adulterous relationships and took three husbands altogether. That two marriages ended as a result of divorces rather than widowhood was unheard of for a woman in her time.

A family connection between Ava and Herodias would certainly make for an interesting story, and many family trees on genealogy sites such as Ancestry.com link Ava's ancestors with the rebel Puritan. However, murky disparities among the dates and birth locations of Herodias's offspring and those of Ava's traceable relatives suggest they may not have been related after all. Ava's branch of the Gardners appears to have settled a bit farther south, in the Westchester area of New York, then New Netherland colony, before branching out to nearby New Jersey, where they stayed until the mid-nineteenth century. War records show that Thomas Gardner, Ava's great-grandfather six times removed, was a wagon master responsible for delivering clothing, food, and munitions to soldiers in New Jersey during the American Revolution. His son Benjamin enlisted as a young teenager and served under the command of two different captains as both a drummer and fifer in the New Jersey Militia. Though not positions directly involved in combat, fifers and drummers were essential to Revolutionary armies, as the instruments were used to signal between company leaders and soldiers.

It was Benjamin's son, Thomas, who moved the Gardners to North Carolina, settling in Edgecombe with his wife, Nancy Poteet, sometime around 1790. With tobacco and cotton booming in the agrarian South, Thomas established himself as a planter. How many acres he possessed remains unclear; but he seems to have been

successful enough to pass the business on to his male children. The 1830 North Carolina census shows that Thomas's son William (Ava's great-grandfather) was prosperous enough to employ six free colored persons and three slaves—a woman of about twenty and two young girls under ten—possibly all from the same family. By 1860, William was sharecropping on a 1,600-acre plot in Wilson County, 516 acres of which he owned. His son David helped with labor; notably, there were no longer any slaves in residence, suggesting either a moral change of attitude on William's part or a monetary setback.

The family trade continued down through two more generations, but the level of prosperity declined in the early twentieth century, as it did for many farmers of the same position. Cash crops that had once been responsible for a great deal of wealth in the South began failing to produce adequate returns even before the stock market crash of 1929 sent the United States spiraling into the Depression. According to former Wilson County journalist and Ava Gardner biographer Doris Rollins Cannon, Jonas Gardner's financial situation took a turn for the worse around 1915. Jonas and his brothers, who lived nearby and helped farm the family plot, could no longer pay their landlord. They were forced to sell and become tenant farmers. To make ends meet, Jonas took on a variety of odd jobs, including running a local store and operating a sawmill.

Things were invariably difficult from a financial perspective and would remain so. Running water, indoor plumbing, and electricity were luxuries the Gardners could not afford. Such details of Ava's childhood bring to mind documentary images of sharecropping families taken by *Life* photographer Dorothea Lange while on assignment in the rural South during the Depression: weariness and poverty mixed with dignity. Much to Jonas and Molly's credit, their children never seemed to suffer. Ava admired her parents' fortitude and later resented reports that she had grown up on the lowest rung of the financial ladder. Lawrence Grobel recalls Ava telling him, "We were poor but I wasn't aware of it, because everyone else was poor. But it was wonderful, because we were loved."

When Ava was three years old a fire tore through Jonas's cotton barn and destroyed what was left of his livelihood as a sharecropper. Though the blaze was likely sparked by accident when son Jack carelessly discarded a lit cigarette, the tears that ran down Jonas's face as he watched his modest crop go up in flames left a lasting impression that Ava carried with her throughout her life. Broke and nearly destitute, the Gardners badly needed a reprieve from their misfortune. It came in the form of a job offer, not for Jonas but for Molly, who was asked to run the teacherage, a local boardinghouse for single female teachers at the elementary school in nearby Brogden.

> *"We were poor but I wasn't aware of it, because everyone else was poor. But it was wonderful, because we were loved."*
>
> —AVA

Simultaneously looking after the teacherage and a toddler—not to mention Inez, Jack, and Myra, who, though older, had not yet left the nest when the family moved to Brogden—was not always easy for Molly. Like any child growing up in the countryside, Ava acquired her fair share of bumps and scrapes, and occasionally her wild streak caused her to run into more serious mishaps. "She was a lively kid, real cute," sister Myra said in 1954. "She was a healthy child, but something was always happening to her. When she was about a year old, she got a hold of a can of lye. Mother caught up with Ava just as she was putting some of the lye into her mouth." Had Molly not quickly intervened with a homemade antidote—scrubbing Ava's mouth with vinegar and making her drink an egg white—the future film idol's life may have ended long before it had a chance to take off.

On the whole, life at the teacherage progressed as pleasantly as the circumstances allowed. Ava was a near-constant presence at the Brogden School. Early family photographs show a cherubic four-year-old with golden curls serving as the mascot for a class of fourth graders. She was soon attending classes herself. Of the boarders at the teacherage, Ava was particularly fond of her first-grade teacher, Maggie Williams, a married woman who was allowed to live at the house on account of her husband serving a prison sentence for murder.

One year after the US government passed the Eighteenth Amendment instating their "noble experiment" of Prohibition, David Marshall Williams was involved in an illicit but widespread trade: bootlegging alcohol. He operated a whiskey distillery near Godwin in Cumberland County that was raided by police on July 22, 1921. As Deputies Al Pate and Bill West and Sheriff N. H. McGeachy approached the scene, Williams and other unseen employees hiding out in the surrounding woods opened fire. Deputy Pate was shot in the waist, the bullet hitting a major artery and killing him instantly. Williams was indicted on first-degree murder charges. His defense team attempted to spare him the electric chair by having him plead guilty by reason of insanity. They presented to the judge and jury a letter written in 1919 by Williams's brother, Reverend J. Mack Williams, attesting to the former's mental instability. It read, in part, "He has what is called paranoi[a]. . . . He has an insane delusion of being a bandit and killing someone, and if he is not restrained in some way the result in two or three years can almost be predicted." Williams maintained his innocence, but after a mistrial was declared he agreed to take a lesser charge of second-degree murder and was sentenced to thirty-three years of hard labor at Caledonia Prison Farm. He was paroled on a governor's pardon after serving eight years. He went on to become famous for inventing the M1 carbine rifle and for being played by Jimmy Stewart in the MGM film *Carbine Williams*.

It is unclear whether Ava actually met her favorite teacher's notorious husband, but a 1951 article in the *Deseret News* reported that Ava used to "play around the machine shop at [Williams's] farm." The scenario fits even if the story itself is dubious. As a child Ava was a self-professed tomboy, preferring to play baseball

with the local boys and running around barefoot with her older brother Jack and his friends, who taught her how to smoke and chew tobacco and steal watermelons from the neighboring farms. It was also from the older boys that she gained her famously colorful vocabulary. Biographer Lee Server quotes Ava's neighbor and schoolmate Clarence Woodell describing another incident from Ava's younger years: "I remember one time she climbed the water tower out back of the school, maybe six feet up and hanging off a little ladder. You just didn't see many girls doing things like that in those days." "We were nothing if not game," Ava would say of her childhood "gang."

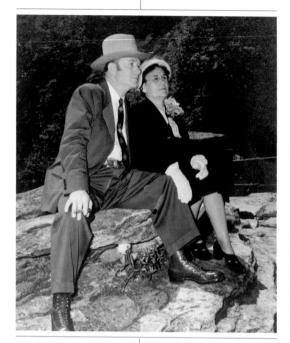

There was one unfortunate aspect of Southern living that seemed to have little effect on Ava's upbringing or her moral character. Segregation and racism were rife in the South during Ava's formative years, but throughout her life she displayed a refreshing lack of prejudice and went out of her way to show support for the black community. As a child she was taught the value of human decency. Blacks were to be respected and treated equally. In Brogden the racial divide, at least in the Gardner household, appears to have been blurry. However, weekend outings to nearby Smithfield brought the unfair treatment of blacks into focus. Ava was likely aware that her pale skin afforded her privileges and opportunities denied to her black friends. When at the local picture house, she could—and often did—sit in the balcony, a space reserved for blacks, without recrimination. Such a situation would have caused trouble had she invited a friend to sit with her down below. Then there was Shine, a black boy a few years older than Ava who came into town every year at the beginning of the tobacco-planting season, around January, and left when it was over in August. The Gardners gave him lodging at the teacherage, and he helped the planters in the fields cultivate crops and prepare cotton bales for auction. Ava, Shine, and Ava's cousin, Al Creech, formed a close-knit trio, playing around the farm after a hard days' work. It was like that every year until Ava turned ten and Molly began to suspect that Shine may have developed feelings for her youngest daughter that went beyond friendship. At the end of that season, Shine left Brogden and never came back.

The local Baptist church was another favorite haunt. On Sundays Ava would tag along with her mother's kitchen helper, Elva Mae, to Tee's Chapel Church (now called Tee's Chapel Free Will Baptist Church) in Grabtown, where the impassioned sermon and the gospel music sung by the Holy Rollers would set her spirit alight. Her participation in religion would wane as an adult, but those Sunday mornings at Tee's served as the inspiration for her lifelong love of music and dancing.

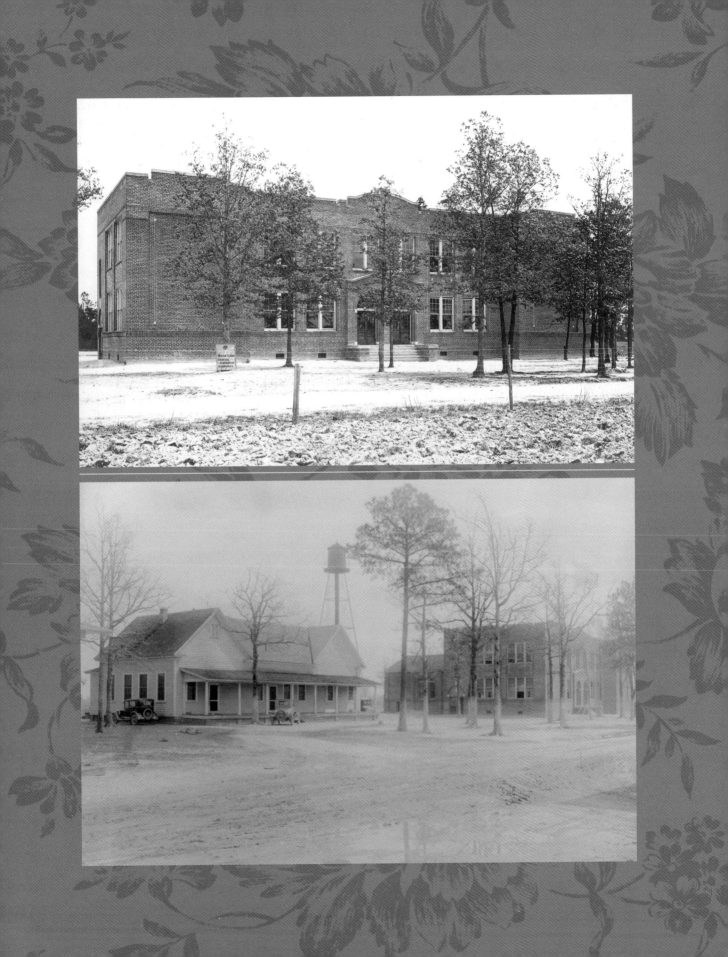

Above all there was the cinema, that mechanical source of escapism where, for twenty-five cents, you could immerse yourself in the magic of the silver screen and forget your troubles, at least for a little while. During the Depression, millions of Americans went to the movies on a regular basis. Ava and her mother were no exceptions. She recalled riding into nearby Smithfield with Molly in a teacher's automobile to see Victor Fleming's steamy pre-Code adventure *Red Dust*. In 1932, there were two dedicated picture houses in Smithfield. The probable venue for this particular moviegoing experience was the Sanders Theater on East Market Street, operated by H. P. Howell. When the Sanders burned down in 1934, Howell built another cinema that bore his name and is still in operation today.

Red Dust is arguably the most memorable of the six films costarring blonde bombshell Jean Harlow and MGM's "King of the Movies," Clark Gable. Set on a rubber plantation in Indochina, the story focuses on a love triangle between a rough-and-tumble planter and two women—a tough-talking vagabond and an elegant married woman. Edwin Schallert of the *Los Angeles Times* described it as "sexed to the limit" and "hardly" appropriate "for the youngsters." Perhaps Schallert was right, yet this film marked the beginning of what for Ava would be a long association with Gable. Ava came of age around the same time that Margaret Mitchell's wildly popular novel, *Gone with the Wind*, was published. She read the book in school, and like many girls and women around the world, she was drawn in by the complicated romance between Southern belle Scarlett O'Hara and swarthy Charlestonian rogue Rhett Butler. Ava was also swept away by Mitchell's romantic portrayal of antebellum plantation life, as far removed as it was from her own lived experience. Above all, she dreamed of one day meeting her own version of Rhett. When Gable came up for the part of Rhett in David O. Selznick's 1939 film version, Ava's crush was solidified, and she joined thousands of female moviegoers across the country in believing him perfect for the role. But for now, Gable and the world of the movies existed only on-screen.

N 1935, WHEN AVA WAS THIRTEEN, THE GARDNERS WERE forced to find a new solution to their economic problems. The local school board decided to close down the teacherage, and Jonas could not support the family on his own. To make ends meet, they packed up and moved north to Newport News, Virginia, where Molly was put in charge of a boardinghouse for dockworkers on West Avenue and Jonas worked in a sawmill. Newport News was

> Above all there was the cinema, that mechanical source of escapism where, for twenty-five cents, you could immerse yourself in the magic of the silver screen and forget your troubles, at least for a little while.

a world apart from rural Brodgen, North Carolina. The construction of the Chesapeake and Ohio Railway terminus in the late nineteenth century transformed what was once a small farming and fishing hamlet into an industrial city whose shipyard played a major role in the mining and export of coal from West Virginia. Ava had marveled at the paved roads and sidewalks in Smithfield, but Newport News had all of that and then some: public transportation in the downtown area, a brewery, fancy hotels, and four-story buildings.

Ava enrolled at John W. Daniel School, located at 222 32nd Street (now Christopher Newport University). Lucille Briggs lived near the boardinghouse in Newport News and recalled that Ava "was a rather shy person, on the quiet side. She didn't have a bubbly personality. She was the last one you'd expect to succeed." Ava never forgot the way her classmates at John W. Daniel School laughed at her when she was asked to tell everyone in her pronounced Tar Heel accent what her father did for a living. It was not just her accent that made her feel self-conscious. Despite her mother having steady work in caring for the male lodgers at the boardinghouse, the Gardners were still poor. Ava wore hand-me-down clothes while the other girls in school seemed to have a never-ending supply of new dresses and shoes. And although she settled in quickly and made friends, she felt embarrassed about her living situation and never invited any of them home after school or to spend the night on weekends.

Ava started ninth grade at Newport News High School in 1936 and fell in with a group of friends that included Lilly Bec Zehmer. They enjoyed roller-skating and riding bicycles around the city. "We used to walk to Newport News High School then, picking up people as we went along," Zehmer told the Newport News *Daily Press*. "She was one of the gang. We all liked her very much." On the whole, Ava kept her head down and stayed out of trouble, which would explain why Ethel Gildersleeve, the

The corner of 30th and Washington Avenue in Newport News, Virginia, ca 1930. The Gardners lived one block west of this intersection at 3012 West Avenue.

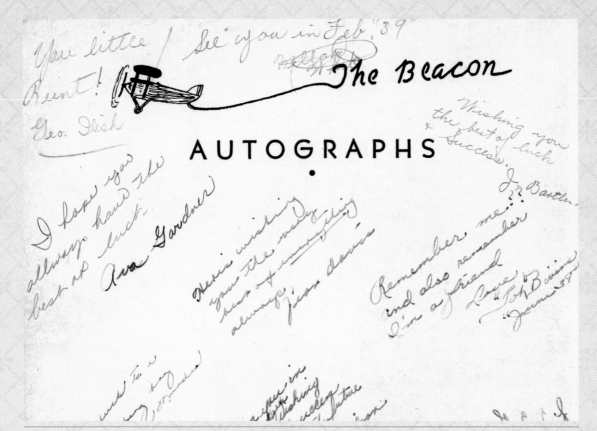

The Beacon

AUTOGRAPHS

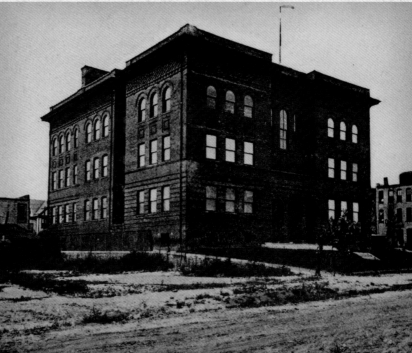

from top: A page from the back of an unknown student's copy of the 1938 Newport News High School yearbook, *The Beacon.* Ava left a message on the left that reads, "I hope you allways [*sic*] have the best of luck. Ava Gardner." • Newport News High School, located at 3100 Huntington Avenue in Newport News, Virginia. The building is now called Huntington Hall and is utilized by the United States Navy.

former dean of girls at Newport News High, didn't remember her. Zehmer recalled Ava's interest in singing, but as a student Ava neither failed nor excelled. Her letters back home to friends in Brogden illustrated her disinterest in academics: "I'm taking French & it's about to run me crazy, in fact everything I'm taking is because I still hate it all."

Even if she disliked learning, high school was a time of great personal change for Ava. When the Gardners moved to Newport News she was still a tomboy in attitude and appearance. A portrait photograph taken circa 1934 shows an androgynous girl with blonde curls cropped above her ears, a sly half smile playing on her face. By fourteen she had let her hair grow out and was experimenting with makeup. By sixteen her hair had darkened to an auburn-brown color, and with a dash of red lipstick and a practiced sultry gaze she looked older and more mature than her years. The little girl from rural North Carolina was blossoming into a striking young woman. She had begun to notice boys, and now, suddenly, they noticed her in return, though Ava's shyness and Molly's fierce protectiveness ensured that first dates rarely turned into second ones.

> By sixteen her hair had darkened to an auburn-brown color, and with a dash of red lipstick and a practiced sultry gaze she looked older and more mature than her years.

Socially, Ava's experience coming of age in Newport News was similar to that of many American teenagers. But there was hardship at home. Her father, Jonas, was ill. What had always been thought of as a smoker's cough had developed into something much more serious in the years since they'd arrived in Virginia. Molly nursed her husband at home until his coughing fits got so bad she had no choice but to spend what little money they had to admit him to Riverside Hospital, where he died on the night of March 26, 1938. He was fifty-eight. Jonas's death was a tremendous blow to sixteen-year-old Ava, who had always felt closer to her father than she had her mother. When he was on his deathbed, Ava visited him daily, relating the latest news of his hero Franklin Delano Roosevelt and holding his hand to ward off loneliness. Jonas had been a man of few words, but when he called her "Daughter" Ava knew she was loved.

Jonas Gardner was buried at Sunset Memorial Park near Smithfield on March 28, and shortly thereafter Ava and her mother returned to North Carolina for good. Molly found a new job at another teacherage in Rock Ridge, not far from Brogden. By this time Ava's brother Jack was earning enough money to help her finish high school. She graduated with the Rock Ridge High class of 1939. Shortly afterward she visited her eldest sister, Beatrice ("Bappie"), and sat in her brother-in-law's camera store while he took several portraits of her, one of which would change the course of her life.

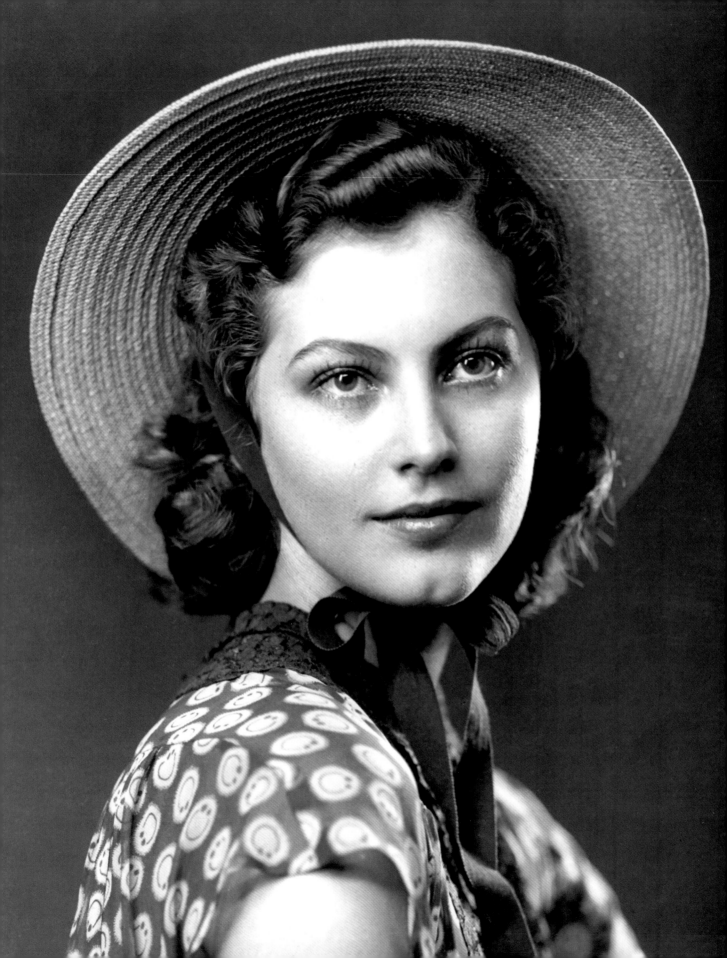

CHAPTER **TWO**:
New York

AVA WAS NOT YET EIGHTEEN WHEN SHE ARRIVED IN Manhattan in 1940. She had visited Bappie before, but it was always under the protection of Molly. This was to be the first adult trip Ava ever made; she hoped to sample some of the glamorous, big-city life that she read about in magazines and that her sister raved about in her letters home. Maybe she would even manage to find work.

Ava's professional ambitions didn't reach far beyond a secretarial job or a sales-girl position at Bloomingdale's. But as she would discover, even those jobs proved hard to get. She felt discouraged after a string of rejections from employment agencies. She had no experience, and her strong Southern drawl made her the butt of jokes wherever she went. Yet despite the rejection, Ava enjoyed New York. The city was buzzing with life. Broadway lights excited her, and she mercilessly dragged Bappie to jazz clubs or to the movies every evening. This was the year *Gone with the Wind* was the biggest cinematic hit in the world, and Ava saw the film many times. Clark Gable was still her favorite movie star, and his image as the dashing Rhett Butler fed her own romantic dreams.

Romance and men, however, were to remain in the sphere of fantasy, at least for now. Ava's beauty attracted attention wherever she appeared, but her solid, old-fashioned upbringing and the constant protection from Bappie kept men at bay.

One man who did not hide his admiration for Ava's looks was Bappie's husband, Larry Tarr. His family owned a chain of photographic shops around New York City, and Larry was in charge of a small but elegant branch on Fifth Avenue. He was a typical New Yorker: fast-talking, wisecracking, full of energy. He was convinced that his sister-in-law was no ordinary girl. He'd photographed hundreds of pretty girls, but in Ava he noticed something special. When she returned to their home after an evening of jazz or a movie with Bappie, her face was lit with excitement; her eyes flashed

opposite: The photograph that launched Ava's career. Taken by her brother-in-law Larry Tarr in his Manhattan studio. Courtesy of Photofest.

like green flames; her every move seemed to be dictated by an electric current within her. Beneath the surface of this well-mannered, shy country girl seemed to linger a whole different person, and Larry was eager to capture that duality with his camera.

Ava agreed to be photographed. She was flattered by Larry's enthusiastic compliments and thought a nice portrait would be a lovely gift for Molly. She posed in the Scarlett O'Hara fashion of 1940, with her angular face framed by a straw hat and a ribbon tied in a bow under her chin. The photo was good, she thought, but nothing out of the ordinary. She didn't consider herself to be particularly photogenic, and she didn't give the session a second thought.

Meanwhile, her trip to New York was coming to an end, and as she hadn't managed to find a job, it was time to go back to North Carolina. Ava was despondent, unsure about what her next step should be. After the experience of trying to find employment in New York, she realized that she did not have the qualifications to be considered for any respectable job, be it in the city or back at home. She wasn't sure what path she wanted to take. There were few professional choices for women outside the home in the 1940s. Secretarial work was popular, and Ava decided, with little enthusiasm, that it was the best option for her. Her brother Jack offered to pay her tuition fees, so she enrolled for the fall semester at Atlantic Christian College in Wilson, North Carolina, where she became a popular student on campus. Although her academic record was never much above average, her physical appearance made her impossible to overlook. She was singled out as a "campus beauty" in the 1941 issue of the *Pine Knot* (the ACC student yearbook). Ava is framed in a medium close-up, looking away from the camera, her head tilted demurely to the side. A string of faux pearls sits around her neck and a garland of flowers covers one shoulder. It is a rather artistic photograph, but Ava had been practicing posing in front of the camera. Among her admirers was Steve Hilliard, the son of the college's president. By that time Ava had developed a real passion for big-band music and went out dancing as often as she could. Still very much under the protective eye of Molly, she was allowed the freedom of seeing a movie or going to a dance with a boy, but she had to be home by eleven.

During her months in college Ava dated a boy named Ace Fordham, who shared her love of dancing and movies. Decades later he would remember that one of the first films they went to see together starred Mickey Rooney. Although her activities at the Atlantic Christian College and her social life kept her fairly busy, Ava had trouble getting her last visit to New York out of her mind. Being back in North Carolina after having experienced the hypnotizing atmosphere of Manhattan's jazz venues and the

> Beneath the surface of this well-mannered, shy country girl seemed to linger a whole different person, and Larry was eager to capture that duality with his camera.

opposite: Ava was singled out as a "Campus Beauty" in the 1941 issue of *The Pine Knot* yearbook at Atlantic Christian College in Wilson, North Carolina. Courtesy of Barton College (formerly A.C.C.).

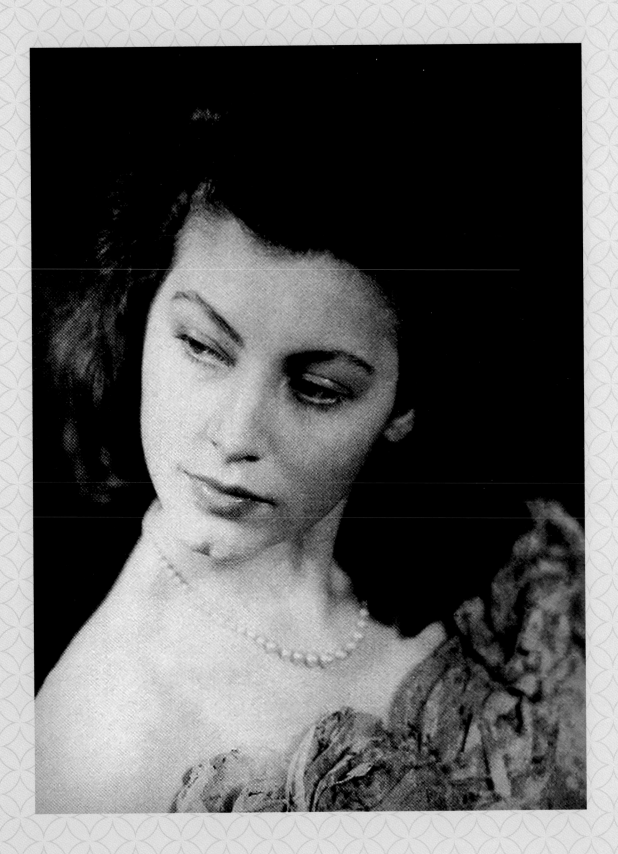

excitement of Broadway, she couldn't help feeling restless and bored. She finally managed to convince Ace Fordham to drive to New York for a few days' visit.

The excitement of being back! Once again Ava couldn't get enough of all the activities the city had to offer: dining out, seeing movies, dancing. And there was no eleven o'clock curfew like there was at home. This city never slept, and Ava loved it. She still didn't dare to dream it could become her permanent way of life, but while it lasted she would enjoy it to the fullest. And this time the city was taking notice of her as well.

One evening, while dining out with Ace and Bappie, Ava spotted Henry Fonda sitting a few tables away in the company of an elegant woman. Ava could not believe her eyes; it was the first time she had come face-to-face with one of those godlike creatures she'd admired on-screen for years. He wasn't Clark Gable, but he was handsome and exuded Hollywood glamour. She simply *had* to approach him and ask for an autograph. Years later Ava still remembered the encounter; in her memoir she wrote with amusement about her nervous clumsiness and Fonda's gracious manner. But it was Fonda's companion who, struck by the young girl's magnetic presence, remarked prophetically, "You are so pretty, you should go to Hollywood." Back at her table, Ava, still shaking with excitement, recounted the conversation to Bappie and Ace. Bappie knew that the woman wasn't just being kind; in fact, Bappie and Larry had been talking for months about the special qualities her younger sister possessed. They wanted to find a way to put those assets to use. But to Ava, Hollywood and the movies seemed so unreal, so far removed from everything she was accustomed to, that she found it impossible to even contemplate such a suggestion. She knew she was pretty. She hadn't failed to notice the effect she had on men as she walked down the street, or on the boys who often peeked through the glass doors to catch a glimpse of her at Atlantic Christian College. But how could any of that compare to the larger-than-life figures on the screen? Joan Crawford, Bette Davis, Katharine Hepburn—these women were stars; they were confident, elegant, independent. She was just a country girl from North Carolina who could barely make herself understood when ordering a soda, never mind delivering a line in front of a camera.

As their brief time in New York came to an end, on their last evening in the city, Ace invited Ava to a jazz club. She had adored the atmosphere of the live bands, and jazz seemed to fuel her energy and suit her nocturnal nature. Once again she attracted attention when a bartender asked if she was by any chance a singer. He knew a bandleader who was looking for a female singer, and if Ava's voice was half as good as her looks, she'd be sure to get the job. She felt a new rush of excitement. A big-band singer! Now that was something Ava could envisage herself doing. Music had been a passion for as long as she could remember. Back home she'd spend hours listening to the radio, and both she and her mother sang around the house. Singing was in her blood.

The next day Ava went to audition for her big job, and Ace was forced to delay their return to North Carolina. In her memoir she remembered recording a song that was to be sent to the bandleader, but Ace maintained that it was a live audition in front of "industry men." Ava lacked two essential qualities of most professional singers: technical training and experience singing in front of an audience. Yet her voice was pleasant, and she had a natural sense of rhythm and a feel for phrasing. She was convinced that she'd return to New York within weeks to start her career with the jazz band.

Back in North Carolina Ava busied herself by telling her schoolmates about the big-band career that awaited her. And in New York, destiny was paving its own path. Larry Tarr had placed his portrait of Ava wearing the straw hat in the window of his shop on Fifth Avenue. It was the same portrait Ava had brought home more than a year earlier as a nice gift for Molly. No doubt many passersby were caught by the young beauty's mesmerizing gaze, but it was one particular New Yorker whose interest would change the course of Ava's life.

Despite the various accounts that make up the mythology surrounding the circumstances of Ava "being discovered" by an MGM talent scout, the man who spotted Ava's portrait in the window of Tarr's photography studio was never even an employee of Metro-Goldwyn-Mayer. In fact, he worked in the legal department of Loew's Inc., a corporate parent of MGM. In the early 1940s, the name Metro-Goldwyn-Mayer resonated power, money, and an otherworldly aura of glamour. This was, after all, the dream factory that prided itself on having more stars than there were in heaven. By his own admission, Barney Duhan often used the close connection between his employer and the famous film studio to his advantage. A young man introducing himself as a runner for Loew's Inc. was unlikely to impress the many young and ambitious beauties of New York, but dropping the name *MGM* could guarantee a date with practically every aspiring ingenue in the city.

It was an early evening in the spring of 1941 when Barney Duhan, on his way to a party, walked past Tarr's on Fifth Avenue. He did not have a date for the evening and, according to his own recollection, "felt what a lousy luck it was" that "with his looks and income" he should be attending a party without a pretty girl by his side. The portrait of Ava, prominently displayed in the window, immediately caught Duhan's eye. Here was a girl he could take to any party and feel proud of. Now was the time to take advantage of his vague MGM connection, just as he had done many times before. Using the phone booth a block away, he called the shop.

"My name is Barney Duhan and I work for MGM. I'm interested in the girl from the photograph in your window. Can you give me her telephone number? I would like to talk to her."

The woman who answered the phone explained that the girl had already returned home, which, to Duhan's dismay, was in North Carolina. She would, however, pass on the message to Mr. Tarr.

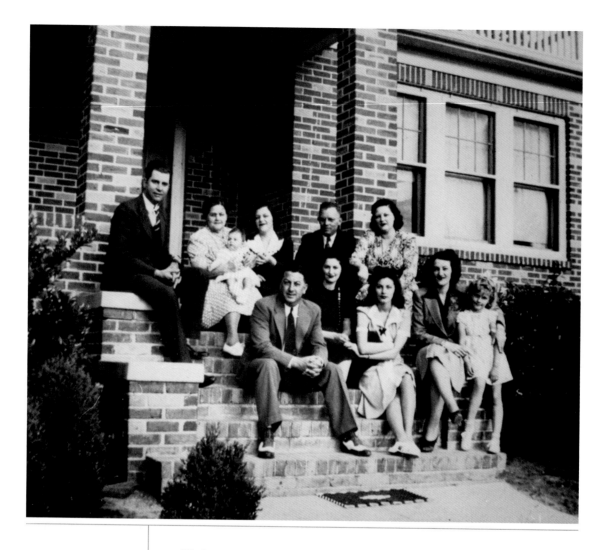

"Yeah, great, you do that." Disappointed, Barney Duhan went to his party alone, forgetting all about the beautiful girl from the photograph.

Ava spent the spring months completing her studies, but most of all waiting for the wire from the big-band leader. When the wire failed to come, she became depressed. What a fool she had been thinking that she could suddenly swap her simple life for a glamorous existence in the big city. Things like that didn't happen, except in the Joan Crawford movies. It was time to grow up, complete her course, find a job, think about marriage. She was still dating Ace Fordham, and, according to some of Ava's friends, he was thinking of proposing after Ava finished her studies at the Atlantic Christian College.

That spring, Ava first became aware of her mother's health problems. Molly never complained, and she kept all her health issues to herself, not wanting to bur-den her children with her troubles. During the early months of 1941 she suffered

severe pains and vaginal bleeding, confiding only in her daughter Elsie Mae and still firmly refusing to see a doctor. Ava knew that her mother wasn't well but was unaware of the seriousness of her condition, as her mother and her older sisters wanted to shield her from the truth. It was only later that summer that Molly finally agreed to seek medical attention. The diagnosis was cancer of the uterus, too far advanced to operate.

In July 1941, weeks after she graduated from Atlantic Christian College, Ava received a phone call from New York. It was Bappie. The line was bad and her sister highly excited, but from what Ava could make out, after a call from a man who had spotted Ava's picture in the window, Larry took some of her portraits over to MGM's New York office, and now they wanted to see her.

Ava was taken aback; she was angry that Bappie and Larry had made such elaborate decisions about her future behind her back. She was still recovering from the blow of not hearing back from the jazz band, and now this: another pipe dream. Molly and Bappie both agreed that Ava had to at least try. Although she was reluctant, deep down Ava longed for the opportunity. She feared rejection and disappointment, but she knew she had to go. She sent her friend Alberta a postcard in which she briefly summarized the situation. Decades later Alberta remembered getting the postcard and thinking that Ava was simply daydreaming about becoming a movie star: "I thought nothing of it. I threw the postcard away and have regretted it ever since."

Before she left for New York, Ava had a talk with Ace Fordham. She invited him to go with her, but he refused. He did not believe that Ava would end up in the movies; things like that just didn't happen to girls from Rock Ridge. He thought he'd be seeing her again within weeks, not ever imaging that it was their good-bye.

New York in 1941 was still instrumental in supplying Hollywood with talent and beauty needed for the production of motion pictures. When the business moved to the West Coast more than two decades earlier, the studio bosses made sure to leave trusted men behind to keep their eyes and ears open for new talent. MGM's talent hub was located at 1540 Broadway, and as the center of operations, the office was responsible for finding new contract players, directors, and writers, as well as plays and novels that would serve as the basis for movie scripts. It was to that very office that Larry Tarr personally delivered photographs of Ava in the spring of 1941, and it was there that Ava arrived with Bappie one summer morning.

She was interviewed by Marvin Schenck, head of the talent department, who, impressed by Ava's sultry looks, arranged for her to have a screen test the following day. The test was to be directed by Al Altman, renowned for his ability to spot potential and talent in untrained young actors. When MGM studio head Louis B. Mayer relocated to California, he left Al in charge of the East Coast talent search. It was Altman who, in 1924, discovered Lucille LeSueur, a shy chorus girl from Texas. He was convinced that she possessed special qualities, despite the fact that

opposite: In 1941, not long before leaving for Hollywood, Ava was photographed among family on the porch of her brother-in-law's house in Raleigh, North Carolina. Top row L–R: Bronnie Pearce, Molly Gardner, unidentified (possibly Ava's sister Myra Pearce), Johnny Grimes, Inez (Ava's sister). Bottom row L–R: Jack (Ava's brother), Myra (Ava's sister), Ava, Bappie (Ava's sister), and Mary Edna Grimes (Ava's niece). Courtesy of the State Archives of North Carolina.

the first two tests he shot of her had been rejected by the studio. Never one to give up on one of his discoveries, he shot a third test, capturing LeSueur in a natural and spontaneous mood. The bosses finally agreed to sign her. Lucille LeSueur assumed the name Joan Crawford and went on to become one of the biggest movie stars of all time.

Although Altman directed hundreds of girls, he maintained that he hardly ever encountered one who was truly beautiful. "Most of them were just pretty." Diana Altman, Al's daughter and a film writer, remembers that her father always maintained that Ava Gardner was the most beautiful woman he'd ever seen. She possessed a magnetism that made one feel he or she was in the presence of someone exceptional, an aura that went beyond her exquisite looks. Al was excited and couldn't wait to shoot the test. He began by asking her simple questions and encouraging her to tell him more about herself—where she was from, what school she went to, who her favorite movie stars were. It soon became clear that although the camera missed none of her beauty, Ava's strong Southern accent was almost incomprehensible. Not discouraged, Altman asked her to walk across the stage, carry a vase of flowers, and place it on the table. He wanted to show the feline grace with which Ava moved and the flawlessness of her slim figure. Yet nerves got the better of her; what was she doing here anyway? Who were all these men staring at her from behind the camera, and why were these damn lights so bright? She felt like a fool, and the experience left her humiliated.

> Her eyes narrowed and, no doubt fueled by the humiliation she felt, flashed a glimpse of a wild fire that only the eye of a movie camera could see.

To finish the test, Altman brought the camera forward and focused for a moment on Ava's face in a final close-up. A mere blink of an eye, yet it was this close-up that showed the magic quality that rested beneath the nervous exterior. Her eyes narrowed and, no doubt fueled by the humiliation she felt, flashed a glimpse of a wild fire that only the eye of a movie camera could see. The test was over, and Ava was convinced that her movie career was, too. Another disappointment, another humiliation to overcome.

That same evening, Al Altman and a few others from the talent department gathered in the projection room to view the day's tests. When Ava came on the screen, everyone was electrified by her presence. Was she the same nervous wreck they'd seen on the stage a few hours before? Sure, they couldn't understand a word she was saying, but it did not matter. The final close-up convinced everyone that they had before them someone very special. Altman knew that MGM would reject Ava if they heard her Southern drawl. If they rejected Joan Crawford they would surely reject this kid, too. Yet, just like with Crawford two decades earlier, Altman knew beyond any doubt that Ava Gardner's place was on the movie screen. He spent that sleepless night editing the test: cutting out the interview and focusing exclusively on the parts

in which Ava's looks were highlighted. He eliminated the soundtrack completely and sent the silent screen test to Hollywood.

Ava had just returned home to North Carolina when she received a phone call from New York. MGM had seen the test and was ready to sign her to a contract. She would have to be back in New York within a week and depart for California thereafter. Ava was stunned. The whole family was. Yet there was no doubt: Ava had to go. It was a chance for a better future, a fairy-tale life she could not turn down. Molly, still concealing the seriousness of her condition, gave her beloved daughter her blessing. She was, however, adamant about one thing: Ava could not go on her own. Bappie would go to California to look after her younger sister while Larry Tarr stayed behind to mind the family business in New York.

On July 31, 1941, the *Film Daily* reported, "Ava Gardner, MGM's latest eighteen-year-old Cinderella, is on her way to the Coast after successfully passing a screen test." To Ava it all seemed like a dream; just weeks before she'd been trying to find a job as a secretary, and now she was on her way to Hollywood to be an MGM actress. Such things did not happen to farmers' daughters from Grabtown, North Carolina. The sisters boarded the Twentieth Century Limited train in New York, accompanied by a publicist named Milton Weiss, whose job was to protect newly acquired studio property. By sheer coincidence, traveling on the same train was Hedy Lamarr, Hollywood's latest exotic glamour girl. Her presence only added to the fantastic aura that surrounded those three days. Ava gazed out the window at the changing scenery, imagining the mysterious place they called the dream factory that awaited her at the end of the trip.

Ava as she appeared in her first screen test in New York. Director Al Altman felt that sending a silent test to his boss in Los Angeles would be Ava's best bet for a contract.

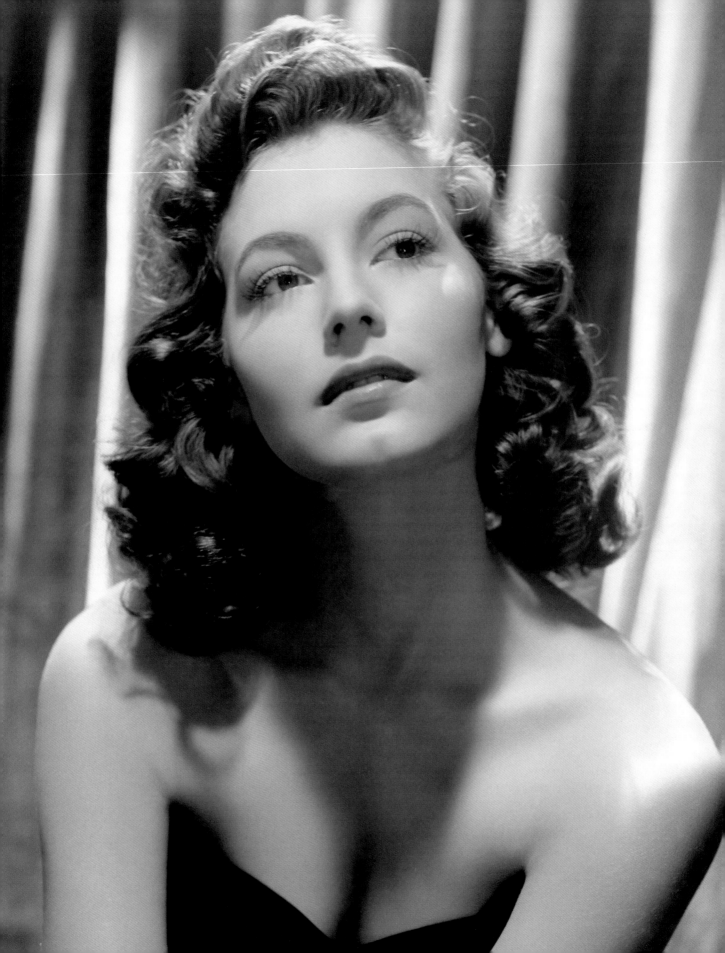

CHAPTER THREE:
The MGM Starlet

LOS ANGELES WAS UNLIKE ANY PLACE AVA HAD EVER BEEN to. It lacked the skyscrapers of New York and the compactness of Newport News, and it was certainly more sprawling and busy than Smithfield or Brogden. Its year-round temperate weather and close proximity to the ocean, mountains, and desert made it a perfect playground for the nouveau riche of the film industry.

Ava and Bappie settled into a small studio apartment at Hollywood and Wilcox, near the Iris Theatre (now the Fox). It had a bed that pulled down from the wall and a small kitchen where the sisters could cook. In spite of the variety of cuisine she was introduced to during her career, Ava never forgot the taste of good Southern home cooking. "I *love* to cook," she said. "All my family does. Plain, simple meat and potato things. Being from the South I suppose fried chicken is my specialty." It wasn't much in terms of space, but it was all they could afford on Bappie's earnings from the I. Magnin department store and Ava's paltry starting salary of fifty dollars per week.

On August 24, 1941, Milton Weiss introduced Ava to her new place of employment. MGM was then the largest of the major film studios operating in southern California. There were three lots spread over 167 acres in Culver City; thirty soundstages; thirteen miles of paved streets in replica historic towns; a patch of jungle; a man-made lake; a working zoo that was home to Leo, the company's famous lion mascot—not to mention a hospital and a school where child actors received a semblance of education. *Life* magazine called it "a complete little city in itself." "In periods of peak production, which was most of the time, the studio had six thousand employees and three gates to accommodate them," wrote Scott Eyman, in his biography of Louis B. Mayer. The studio boasted "more stars than there are in heaven," with a roster that listed some of the top talent in American cinema, including James Stewart, Katharine Hepburn, Greer Garson, and the "King of Hollywood" himself, Clark Gable. Heading the operation was Mayer, a Ukrainian-Jewish émigré who had fled Russia with his parents to escape religious

opposite: An early Hollywood glamour portrait taken by MGM's Clarence Sinclair Bull around 1942.

MGM publicity portraits taken by Clarence Sinclair Bull, early 1940s.

persecution and the pogroms. Having risen from salvaging and selling scrap metal as a young man in St. John, Canada, to becoming a major power player in the film industry, Mayer exemplified the American dream.

Sitting behind "a white-leather-sided crescent-shaped desk" in an office that, in Eyman's words, "was designed to intimidate and it succeeded splendidly," Mayer ruled over his "family," as he referred to his employees. He arranged marriages, covered up scandals, issued suspensions to actors, and for a quarter century produced a steady output of films that kept Americans glued to cinema screens. He preferred his employees to call him "Uncle Louis," and was referred to in return as "the devil incarnate," "a Jewish Hitler" with "no feeling for people, period," "a great executive," and "a showman." People either loved him or hated him, but few would deny that he ran his business shrewdly and effectively. Ava would have plenty of time to decide how she felt about her new boss.

Getting the hang of life at MGM at first proved difficult. Ava was shy and insecure, and the fast-paced environment of a film studio was a frightening new experience. All new MGM recruits underwent a process of transformation. It was part of the Hollywood system and the basis on which the big studios operated. No one was more adept at creating somebodies out of nobodies than Mayer. "The idea of a star being born is bushwah," he said. "A star is created, creatively and cold-bloodedly, built up from nothing, from nobody. . . . We could make silk purses out of sow's ears any day of the week."

In Ava's case, the goal was to transform her from a country bumpkin into something otherworldly. She reported to acting classes with resident dramatic coach Lillian Burns, who taught her how to walk and sit with correct posture, and how to emote and emphasize her line reading. Elocution lessons were also required to rid Ava of her Southern accent. It took her six months to lose it. "I worked very hard and disliked my accent intensely," Ava told reporter Gladys Hall. "We kidded about it so much." Many American film actresses of the time acquired what was referred to as a mid-Atlantic accent. Katharine Hepburn, Carole Lombard, and Bette Davis were classic examples with their half-British, half-American vocal inflections that couldn't be traced to any one location or another. In her early speaking roles, Ava would affect a similar dialect, but it never quite managed to sound natural. Only years later would she let some of her natural drawl come through, and by then she had come into her own as a performer and a star.

Makeup artists Jack Dawn and Charlie Schram took charge of Ava's look. Her natural beauty lent itself to glamour, but too much makeup could make her look vampish. Ava allowed Dawn and Schram to experiment with her lips' shape and color but refused to have her eyebrows plucked to the point of obliteration, as happened to many starlets. Red or orange-tinted lipstick, powder, mascara to set off her green eyes, and long curls parted on the side appeared to be the right combination for the fresh and beautiful girl-next-door persona she embodied early in her career. Unseemly "defects" were covered up. In a conversation with Lee Server, Ann Rutherford (who played Scarlett O'Hara's little sister in *Gone with the Wind* and was the costar of the Andy Hardy movies) remembered seeing Ava in the makeup department, where "the makeup man was busy attempting, against his better judgment, to fill that dimple in her chin . . . with mortician's wax!" Fortunately, the "brainless producer" who suggested that particular touch-up had a change of heart. Ava's cleft chin was arguably her defining feature.

Ava's hair was placed in the capable hands of Sydney Guilaroff, the expert hair stylist responsible for Louise Brooks' signature black bob and many a famous cinematic coiffure. He and Ava met in the makeup department on Ava's second day at work. "With one glance I was swept away by her breathtaking beauty," Guilaroff wrote in his 1996 autobiography, *Crowning Glory*. "She didn't even need cosmetics to be stunning. . . . She was impossible to ignore." Their friendship was sealed soon afterward when he was doing a teaching demonstration in his salon for his junior stylists. Ava irritated him by nervously cracking a piece of chewing gum between her teeth and lips. Ava was so timid when he approached her that he "found her crouching down in her chair, cowering in fear lest she arouse my anger."

This studio test shot was attached to Ava's MGM employment questionnaire in 1942. Courtesy of Royal Books, Baltimore.

"With one glance I was swept away by her breath-taking beauty. . . . She didn't even need cosmetics to be stunning. . . . She was impossible to ignore."

—SYDNEY GUILAROFF

Although Guilaroff was known among Hollywood actresses for his discretion and trustworthiness, his memoirs are somewhat dubious. In addition to styling her hair, he took credit for guiding Ava's career and also claimed that they later had a sensuous love affair. This last detail seems particularly suspect. Guilaroff's homosexuality was an open secret in the film community, despite his transparent denial in the pages of *Crowning Glory*. How much truth is in his story about Ava remains unknown. But they did become close friends and worked together on several of her films, and he made some pointed observations about her career, particularly MGM's apparent inability to figure out how to use their new contract player.

Ava was thrust into background work, posing for cheesecake shots to get a feel for the camera, and to learn firsthand what happens on a film set. In her first five years as a contract player for MGM, she appeared (uncredited) in no fewer than twenty features and shorts. Some of them were big films with bigger directors and established stars—*Reunion in France*, starring Joan Crawford; *Shadow of the Thin Man*, directed by Woody Van Dyke and starring Myrna Loy and William Powell; *Babes on Broadway*, directed by legendary choreographer Busby Berkeley, featuring Judy Garland and Mickey Rooney. Blink and you'd miss Ava playing a waitress, a graduate, a shopgirl, the girl in a car lighting someone's cigarette. Her job then was to simply look pretty, and Guilaroff helped by making sure her hair looked perfect even if she was just an extra.

When not flitting from one soundstage to another as an extra, Ava could often be found having her portrait taken for publicity. Printed material was just as important as films were when it came to keeping a star of any magnitude in the public eye. Studios employed in-house photographers to capture stars at work and at play. A steady stream of portraits of stars both in and out of costume, scene stills, modeling shots, and candids were mailed to magazines and newspapers around the country and abroad. Ava posed for some of the great photographers of the studio era. Eric Carpenter captured her frolicking on the beach in Santa Monica with Leatrice Joy Gilbert (daughter of silent star John Gilbert). She was photographed modeling lingerie by Irene Gibbons for *Life* magazine, and she posed for Luis Lemus wearing a blue satin gown for American *Vogue*. In the gallery at MGM, Clarence Sinclair Bull, Laszlo Willinger, Virgil Apger, and Carpenter applied their own specific brands of lighting and expertise. Willinger, who had trained in the style of German Expressionism, was particularly adept at using harsh light and shadows to create a mysterious

Playing tennis in the early 1940s.

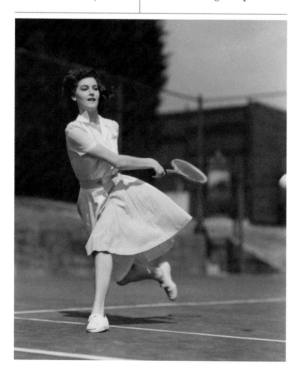

quality in his portraits. The goal of studio portraits was "glamour," loosely defined by Howard Strickling as "you know, sort of a suffering look."

It was the photographer's job to make sure publicity portraits were sexy and earnest but not so much so as to be penalized by the Production Code that governed morality in Hollywood cinema. "For instance," Willinger later said, "you couldn't show the inside of a thigh! Ever tried to photograph a dancer like Eleanor Powell and not show the inside of a thigh? You couldn't show cleavage. What the retouchers did was make a breast that started at one shoulder and continued to the other—no shadow!" Ava commented on Eric Carpenter's method of eliciting glamour for his photographs: "He stands behind the camera and says 'O.K. let's make this one sexy.' Then he tells me to slit my eyes and poke out my bottom lip and wet it. That's supposed to be sexy too."

Happy, sultry, serious—Ava portrayed a range of instructed emotions for the still cameras. She was photographed wearing swimsuits and the latest in 1940s day and evening wear. She was pictured getting the mail on a bicycle, playing tennis, saluting the American flag. All holidays were covered for publicity; Ava pretended to paint Easter eggs, and she posed as a beautiful witch for

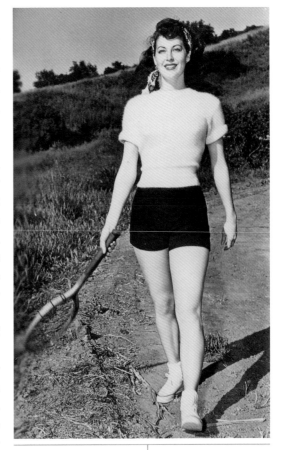

Ava on her way to the tennis court in Los Angeles. Despite her glamorous appearance, she remained a tomboy at heart.

Halloween and as Santa's sexy helper for Christmas. Looking back on those early years, she brushed off her photographic work with self-deprecation, much as she would many aspects of her career: "I spent a lot of time doing publicity stunts. Sitting with skis on a sand dune down at the beach, posing on a block of ice, crap like that. So there are ten million photographs of me."

Her early publicity portraits show a beautiful young woman with striking features—no different from other starlets in that respect. But there is something more to these photographs of Ava. Acting skills could be learned; presence was innate. She may not have been aware of possessing star quality, but it came across in photographs and would do the same on-screen.

Ava's first real exposure to fame came not from being a movie star but from marrying one. Elfin in stature and perpetually boyish in nature, Joe Yule Jr., better known to movie audiences as Mickey Rooney, was then MGM's top moneymaker, with the Andy Hardy franchise and his popular on-screen partnership with singing sensation Judy Garland leading him to be branded the "All-American Boy." Being a film fan, Ava had of course seen him on-screen at the picture house back in Smithfield, but she was thrown off guard during their first encounter.

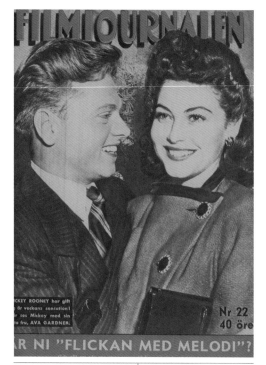

Ava and her first husband, Mickey Rooney, on the cover of Swedish magazine *Filmjournalen*.

opposite, clockwise from top: Newlyweds Ava and Mickey Rooney on the golf course in 1942. Golfing was one of Mickey's favorite activities. • Ava accompanied ex-husband Mickey Rooney to the premiere of *The Story of Dr. Wassell* at the Paramount Theatre in Los Angeles, June 10, 1944. • A colorized portrait of Ava and Mickey at home.

It happened during her initial tour of MGM. She and Milton Weiss stood off-camera on Sound Stage 7, watching a film in production. Suddenly Mickey appeared in full drag as Carmen Miranda—platform heels, giant fruit hat, and all. He was in character for a scene in *Babes on Broadway*. The introduction could not have been more bizarre if it were planned in advance.

Mickey was immediately taken with Ava, so much so that he phoned her that very evening and asked her to dinner. She declined, as she did the next night, and the night after that. Finally, at the urging of Bappie and of Mickey's friend Sidney Miller, Ava agreed to go on a date. Photographers would be out in force; a photo of Ava with Mickey would put her in the spotlight, and association with him could help her career. They ended up at Ciro's nightclub on Sunset Boulevard in West Hollywood, a popular spot for dancing and live music. Ava's shyness wore off as the evening went on. Mickey had charm and energy in abundance, and a certain kind of attraction. "He would have had a beautiful body if he were a foot taller," she later told Joe Hyams.

After that first evening at Ciro's, Ava and Mickey became an official item. According to Rooney biographers William Birnes and Richard Lertzman, "Mickey was obsessed with Ava." He proposed marriage on a daily basis, and as she had when he'd called her after their first meeting, Ava turned him down. She was only eighteen and still a virgin. Her previous experience with dating had been awkward and limited. Now she had one of the biggest stars in the business—just two years her senior—trying to coerce her into matrimony. Mickey was not deterred. If anything, her rejections emboldened his fervent attempts to break down Ava's barriers: "After the first date, every day I proposed marriage. She didn't say yes, but her no began to sound less firm after a time. She went from 'You're crazy, Mickey, I hardly know you' to 'Marriage is a serious thing, Mick,' to 'What'll our life be like?' It was clear to me that I was making some progress."

Just before Christmas of 1941, she and Mickey announced their engagement. On January 10, 1942, two weeks after Ava's nineteenth birthday, they were married in a civil ceremony in Ballard, California, with Bappie and Les Petersen, Mickey's ever-present right-hand man, as witnesses. The one person who Ava wished could have been there to see her get married was unable to attend. Molly Gardner was ill with terminal cancer and not well enough to make the journey from North Carolina.

Not everyone was pleased with Ava's becoming the first Mrs. Mickey Rooney. Louis B. Mayer was infuriated when the couple broke the news of their engagement to him. It was bad for Mickey's boy-next-door image, even though an image was all

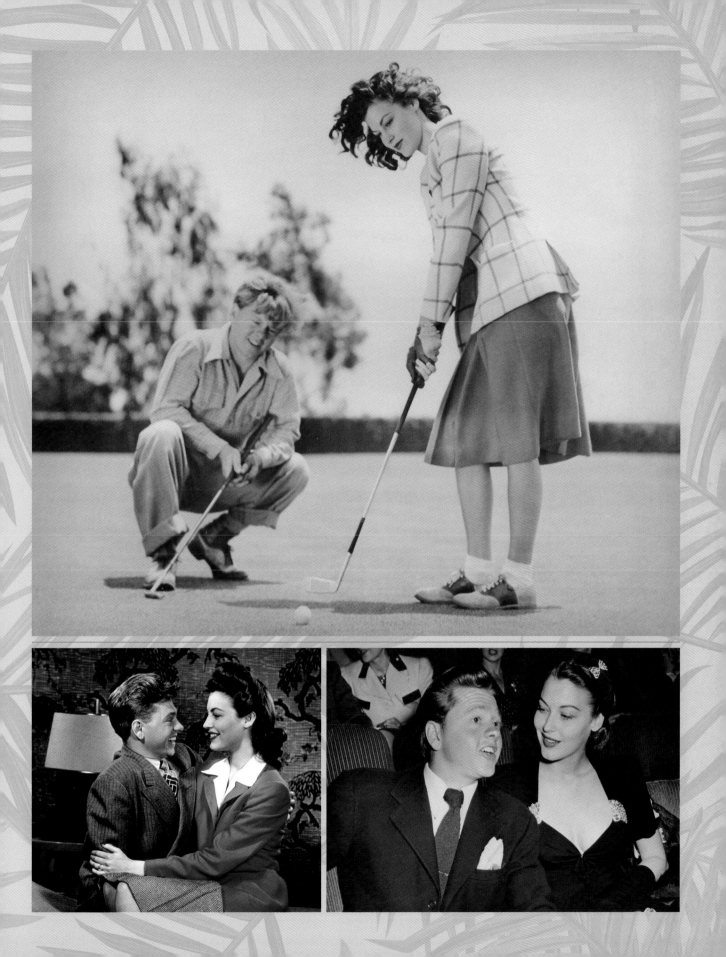

it was. He was well-known for chasing ladies on the MGM lot. Sydney Guilaroff also had strong opinions about Ava's paramour: "I called him the 'All-American Nothing.' I found him vulgar, coarse, and common, so very obnoxious that I couldn't even bear to talk to him." Still, what would his fans think of Andy Hardy being taken off the market? "I was lousing up his career by marrying him, everyone said," Ava later told Joe Hyams. Mickey had threatened to break his MGM contract and lend his services to another studio if Mayer refused them permission to marry. Given the actor's financial worth, Mayer had little choice but to relent.

From day one, the studio played a major role in the Rooneys' relationship. Les Petersen was constantly in the background. Publicity was tightly controlled. There were perks for Ava, including experiencing a sexual awakening. She also got to meet her father's hero, President Roosevelt, during a special White House luncheon for FDR's sixtieth birthday. Ava, Mickey, and others from the Hollywood community had partaken in a fundraiser for an infantile-paralysis campaign headed by the president. Ava had a traditional view of marriage: being a faithful partner, running a household, having children. But she discovered early on that they were both too young to adhere to those ideals, and Mickey, in particular, was too absorbed in his career and his bachelor lifestyle. He had been in show business his whole life and didn't know how to settle down in a serious relationship with one woman. "Ava feared that living with Mickey would be like [being] on a soundstage 24/7, and that Mickey would always be on," wrote Birnes and Lertzman. "And he was, because he didn't know *how* to be off."

Nine months after it began, the Rooney marriage was over. Ava sued for divorce in Los Angeles on September 15, 1942, citing "mental cruelty" and asking for "reasonable alimony." A year later it was final. Looking back on the situation, she told Joe Hyams, "I thought I had found what I wanted when I married Mickey, but I found I was neither a wife nor a companion—just a bewildered audience for Mickey's personality."

By age twenty, Ava had learned some hard lessons about life and marriage, and there were still more to come. On May 21, 1943, the day Ava's divorce from Rooney was legally granted, Molly Gardner died of uterine cancer at Rex Hospital in Raleigh, North Carolina. The funeral was held on the 24th, in Smithfield, delayed for a day so that Ava and Bappie could attend. Molly was fifty-nine years old. It was a harsh blow for Ava, who always felt guilty about leaving her sick mother behind. Molly had been the family matriarch and breadwinner. She had instilled tough morals in Ava while at the same time encouraging her to seize the opportunity to get out of the South and become a star.

That same year, MGM decided to loan Ava out to Poverty Row studio Monogram for the small part of Betty in the horror-comedy *Ghosts on the Loose*. The film was a

By age twenty, Ava had learned some hard lessons about life and marriage, and there were still more to come.

opposite: Ava and James Craig in a publicity portrait from *She Went to the Races* (1945).

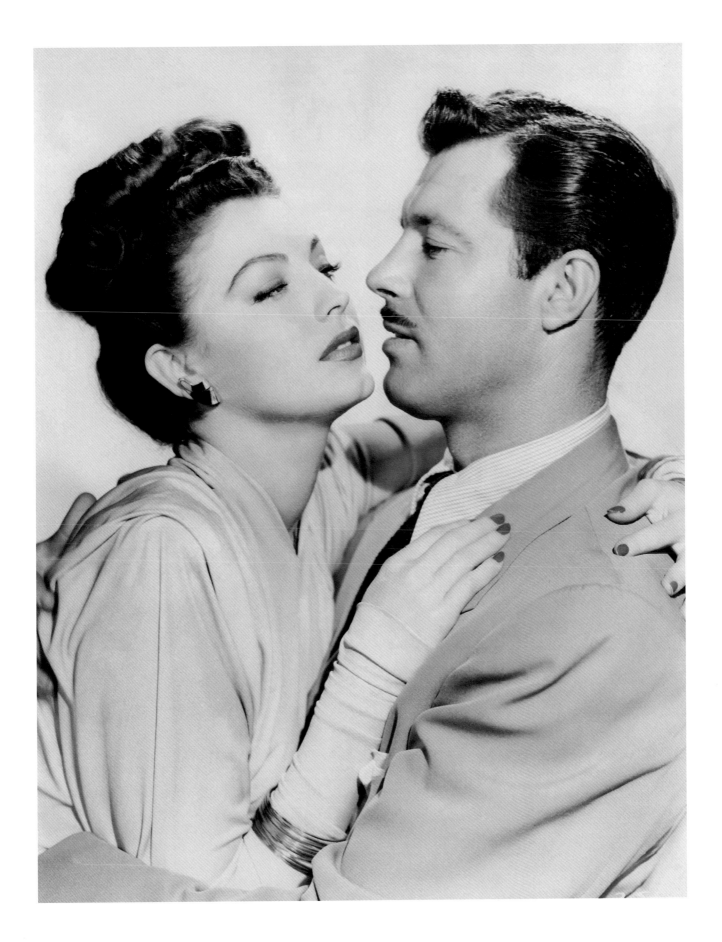

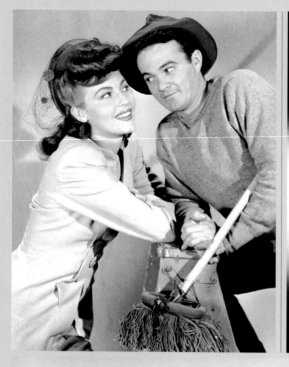

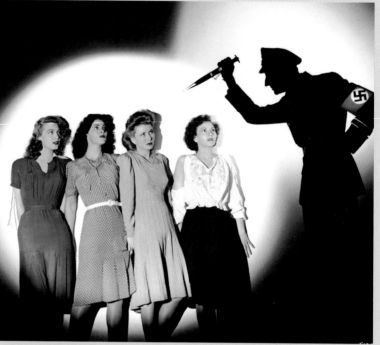

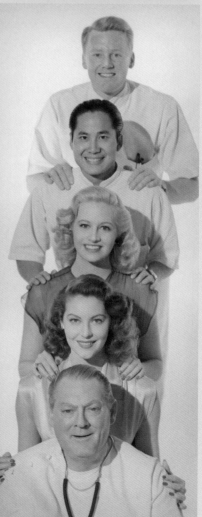

Clockwise from top left: Ava and Leo Gorcey of the East Side Kids in a publicity portrait for the Monogram horror picture *Ghosts on the Loose* (1943). • Vicky Lane, Natalie Draper, Ava, Jorja Rollins, and John Carradine in the wartime thriller *Hitler's Madman* (1943). • *Three Men in White* (1944) presented Ava with one of her first supporting roles. Part of the popular Dr. Gillespie film series, it starred Lionel Barrymore and featured Van Johnson, Marilyn Maxwell, and Keye Luke. • Despite Hilda Spotts being a supporting character, Ava stole the film from would-be star Frances Gifford (right) in *She Went to the Races.*

showcase for the East Side Kids, the rag-
tag teenage version of the Little Rascals,
headed by Leo Gorcey. *Ghosts on the Loose*
is "the sort of film that makes other East
Side Kid pictures, *Spooks Run Wild*, for
instance, look awfully good in compar-
ison," wrote Tom Weaver in his study of
Poverty Row horror films of the 1940s.
True, the plot—the East Side Kids renovate
a house that they're convinced is haunted,
only to realize there is a Nazi spy ring
operating out of the estate next door—is
thin, the laughs forced. The small budget,

coupled with the six-day shooting schedule, underscored the film's quality. However,
it marked the first time that Ava received accredited billing; her name even appears
on publicity materials above that of the famous star of *Dracula*, Bela Lugosi. She never
forgot the excitement of walking along a street in Los Angeles with Bappie and seeing
her name on a cinema marquee for the first time: "I've got to say it was a thrill."

Over the next two years, Ava alternated between uncredited roles and supporting
parts in MGM B-movies, including appearing in installments of the popular Maisie
and Dr. Gillespie series. Although a preview audience voted her "one of the most
promising young actresses" of 1944 for her performance in *Three Men in White*, it was
not until 1945 that the Ava Gardner audiences know today began to emerge.

She Went to the Races introduced Ava for the first time as the sultry brunette, no
longer just a pretty face in the background. As Hilda Spotts, she presents a dan-
gerous temptation to her racehorse-owning ex-boyfriend, Steve Canfield (James
Craig), and is a foil to Frances Gifford's nice-girl scientist, Dr. Anne Wotters. Again
Ava plays the supporting role, yet she steals the film, not through talent but through
star power. Historian Jeanine Basinger explains it best in her book *The Star Machine*:
"Gardner was cast in the second lead, and the star was the lovely Frances Gifford, who
was being heavily groomed for the top rank at MGM that year. Gifford had charm,
talent, beauty—everything she needed—but she was no Ava Gardner."

One scene in particular solidifies the film as Ava's: Dr. Wotters and Steve are
embracing in the hallway of a hotel when the camera cuts to an elevator door open-
ing, revealing Hilda Spotts in an alluring black gown accentuated with white flowers.
A knowing smile plays across her face as Steve introduces Dr. Wotters. "Hello Doc-
tor," she says, before addressing Steve. "I just wanted to say, sweet man, if I'm not in
my room when you call, I'll be in the bar." "It's not much, but it's everything," writes
Basinger. "The minute Gardner appears, she takes it all away from both Gifford and
Craig. . . . Gardner's got something extra—a lot of it, in fact—and it's fully on display.
She's got *star* written all over her, and within a year, she was one."

Ava played Gloria
Fullerton in *Maisie Goes
to Reno* (1944). The
Maisie films were popular
B-comedies, produced
by MGM and starring
Ann Sothern. In this film,
Maisie attempts to save
the marriage of Gloria
and her husband (played
by Tom Drake).

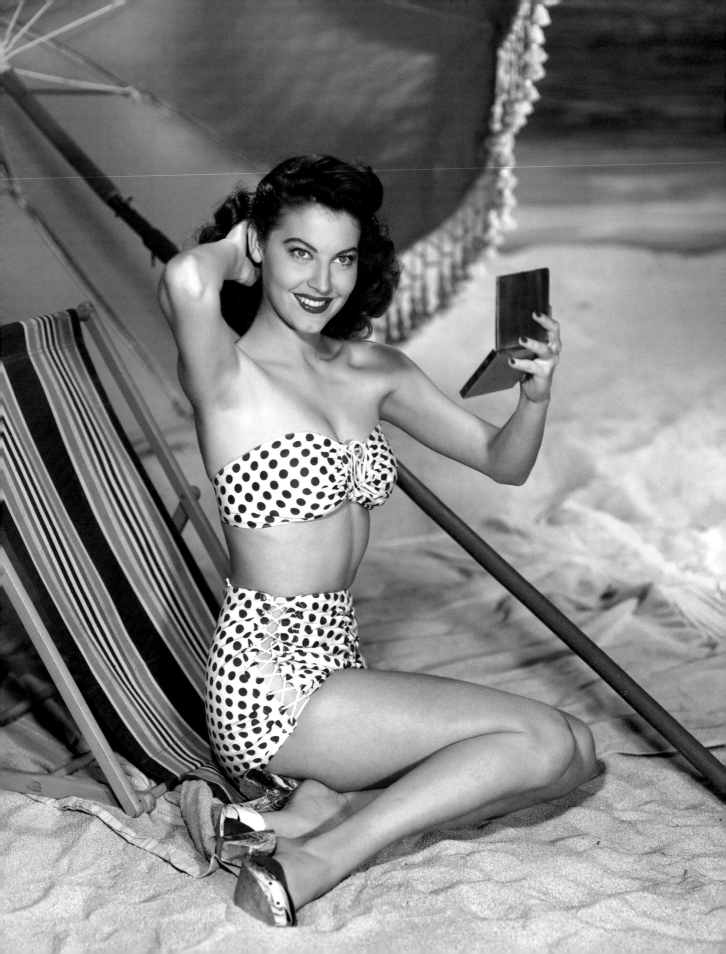

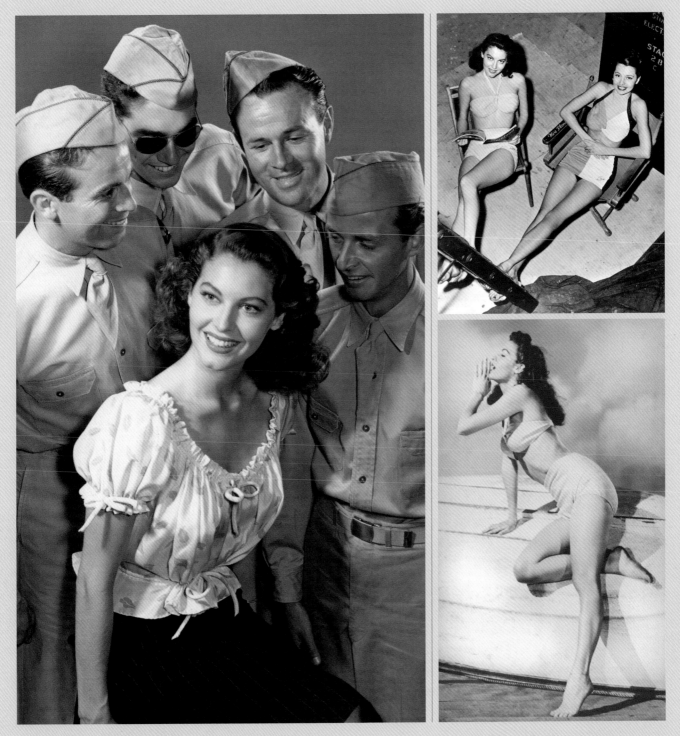

above, clockwise from left: Ava showing her patriotism by posing with servicemen during the war. Photo by Paul Hesse, ca. 1944.
• Ava and fellow MGM up-and-comer Cyd Charisse on Stage 28 in 1945. They appeared in two films together: *East Side, West Side* (1949) and *The Band Wagon* (1953). • A posed "candid" of Ava in beachwear. *opposite:* Ava in Kodachrome, by Clarence Sinclair Bull.

"I T WILL BE A LONG TIME BEFORE I THINK OF MARRIAGE AGAIN,"
Ava told Thomas Reddy in early 1944. Reddy's *Los Angeles Examiner* and several
other papers had run stories on Ava's reaction to the failure of her first marriage.
She had been spotted around Hollywood with other men, including eccentric
billionaire Howard Hughes, whose spies would follow Ava for years to come, but
none of their encounters amounted to anything more than dates or shopping trips
to Mexico courtesy of Hughes and his private planes. Therefore, it may have come as

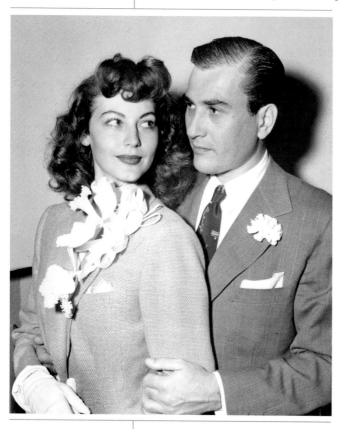

Ava and second husband
Artie Shaw on their
wedding day.

Opposite: Ava as Mary in
Whistle Stop (1946).

a surprise to readers who picked up news-
papers on October 18, 1945, to read that Ava
had tied the knot with big-band leader and
clarinetist Artie Shaw. If the fact that Shaw
had been married and divorced four times
by age thirty-five (once to Ava's friend Lana
Turner) was a red flag, Ava took no notice.
She would later admit to the difficulties in
maintaining any sort of relationship with
him, but she loved the arrogant musi-
cian and was in awe of his talent and self-
professed intellectualism.

Ava's marriage to Shaw coincided with
her next film assignment. Her career was
on the rise, but not at MGM. Critics noticed
her in *She Went to the Races*. Jack D. Grant
of the *Hollywood Reporter* commented that
"MGM has a great bet in this girl and her
promise should not be lost in the shuffle."
Yet despite receiving good notices for the
film and the press's suggestions that she
could be a nice asset for the studio, Mayer
decided to loan her out again—a move that
was lucrative for him due to inflated loan-out fees, but not for Ava, who received
no addition to her salary.

This time she went to United Artists for her first leading role in *Whistle Stop*,
very loosely adapted by Philip Yordan from Maritta M. Wolff's 1940 novel, produced
by Seymour Nebenzal for Nero Productions, and directed by Russian-born French
filmmaker Leonide Moguy. The Hays office had already "banned" Wolff's novel about
the Veech family, poor farmers in post-Depression Michigan, for its risqué content.
Yordan had to come up with creative ways of watering down the screenplay to get a
passable rating. The screenwriter took the original story and scrubbed out question-
able content like hints of incest, copious profanity, a love child, and other elements
that would have made the Hollywood censors' hair stand on end. The characters of

Ava and George Raft in a scene still from United Artists' noir thriller *Whistle Stop* (1946).

Kenny Veech (George Raft) and Mary (Ava) are also removed from their original context as siblings. Despite Yordan's efforts, the film received a B rating from the National Legion of Decency. (A C, or "condemned," rating would have seriously hindered chances of distribution.) Their objections: "Suggestive dialogue, sequences, and costumes" and "insufficient moral compensation."

Whistle Stop might be called a pseudo-noir. The story's dark and rough textures are enhanced by Russell Metty's cinematography and Moguy's Europeanized direction. *Saturday Evening Post* journalist Pete Martin reported that Seymour Nebenzal personally requested that Ava be lent to him for the film: "Nebenzal . . . saw latent talent in MGM's leg-art queen that others hadn't seen. . . ." As Mary, Ava displays some aspects of the classic noir femme fatale. The love interest of both Kenny and hotelier Lew Lentz (Tom Conway), she plays up the sensuality demanded by the character. A murder plot is even hatched because of her. Yet Mary is not quite as hardened or conniving as noir archetypes Gilda (Rita Hayworth, *Gilda*) or Phyllis Dietrichson (Barbara Stanwyck,

> . . . both the film and the role were significant in preparing Ava to delve into the dark underbelly of on-screen crime and seduction . . .

Double Indemnity). She is kind at heart, in love with Kenny but dissatisfied with his unwillingness to get a job and provide her with a stable relationship.

The film opened to mixed reviews in January 1946. Some, like Bosley Crowther of the *New York Times*, found the film lacking in "flavor, consistency, reason, and even dramatic suspense." Crowther also thought the entire film "abominably acted." Other reviews were kinder. The *Variety* critic wrote that "Miss Gardner displays her best work to date as the girl who must have her man," while the *Los Angeles Times*'s Edwin Schallert said she "fills her assignment creditably." On the whole, the film's biggest fault was attributed to censorship. By so diluting Wolff's potent original, critics felt Yordan turned the plot into something unrecognizable, a sentiment best summed up by critic Jim Henaghan: "The plot substituted for the wanton Wolff tale is not too well contrived, and the writer lacked, incredibly for one so importantly assigned, the craftsmanship and artistry, in fashioning characters, of the book's author."

According to George Raft biographer Everett Aaker, Yordan held neither of the film's stars in high esteem: "Yordan said that both Raft and Gardner were clueless about the characters they were playing and in one scene had to have their dialogue pared to the bone because neither of them could speak the lines written," adding, "both of them were pathetic, acting-wise, but had to admit that in terms of sheer star power they were magic." In fact, neither Raft nor Ava is as bad as Yordan or Bosley Crowther thought they were. They make an odd on-screen couple, but both perform their roles adequately with the material they were given. *Whistle Stop* is not the best film in Ava's 1940s lexicon, nor was Mary as hearty a character as she could have been. Yet both the film and the role were significant in preparing Ava to delve into the dark underbelly of on-screen crime and seduction from which she would emerge, in late 1946, as one of the iconic women of film noir.

Studio portrait, mid-1940s.

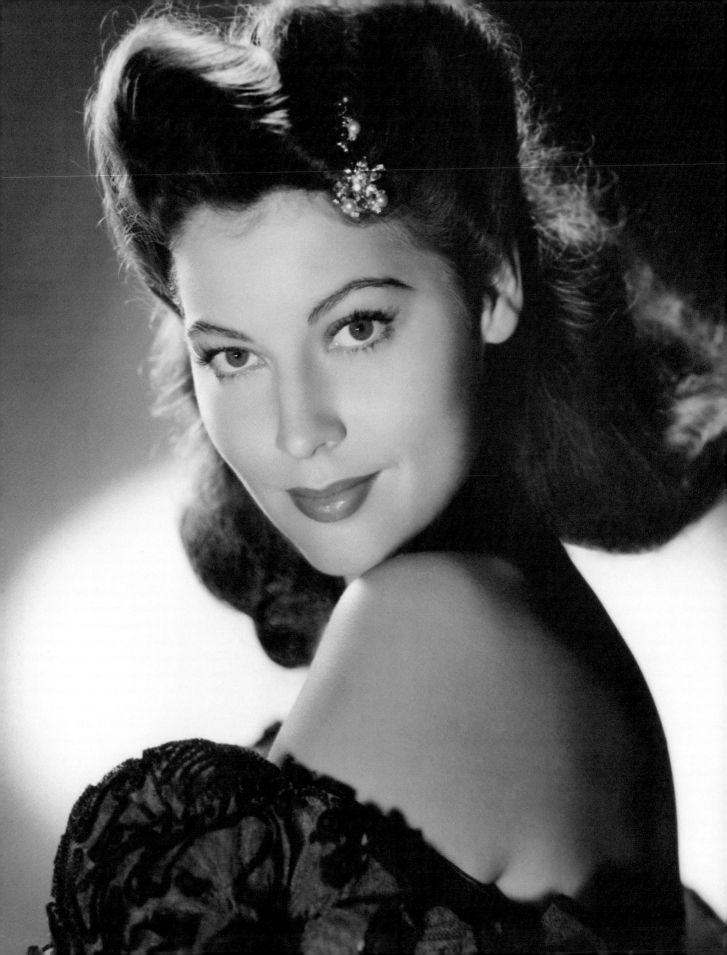

CHAPTER **FOUR**:

The Femme Fatale

THE LIGHTS WERE DIMMED AND THE MOVIE BEGAN. The audience watched as the mysterious brunette, draped in mink, emerged from a train carriage. She was beautiful all right, there was no question about it. But she was also mysterious, with an air of sophistication and glamour, the kind that made Hedy Lamarr such a big star. One man watched more attentively than all the rest. Could this unknown starlet be his Kitty? The plot of the film was ridiculous and the young beauty clearly wasn't in possession of much acting experience, yet the longer he watched her the more convinced he became that his casting dilemma was over. The next day he called her studio and asked if he could request the services of one Ava Gardner. The picture he wanted her for was called *The Killers*.

New York–born producer Mark Hellinger's fascination with Ernest Hemingway's 1927 short story went back to his Warner Brothers days, and now he felt that producing the cinematic adaptation of this controversial piece would be the perfect feature to kick-start his freelance career. This, however, was no easy task. Hemingway, known for his derogatory attitude toward Hollywood, was reluctant to sell the rights to his story. Being "Papa's" old pal, Hellinger finally convinced the famed writer with an offer of $36,000, making it the most expensive short story in Hollywood's history up to that point (for the purpose of publicity Hellinger quoted an even higher sum).

But owning the rights was only a small victory on the road to success; creating a movie script out of a story that consisted of a single scene required a skilled writer. For this task, Hellinger turned to his Warner Brothers colleague and drinking buddy, John Huston, who had previously written the Oscar-nominated screenplay

opposite: A portrait by Laszlo Willinger, one of the most renowned studio portrait photographers of the era.

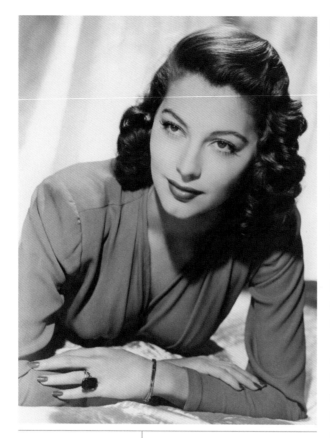

This studio portrait from the mid-1940s shows Ava in a reflective mood, yet still groomed to movie-star perfection.

for *The Maltese Falcon* and had cowritten *High Sierra* for Hellinger. Still under contract to Warners, Huston worked after hours, and together with his friend and writing partner, Anthony Veiller, wrote most of the screenplay in the winter months of 1945 and early 1946. Due to his contractual commitment to Warner Brothers, Huston was not credited with writing the script and therefore later missed out on an Oscar nomination. He hoped that Hellinger would approach Warners to loan him out to direct *The Killers*, but Hellinger feared that Huston's own artistic vision would overshadow his role as the film's visionary producer. At the end of the day, Hellinger saw *The Killers* as his own personal triumph, and he was reluctant to share the credit for it with anyone else.

Robert Siodmak, a contract director for Universal, was hired for the job instead. As part of the wave of Jewish directors who had fled Germany after the rise of Hitler, Siodmak possessed a magic touch and a dark, haunting visual style, which was perfectly in tune with the mood of the story. His vision, inspired in part by German Expressionism, would become a vital part of film noir iconography.

With a completed screenplay and a director ready to work, Hellinger had to cast his film within a few weeks, a task that proved more than a little difficult. Using Universal's contract players seemed like the obvious option because the studio provided financial support for the project. Hellinger, however, didn't see *The Killers* as just another crime flick churned out by the conveyer belt of the studio system. He believed that Hemingway's story, along with the Huston-Veiller screenplay, had potential for greatness, and casting was the final piece in the jigsaw puzzle of creating the perfect motion picture.

The central character of the Swede required an actor who could convey both the physical strength and the vulnerability of a broken man who awaits death with resigned serenity. At thirty-three, Burt Lancaster was an aspiring actor who had recently returned from the war. With a single Broadway credit under his belt, he arrived in Hollywood at the urging of his newly acquired agent, who wanted him to test for *The Killers*. Both Hellinger and Siodmak were struck by Lancaster's blend of tough masculine beauty and tender sensitivity. He displayed the tortured, lost quality that made him an ideal embodiment of the story's antihero, and was cast soon

afterward despite his lack of acting experience. Other inspired choices were added to the ensemble, including Edmond O'Brien as the inquisitive life-insurance investigator, Albert Dekker as the gangster Colfax, and Sam Levene as the sympathetic lieutenant Lubinsky. Finding a suitable femme fatale was at least as vital as casting the part of the Swede, and Hellinger frantically searched through the ranks of Hollywood starlets before Walter Wanger, a friend and fellow producer, urged him to see *Whistle Stop*. Upon seeing Ava, Hellinger's vision of Kitty Collins immediately came to life. Here was a girl who could easily convince the audience that a man was willing to sacrifice everything for her and would choose death over life without her.

Ava met Hellinger a few days after he saw *Whistle Stop*. She was excited and nervous, not quite able to believe that he wanted her for such an important part. What's more, Hellinger was the first director she'd worked with who treated her like an actress. He discussed his vision of Kitty and asked Ava questions about her interpretation of the character and how she wanted to play her. To Ava this was new territory, to say the least, and she initially felt out of her depth, waiting in fear for Hellinger and Siodmak to realize their mistake. The two agreed that Ava was perfect for the part, and Hellinger quickly arranged for her loan-out from MGM. Because her parent studio had no ideas for the development of their young starlet's career, they were more than happy to oblige, especially given the handsome financial settlement, which required Hellinger to pay them $1,000 a week for Ava's services.

The shoot proved an exciting and challenging time for Ava. She was shy and slow to come out of her shell, nervous and inhibited before each take. But with Hellinger's sympathetic encouragement, Ava gained a measure of confidence and grew more comfortable and determined in her abilities as the shoot progressed. No doubt she felt buoyed by the enthusiasm displayed by her cast mates. Burt Lancaster, in particular, was full of vigor, eager to prove his talents in this, his first film appearance.

Siodmak's vision for the film was gritty and sharp. The people he wanted to present were shady characters, alienated by modernity, disillusioned by war, struggling to

from left: Ava and Lancaster chatting on the set of *The Killers*. The film would turn them both into major stars. • Robert Siodmak and Ava on the set of *The Killers*. Under his masterful direction Ava gave a complex and sophisticated performance, which established her as one of the great heroines of film noir.

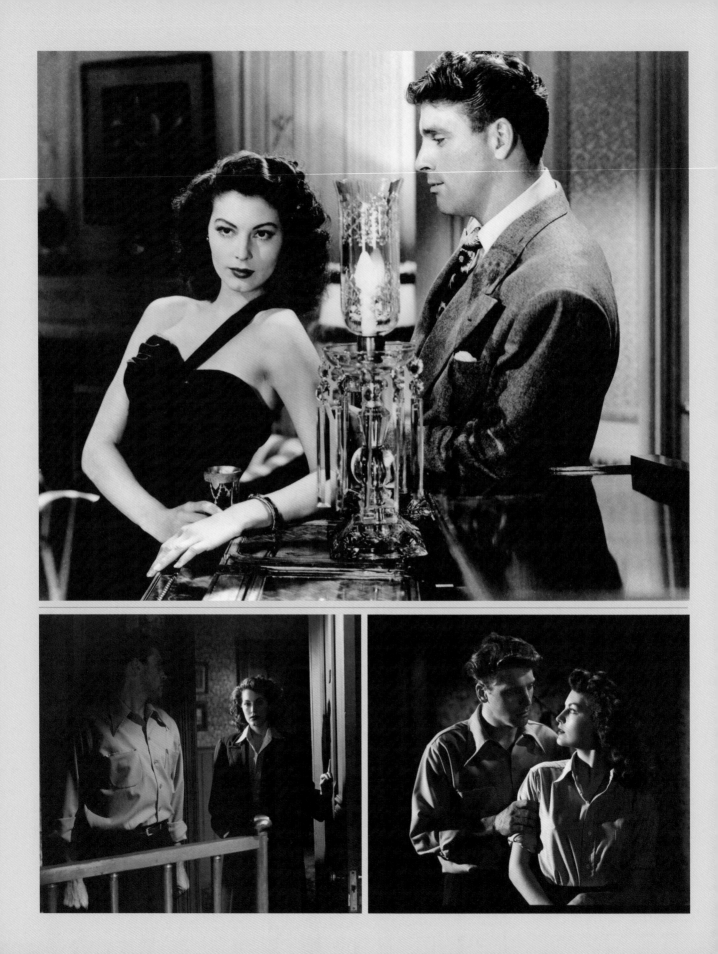

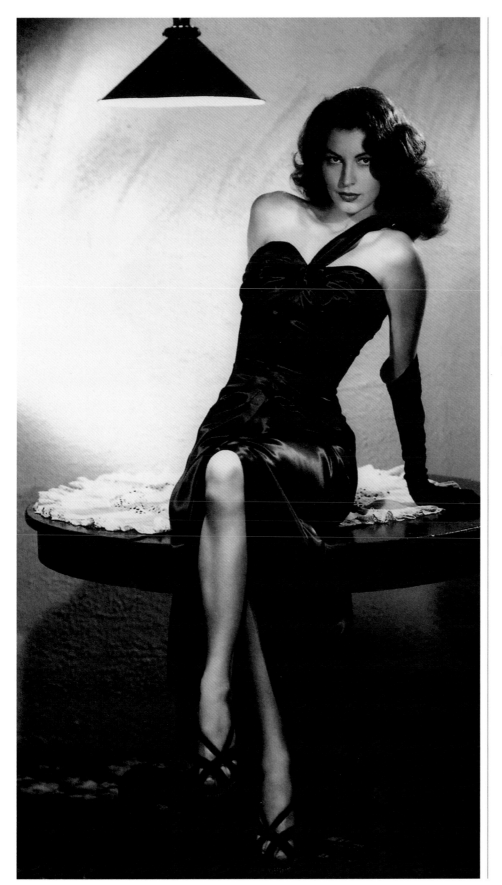

left: Ava posed in the famous black gown worn by Kitty Collins in *The Killers*.

opposite, clockwise from top: The look that spells imminent disaster: Burt Lancaster and Ava in *The Killers* (1946). • *The Killers* would in time become one of the most notable examples of the film noir genre. • In the hard-boiled world of *The Killers*, Kitty Collins relies on her sexuality as her most powerful weapon, seduction as her most reliable strategy.

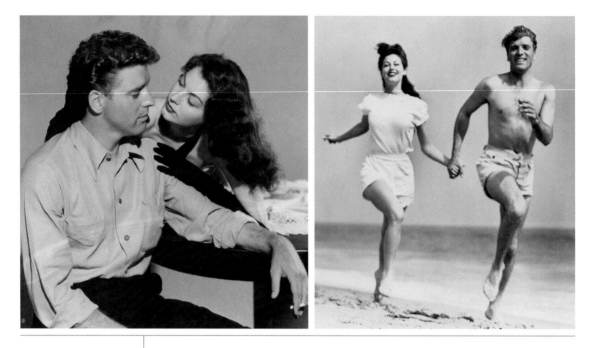

find their place in a corrupt and unforgiving reality. There was no place in that reality for MGM glamour. Siodmak knew that Ava's beauty and coloring were able to carry off his vision, so he dispensed with her coiffed hair and makeup on day one of filming. For the first time since her New York screen test nearly six years earlier, Ava was able to showcase the natural, electrifying quality that had brought her to Hollywood in the first place. Siodmak, like Al Altman, saw the exciting, restless sexuality that simmered beneath the surface of a coy and insecure young actress, and he knew how to bring it out.

For the first time Ava got a chance to sing on film, with Siodmak choosing the sultry and smooth "The More I Know of Love" as Kitty's fatal anthem of seduction. Ava was excited at the prospect of performing the number; however, when the time came to record it, she froze with anxiety. No doubt the rejection of the big band from years before suddenly sprang to mind. She struggled to find her voice and project the confident sensuality the song required. With characteristic patience and encouragement, Hellinger again gave Ava confidence. Her soft, erotic purr suited the film perfectly.

Aside from singing, Ava had to work hard on her acting. Kitty is vulnerable and lost yet needs to remain in control to survive as the only woman in Hellinger's harsh, male-dominated world. In the scene where Kitty's violent boyfriend, Colfax, tries to strike her, she declares, "I can look after myself," and when the phrase comes from Ava's lips, the audience believes it. Siodmak encouraged Ava to tap into her emotional reserves in order to give Kitty life. Ava had never worked in this way before, and she suddenly became aware of all the anger, frustration, and insecurity she had bottled up for so long and that she was now able to channel into her character.

The final scene in the film, revealing an unexpected twist, proved to be the most difficult and emotionally draining for Ava. The screenplay required her to fall to her knees beside her dying husband and beg him hysterically to lie to the police in order to spare her from jail. Ava dreaded shooting the scene, convinced she was unable to do it. Siodmak knew that Ava didn't possess the technical skill to realistically portray desperate hysteria, but he sensed that her personal experiences would provide the necessary trigger if he could only get her to access that place within herself. On the day of shooting Siodmak came to the set with a cold air of unpleasant impatience. Ava, already nervous about this most challenging scene in the film, looked to her director for the usual dose of support and encouragement. Instead, Siodmak set up the scene and called action before Ava had a chance to seek his advice. The tension escalated with each take. Finally, emotionally and physically exhausted, releasing the tension of weeks of hard work, Ava collapsed, sobbing uncontrollably, crying out her lines in a distraught voice. When it was over, Siodmak put his arms around her: "I knew you could do it."

ONCE AGAIN, MARRIED LIFE DIDN'T TURN OUT TO BE AS blissful as Ava had hoped. As Shaw confessed many years later, they should never have married to begin with: "Marrying Ava was purely an act of propriety. We had the best of our lives when we just lived together." In his mind she represented the Hollywood glamour girl he had always felt attracted to. Although Artie may have considered his marriage to Ava little more than a dazzling episode in his rich love life, for Ava it was a more serious matter.

Artie was a dark, mysterious figure, steeped in the aura of late-night jazz that Ava found spellbinding. Already regarded as one of the most talented musicians of the

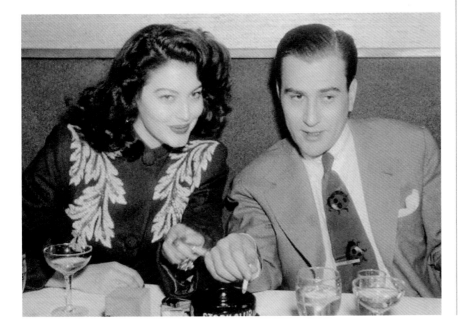

Ava and Artie at the Stork Nightclub in Manhattan. Ava was under the bandleader's spell, but their short-lived marriage would bring her more heartache than happiness.

big-band era, Artie was a celebrity in his own right, and at the time his fame was far greater than Ava's. Shaw had a reputation for being a very difficult man, an obsessive perfectionist, in life and in art. Yet beyond his magnetic eroticism and musical ability, Artie had awoken in Ava something deeper, something no man had previously accessed. Her modest education had rarely bothered Ava before; on the MGM lot a girl's IQ was hardly the first or even the last thing anyone cared about. And yet, as Sydney Guilaroff remembered, "Ava had a wonderful mind," and in her own words, Artie was the first "intelligent, intellectual male" she had ever met. His grand ideas about life and art shook her perception to its very core. Shaw was from New York, and he brought with him an East Coast outlook that stood in direct contrast to the happy-go-lucky attitude of the film people Ava knew in Hollywood. He introduced Ava to classics of Russian, German, and American literature, opening new and exciting horizons for her while at the same time making her painfully aware of the vast gaps in her education.

Although their courtship had been an exciting time for Ava, married life quickly exposed their differences, and Shaw's notorious need for perfection soon manifested itself. His new wife was like an unpolished jazz tune: beautiful and raw, in desperate need of work. Shaw positioned himself as a Henry Higgins–like character, determined to improve Ava's intellectual prowess. But what for Ava began as a genuine desire to learn had become a desperate need to live up to her husband's expectations.

Undoubtedly Ava felt lonely, having lost both parents, living in Hollywood's harsh, unsympathetic environment, and going through a second unsuccessful marriage.

"Of course, my home studio, MGM, won't give me leave of absence to go back to school," she told the *LA Times*, "so I'm doing the next best thing, taking extension courses." She enrolled in a number of classes at UCLA even before *The Killers*, and for a time the need for self-education became more important than the need to move forward with her career. English literature and psychology were among her choices of subjects. When she told her costars on the set of *The Killers* about her grades, the response was not what Ava expected. Stardom and academics seemed to be contrasting ideas. Fame did not require a degree, and many in Hollywood appeared to her to be complacent with their education—or lack thereof.

Through Shaw's eclectic mix of friends, Ava also became involved in psychoanalysis, which by that time was a fashionable practice among intellectuals, particularly on the East Coast. Ava's initial interest was sparked by her desperate need to prove to Artie that she was more intelligent than he gave her credit for. She convinced one psychoanalyst to give her an IQ test, which, to her relief, showed that her mental capacities were in fact high above average. Subsequent sessions, including several with the celebrated Dr. May E. Romm, shed light on darker corners of Ava's consciousness, uncovering deep emotional scars left by the traumas of her young life. A celebrity psychoanalyst,

Romm had served as an advisor on the 1945 Alfred Hitchcock film *Spellbound* and eschewed ethical concerns by partying with her patients. "I was hoping she would be able to build a set of standards by which I could judge people in [the] future," Ava said of Romm.

Undoubtedly Ava felt lonely, having lost both parents, living in Hollywood's harsh, unsympathetic environment, and going through a second unsuccessful marriage, all before her twenty-fifth birthday. Ava often thought back to her childhood, to the life on the tobacco fields, to just how happy her parents had been together, and couldn't help but compare to theirs her own relationship with Artie, which was quickly disintegrating. She also felt a profound sense of guilt and regret for not having been there when her mother died, just as she had felt that she "didn't do enough to help Daddy in those last sad days" before his death all those years before. Despite these issues, Ava found psychoanalysis to be helpful, and she often resorted to self-exploration throughout the years to come, with works by Freud always part of her ever-growing library.

Photographed at home in the mid-1940s. Although she attended college through her freshman year, Ava felt self-conscious about what she perceived to be her lack of education. When husband Artie Shaw criticized her lack of intellectualism, Ava took an IQ test that proved she was more intelligent than she was given credit for.

It was during her marriage to Shaw that Ava established a number of close friendships, some of which were to last for many years. Perhaps sparked by the psychoanalytical sessions, or by the profound sense of being unappreciated at home, Ava began surrounding herself with loyal friends who didn't expect her to be anyone but herself. Actor Van Heflin and his wife, Frances, had been Ava's friends even before her marriage to Shaw (in fact, it was Frances who introduced the two), but during the last unhappy months of their union, the Heflins became her close allies and confidants. Their support meant a lot to Ava, who was now spending increasingly more time out of the house.

After the release of *The Killers* Ava began to enjoy Hollywood's nightclub scene, often spending evenings at the Mocambo and Ciro's in the company of her new female friends, including Lana Turner and Ann Sheridan. Ava and Lana, in particular, had a lot in common, not least the fact that they were both left heartbroken by the experience of marriage to Artie. Lana's daughter, Cheryl Crane, later wrote, "Of all [Lana's] friends, I think Ava was the closest in temperament and outlook on life. They shared many of the same tastes and even fell for many of the same men,

yet they never let it affect their friendship." Ava and Lana enjoyed long nights and dancing, and by 1946 they were both steady drinkers. During her early years in Hollywood Ava rarely touched alcohol, hating the taste and the effect it had on her sensitive stomach. But marriage to Artie required an emotional buffer. She found that a martini or two helped her build up the confidence to speak and eliminated her feeling of inadequacy when faced with Artie and his intellectual friends. By the time the marriage ended, dry martinis were daily companions.

As Ava was finishing *The Killers*, for no apparent reason Artie suddenly decided to move them to a small, uncomfortable house in Burbank, over the hills northeast of Hollywood. Ava saw the act of selling his beautiful mansion on Bedford Drive as a clear sign that Artie was preparing to end the marriage and wanted to avoid the prospect of dividing his property in a divorce settlement. They continued to argue bitterly; some have even suggested that on occasion physical force was used. The stress of having to come home after a long day at the studio, where she was working on the most challenging role of her career so far, only to confront Artie's hostility finally became too much to bear. Ava lost a dramatic amount of weight, and she continued to drink. After one particularly upsetting row, Ava stormed out of the house and went to stay with Minna Wallis, a Hollywood agent and friend from the days before her marriage. Although Ava didn't anticipate this to be the last straw, she was never to live with Shaw again. Weeks later Artie asked to meet her. Ava hoped it would be the first step toward a reconciliation, something she still wanted. She looked particularly beautiful when she arrived at Shaw's Beverly Hills office that summer day, but Artie paid little attention to his wife's charms. He coolly informed her that he had decided to seek a divorce and asked if she would object to a quick trip to Mexico, where it could be fixed without unnecessary ado. Ava was too stunned to protest or ask questions. Weeks later Shaw married author Kathleen Winsor. Ironically it was Winsor's bestselling novel, *Forever Amber*, that Artie caught Ava reading during a trip to Chicago. He tossed the book out the window, raking Ava over the coals for polluting her mind with such garbage.

The Killers opened in New York on August 28, 1946, and immediately became a smash hit. If Ava was brokenhearted over the breakup of her marriage, this unexpected turn in her professional life provided her with a much-needed boost of confidence. Despite having relatively little screen time, Ava, along with Lancaster, received star billing, and as part of the promotional campaign the image of Ava as Kitty wearing a soon-to-be-famous black dress adorned billboards all over the country. After years of appearing in small parts in second-rate films, she was finally the star of an important, critically acclaimed production. The gritty, somber mood of the film struck a chord with audiences. Crowds lined up outside the movie houses to see the picture the Universal publicity department branded "the screen's all time classic of suspense." Ava also got her first real taste of critical attention. Her mysterious, understated performance as Kitty, the quintessential femme fatale, was highly

opposite: After her divorce from Artie Shaw, Ava embarked on a series of short-lived love affairs. Of these, with actor Howard Duff, lasted the longest and was the most tempestuous. Duff hoped Ava would marry him, but she was reluctant to give up her hard-won freedom, eventually ending the relationship.

praised. In his review for the *New York Times*, Bosley Crowther called Ava's interpretation "sultry and sardonic." Later Pauline Kael would declare, "Robert Siodmak does wonders with Ava Gardner."

Some years ago, when presenting *The Killers* for British television, film aficionado Mark Cousins gave a perfect description of the movie's initial appeal and the source of its deep impact on the audience: "Imagine that: late night, somewhere in Chicago, maybe you're just back from war, you saw some terrible things, and then this movie comes on with its fear of the past, its melancholic beauty, shattered like a mirror, drenched with desire."

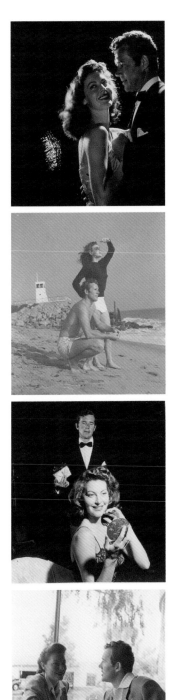

THE MONTHS FOLLOWING THE RELEASE OF *THE KILLERS* were strange and confusing for Ava. She found herself alone for the first time in her life. Although she remained close to Bappie, she preferred to be independent, renting a series of small apartments on her own. Her recent, unexpected professional success removed her from the ranks of anonymous Hollywood hopefuls, the nameless contract players with whom she'd always felt she belonged. She was now a star, a name in the movie magazines and on billboards, and the recipient of *Look* magazine's Film Achievement Award for having made "an outstanding contribution to American Screen Entertainment." Ava was overwhelmed and with typical self-deprecation believed that the fuss over her was someone's mistake. Her success in *The Killers* was all due to Siodmak and Hellinger, she thought. Once everyone realized she had no talent, things would go back to normal.

If working on the film sparked a note of ambition in Ava's professional attitude, it was soon extinguished by MGM's customary treatment. The studio's surprise at Ava's success was even greater than her own, and for months their new star was left unemployed, with an increased salary but without an assignment. This no doubt contributed to Ava's already shaky self-esteem, which plummeted even lower. Had she been signed at a different studio, it is very likely that her growing potential would have been recognized and used, but MGM dealt in a manufactured kind of artificiality, particularly with their female stars, a treatment that Ava resented and that didn't suit her.

Autumn of 1946 was spent trying to forget Artie and get on with her life. She began discovering new people and new places that appealed to her evolving tastes. For the first time in her adult life she had the time, the freedom, and the money to think about what she wanted to do, what kinds of things she liked, and how she wanted to live. She went out with her studio girlfriends to fashionable nightclubs, often photographed dancing or dining, always personifying the Hollywood glamour girl. But aside from Mocambo or Ciro's, away from the Hollywood scene, Ava also discovered other parts of town, places where she wasn't likely to be photographed by the studio publicity men. She loved jazz and she was eager to experience a more authentic scene, venturing to places rarely frequented by movie stars. Many of these

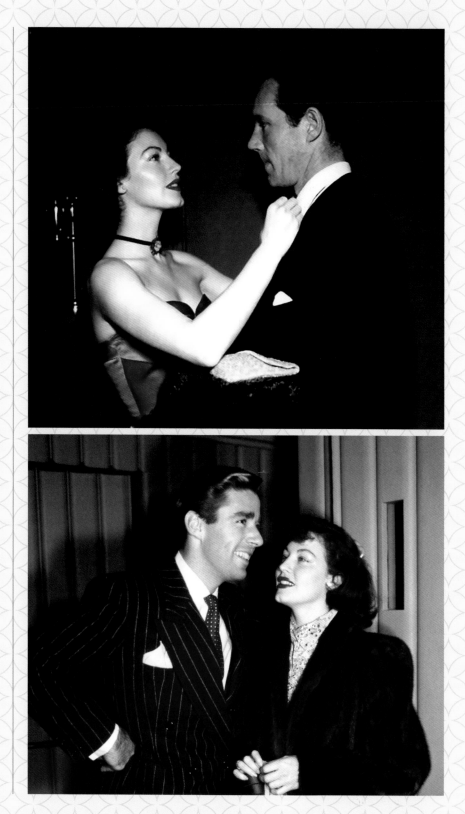

from top: Ava and Howard Duff getting ready for a night on the town. Ava was never short of a handsome escort, but she just as often chose to go out alone. • Peter Lawford was one of Ava's frequent escorts during the later part of the '40s.

were clubs in downtown Los Angeles with a predominantly black clientele. Ava harbored no racial prejudice. Many of the musicians became her close friends, and she was always guaranteed a prime table at any of her favorite jazz joints. It was around this time that Ava engaged a housekeeper. Mearene Jordan (nicknamed Rene, which was pronounced "Reenie") was a young black woman from Chicago who arrived at Ava's door after being recommended by Rene's older sister, who occasionally had worked for Ava in the past. The two immediately felt at ease with each other, and Rene would remain an important presence in Ava's life for many years.

There were also men, mainly handsome young actors, always eager to escort her to a Hollywood event or take her dancing or out to dinner. Ava enjoyed the attention and the company, but she was reluctant to give up her hard-won freedom. She preferred to keep it friendly, and indeed some of her escorts from the time, such as Peter Lawford, Errol Flynn, and David Niven, would remain her friends for years to come. Very often, breaking with the social conventions of the time, Ava went out alone.

In early 1947 Metro finally found a role suitable for their new star. Ava's new agent, Charles Feldman, encouraged the studio to give her the opportunity to show what she was capable of, and it paid off. Feldman had recently been successful in helping to establish another sultry young actress, Lauren Bacall. Like Ava, Bacall swept into public consciousness as a confident, jaded seductress, and Feldman knew that the public was hungry for movies featuring this new kind of cinematic heroine. The film Ava was recommended for was *The Hucksters*, based on Frederic Wakeman's best-selling novel. Ava was cast as Jean Ogilvie, a warm-hearted, fast-talking singer with Hollywood aspirations. Although it was again a supporting role (the leading lady was another newcomer, Deborah Kerr), Ava's part was better written and more interesting, not to mention far sexier, than Kerr's. Ava didn't think much of the film besides the fact that she was acting opposite Clark Gable.

> There were also men, mainly handsome young actors, always eager to escort her to a Hollywood event or take her dancing or out to dinner. . . .

Gable had an affable personality that made people feel at ease in his company. Despite being one of the most popular male stars in the history of filmdom, he had few pretensions. He was famously quoted as saying, "I'm just a lucky slob from Ohio who happened to be in the right place at the right time." The years immediately following the war were a trying time for Gable, who had left Hollywood in August 1942, at the height of his fame, to enlist in the US Army following the tragic plane crash that killed his wife, Carole Lombard. He returned to filmmaking looking older and world-weary. His first postwar picture, *Adventure* (1945), had been a flop. But he was still "The King," and Ava was nervous about playing his leading lady. "They've been after me to talk you into it," Gable told her on a visit to her apartment before filming started. "I told them I wouldn't do it. I've been talked into too many parts I didn't

below: Ava and Clark Gable in a scene from *The Hucksters*.

opposite, clockwise from top left: Publicity portrait released to promote *Singapore*. • The challenge of simultaneously starring in two movies was made sweeter by Fred Mac-Murray, Ava's leading man in *Singapore*. • *Singapore* met with lukewarm reviews, but it helped to reaffirm Ava's image as one of the most glamorous femme fatales of the era.

want, to talk somebody else into one." Ava appreciated his honesty. The two became good friends, often sipping martinis in Ava's dressing room between takes.

Despite recent critical successes, the studio was still reluctant to admit Ava to their pantheon of top stars, feeling more comfortable lending her out to other studios, who were eager to work with Hollywood's latest sex symbol. While still working on *The Hucksters*, Ava was loaned to Universal for *Singapore*. For a few weeks she would divide her time between the two films, working opposite Gable and Kerr at MGM until lunch, before being driven to Universal, where she had to play the complex and demanding part of an amnesia-stricken expat opposite Fred MacMurray. This was not an easy position to be in, particularly for Ava, who was still trying to find her confidence before the camera. The stressful situation was somehow sweetened by the instant sparks that flew between Ava and MacMurray. He was tall and handsome, with a strong, muscular physique, and Ava found him instantly attractive. The affair was discreet and short-lived. According to Rene Jordan, once Ava found out about MacMurray's sick wife, Lillian Lamont, she broke it off: "She didn't object to secret adultery, but when a guy was two-timing a sick wife, she objected to that—strongly."

Singapore was a poor imitation of *Casablanca*, perfectly enjoyable but in no way exceptional. Some of the off-screen chemistry between Ava and MacMurray was cap-

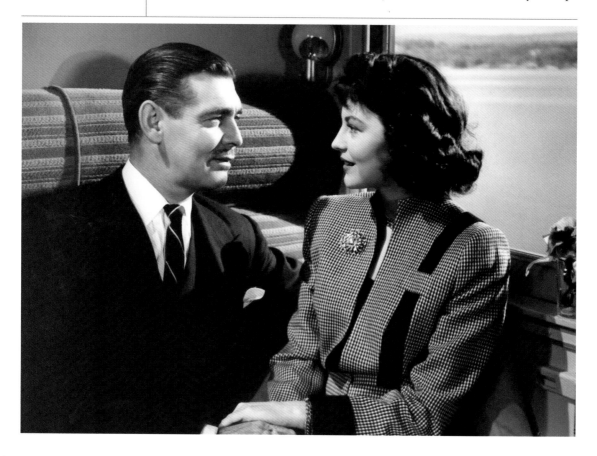

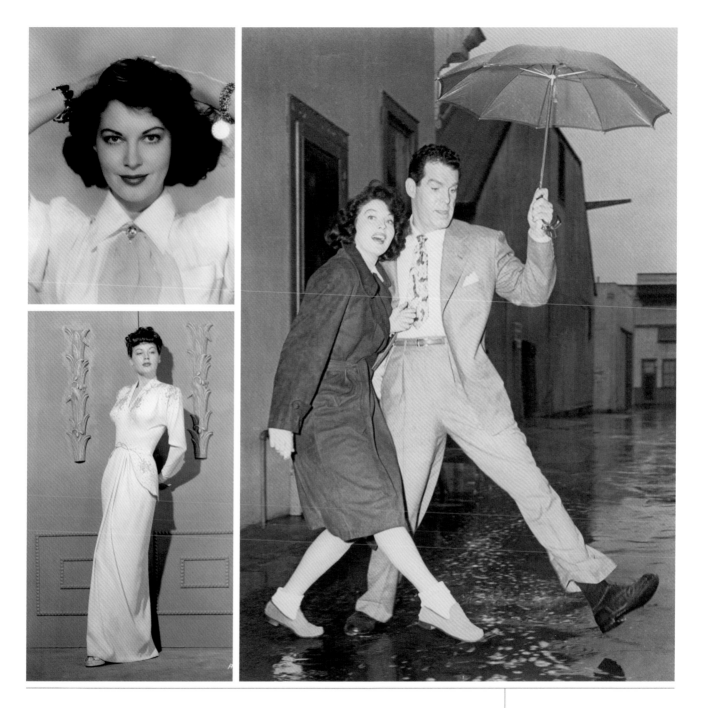

tured by the camera, but it couldn't save the film. For her next project Ava stayed at Universal. *One Touch of Venus* was to become an important step in creating the myth of Ava the screen goddess. In the minds of the public Ava was already associated with the divine spark of Hollywood glamour, which had been reserved for stars like Dietrich and Garbo, and in postwar years Rita Hayworth, Hedy Lamarr, and Lana Turner. Before *Venus*, Ava's glamorous image was mainly derived from the studio publicity machine. Now she was finally being given a role that perfectly suited her emerging

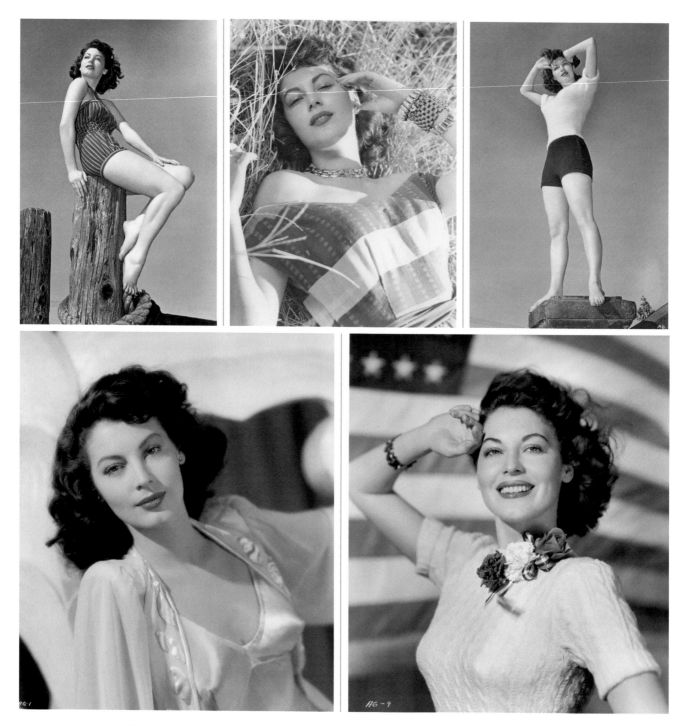

top row and lower right: Publicity portraits, 1947. *lower left*: Ava photographed at Universal as part of the promotional campaign for *One Touch of Venus*. *opposite*: By the end of the 1940s, Ava's image as one of the great sex symbols of Hollywood was firmly established. The fact that the majority of her parts lacked the complexity that would prove her acting talent did nothing to diminish Ava's box-office potential. Photo by Virgil Apger.

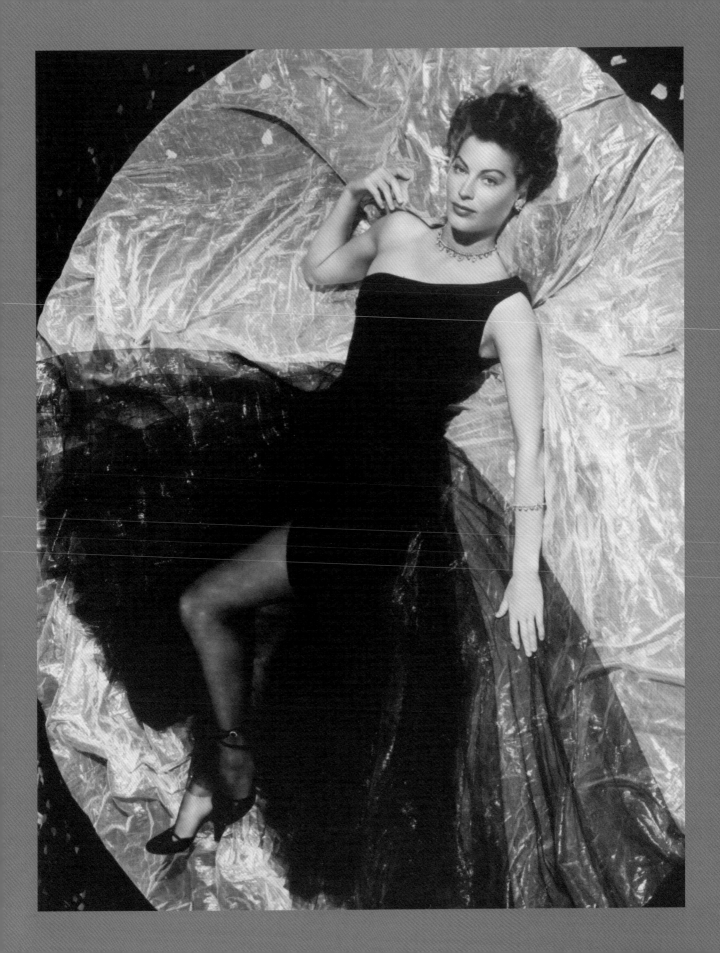

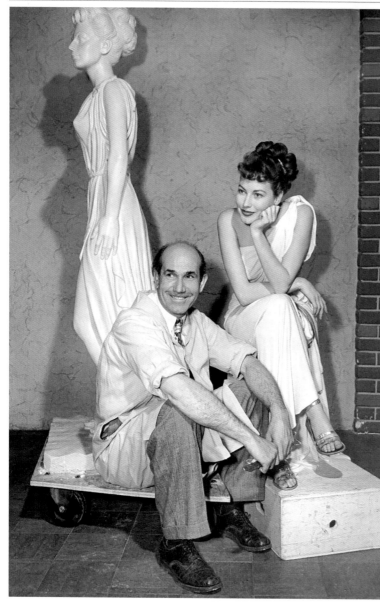

clockwise from top left: Ava and Robert Walker in a scene from *One Touch of Venus*. • Robert Walker was the perfect comic partner to Ava's mischievous goddess. • Ava as Venus, the mythical goddess of love. In the film she plays a statue come to life. • Ava in her Venus costume, posing with the sculptor Joseph Nicolosi. This was the second statue, the first deemed too provocative for the public in 1948.

clockwise from top left: Movie magazines declared Ava the perfect embodiment of the Goddess of Love. • Ava poses alongside the statue of herself created especially for *One Touch of Venus* (1948). • *One Touch of Venus* solidified Ava's status as a silver-screen goddess.

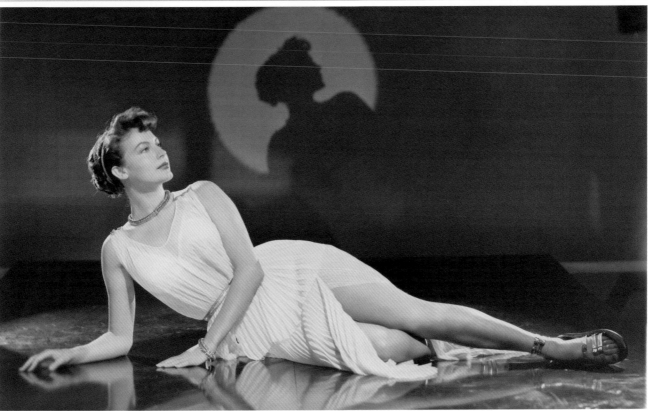

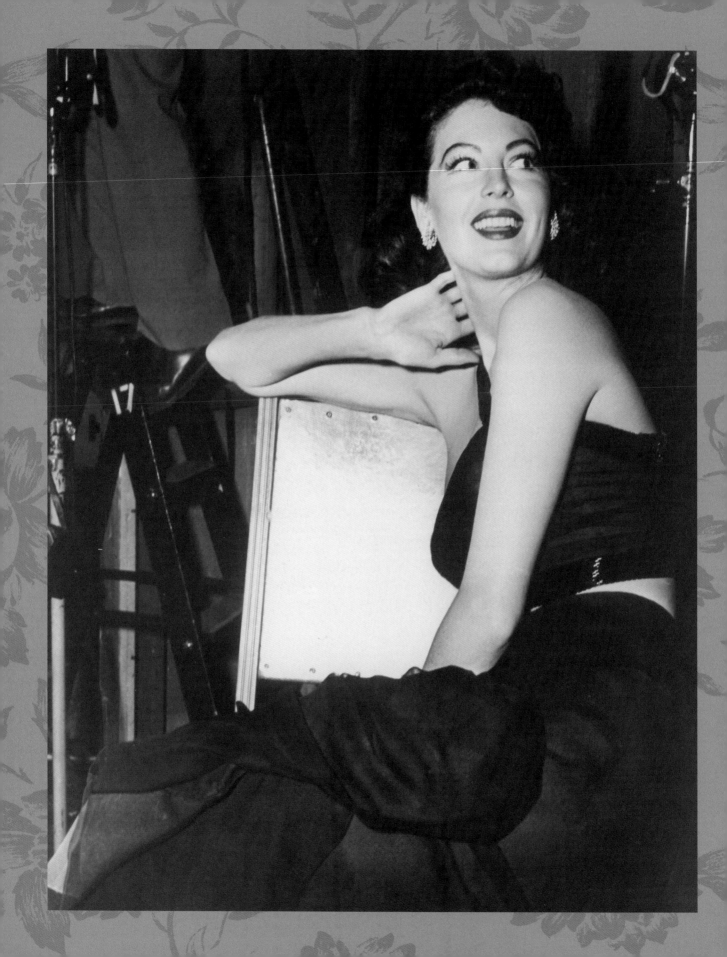

public persona. For the purpose of the film, a life-size, Greek-style statute of Ava was created (the one seen in the movie is the second version; the original was rejected by the studio due to its immodesty). Although the screenplay was inferior to the Broadway musical play upon which it was based, the film was charming, and it showcased Ava's surprising comedic timing. Rene Jordan remembered that Universal "was quick to recognize" Ava's talents as a comedienne: "Anyone who knew her recognized that she had a great sense of humor, a quick wit, followed by a noisy, joyful stream of laughter, and most importantly, when needed, a wonderful wide-eyed air of innocence."

When *Venus* was released it was not a great success, but it meant only good things for Ava's image, and it was a significant film in her continued rise to stardom. MGM finally got the message and realized that in Ava they were in possession of an asset who had the potential to make them a lot of money. They tried to cash in on her new-found popularity by casting her in a succession of sultry, showy roles that solidified her status as a sex goddess. The first of these was in *The Bribe*. Shot quickly on the MGM back lot, the film was a typical noir enterprise, with an exotic location, a convoluted plot, and a love affair at its center. Ava's entrance was no less spectacular than in *The Killers*. She was deeply upset that MGM decided to dub her singing voice. It was the third time in two years that she was not allowed to sing in a movie, having also been dubbed in *The Hucksters* and *One Touch of Venus*. However, she did enjoy working with the impressive ensemble cast, which included Robert Taylor, Vincent Price, and Charles Laughton. Ava and Laughton struck up a warm friendship. The

from top: Ava and Robert Taylor between takes on the set of *The Bribe* (1949). Taylor's smile carefully hides his guilty conscience. • With Robert Taylor on the set of *The Bribe*.

opposite, from top: Behind the scenes on *The Bribe*. • Ava and Joseph Cotten performing *The Bribe* for the Camel Screen Guild Theater on NBC radio, November 9, 1949.

above, from left:
Behind the scenes during
the filming of *East Side,
West Side.* Director
Mervyn LeRoy is seated
on the right. • Ava
seduces James Mason's
character in *East Side,
West Side* (1949).

opposite: Ava was
photographed for the
Raleigh News & Observer
during one of her trips
back home to visit family
in the late 1940s. She
is holding a reporter's
camera. Reprinted
with permission from
The News & Observer,
Raleigh, NC.

veteran English actor encouraged her to experiment with her acting and coached her between takes. His support meant a great deal. If this gifted Shakespearean actor insisted she had talent, maybe she really did.

Off set, Ava enjoyed the private company of her leading man. Like Ava, Robert Taylor was in possession of extraordinary good looks and was rarely expected to do much more than stand in the key light and accentuate his sharp features. He was at the time unhappily married to Barbara Stanwyck, one of the great leading ladies of the era. Ava was smitten by his charm and his tortured dissatisfaction with his image, which in many ways mirrored her own. The two became lovers and shared what Ava later described as a "magical little interlude." The affair, steeped in secrecy and guilt, only lasted a few months. In an ironic twist of fate, later the same year Ava was cast opposite Barbara Stanwyck in *East Side, West Side,* a sleek noir melodrama in which Ava portrayed the lover of Stanwyck's husband (played by James Mason).

After a succession of failed, short-term affairs, including a tempestuous relationship with actor Howard Duff, Ava was again drifting. Her career seemed to be developing, although she didn't believe she was a good actress, and what's more, she didn't think MGM thought so either. She longed for stability and a sense of security, something she hadn't yet found in work or marriage. An important step toward achieving that was the decision to purchase her first house. The modest one-story cottage in Nichols Canyon became her refuge, a place where she could entertain her friends, cook, and be alone. Rene moved to Nichols Canyon with her and became much more than a housekeeper: the two were now close friends.

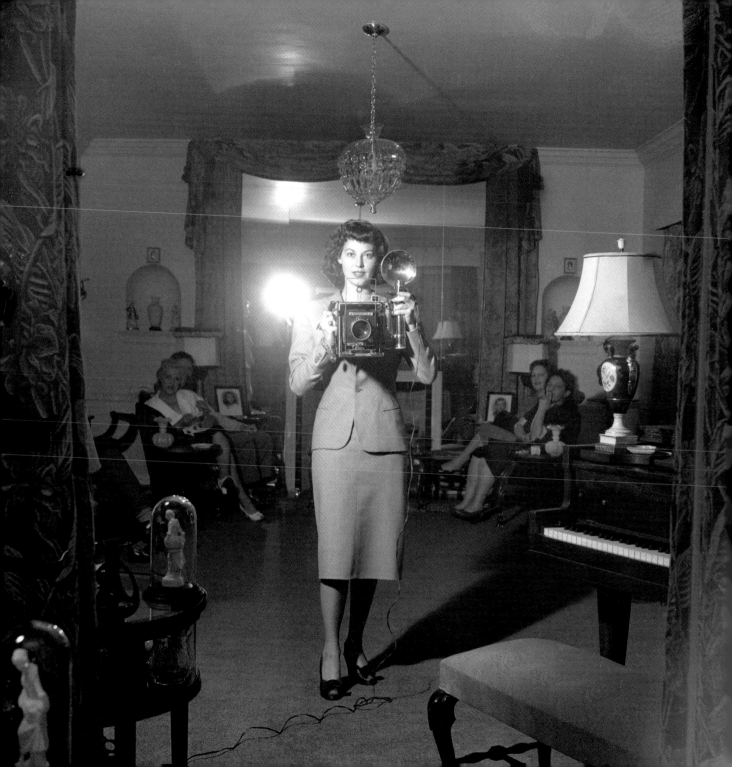

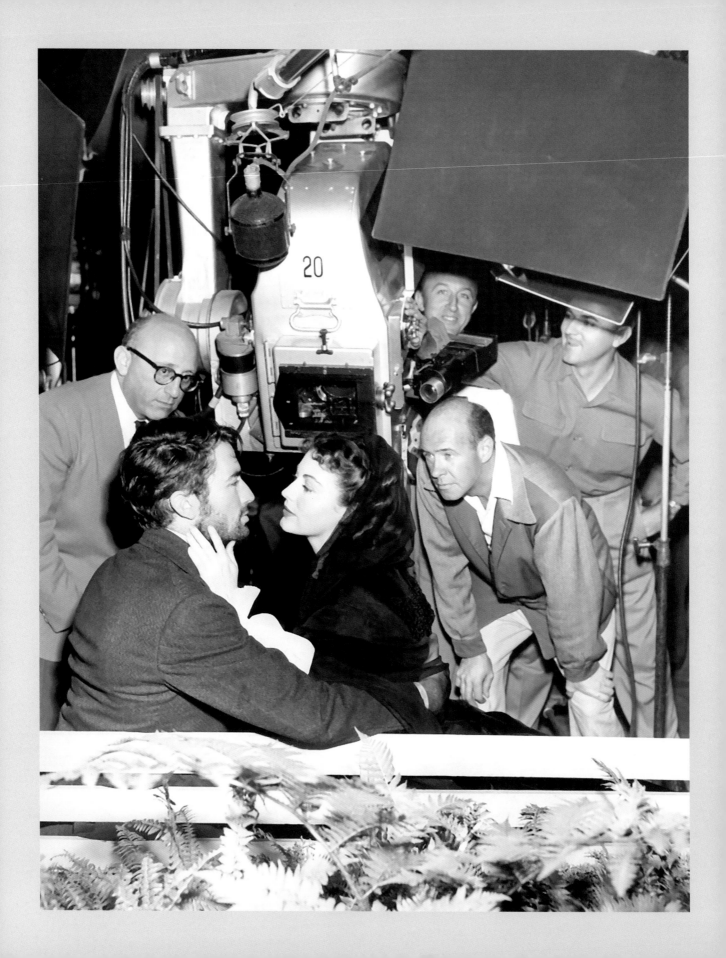

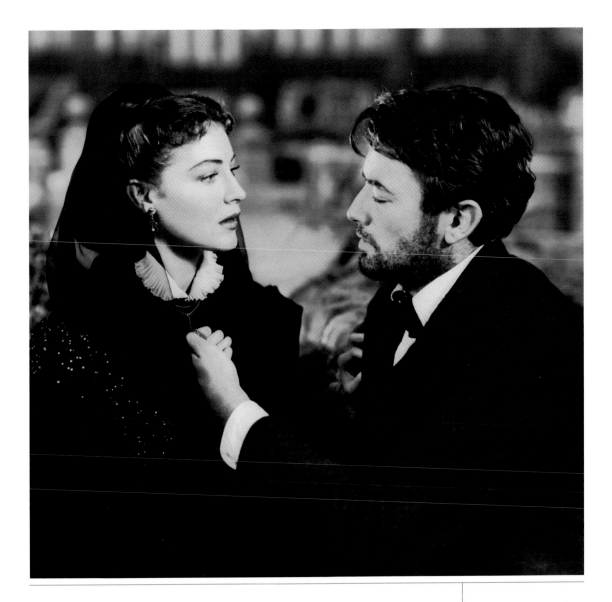

In 1949, while working on MGM's lavish adaptation of Dostoyevsky's *The Gambler*, re-titled *The Great Sinner*, Ava met Gregory Peck, who would become one of her dearest friends. The film was beautifully shot by George Folsey, and it also reunited Ava with Robert Siodmak. Eventually heavily cut in postproduction, *The Great Sinner* was not a success, but Ava's performance was praised by many. Unbeknownst to herself, Ava had slowly developed into a very capable movie actress, able to act her costars off the screen and to hold her own in scenes she shared with such established and acclaimed talents as Laughton, Stanwyck, and Ethel Barrymore. Once again, however, her career would have to take a backseat, as love was about to make another grand entrance into her life.

above: *The Great Sinner* (1949) marked the beginning of a lifelong friendship between Ava and Gregory Peck.

opposite: Ava and Gregory Peck film a close-up for *The Great Sinner*. Director Robert Siodmak is pictured on the left.

top left: Howard Keel pays Ava a visit on the set of *The Great Sinner. right and lower left:* Candid moments on the set. *opposite:* Ava and Gregory Peck in a publicity still promoting *The Great Sinner.*

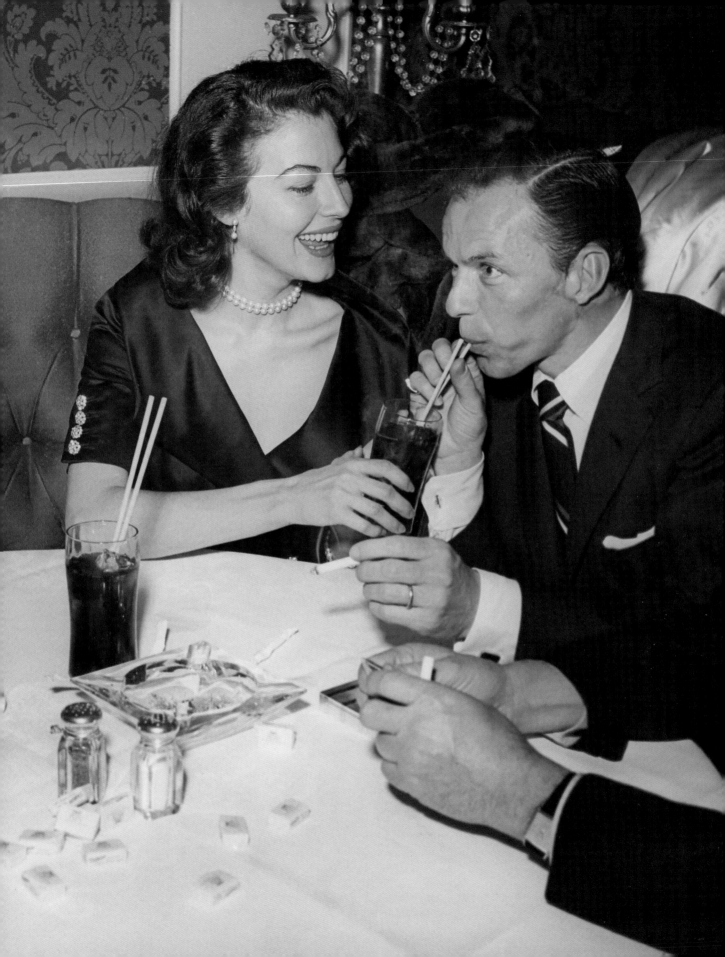

CHAPTER **FIVE**:
Mrs. Sinatra

FRANK SINATRA'S CAREER WAS IN A SLUMP. NICKNAMED "the Voice" and "Swoonatra" by his PR agent, George Evans, Frank became a solo sensation after breaking from the Tommy Dorsey band in 1942. Young fans—primarily bobby-soxers—acted around Frank much like they would act during Beatlemania in the 1960s. With his bright blue eyes and smooth baritone voice likened by some critics to "worn velveteen" or "being stroked by a hand covered in cold cream," Frank was a heartthrob with legitimate talent who found fame before age thirty. Yet fame, unless carefully handled by both its possessor and his team, can wither just as fast as it blossoms. By 1950, Frank had a string of critically panned film performances under his belt and was receiving the wrong kind of attention for his violent temper and unwillingness to comply with the press.

Ava first met Frank in 1943 when she was at a Hollywood nightclub with Mickey Rooney, and Sinatra quipped that *he* would have married her if he'd spotted her first. The idea was absurdly comical at the time: Sinatra was married and had a young daughter. Still, Ava admitted to finding him attractive. Working for the same studio, they met casually over the years and even went on a few dates—nothing out of the ordinary. But Frank's attitude toward Ava became more serious when they both sat for the MGM Stock Company group portrait in 1949: "I looked at her and said, 'Jesus, you got prettier since last time I saw ya.' This was not the young girl from Carolina at the studio. This was a woman who was glorious."

Entering into a serious relationship with Frank was challenging, as Ava would soon find out. His reputation as a ladies' man was long-standing. Marilyn Maxwell, Gloria DeHaven, and Lana Turner had all been spotted by his side. "Frankie had every dame on the Metro lot," publicist Jack Keller admitted. Keller, who was assigned to look after Frank but who never did any actual publicity for him, let slip some lascivious stories for gossip columnist Hedda Hopper's files, now held at the Margaret Herrick Library in Beverly Hills. Among them was Frank's acquaintance

opposite: Ava and Frank photographed ca. 1950 at Danny's Hideaway in New York City.

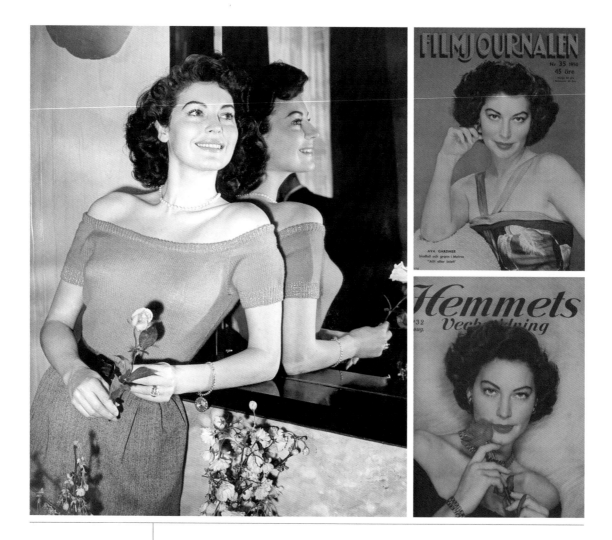

FILMJOURNALEN
Nr 35 1950
45 öre

AVA GARDNER

Hemmets
Vecko...

with mobster Lucky Luciano. Keller also procured women in each city Frank visited while on tour: "If he arrived on a plane in New York at 3:00 a.m., he had a girl in bed with him at 4:00. He never could go to sleep without having a woman. He hasn't been without a woman 7 nights in the past five years." Still another task involved bailing Frank and Ava out of an Indio, California, jail after a three a.m. drunken joyride and two pistols resulted in several shop windows being blown out. Keller bribed the police with $20,000 to keep mum about the incident.

Fans did not take kindly to reports of Frank's philandering. Unsurprisingly, gossip columnists like Hopper were sounding boards for fans' indignation. In 1946, Hopper received letters from bobby-soxers about how disgusted they were to read in her column that Frank had left Nancy for Lana Turner. They threatened to stop listening to his records and to put him "on the skids" for disrupting his family life. Lana was saddled with a significant portion of the blame.

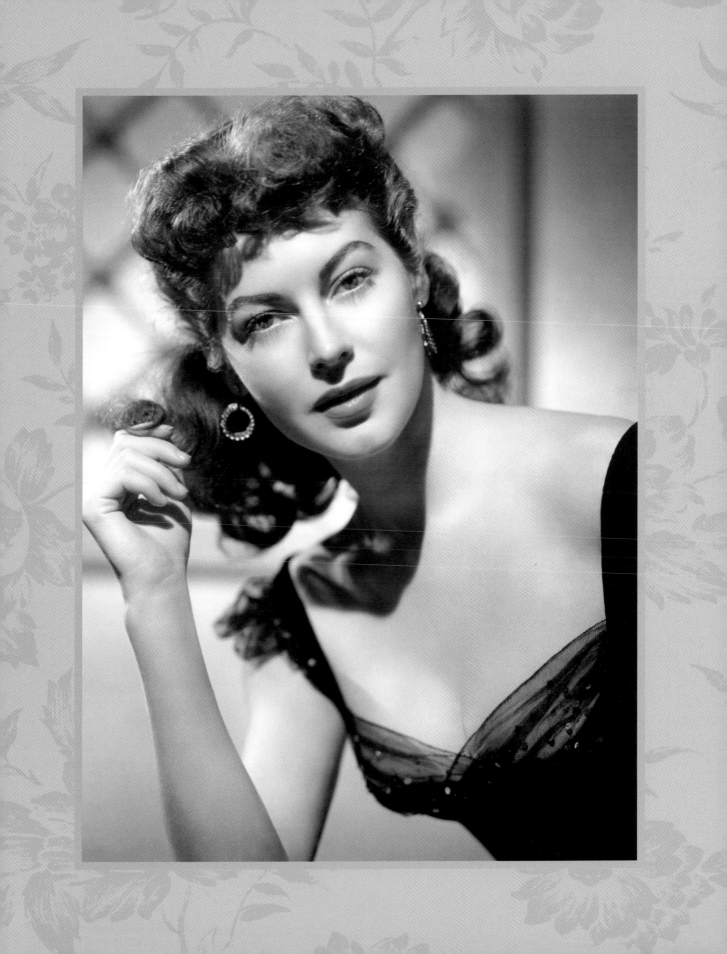

And then there was Frank's wife, Nancy Barbato. Nancy and Frank had met and married in New Jersey, where they both grew up. They started a family and moved out to Hollywood together. A proud Italian American, Nancy was not the type of woman to roll over easily. She put up with her husband's affairs, but when another woman threatened to take Frank away, Nancy was prepared to fight. So it happened when Ava and Frank fell in love and Frank decided to leave Nancy and their three children.

Nancy later spoke about a particular incident when Frank and Ava drove up to the gate of the Sinatra house: "They were together one night in the car. I could tell they had both been drinking. We had a buzzer at the gate and he said, 'Nancy, will you please tell Ava that I've asked you for a divorce?' I said, 'Frank, you're out of your mind,' and I hung up. I wouldn't tolerate it. And she was a real bitch, too."

Frank's youngest daughter, Tina, first met her future stepmother at Bappie's house in the Hollywood Hills. She has a different impression of Ava than her mother did:

What I remember most, and what I think of first, is her sleekness and her cleanliness and her scent. Her casual air, with every hair in place, without make-up. Her flared skirt, right out of the '50s, and a beautiful—you knew it was truly leather—belt, and flats, like a ballet slipper.

She was as low to the ground as she could be, and when we met she came down and stooped low to my level, which always impresses a kid whether you know it or not at the time. It's rather a gentle and generous thing to do. She was groomed, and she was very calm and calming. By six or seven I was very aware of them and who they were. Ava was tender and sweet, and had a bit of a tomboy air to her. She wasn't a frail woman reclining on a chaise, she was up and moving. As I got older and saw her periodically, she was very maternal, and a good friend. She loved Frank and she loved what was Frank's.

But the truth is, [Frank and Ava] were never here. Dad was more into looking at singing at the time. His crest was on the downside as hers was ascending.

Louis B. Mayer threatened to cancel Frank's contract over the affair. Curiously, it doesn't appear that Ava's employment status was also threatened, possibly because her recent films for MGM, with

below: Ava photographed in Los Angeles with her *East Side, West Side* costar Van Heflin in 1950. They were slated to star together in a film titled *Upward to the Stars*, but the project fell through.

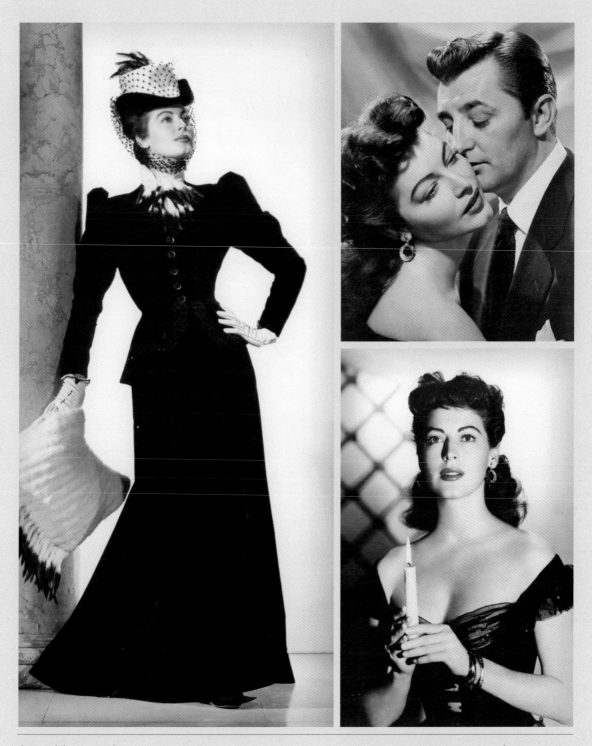

left and bottom right: RKO publicity portraits taken in 1950 to promote *My Forbidden Past* (1951). *top right:* With Robert Mitchum in a publicity portrait for *My Forbidden Past*.

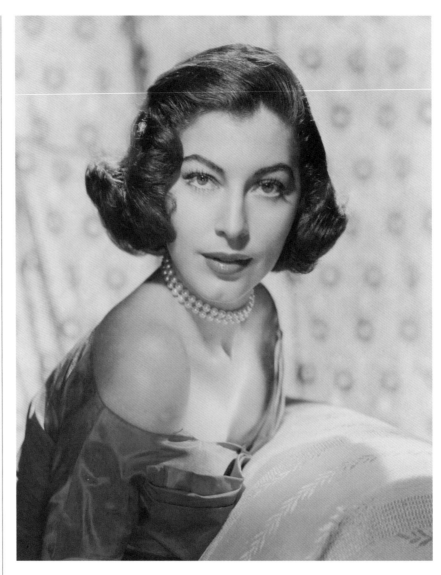

A Virgil Apger studio portrait, ca. 1950.

the exception of *The Bribe*, had turned a profit. Ava's star was on the rise, and she was about to bring a touch of Hollywood glamour to the film capitals of Europe.

Hollywood producers had been making films outside the United States since the early days of cinema, but by the 1950s the studio system was beginning to crumble and producers found themselves battling opposition on two fronts. Senator Joseph McCarthy and the House Un-American Activities Committee were on a witch hunt to weed out suspected Communist sympathizers and blacklist them from working in entertainment. Despite growing up in the South, Ava did not shy away from making her liberal political beliefs known. In 1947 she joined Gregory Peck, Paulette Goddard, Moss Hart, Arthur Miller, and other big names of screen and stage in taking out a full-page ad in *Variety* stating their opposition to HUAC:

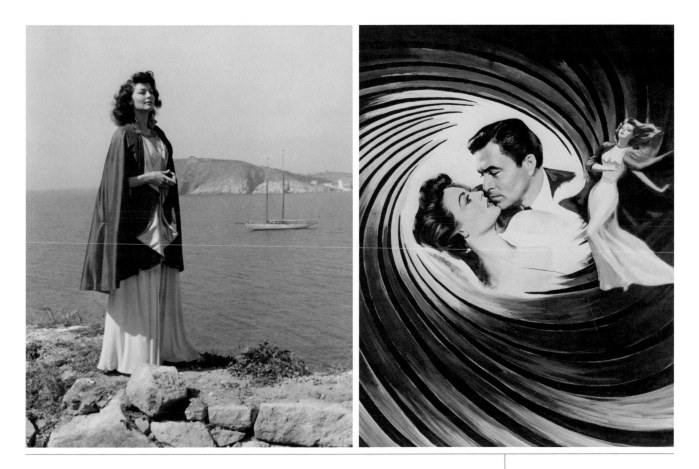

from left: Pandora Reynolds stands on the cliffs of Esperanza with the Flying Dutchman's yacht in the bay. • An artistic James Bond–style publicity picture featuring Ava and James Mason for *Pandora and the Flying Dutchman* (1951).

"We, the undersigned, as American citizens who believe in constitutional democratic government, are disgusted and outraged by the continuing attempts of the House Un-American Activities Committee to smear the motion picture industry and Broadway.

"We hold that these hearings are morally wrong because: Any investigation into the political beliefs of the individual is contrary to the basic principles of our democracy. Any attempts to curb freedom of expression, and to set arbitrary standards of Americanism, are in themselves disloyal to both the spirit and the letter of our Constitution."

Television was the other major factor bearing down on the film industry in the early 1950s. Ticket sales dwindled as audiences chose to stay home and gather around the TV. Facing financial difficulties at home, studio bosses decided to utilize overseas funds that had been "frozen" during the war, ultimately finding it cheaper to film on location abroad or in the studios of Rome, London, and Madrid than on California soil. Thus, in February 1950, Ava made her first trip to Spain via London and Paris to play one of the title roles in *Pandora and the Flying Dutchman*.

Shot primarily in the seaside town of Tossa de Mar, on the Costa Brava, *Pandora* was a big-budget film that might be called "art house," or something close to it.

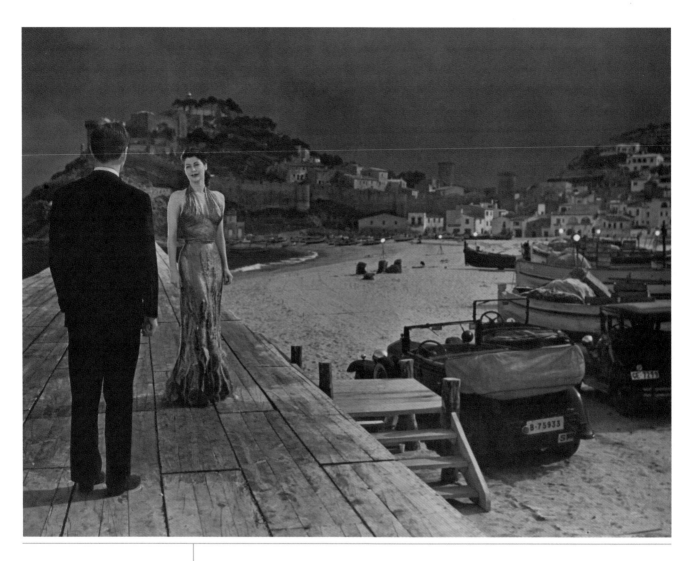

A moonlit scene from *Pandora and the Flying Dutchman.*

Produced, scripted, and directed by Albert Lewin, it tells the story of Pandora Reynolds, a beauty from Indianapolis who defects to the fictional Spanish town of Esperanza and has men literally falling at her feet. Pandora entertains lovers—a race-car driver (Nigel Patrick), a torero (Mario Cabré)—but is only capable of giving her love to the mysterious Hendrick van der Zee (James Mason), a Dutchman who appears as if from another time on a ghostly yacht in the Esperanza harbor. Van der Zee turns out to be the embodiment of a seventeenth-century nautical legend, condemned for murdering his wife and doomed to sail the high seas for eternity unless he can find a woman who is willing to die for him and save him from eternal purgatory.

Lewin had been with MGM since the 1930s and made a name for himself working with the young producer Irving Thalberg. As a director he brought creative flare to adaptations of literary classics such as Maugham's *The Moon and Sixpence*, Wilde's *The Picture of Dorian Gray*, and Guy de Maupassant's *Bel Ami*. When it came to filming *Pandora*, however, MGM refused to give financial backing, so Lewin, deciding to go independent, asked the studio to loan Ava to him as a payout.

In terms of artistic vision, Lewin could not have done much better than borrowing British cinematographer Jack Cardiff to do the camera work. Cardiff was a master at color photography and at using creative angles to achieve visual poetry, as seen in his collaborations with Michael Powell and Emeric Pressburger. Cardiff thought Ava "great fun to work with and very beautiful." "The first time I met her she was very natural, very common sense natural. She used to swear a bit sometimes. I was introduced to her and she said, 'Jack, I'm pleased you're going to photograph me but you have to watch me when I have my period because I don't look so good.' I said, 'Don't worry, I'll look after that.' It was the very first thing she said to me." It was strange but perhaps good advice; Tossa serves as a picturesque backdrop with its historic castle and mystical atmosphere, and Beatrice Dawson's costumes work well to enhance the overall aesthetic of the film, but Ava's face plays a significant part in the film's visual landscape. In an interview with Justin Bowyer, Cardiff spoke of the reason for this: "[Lewin] thought Ava was the most beautiful person ever, and he used to just gaze at her and he would shoot so many close-ups and then say, 'Do it again!' Always doing extra close-ups. Quite mad." Ava later quipped, "One day I had to say to him, 'Al, do you think I can go to the bathroom after the eighty-first take?'"

Pandora was "a very pleasant film to work on because it is what I would call an 'artistic film,'" said Cardiff. "Everyone concerned was very artistic." Among the film's collaborators was the surrealist photographer Man Ray, who did an early version of Hendrick van der Zee's "egghead" painting of Pandora, as well as the color photograph of her on the nightstand in the seventeenth-century flashback scene. This was the second film Ava did with British star James Mason, and although their chemistry is not as potent as it was in 1949's *East Side, West Side*, Ava's performance in particular is worth revisiting for its quietude and naturalness. She is often photographed in a stationary position—sitting or standing—and lets the eroticism that conquered men both on- and off-screen shine through with a flash of her eyes or a coy smile. As director George Cukor once said of her, "Eroticism is the whole climate of attractiveness, of voluptuousness, of sensuousness, that you achieve in various ways, and [some] people have that in their personality. I don't think a beautiful girl like Ava Gardner has to huff and puff and do an awful lot; she carries it with her. It touches their imagination."

When not needed on set, Ava began a love affair with the country she would later make her home.

When not needed on set, Ava began a love affair with the country she would later make her home. She learned flamenco dancing at a festival in Valencia and was introduced to the bullrings of Gerona, where *Pandora*'s bullfighting scene was filmed. The nocturnal culture of drinking and dancing perfectly suited Ava's sensibilities, which would become part of her image in the mid-1950s and beyond.

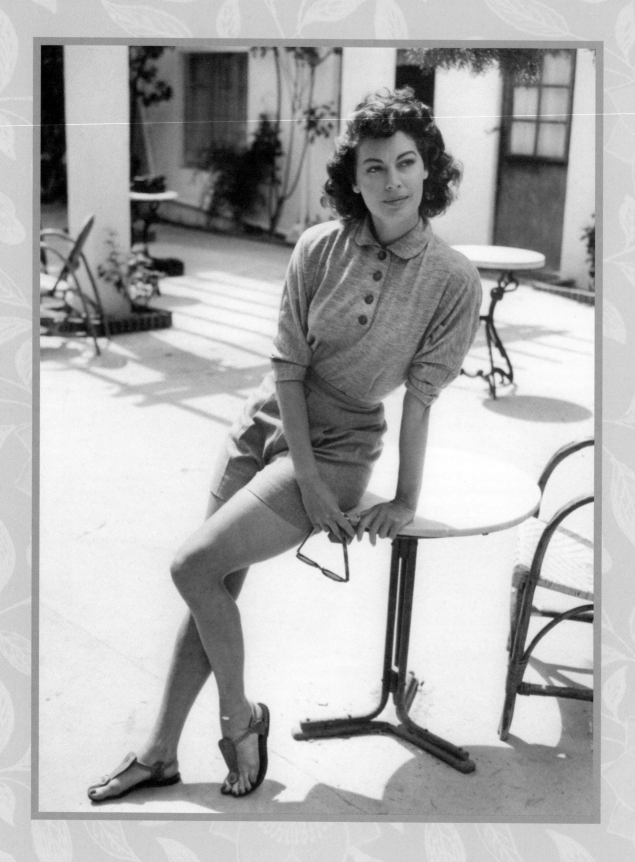

Cardiff recalled tagging along with Ava on one of her late-night adventures: "When we got back to England after [*Pandora*], Frank came over to London and he and Ava and I went out for two or three evenings, which was more than I could handle because it wasn't just a nice dinner and then home, it was on to a nightclub and then another nightclub and then another and we would end up at six in the morning in the dawn light."

It was after one of those late nights of wild abandon that Ava slept with Mario Cabré. It was a one-time affair that Ava regretted, but it was enough for Cabré to go public with declarations of love and to pen romantic poems in Spanish with stanzas like:

> The centuries hammer into the rocks
> Words heard by the dawn.
> Such exchanges has the soul
> With the secret meaning of things!

Ava with Mario Cabré in Spain during the filming of *Pandora and the Flying Dutchman*. The Spanish bullfighter-turned-actor turned out to be an ardent poet who used his brief affair with Ava to get media attention.

opposite: On a day off from filming *Pandora and the Flying Dutchman*.

Ava found the poetry difficult to translate, but if there was one thing she understood and abhorred, it was the invasion of her privacy by journalists who were only too eager to give Cabré's one-sided infatuation space in their columns. Photographs of her and Cabré in close proximity were published on both sides of the Atlantic with headlines such as "Crooner or Toreador?" and "Bullfighter Rival of Sinatra Quite Sure of Ava's Love." Ava thought Cabré a "pain in the ass" who was "better at self-promotion than either bullfighting or love."

If Cabré's intention was to make Frank Sinatra jealous, it certainly worked. Ava and Frank "were combustible," says Tina Sinatra. "You can't possess someone, and I think this is something everyone learns in life, if they're lucky. I think Dad was overly possessive and Ava was the last person to smother. At times maybe those roles even changed. They were very alike and I can't imagine either of them surprising each other with their behavior." Frank flew to Barcelona with his right-hand man, Jimmy Van Heusen, for a short, preplanned visit in May 1950 and was furious when reporters relayed the gossip about his mistress and the bullfighter. In an effort to diffuse the situation, Lewin made sure Cabré was filming in Gerona while the couple spent time together in small bars and hotels in Tossa de Mar.

Despite the distance between them, the specter of Cabré overshadowed what was intended to be a peaceful rendezvous while Frank recovered from a recent

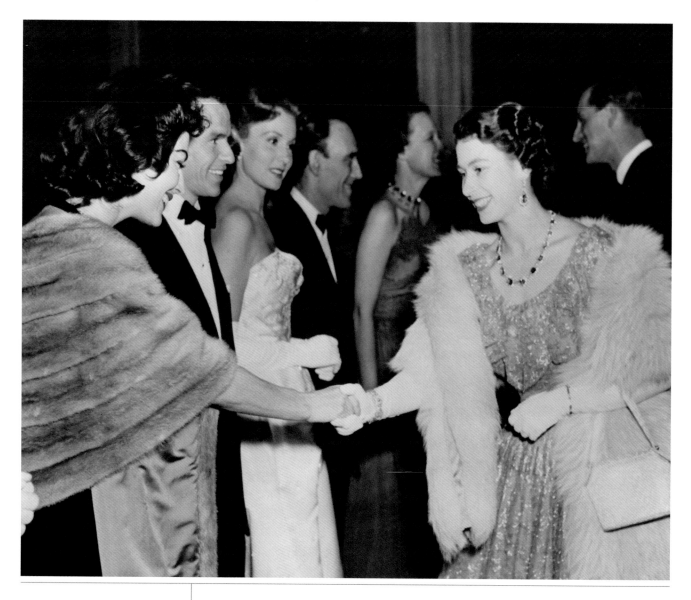

Ava and Frank greet the future Queen Elizabeth II at the London Coliseum during a star-studded charity performance in 1951. Philip Mountbatten (future Duke of Edinburgh) can be seen in the background.

throat hemorrhage. From Gerona, Cabré continued to tell reporters of his devotion to Ava and his surety that their feelings were mutual: "After Sinatra's visit is over and Ava and I are alone again, I think you will find that our love has survived." Had Cabré not attempted to blatantly use Ava's fame to boost his own, the story may have blown over without becoming a scandal. As it was, Frank's posse laid the blame on Ava for inflicting distress on the wounded singer. "He was having a really bad time with Ava Gardner," said Jimmy Van Heusen. "She was terrible then. Terrible. Just grinding her feet into his face in the dust, you know."

When *Pandora* wrapped, Ava returned to California and to Frank, without a second thought for Cabré and his brash romanticism.

A VA'S NEXT FILM, A GRAND TECHNICOLOR PRODUCTION of *Show Boat* produced by Arthur Freed, began filming in late October 1950. This was to be the third film adaptation of the beloved Jerome Kern–Oscar Hammerstein musical (not to mention the four successful Broadway productions). She was cast as Julie LaVerne, a cabaret singer aboard the traveling show boat *Cotton Blossom* whose life takes a hard turn when it is revealed she is part black and married to a white man. It would have been an ideal part for Ava's friend Lena Horne, the talented black actress and singer who had performed Julie's songs at the end of *Till the Clouds Roll By*. But Hollywood was still mired in racism as potent as that which existed in the late nineteenth century, when *Show Boat* takes place. "We understand that you are planning a production of Showboat," wrote Joseph Breen to Louis B. Mayer. "We call to your attention the production code: Section II—Sex, Article 6—Miscegenation (sex relationship between the white and black races) is forbidden." According to Hugh Fordin, author of *The Movies' Greatest Musicals*, Mayer reminded Breen of the precedent set in that area by the 1936 film version of *Show Boat* starring Irene Dunne, Helen Morgan, Allan Jones, and the great Paul Robeson.

The relationship between Julie and her husband was allowed to stay in. Still, when it came to casting, it was considered preferable to cast a white woman who could be made to look part black with the aid of makeup than it was to cast someone who was actually half black. "You couldn't pass Lena off as white," Arthur Freed told historian John Kobal. "The girl that played the part had to look white, and had just one drop of colored blood, which was the biggest injustice in the world against this girl. With Ava you could believe she had a drop of colored blood." Horne never bought such excuses.

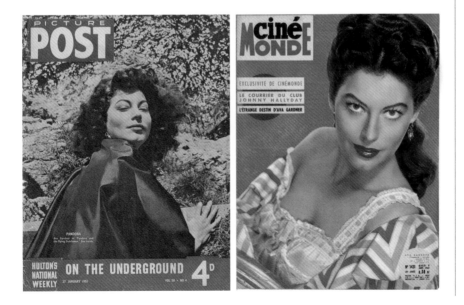

from left: The British newsmagazine *Picture Post* featured Ava on the cover of its January 1951 issue to promote *Pandora and the Flying Dutchman*. • As Julie LaVerne in *Show Boat* (1951) on the cover of the French film magazine *Cinémonde*.

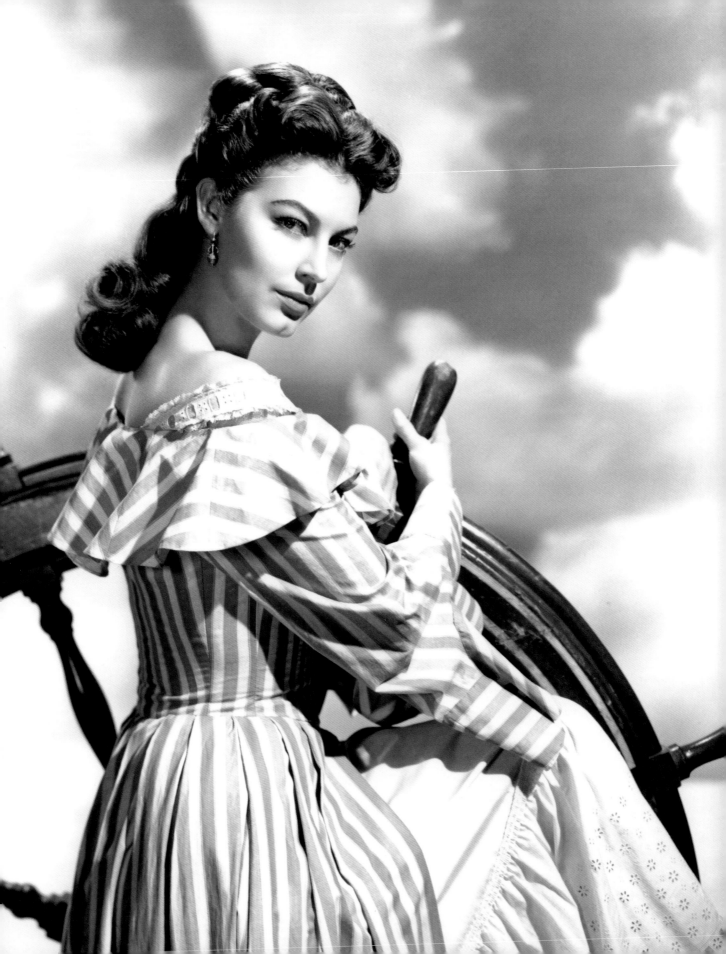

Freed, director George Sidney, and MGM's soon-to-be president, Dore Schary, considered Judy Garland and Dinah Shore for Julie before casting Ava. There are conflicting stories as to how much those in charge of production really wanted Ava in the film. On the one hand, Sidney confessed that "there wasn't much enthusiasm about Ava, even making a test." She reportedly disliked Walter Plunkett's costumes and wanted to be kicked off the picture. On the other hand, in Freed's estimation, Ava was the perfect addition to an already strong cast:

> Kathryn Grayson was right [as Magnolia], and Howard Keel was perfect [as Gaylord Ravenal], he was just square enough for that part, which was a help and he had a good voice. . . . William Warfield . . . stopped the show singing "Ol' Man River." Every song in Show Boat was one of Kern's great gems. But Ava Gardner was the one that really made that part in there. I knew we had made it big when I finally got Ava into it. Ava was wonderful in that picture. . . . I had a hell of a time with Dore Schary because he wanted to put Dinah Shore in that part. And Dinah was sending me flowers to the house and everything, and I love Dinah, and she finally said: "Why don't you give me the part?" and I said: "Because you're not a whore." And I said: "Ava is. When she sings 'Bill' she's every streetwalker you ever saw."

Members of the MGM makeup department touch up Ava's look for her first scene in *Show Boat*. Makeup for the film was devised by William J. Tuttle.

opposite: Publicity portrait of Ava as Julie.

John Kobal was quick to clarify the producer's words: "Freed gives this exchange with swelling pride and admiration which let you know he didn't really mean that Gardner was a prostitute at heart, but that she could play the part of a prostitute in a way that would rip everybody else's heart out watching her."

There is little doubt that Ava's popularity at the time was a contributing factor to her playing Julie. In spite of the scandal surrounding her love life, MGM was sending out publicity portraits to fans and publications by the thousands. Ava was now a big name who could carry a film at the box office, proving her worth as a major star. Her new salary also reflected her status at the top of the MGM star ladder. She was paid $140,000 for what amounted to about thirty minutes of screen time.

Although she sang in several of her earlier films, this was Ava's first appearance in a movie musical, and she was eager to prove that she could hold her own against professionally trained Grayson and Keel. Determined to work hard to make successful recordings of Julie's two songs, "Can't Help Lovin' Dat Man" and "Bill," she practiced with Lena Horne's teacher. *The Killers* and *Pandora* had showcased her natural mezzo-soprano range and proved she could carry a tune. Her voice was earthy and perhaps better suited to accompanying actor-singers like Gene Kelly or even Frank Sinatra. Compared to the operatic tones of Grayson and Keel, Ava's own singing was considered by composer Roger Edens, who conducted Ava's test recordings, too

from left: Kathryn Grayson and Ava behind the scenes on *Show Boat*. The two became friends at the studio, although Grayson couldn't keep up with Ava's fast-paced lifestyle. • Magnolia (Kathryn Grayson) and Julie (Ava) dance on the deck of the *Cotton Blossom* in *Show Boat*.

opposite: Kathryn Grayson, director of photography Charles Rosher, and Ava on the deck of the *Cotton Blossom*.

"pale, thin, and tentative." Based on Edens's assessment, Annette Warren was brought in to dub Julie's songs, much to Ava's chagrin. She was already disillusioned with what she considered MGM's poor treatment of her career. This was another nail in the coffin; she carried her bitterness about it to the end of her life.

Ava's voice does survive on the soundtrack recording for the film and can be heard overlaid onto Julie's musical numbers in fan videos on the Internet. When watching the dubbed scenes back to back with the same ones containing Ava's restored voice, Ava's soulful singing noticeably matches the visuals in the film even better than does Warren's. What was considered the better choice in 1950 doesn't quite hold up in the light of retrospect. Kathryn Grayson agreed. Speaking of Ava and *Show Boat* in a 1990 oral history, she told Rex Reed, "Boy could she sing! It was so stupid to dub her songs in *Show Boat,* and I told George Sidney so. Southerners never pronounce *R*'s, and when she sang 'Oh listen, sistuh, I love my mistuh man,' it was very touching."

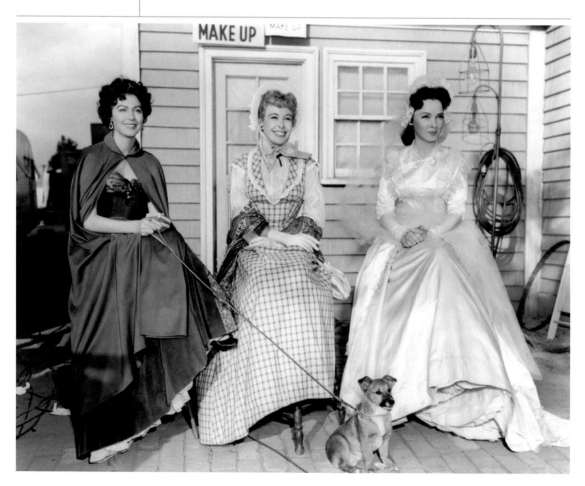

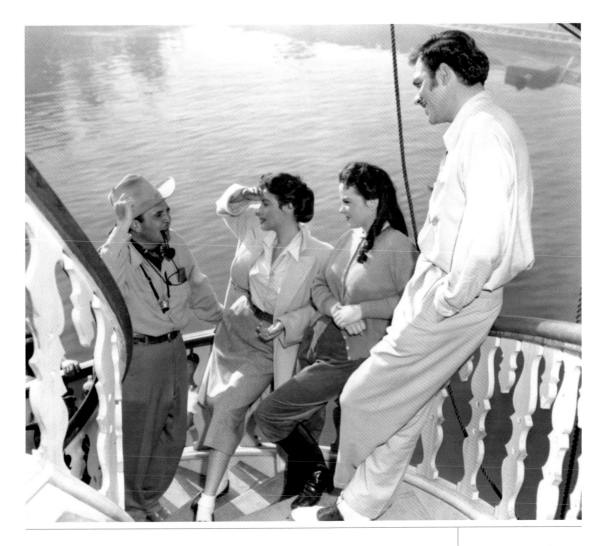

Musical decisions aside, Ava seemed to enjoy working on the film. She became good friends with her cast mates, often spending time with them between scenes and on her days off. Marge Champion remembered Ava spending time at her Nichols Canyon house and skinny-dipping in the pool. "Ava had really astonishing beauty, a piercing vulnerability, and also a kind of regalness, but she could be as common as sand between your toes. But everyone on set was drawn to her."

Howard Keel considered her one of the boys. They became drinking buddies behind the scenes: "You couldn't help but love Ava. She knew how to be around men. You could always open yourself up to her. She was wide open, a lot of fun, and full of hell, you know? She hated bullshit, and so did I. . . . She was a great, great broad."

"Mr. Mayer sent around a note forbidding drinking on set," said Kathryn Grayson. "I had the big, luscious dressing room with all the cupboards and cabinets and closets, so Ava kept her tequila there, and if I had to go back for a change, she

Director George Sidney converses with Kathryn Grayson, Ava, and Howard Keel on the *Cotton Blossom* at MGM.

opposite, from top:
ABC magazine cover, 1952. • Ava, Marge Champion, and Kathryn Grayson wait outside the makeup cabin on the MGM back lot during the filming of *Show Boat*.

and Howard Keel locked me out. So I had all the locks changed and went behind the camera one day with the lime and salt on my hand, and Ava yelled, 'Look at that little son of a bitch. She's got our tequila!'" Filming *Show Boat*, Grayson recalled, "was a very happy experience."

Both *Pandora* and *Show Boat* premiered in 1951. The latter garnered overall enthusiastic reviews in the United States. It had color, action, and good family fun. MGM held a preview screening at the Bay Theatre in Pacific Palisades on March 22, 1951. Comment cards that are now part of the Arthur Freed Collection at USC show that audience members voted Ava's the most "excellent" performance in the film. "Ava Gardner terrific," and "Ava Gardner splendid, Kathryn Grayson shows ability to act, for first time" were among the comments that got back to publicist Howard Strickling at the studio. Bosley Crowther of the *New York Times* thought the editing and abundance of close-ups blighted Ava's dramatic performance, but that her musical renditions (or Warren's) were "haunting and moving." Wrote the *LA Times*'s Edwin Schallert, "Miss Gardner comes definitely to the rescue in the picture when she jolts the romance into being again after her own decline as Julie. She is tremendously effective."

Pandora and the Flying Dutchman proved more divisive, with several American critics labeling the film too highbrow for general audiences. Ava, however, left a strong impression both at home and abroad. The *Los Angeles Herald-Express* declared *Pandora* "the greatest screen performance of her career." Louella Parsons thought Ava "the most ravishing 'femme fatale' I've ever seen, who gives a laughing, brooding, amoral portrayal." Albert Lewin "has succeeded in elevating Miss Gardner to the status of a first-magnitude star as the sirenic femme fatale," Schallert told his readers.

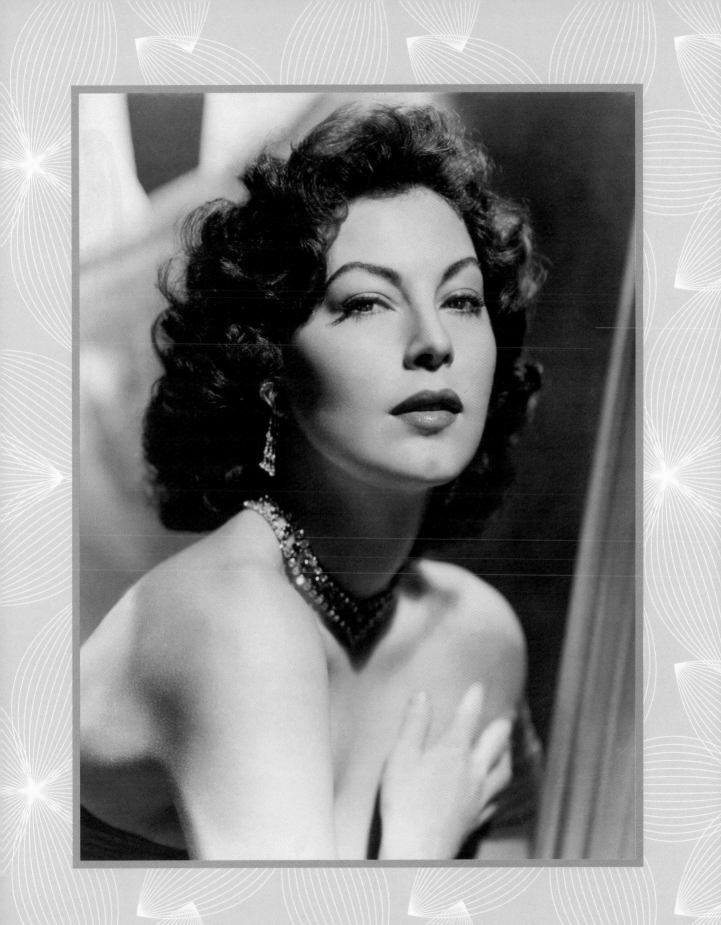

More interesting was the reception the film garnered overseas, particularly in France, where the Europeanness of *Pandora*'s artistry was welcomed with open arms and Ava became an unlikely muse for New Wave cinema. In his assessment of the film, director Adonis "Ado" Kyrou wrote, "Pandora is the only resolutely surrealistic woman in the whole movie history. Ava Gardner was never more beautiful, I have never felt so intensely, how available for *l'amour fou* a woman could ever be." To Jacques Fieschi, screenwriter and former critic for *Cinématographe*, "Only Ava Gardner could portray that ideal of a model, under the thumb of its creator, a statue coming to life, loving and suffering as a woman forever prisoner of her status as idol." Could Ava have made a success in European cinema, as foreign actresses like Sophia Loren did in Hollywood? Judging from the reactions of the French, it seems a pity that film lovers never got to find out.

THOUGH HER ON-SCREEN PERFORMANCES IN THE EARLY fifties were crowd-pleasers, Ava found herself on the receiving end of public indignation regarding her private life. She was labeled a home wrecker and a gold digger. *Modern Screen*'s Arthur L. Charles wrote, "The year 1950 will go down in the records as the year of the open season on Ava Gardner and Frank Sinatra." Much of the derision was published in Hedda Hopper's syndicated *LA Times* column. One Marie Miller wrote in to declare, "[Ava and Frank] are the most *disgusting objects* in Hollywood. . . . If she were any part of a lady, she would not break up a home, where there are three lovely children. And if he had all of his *beans* he would not pick up with a woman who had so many husbands. What is he getting? Nothing by [*sic*] a *has been*." Mrs. C. Cassidy wrote to Hopper of her "disgust" with both parties: "I have always watched for a Gardner picture. Now I don't want to see another. As for Frank it is just about time he grew up. If he will sum up his charms I am afraid he will find he has none for a beautiful siren. He is just a rebound to make her beaus jealous. About the only thing the lady could be interested in is his money."

"I'm being vilified," Ava told journalist Earl Wilson. "It's incredible—where do they get these vicious stories?" She was not above accepting expensive gifts from her suitors or appreciating the finer things in life. However, she resented being dubbed a real-life femme fatale, especially because she was the breadwinner at the beginning of their relationship, something that Frank found difficult to cope with. Actor Farley Granger claimed to have had a brief affair with Ava around the time she made *Show Boat*. They spent time in jazz clubs around Hollywood and at the beach in his hometown of Carpinteria. In his 2012 memoir, *Include Me Out*, Granger wrote about

> "The year 1950 will go down in the records as the year of the open season on Ava Gardner and Frank Sinatra."
>
> —ARTHUR L. CHARLES

opposite: Ava and Frank Sinatra play ball, ca. 1952.

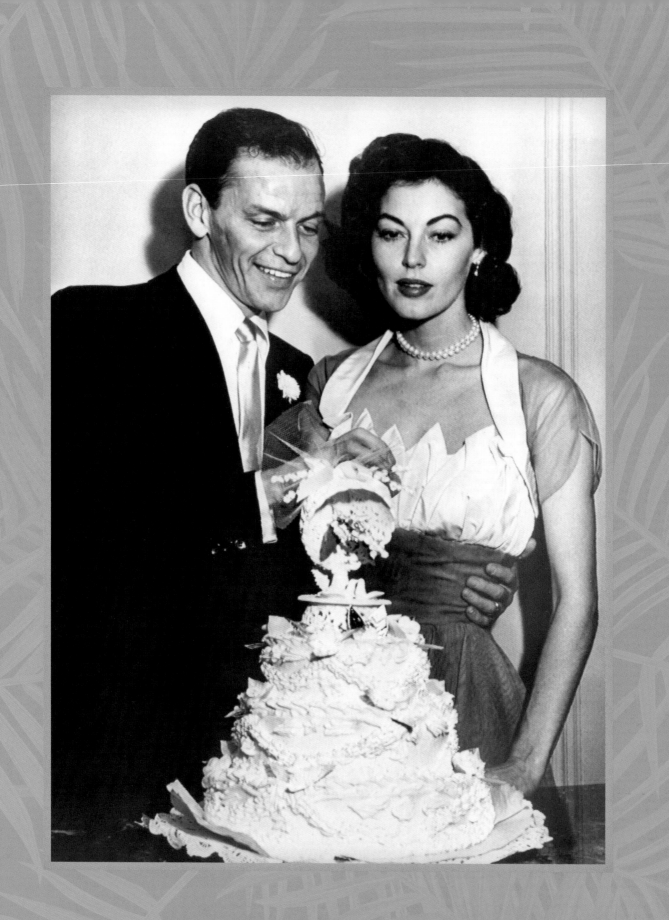

Ava's opinions on being held to the double standards that applied to women in the 1950s: "Ava was . . . ahead of her time in terms of equality for women. Ava felt that for a man to be admired while he played the field while a woman was called a slut for doing the same thing was 'bullshit, honey!'"

"It was a nightmare time," Ava remembered, referring to her affair with Frank, the invasiveness of the press, and the subsequent upheaval of the Sinatra household. Nancy's obstinacy in trying to keep hold of Frank angered her, and it was only near the end of her life that Ava could look back and view the situation differently. "[Nancy] played hardball, but I couldn't blame her," she told Peter Evans. "She'd been a good wife. She was the mother of his children. She had every right to fight for him, for their marriage. She'd stuck by Frank through thick and thin."

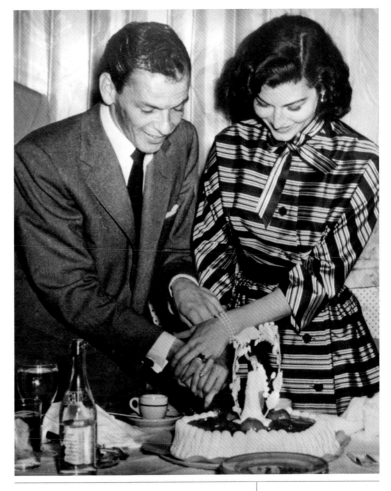

The newlyweds cut a wedding cake while on honeymoon in Havana, Cuba, November 9, 1951.

opposite: Ava became Mrs. Sinatra in a civil ceremony at the Philadelphia home of Lester Sacks on November 7, 1951.

Eventually the tide of public opinion began to shift. After twelve years of marriage, Nancy filed for divorce. Ava became Mrs. Sinatra in Germantown, Philadelphia, at the home of Lester Sacks, on November 7, 1951. As a gift, Ava presented Frank with a gold locket with St. Christopher emblazoned on one side and St. Francis of Assisi on the other. The inside contained Ava's picture and the inscription "To FS, always yours, AS." Frank's younger daughter, Tina, now treasures the locket. "In Ava," she wrote, "Dad had met his match."

Ava knew that with their highly strung personalities and their careers and self-esteem on different levels, marriage to Frank might be difficult. But they were in love, and Ava hoped she had found in him the man who would stick around for the rest of her life.

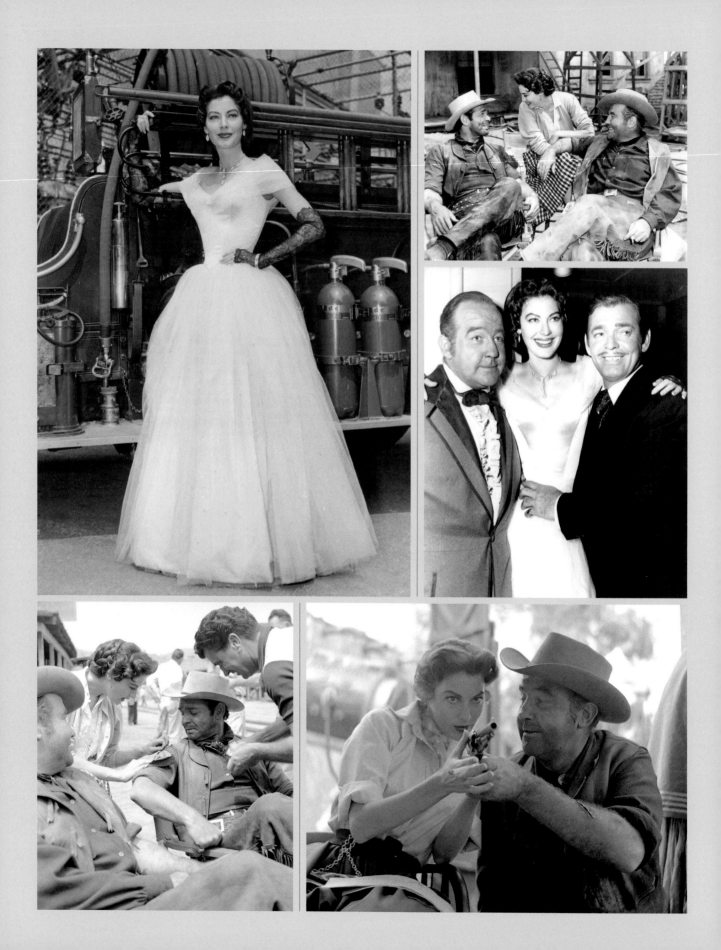

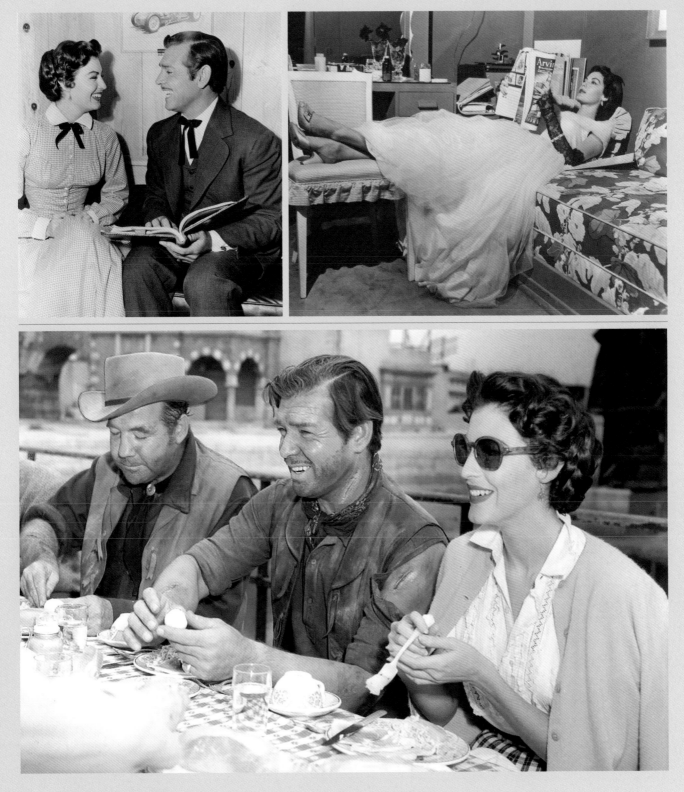

clockewise from top left: *Lone Star* was the second film Ava made with her girlhood idol Clark Gable. • Ava relaxing in her dressing room during filming. • Lunching with Broderick Crawford and Clark Gable during *Lone Star*.

opposite, clockewise from top left: Behind the scenes on *Lone Star*. • With Broderick Crawford and Clark Gable. • Broderick Crawford shows Ava how to handle a gun. • Ava tends to a wound on Clark Gable's arm during a break from filming.

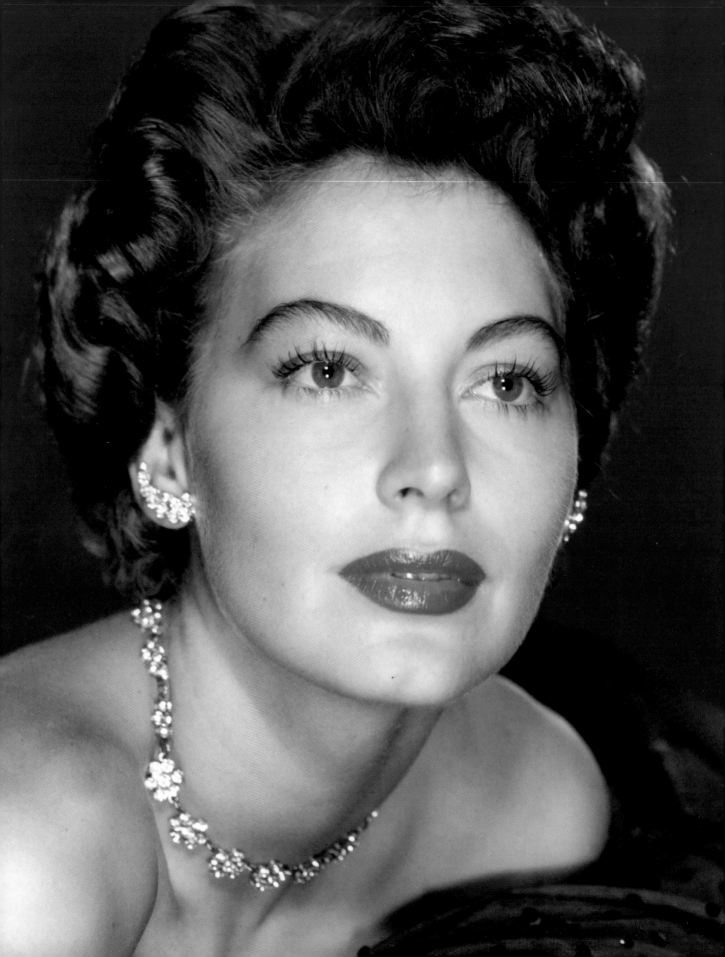

CHAPTER SIX:

International Stardom

THE HONEYMOON WAS BRIEF. AFTER A COUPLE OF DAYS IN Miami, where the press haunted them relentlessly, the newlyweds set out for Cuba. Before Fidel Castro came to power Havana had been a popular hot spot for wealthy Americans—socialites, power players, as well as writers and artists looking for inspiration in this vibrant and colorful world of casinos, clubs, and cocktail bars. Ava loved the city, and Frank loved the fact that they were virtually uninterrupted by the press. Aside from the curious glances of the passersby, they could have just been another all-American couple on their honeymoon. They stayed at the now legendary Hotel Nacional de Cuba, the glamorous center of Havana's decadent landscape. Away from home and the pressures of their careers, without the persistent reporters and nagging voices, the newlyweds were able to remember why they went through so much to be together. They took long walks by the beach, talked, drank, danced, made love. It was as though time had stopped. For a brief moment they were completely blissful, and it seemed that nothing could stand in the way of their happiness. Today guests can stay in room 225 at the Hotel Nacional, named after Ava and Frank, a witness to a legendary love affair during its happiest and most sacred moments.

After three glorious days and nights they flew back to New York, and from there to Los Angeles. Frank planned an elaborate wedding reception for their Hollywood friends at his Pacific Palisades home. They were young, beautiful, and in love, beaming with happiness. Their guests couldn't believe they were the same rowdy Frank and Ava who had battled in public just weeks earlier. Ava was now determined to be

opposite: Color studio portrait taken around 1952

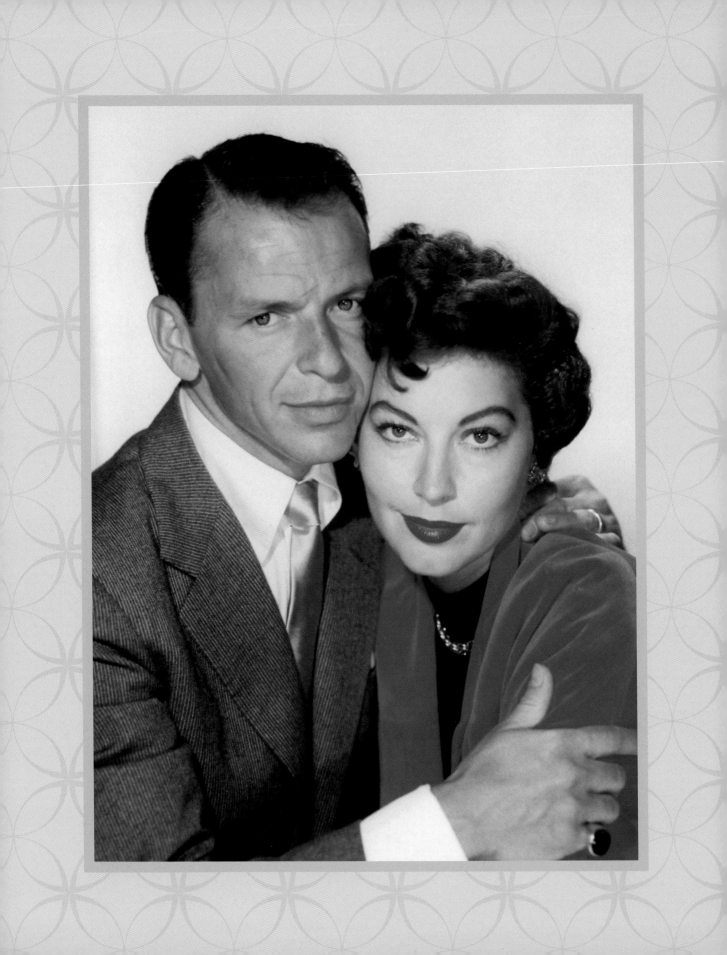

Mrs. Sinatra. Things hadn't always worked in the past, but she would do it right this time. They were both scarred and battered by the months of press scrutiny, the criticism, and the constant invasion of their privacy. Ava, however, was the stronger one. She could handle it better, and she still had her career; in fact, the studio had asked her to come back to work the moment she and Frank returned from their honeymoon. Frank, on the other hand, was quickly losing ground, and his popularity was at an all-time low. Ava knew he needed her to be there by his side to support him, like a good wife should. With no offers of film work, Frank went to New York for the second season of *The Frank Sinatra Show* and to try to secure some bookings on the Manhattan nightclub scene. The show had poor ratings, and everyone, most of all Frank, knew that it would get cancelled. Ava went to New York with her husband and continued to ignore MGM's demands that she return to work.

The fairy tale was over. The cold and bleak New York winter only highlighted the hopeless feelings of anxiety they were both experiencing. Frank's self-esteem was plummeting, and Ava felt helpless, unable to cope with his dark moods and self-pity. They began to argue again, and soon the sun-filled days in Havana seemed like a distant memory. Then an offer arrived from Hollywood. Twentieth Century Fox wanted Ava for the part of Cynthia in their adaptation of Ernest Hemingway's *The Snows of Kilimanjaro*. Although she'd promised herself she would not leave Frank in New York, this was a tempting opportunity she didn't want to turn down.

Since *The Killers*, Ava had become an avid fan of Hemingway's work, and she strongly identified with his literary heroines. At that time Hemingway was considered by many to be the most important author in the world and, according to author John O'Hara, the greatest figure in literature "since the death of Shakespeare." As was *The Killers*, *Snows* was only loosely based on Papa's short story of the same name; it was heavily embellished, with a string of characters borrowed from his other works or purely invented for the screen. Cynthia, the central female character, is a romantic figure, representing the anguish of the Lost Generation and the longing for lost love. Based in part on Lady Brett from *The Sun Also Rises*, she is a sympathetic, independent, and elusive heroine who fits seamlessly into the fabric of the film, although she does not appear in Hemingway's original story.

Ava loved the script of *Kilimanjaro* and was eager to reunite with Gregory Peck, with whom she had struck up a warm friendship while working on *The Great Sinner* in 1948. Frank

On the cover of a Dutch magazine.

opposite: The Sinatras in love.

Since *The Killers*, Ava had become an avid fan of Hemingway's work, and she strongly identified with his literary heroines.

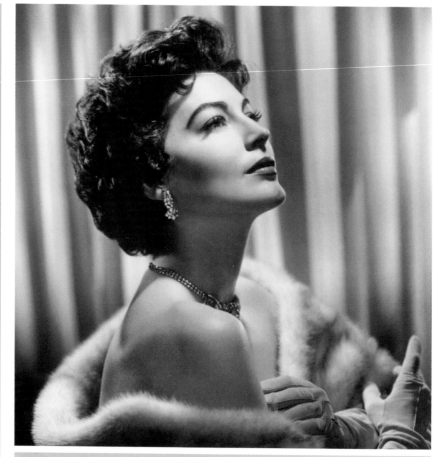

from top: Studio portrait taken around 1952. • Expecting them to pose for glamorous shots like these was part of MGM's customary treatment of its female stars.

opposite: Ava in the early 1950s. She would be one of the top stars of the decade.

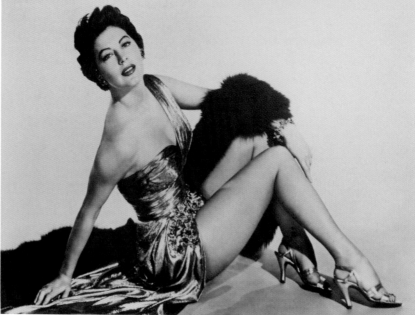

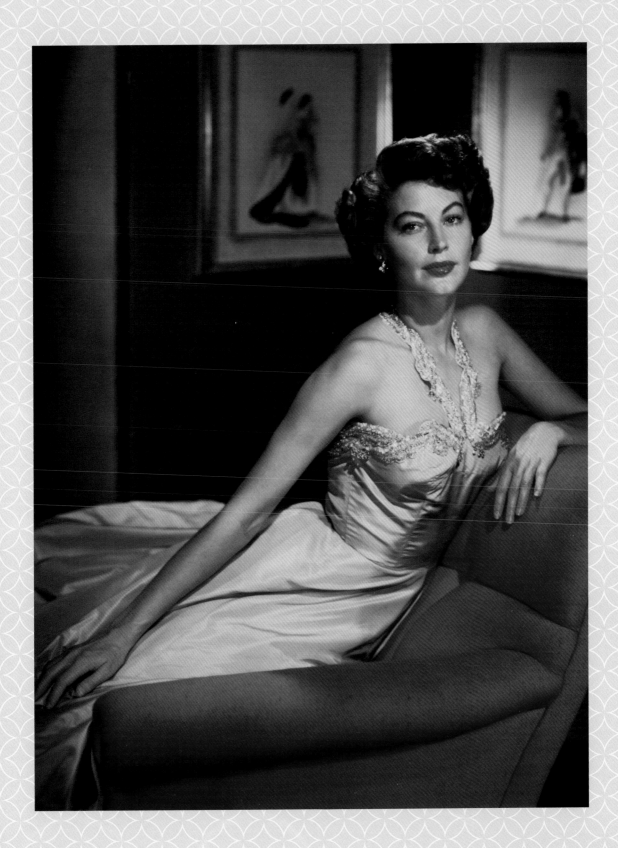

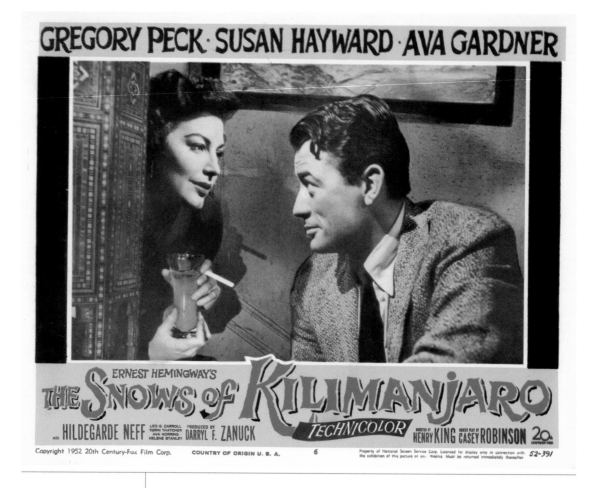

GREGORY PECK · SUSAN HAYWARD · AVA GARDNER

ERNEST HEMINGWAY'S
THE Snows of KILIMANJARO
TECHNICOLOR

with HILDEGARDE NEFF LEO G. CARROLL TORIN THATCHER AVA NORRING HELENE STANLEY PRODUCED BY DARRYL F. ZANUCK DIRECTED BY HENRY KING SCREEN PLAY BY CASEY ROBINSON 20th CENTURY-FOX

Copyright 1952 20th Century-Fox Film Corp. COUNTRY OF ORIGIN U. S. A. 6 Property of National Screen Service Corp. Licensed for display only in connection with the exhibition of this picture at your theatre. Must be returned immediately thereafter 52-391

Lobby card featuring Ava and Gregory Peck in *The Snows of Kilimanjaro.*

did not want her to go. He dreaded being alone in their hotel room. And the thought of Ava in Hollywood, starring in a major motion picture while he struggled to secure a singing engagement in a second-rate New York nightclub, anguished him beyond words. Wanting to remedy the situation with the least possible damage to Frank's already wounded ego, but refusing to turn down the part, Ava arranged for all her scenes to be shot within ten consecutive days—a grueling schedule, considering the number of different sets and scenes that had to be set up, among them a Parisian bistro, a Spanish *corrida*, and an African safari. Frank reluctantly agreed to let Ava go.

For the first time, returning to Hollywood felt to Ava like coming home. After weeks of cold weather and Frank's dark moods, Ava was happy to be among her friends, and this time she actually enjoyed her work. Despite the punishing schedule and the long days, the atmosphere on set was friendly and warm. Cynthia was the first part that Ava felt she could really identify with. She also enjoyed working with the veteran director Henry King. According to Rene Jordan, King was "a gentleman of the old school and he gave her a lot of help."

from top: Posing with Gregory Peck, her costar in *The Snows of Kilimanjaro.* • Publicity portrait for *The Snows of Kilimanjaro* (1952).

King had worked in the theater before starting in movies during the early silent days, and by the 1950s he possessed something of a legendary status. Ava trusted him, and under his skilled direction she created her first truly complex character, a woman who wasn't just a sexpot or a one-dimensional cardboard cutout as she so often portrayed in her Metro films. Her Cynthia was warm and sympathetic, at once mysterious and familiar, vulnerable and strong. Encouraged by King, Ava was confident enough to really bare her soul for the camera and show aspects of her personality she had never before exposed to the audience.

Gregory Peck was impressed by his friend's transformation, later admitting that "she did things in *Kilimanjaro* that she could not have done three years earlier in *The Great Sinner*. And I think that's largely because Henry King was the kind of man she could trust." Ava trusted Peck as well, and she was unafraid to respond to him before the camera in a way that gave their scenes a unique sense of closeness and tenderness. In Cynthia, Ava was also able to showcase the duality of her own character—both the strong, independent side and the vulnerable side, which searched for protection and confirmation of her value. In a cruel example of life imitating art, many aspects of Cynthia's story would be played out in Ava's life in the months that followed.

Despite efforts on everyone's part to finish Ava's scenes within the promised ten days, the last scene ran behind schedule, and Ava had to remain in Hollywood for an extra day. Some colleagues saw her weeping on the set as she put the phone down. Frank had apparently unleashed a torrent of anger.

Although Metro was keen to keep Ava in Hollywood, she knew she had to return to Frank, who was sinking lower every day. He was performing to half-empty clubs in Manhattan, and his latest film, *Meet Danny Wilson*, was a critical failure and a box-office bomb. Determined to keep his spirits up, Ava continually reassured him. A journalist overheard Ava boosting her husband up before one of his performances: "No one with your talent is ever washed up. Trust me. This is just a bad time."

But the bad times continued for Frank. Later that spring he was dropped by both Columbia Records and his talent agency, MCA. At the same time, Ava's popularity soared. MGM had prepared a new, more lucrative contract for her, guaranteeing her $100,000 per picture. She refused to sign the deal unless MGM included what came to be known as the "Sinatra Clause," which meant that the studio was forced to produce a film costarring Ava and her husband. Although the project never materialized, it served as a clear indication of how desperate Ava was to save Frank's career—and his ego—even if it meant compromising her own professional standing.

With the new contract signed, and the bills mounting, Ava was soon forced to return to work. *Ride, Vaquero!* was shot in Kanab, Utah, over the summer months of 1952, and with its weak and formulaic script it was certainly a step back for Ava after

her nuanced performance in *The Snows of Kilimanjaro*. She did not enjoy working with her director, John Farrow (whose daughter Mia would one day become the third Mrs. Frank Sinatra), finding him difficult and unsympathetic. She again starred opposite Robert Taylor, with whom she'd enjoyed a tender, if brief, affair years earlier. This time around, despite the fact that Taylor was freshly divorced from Barbara Stanwyck, they shared a cool and cordial working relationship, the old spark apparently extinguished. Working in the sweltering heat of the Utah desert was exhausting, and Ava, along with everyone else involved, couldn't wait to get the picture finished.

Ava returned to Hollywood in late August. Frank was waiting for her. He was full of new hope. He had discovered that Columbia was planning an adaptation of a bestselling novel about US soldiers stationed in Hawaii during the months leading up to Pearl Harbor, and he believed that one of the characters suited him to the bone. It was the sort of part that had the potential to rejuvenate his career. Sinatra went after it with the sheer determination of a drowning man. The movie was *From Here to Eternity*, and it was to be Columbia's most important production of the year, if not the decade.

The part of Maggio, an Italian American from Brooklyn, was a strong supporting role that in many ways constituted the heart of the story. Harry Cohn, head of Columbia Pictures, refused to even speak to Sinatra about the film. This was a serious

Publicity still for the western *Ride, Vaquero!* (1953), with Ava, Robert Taylor, and Howard Keel. This was the second of three films Ava did with Taylor and the second of two she made with Keel.

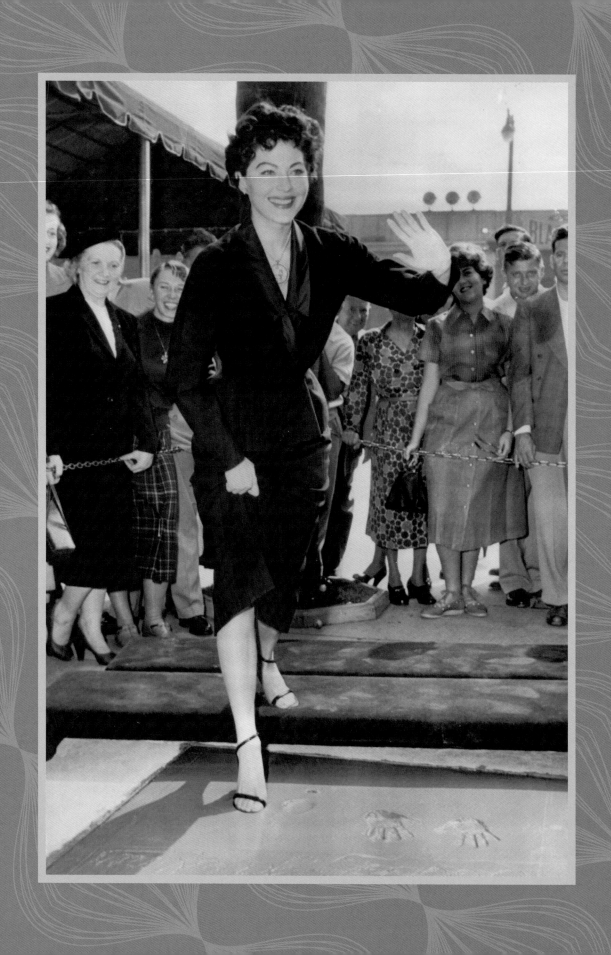

production, and every bankable actor in Hollywood was keen to be part of it. Why waste time on a washed-up singer? Ava agreed that Frank suited the part. She knew how unfair the casting system could be; how often had she seen the perfect actor being turned down for a part in favor of a more bankable box-office name?

As the summer ended, Frank's depression and helpless agitation deepened. His feelings of guilt toward Nancy and the children returned with great force, and Ava often felt that he might have regretted leaving his family. They argued bitterly and made up passionately, a familiar pattern that was beginning to wear them both out. If Ava felt any resentment toward Frank's family, she never let it show, at least not in front of his children. Tina Sinatra remembers that Ava "was wonderful" toward her and her siblings. She would take the girls to her bedroom and let them play with her jewelry and makeup. Tina remembers thinking her "impossibly beautiful" as well as "kind and generous."

In October Ava was asked to leave her hand- and footprints outside Grauman's Chinese Theatre, the ultimate token of Hollywood success. *The Snows of Kilimanjaro*, which had premiered some weeks before, was playing all over the country and was a smash hit. Although the reviews were mixed, Ava received almost universal praise. But her moment of triumph outside Grauman's was marred by press reports of another row with Frank: "Since yesterday there's been a stream of secondhand reports that Ava and the crooner split up over the weekend with plenty of fireworks at Sinatra's Palm Springs home." The incident in question has since become legendary as a pinnacle of the public spectacle that was the "Battling Sinatras." It involved a very intense fight at Frank's house in the presence of Lana Turner and her business manager, Ben Cole, that culminated in the arrival of the police and the press. It also put a strain on Ava's friendship with Lana, who rightfully felt hurt by Frank's behavior. Lana was one of a number of Ava's friends who believed that Ava's marriage to Frank had changed her, and that the constant battling was damaging to her. Despite years of close friendship, they eventually drifted apart. Ava refused to comment, but Frank's absence at the handprint ceremony was noted by everyone present.

In early November, Ava and Frank were reunited at a Democratic Party fundraiser for Adlai Stevenson. As Democrats and fervent Stevenson allies, neither could refuse when his office asked if they would be willing to make an appearance to publicly show their support. Upon seeing one another again, all the anger immediately

MGM made the most out of Ava as a commodity once her star power reached its peak. Her face was used to advertise Max Factor face powder in Britain, 1953.

opposite: As an ultimate token of Hollywood success, in October 1952 Ava was invited to leave her hand- and footprints outside Grauman's Chinese Theatre on Hollywood Blvd. Frank was notably absent from the ceremony.

A rare color makeup test photograph of Ava as Eloise "Honey Bear" Kelly in *Mogambo* (1953).

left them. They were as much in love as they had ever been. Once again the happy occasion seemed to fill them with hope that things might work out after all.

During their brief time apart Ava was offered the part of Eloise "Honey Bear" Kelly in *Mogambo*, MGM's remake of the 1932 pre-Code classic *Red Dust*. Although the original film had been made on a soundstage in Culver City, *Mogambo* would take advantage of the current trend of making films overseas and shoot on location in Kenya. Clark Gable was again Ava's costar, reprising the role he had played twenty years earlier.

John Ford was assigned to direct. The veteran filmmaker wanted his favorite leading lady, Maureen O'Hara, for the part of Honey Bear. The studio, however, knew that Ava's star power was greater than Maureen's, and as the film would be the costliest production of the year, they refused to gamble with its box-office potential. Gable also favored Ava, believing that she was more suitable for the part.

For the second female lead the studio cast a stunning twenty-four-year-old starlet who had recently appeared opposite Gary Cooper in the acclaimed western *High Noon*. Grace Kelly came from an affluent East Coast family, and she possessed the

kind of cool sophistication that stood in perfect contrast to Ava's sultry earthiness. Although the script called for a bitter rivalry between the two beauties, in reality there was no question that Ava was the star of the show. Grace was shy and inexperienced, giving little indication of the wonderful, star-making performance she was about to deliver.

Before departing for Africa, Ava made an attempt to help Frank get the role of Maggio in *From Here to Eternity*. According to Tina Sinatra, she personally telephoned Harry Cohn to say, "You know who should play Maggio? That son of a bitch husband of mine."

She also persuaded Cohn's wife, the actress Joan Perry, to put pressure on her husband and convince him to give Frank a chance to audition. Frank still desperately wanted the part, but after hearing that Cohn auditioned Eli Wallach, a renowned Method actor from New York, he all but gave up hope. Without any imminent prospects for his own career, he decided to accompany Ava to Africa. The drama of Spain, *Pandora*, and Mario Cabré was still fresh in his memory, and he didn't want to take any chances.

Filming *Mogambo* was a thrilling prospect for Ava's adventurous spirit. For once she wouldn't have to pretend that the back lot at MGM was an exotic location. This time it was to be the real thing. She also relished the idea of playing a part originally created by Jean Harlow, who, along with Joan Crawford and Katharine Hepburn, had been one of Ava's favorite childhood stars. And all this opposite Gable, whom she had seen in the original all those years ago while sitting by her mother's side in the little movie house in Smithfield. She also liked the screenplay, feeling that the "sassy, tough-talking playgirl" was perfect for her.

Ava and Frank boarding the plane for Nairobi.

They set out on their long flight to Nairobi in early November 1952, Ava with an eager curiosity to discover this faraway land and Frank, still in anguish over *From Here to Eternity*, in a much darker mood, acutely aware that he was playing second fiddle to his wife. In Nairobi they were met by John Ford's assistant and driven to the New Stanley Hotel, the most exclusive in the city. Although principal photography was not scheduled to commence for another two weeks, Ford wanted the cast to acclimatize and "get a good sun tan" before the cameras started to roll. Gable, Grace Kelly, and Donald Sinden arrived the following day. For the first couple of days Ava and Frank stayed in their suite, having all their meals in bed. Traveling always seemed to reinstate the passion in their relationship, and being away from Hollywood gave them fresh hope for a happier future.

Donald Sinden, a dashing, up-and-coming British actor who was cast to play Grace's unsuspecting and good-natured

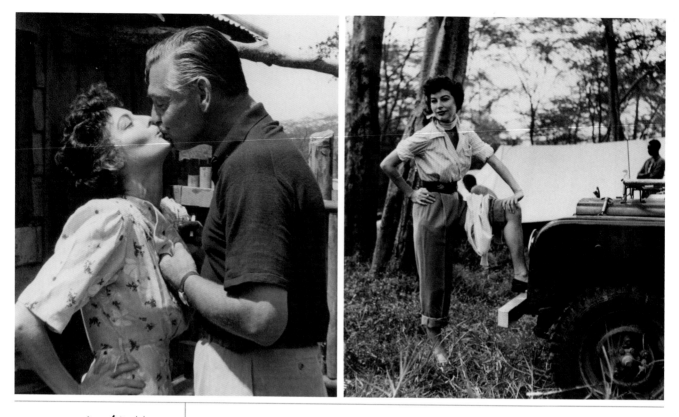

from left: A happy reunion with Gable, in what would turn out to be their most memorable on-screen pairing. • Ava takes a break during the shooting of *Mogambo*.

husband, thought Ava's aloofness unfriendly and antisocial. In spite of Gable's amused protesting, Sinden took it upon himself to summon her to the dining room: "My name is Donald Sinden. We are supposed to be working together; I've come to take you down to dinner." Surprised and at first slightly annoyed at his directness, Ava hesitated for a moment before asking Sinden to help himself to a drink while she bathed and dressed. Surprisingly, Sinden's account does not mention Frank's presence in the suite, nor does Frank seem to have been present at the subsequent dinner with the *Mogambo* cast.

As the company moved into the location with the enormous village of tents built specially for the cast and crew, Ava began to feel the pressure of the part, and the uncomfortable and often dangerous conditions made her weary. She initially clashed with Ford, who still held a grudge over being forced to cast Ava in the part he felt belonged to Maureen O'Hara. After a very unpleasant exchange between them that took place in front of the entire cast and crew, Ava retreated to her tent, convinced she had made a mistake by accepting the part and coming to Africa.

The atmosphere gradually improved. By the second week everyone got along famously, including Ava and Ford, whom she started referring to as "Jack." Ava's biographer Lee Server later quoted Ava as saying, "He could be the meanest man on earth, thoroughly evil, but by the time the picture ended, I adored him." The feeling was mutual as Ford quickly became aware of Ava's natural talent and realized that her warm and witty delivery suited the part far better than he had initially imagined. After one particularly impressive scene he told her, "You are damn good." For Ava, the trust

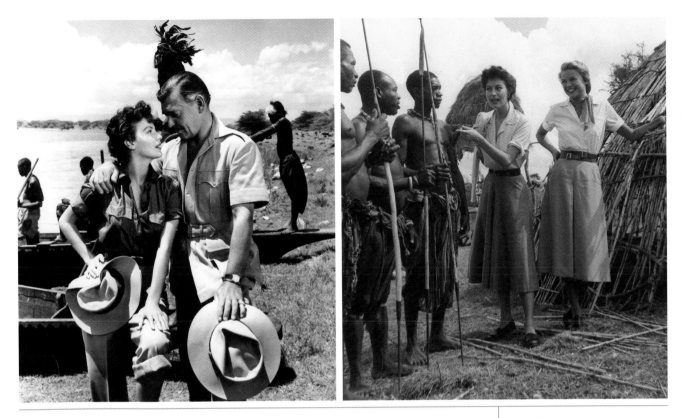

and approval of a strong director meant more than anything. There can be no doubt that Ford's skillful, if sometimes less than delicate, direction enabled her to give one of her most accomplished performances.

Meanwhile, Frank received word from Hollywood that Harry Cohn was ready to test him for the part of Maggio. He was ecstatic. Whether due to Ava's influence, the fact that Eli Wallach proved too muscular to play the slight Maggio, or, as some continue to believe, threats from Frank's mobster friends, Sinatra's fortunes seemed to be turning. Ava was happy for him. She had believed from the start that he was perfect for the part, and now he had the chance to prove it. The couple of weeks they'd spent together in Africa were tense. Ava was preoccupied with the film, and Frank's volatile moods caused them to argue bitterly on a number of occasions. If their rows were heard by the entire company, their passionate reconciliations were no less audible. Not long after Frank's departure, Ava discovered she was pregnant. In his memoirs, Donald Sinden mentions that Ava "had to pay a flying visit to London" just before Christmas. However, either good taste or unawareness prevents him from specifying the reason for her trip.

According to Rene Jordan, this was Ava's second abortion during her marriage to Frank. Ava had always wanted a family, but unless she was

from left: Shooting the final scene of *Mogambo* with Clark Gable. Her performance as Honey Bear Kelly would bring Ava her first and only Oscar nomination. • Ava and Grace Kelly chat with the local extras from the Turkana tribe, on the set of *Mogambo*.

There can be no doubt that Ford's skillful, if sometimes less than delicate, direction enabled her to give one of her most accomplished performances.

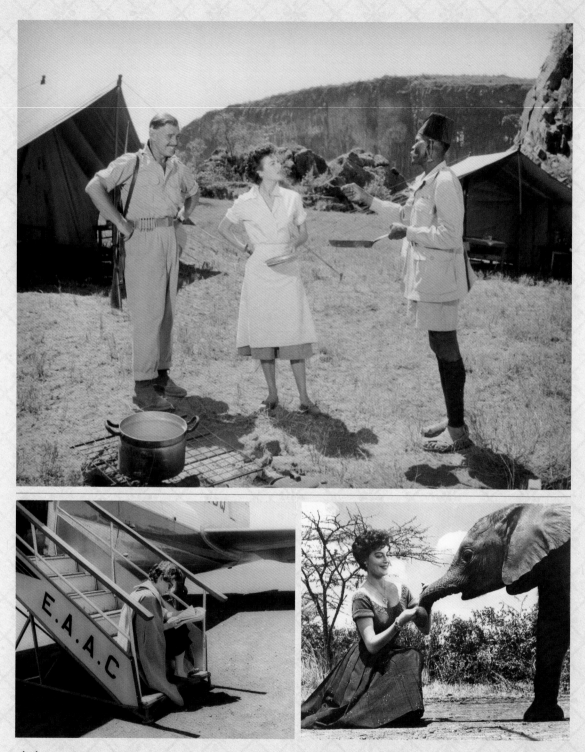

clockwise from top: With Clark Gable and an unidentified extra in *Mogambo*. • Ava in one of the improvised scenes in *Mogambo*. • Ava studies her script for *Mogambo* on the steps of the plane before embarking from Nairobi for location shooting.

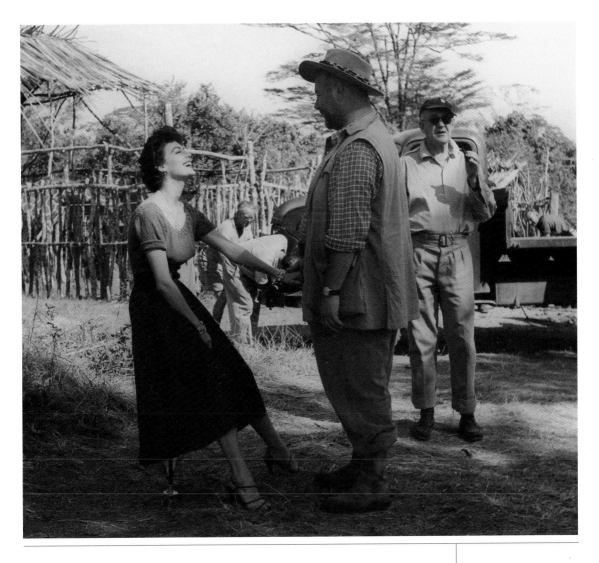

A moment's rest on the set of *Mogambo* with costar Eric Pohlmann and director John Ford.

able to provide the child with the kind of emotional stability she had been given by her own parents, she did not think it fair to bring a baby into the world. It was not an easy decision, particularly in light of the fact that abortion was at the time illegal, and Frank, being Catholic, would almost certainly want her to keep the baby. John Ford was one of the few people who knew about the pregnancy, and he, too, tried to talk Ava out of terminating it.

She flew to London in late November, and the press soon caught her trail. On the twenty-fifth, the *New York Times* reported that "Ava Gardner was receiving injections of streptomycin for a type of dysentery she contracted in Africa while filming *Mogambo* with Clark Gable." MGM was extremely careful to keep the real nature of Ava's "illness" out of the papers. Miraculously, it appears that Frank, busy with his screen test in Hollywood, was unaware of the entire episode.

Ava returned to Kenya and threw herself into work. She enjoyed playing Honey Bear, and the traumatic experiences of the past months aided her in creating a woman who, as she herself did, carefully hid the deep emotional scars under a valiant facade.

Frank arrived just in time for Christmas, which was to be grandly celebrated. MGM provided the company with crates of champagne, turkeys, and other Christmas staples flown in from the States. Ava celebrated her thirtieth birthday with Frank singing Christmas carols and John Ford reading passages from the Bible. It was a magical Christmas and a happy reunion for the Sinatras. Frank had been told that his test for Maggio was a success, and he was almost convinced that the part was his. In early January he returned to the States to fulfill some singing engagements and to be on hand in case he was needed for further tests at Columbia.

The shooting of *Mogambo* continued through January 1953 in various locations around the main camp. As reported by the *New York Times*, it was the "largest safari camp ever organized in Africa," located on the "crocodile-infested banks of the Kagera River, some 150 miles from the western shores of Lake Victoria."

With location work completed, and with some free time before she had to report for additional studio shots in London, Ava decided to take a short holiday in Rome. She persuaded Grace Kelly to accompany her. Grace, who had been initially intimidated by both Ava's celebrity and her direct manner, was by now a great friend. Ava quickly discovered that under the appearance of a prim and proper Philadelphia socialite, Gracie, as she liked to call her, had a mischievous sense of humor and a taste for a good time almost equaling her own. The weeks spent in the Kenyan wilderness created a unique bond between the two actresses, a connection that was to last until Grace's untimely death in 1986.

From Rome, Grace wrote to a friend, "Ava and I are now great pals." She also liked Frank, but as Lana Turner had, she noticed the distracting effect the relationship had on Ava: "There was a terrible champagne binge for about ten days over Christmas. Frank

from left: During a break on the set of *Mogambo*. • Ava poses with one of the extras. • After a rocky start, Ava and John Ford got on famously.

opposite: Ava and Frank walk from the beach at Lake Victoria toward the village of Bokoba during the shooting of *Mogambo*.

The cast and crew of *Mogambo*. Ava is seated second row, center, behind John Ford.

opposite: Ava as Guinevere and Robert Taylor as Lancelot in *Knights of the Round Table*.

left Friday so maybe things will get easier." Ava and Grace also spent time together in London, where they were happy to explore the city, unrecognized by the public.

Meanwhile, Frank was finally signed to play Maggio, and he immediately departed for Hawaii to begin work opposite Montgomery Clift, Burt Lancaster, and Deborah Kerr, with Fred Zinnemann directing. The big reversal of fortune he so longed for had finally arrived. He threw himself heart and soul into making the film. Ava, advised by MGM to remain in Europe to avoid heavy taxation upon returning to the States, agreed to make another film in England.

Knights of the Round Table was a dull enterprise, set to capitalize on the recent success of Metro's *Ivanhoe*. Once again paired with Robert Taylor, and with a supporting cast that included Mel Ferrer and Stanley Baker, Ava felt uninspired by the screenplay and often out of place on the set. She spoke to Frank on the phone daily, and he wrote her letters and telegrams, sometimes more than two a day. She missed him, but she also felt that the bond they shared was loosening, at least on her part. She longed to see him, yet she also wondered how long it would take for them to start fighting all over again.

According to Ava's memoirs, while in London she underwent another abortion. This time Frank not only knew about it but was by her side when she woke up after the procedure, tears streaming down his face. Some dispute whether this pregnancy actually happened and maintain that Frank found out about the first London abortion instead, and that it broke his heart. Frank's manager, Hank Sanicola, was quoted as saying, "He never got over it. He never discussed it either. The only thing he ever said to me about it was 'I shoulda beaten her fuckin' brains out for what she did to me and the baby, but I loved her too much.'"

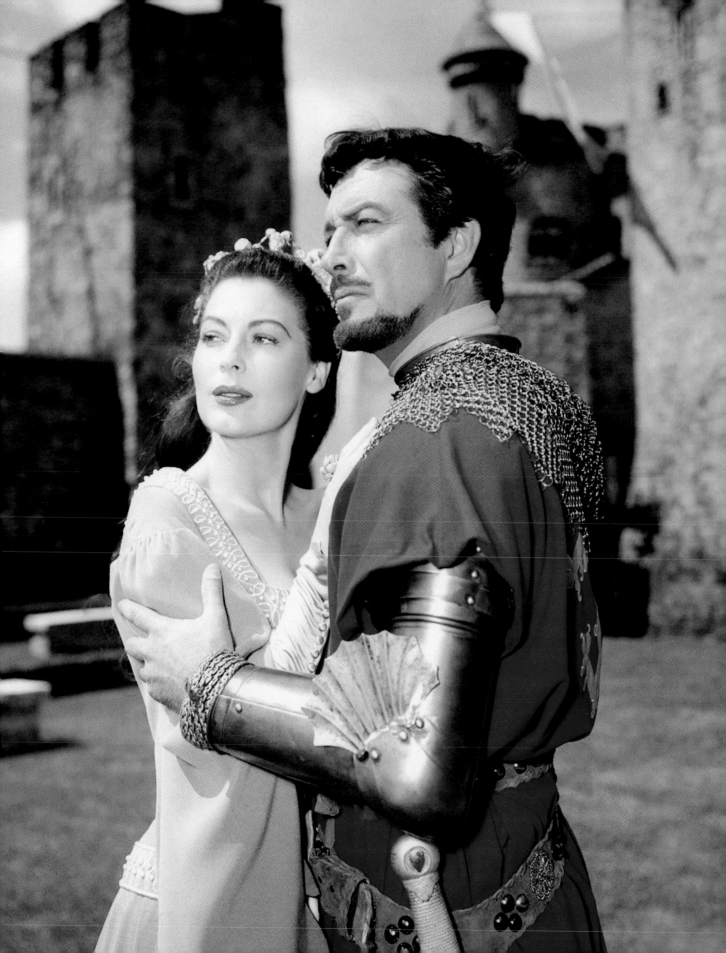

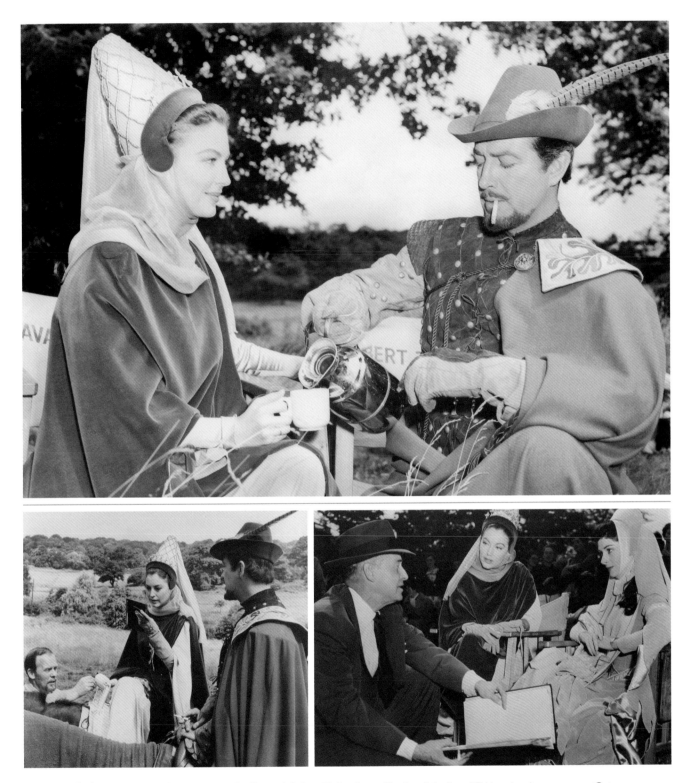

clockwise from top: Sharing a pot of coffee with Robert Taylor during *Knights of the Round Table*. • Ava (in costume as Guinevere) and Maureen Swanson (as Elaine) go over dialogue with director Richard Thorpe for an upcoming scene in *Knights of the Round Table* (1953). • Ava inspects her makeup as Robert Taylor looks on. *opposite:* Ava posed for noted British fashion photographer Norman Parkinson while in England filming *Knights of the Round Table*.

A FTER COMPLETING THEIR RESPECTIVE MOVIE OBLIGATIONS, Frank flew to London. He was full of renewed energy and optimism as he embarked on a concert tour around Europe with Ava by his side. The trip commenced well enough; they were genuinely happy to be reunited, just as they had always been. Ava began to realize that she did love Frank deeply—that was not the problem. The problem was that they could not stand to be together any more than they could stand to be apart. After Italy and Scandinavia, where Frank received a less than enthusiastic reception, the second honeymoon was over. Ava wanted to be supportive, appearing at each gig, seated in the front row, and even signing autographs as Ava Sinatra. But it was to no avail. It was a familiar pattern: the audiences seemed more entranced by the beautiful movie-star wife than by the skinny crooner husband. Ava remained in London to complete the six months necessary for her tax break while Frank left for America to prepare for the release of his picture.

Ava spent the next weeks exploring the city. She loved the parks, the volatile weather, the politeness of the people. She felt at peace, able to gather her thoughts and relish her privacy. She knew she had to make some plans for the future; most importantly she had to decide whether she still wanted to save her marriage.

From Here to Eternity opened in August 1953. Just as anticipated, it was a critical and popular success. Frank's performance was universally praised. Suddenly, almost overnight, he was a hot commodity once more. Ava wanted to be there with him to celebrate his success, and so, ignoring the tax-break period, she returned to New York in early September, losing thousands of dollars in the process. But the happy ending was not to be. Frank wasn't at the airport to meet her. Ava felt embarrassed as the reporters questioned her relentlessly about the whereabouts of her husband. Furious, she refused to speak to Frank when he phoned her hotel later that day. When they did finally reunite at Frank's parents' house, the happiness was fleeting. "They were too much alike," remembers Tina Sinatra. "They were the best of friends, they loved each other deeply, but at that point nothing mattered more than their careers."

In October the Sinatras attended the New York premiere of *Mogambo* at Radio City Music Hall. The film

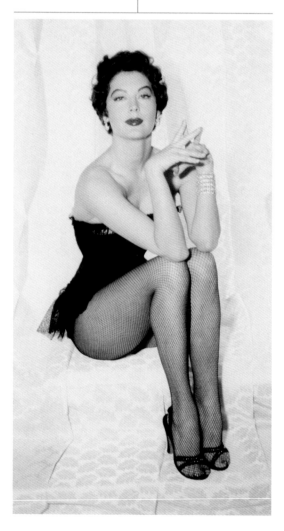

Kodachrome color portrait by Virgil Apger, ca. 1953.

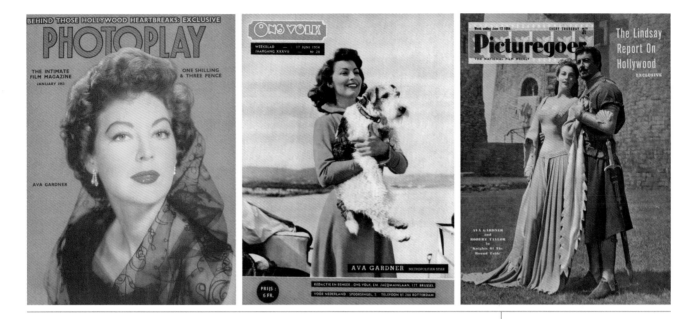

opened to glowing reviews and quickly became the major box-office rival of *From Here to Eternity*. Ava earned some of the best notices of her career. Critics praised her warm and uninhibited performance, with the *New York Times* calling her "amusingly bewitching." The acclaim culminated the following spring when she received her first and only Oscar nomination, eventually losing to Audrey Hepburn for *Roman Holiday*. Ironically, that same year Frank won the golden statue for his performance in *From Here to Eternity*. Ava was finally acknowledged as a gifted actress, not just a glamorous star. She enjoyed the success, but as was the case with *The Killers*, her professional triumph was once again overshadowed by personal heartbreak.

The marriage was not going to work. They both knew it by now. Frank was desperate to keep things going—he needed her, and he was convinced that he couldn't live without her. Ava saw things differently. With his newly reclaimed success, Frank had returned to his arrogant ways, seducing women everywhere he went just to spite her. She was tired of his jealousy, his possessiveness, and his oversensitive ego. She didn't want to continue to suppress her own identity for any man, not even for Frank. The months spent in Europe had given her a taste of freedom and independence, and now she longed for them. She was fed up with Hollywood, with studios and contracts, with the press, and with the hypocrisy and constraining conventions of a stifling business.

from left: Ava on the cover of *Photoplay*, 1953. • Ava, "Metropolitan Star," on the cover of the Flemish newspaper *Ons Volk*, 1954. • Ava and Robert Taylor on the cover of British fan magazine *Picturegoer*, June 12, 1954.

> Ava enjoyed the success of *Mogambo*, but as was the case with *The Killers*, her professional triumph was once again overshadowed by personal heartbreak.

CHAPTER SEVEN:

Woman of the World

FRESH ON THE HEELS OF HIS OSCAR-WINNING MASTERPIECE *All About Eve,* director Joseph Mankiewicz was looking for the right actress to play the female lead in his next film, to be produced by his newly formed company, Figaro, Inc. *The Barefoot Contessa,* based on Mankeiwicz's original script, offered a scathing commentary on the Hollywood film industry. Its central figure, Maria Vargas, a wild and tragic Spanish gypsy, is convinced by a jaded film director to trade her simple life in Spain for a glamorous one on the big screen. Elizabeth Taylor wanted the role, as did Linda Darnell, who believed that Mankiewicz had written it for her. So did Rita Hayworth, who was rumored to be the original inspiration for the part. Jean Simmons was crazy about it, having read the script already. Another actress who lobbied for the role was Jennifer Jones, although Mankiewicz, believing Jones to be a manic-depressive, told his agent, Bert Allenberg, that she was a last resort. As for Ava, she seems to have been unaware that Maria Vargas was one of the most coveted roles in Hollywood at the time, or that Mankiewicz thought her ideal and had asked about her availability in the beginning of June 1953.

In the past, MGM had seemed only too happy to loan Ava out to other studios for a tidy profit. This situation proved to be different. Ava's stock at the studio now held significant box-office value. Due to professional disagreements, Mankiewicz was not on good terms with Dore Schary, the young, bespectacled producer who had risen though the ranks and ousted Louis B. Mayer from his throne in 1951 to become head of the studio. Ava found Schary's operation more difficult than that of her former boss: "MGM's no great shakes now, but it was a damned sight better when the old man [Mayer] was around. I never liked him very much, but at least you knew where

opposite: Christmas in Rome, 1954.

Cast and crew of *The Barefoot Contessa* take a break between scenes. Pictured L–R: Humphrey Bogart, Jack Cardiff, Warren Stevens, Joseph Mankiewicz, Ava, and Edmond O'Brien.

you stood. This joint's come down a lot in the world." On June 26, Bert Allenberg wrote Mankiewicz with an update: "I received your wire and the situation with Ava Gardner is simply this. You will recall, some weeks ago I asked Dore Schary if Ava Gardner would be available this early fall and he said to me, 'If you mean for the Mankiewicz picture, forget it, kid.' The inference being, naturally, that he'll never let you have Ava Gardner for CONTESSA."

Negotiations to secure Ava continued into November 1953. Ava was not particularly excited about the film itself—she hadn't even read the script. But she liked the title, and because it was to be filmed in Europe, it meant a ticket to freedom. On October 27, she appeared in Allenberg's office and told him she and Frank were officially splitting; divorce was likely. She wanted the part in *Contessa* and, given her domestic situation, wanted to "get the hell out of town." Three days later Allenberg told Mankiewicz, "Ava has now become so violently rabid to do [the movie] that she said she would tear down the walls in the studio if it could not be arranged." She would meet personally with Schary to press her own case. However, even if Schary did relent, she still had the studio president, Nick Schenck, to contend with, and Schenck disliked Mankiewicz as much as Schary did. Schenck "violently refused" to

loan Ava out, telling United Artists executive Arthur Krim that "for certain personal reasons which he would not discuss, he would not loan her . . . even if she had nothing else to do."

Ava was furious. She'd always felt that MGM was the wrong studio for her, and now they were using her as a pawn in a personal dispute that at its core had nothing to do with her professional interests. In early November, at the suggestion of Benny Thau and executive Eddie Mannix, Ava and Allenberg were able to persuade Schary to relent. The meeting with Schenck was not so easy. "When Nick got here she saw him and put on a helluva performance of pleading, begging, getting angry, crying, etc.," said Allenberg. But Schenck was adamant that "they couldn't loan Ava out to an independent production company because they wouldn't be getting any big star in return." Finally, after months of back and forth between Figaro and MGM, Schenck acquiesced. Mankiewicz could have his desired leading lady for $200,000 cash and 10 percent of the film's gross profits before distribution charges after the first $1.5 million gross. It was a high price to pay, but Mankiewicz felt that Ava's dark looks and raw sex appeal fit his vision of Maria. She arrived in Rome on November 26, 1953.

The making of *The Barefoot Contessa* turned out to be almost as stressful as casting had been. It was Mankiewicz's first film as producer-director-writer, and by taking it upon himself to make sure that everything was in place concerning all angles of preproduction, he perhaps stretched himself too thin. Ava was not set to begin filming at Cinecittà until January 11, 1954. She familiarized herself with the script and had costume fittings with the famed couturiers Sorelle Fontana. Yet despite her earlier eagerness to get out of the States, she wondered why nothing was being done in terms of prepping the actors for their performances. Allenberg got a phone call from Frank Sinatra in mid-December relaying Ava's concern. Apparently she was "quite disturbed" by the lack of activity in Rome upon her arrival and "wonders why she rushed over." She was nervous about her acting ability and couldn't understand why

Ava and Bogie during the filming of *The Barefoot Contessa*.

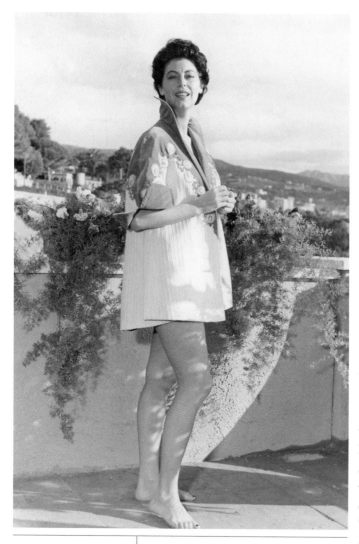

The Barefoot Contessa, Rome, 1954.

opposite: Ava poses for famed Bulgarian sculptor Assen Peikov while filming *The Barefoot Contessa* in Rome.

Mankiewicz wasn't taking advantage of her presence for rehearsals and training.

When the cameras did start rolling, Ava found the mode of filmmaking at Cinecittà very different from what she was used to in Hollywood. The Italian crew was disorganized; no one arrived before shooting time to turn on the electricity and prep the soundstage; extras were late. The most baffling thing to Ava was the lack of knowledge about publicity photography. She ended up taking the situation into her own hands and, using her previous experience in front of the stills camera, arranged and directed nocturnal sittings in the small gallery space at the studio.

Ava looked forward to working with Humphrey Bogart but felt let down by the experience. Bogie played Harry Dawes, the director who lures Maria Vargas to Hollywood. He enjoyed getting a rise out of people, commenting on Ava's lack of talent and making snide remarks about her love life within her earshot. He was also a good friend of Frank's and part of the original Rat Pack, which may have contributed to Bogie's cantankerousness. "Although outwardly cordial and polite and Ava would laugh on the set at Bogie's jokes, no great love was lost between the two stars," wrote publicist David Hanna. "Bogie, on his part, thought little of Ava as an actress, considering her an expressionless automaton who simply followed—and not too well at that—the movements of the camera. . . . Ava bore the shafts with rare good humor and never once publicly displayed her inner feelings.'"

But the biggest disappointment of all, in Ava's estimation, was Mankiewicz. He didn't understand her lack of confidence and need for assurance. In her autobiography she described prepping for a close-up shot with Jack Cardiff, her friend and cinematographer from *Pandora and the Flying Dutchman.* As she sat on the edge of a sofa, waiting as Cardiff fiddled with the camera, Mankiewicz spotted her and admonished her for sitting around. After that her trust in her director faded. Mankiewicz would later sing Ava's praises, saying, "Miss Gardner, especially, seldom receives the

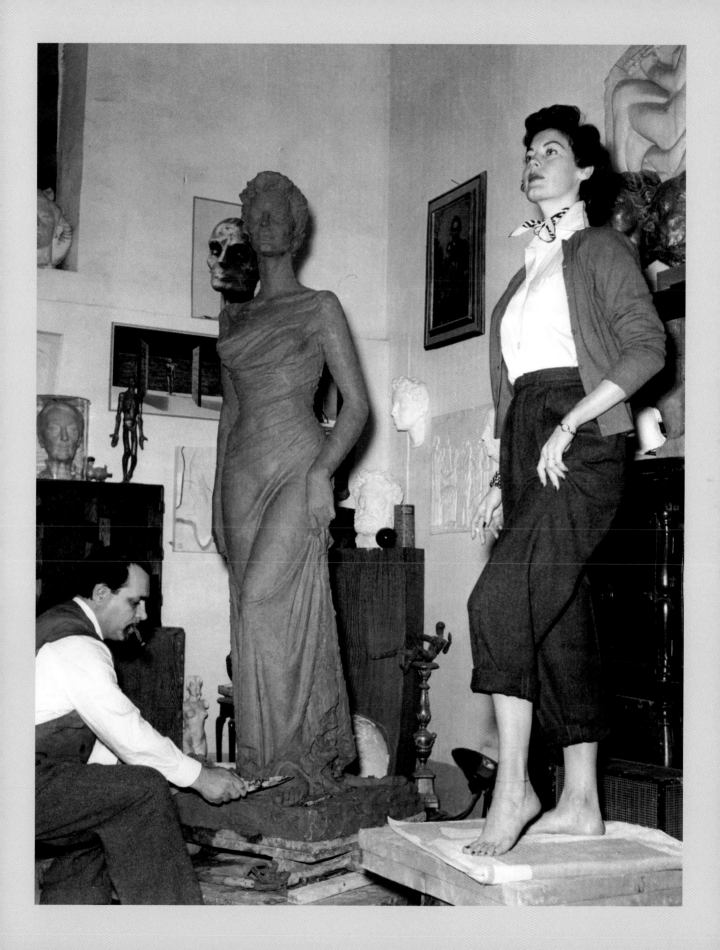

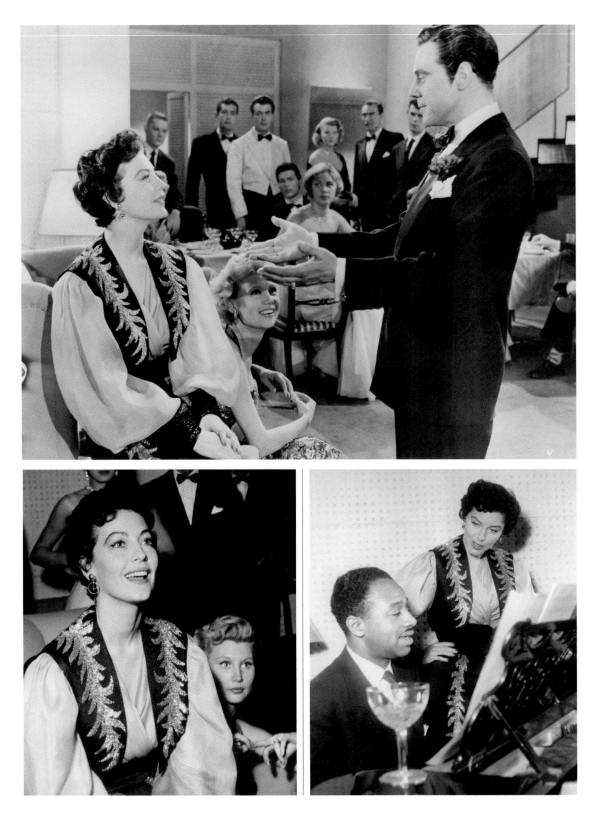

clockwise from top: Ava and Marius Goring in a scene from *The Barefoot Contessa*. • Ava and pianist Eddie Heywood behind the scenes on *The Barefoot Contessa*. Heywood cowrote and performed the piano solo for "Land of Dreams" on the *Contessa* soundtrack. • Ava on the set of *The Barefoot Contessa*.

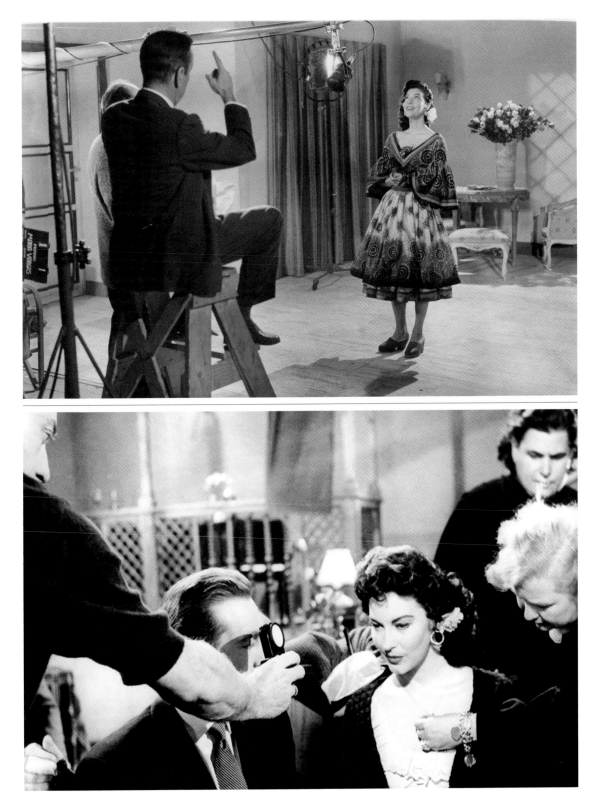

above, from top: A rare behind-the-scenes photo from the set of *The Barefoot Contessa* at Cinecittà in Rome. • Cinematographer Jack Cardiff (left) and wardrobe personnel surround Ava and Edmond O'Brien on the set of *The Barefoot Contessa*.

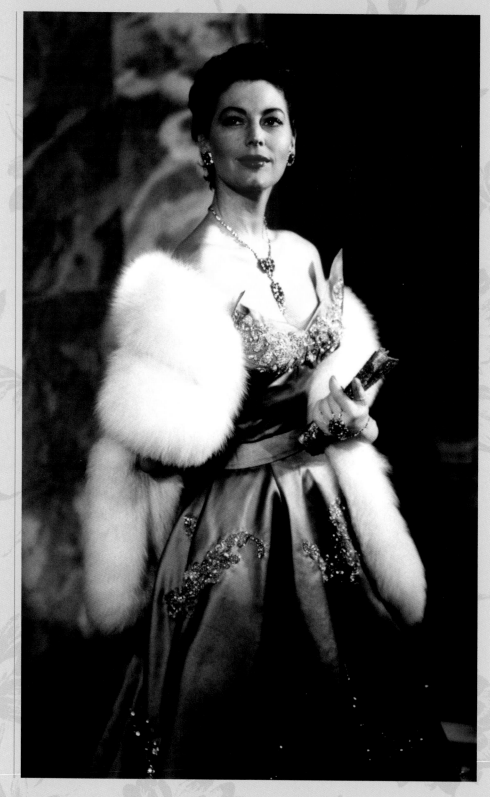

Ava dazzles in a blue Sorelle Fontana gown in *The Barefoot Contessa*.

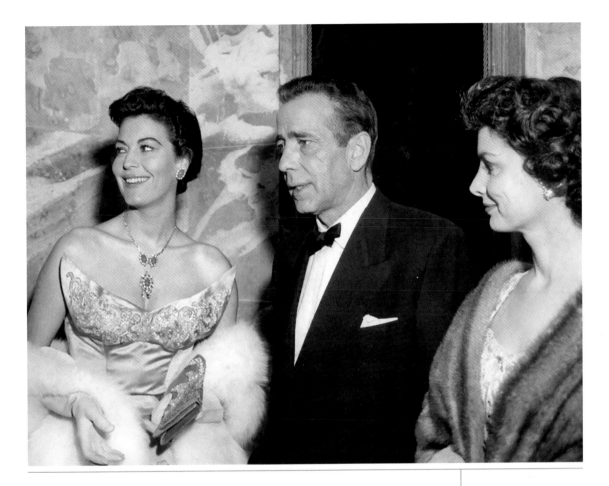

Ava, Humphrey Bogart, and Elizabeth Sellars in *The Barefoot Contessa*.

credit she is entitled to for her work. She is entirely serious about her career and gives everything to it." Ava found words of appreciation for the director more difficult to come by, referring to her experience working with Mankiewicz as "a complete bust."

Part of the deal Mankiewicz made with MGM was that Ava would be limited to $30,000 living expenses for the twelve weeks she was required to work. Any exceeding costs would have to be covered by Figaro. Bert Allenberg assured the director that, with Ava living in an apartment rather than an expensive hotel, there would be no need to worry. Both men underestimated Ava's preferred mode of living.

"Exactly where do living expenses end and infantile insanities begin? Is our commitment to M-G-M or to Ava Gardner?" the director complained to his agent. Ava claimed she was lonely, and she spent Italian lire with abandon. Large amounts of money were expended on booze, opera tickets, furniture for her apartment on Corso d'Italia, telegrams, and overseas phone calls to Frank. She also hired maids and a private secretary on the studio's dime. "There are 625 lire to the dollar," Mankiewicz exclaimed. "Long before we have finished with Ava, she will have spent more than $30,000 to satisfy her personal whims." What worried Mankiewicz was

not so much the money being spent but the threat of the Italian partners of United Artists moving in and taking both financial and artistic control of the film. Allenberg advised Mankiewicz to present Ava with weekly bills and demand repayment of any excess expenditures. She had pulled a similar stunt with MGM in the past, he said, and ended up paying out of her salary.

Difficult working relationships aside, *The Barefoot Contessa* has since become one of Ava's most iconic films, and Maria Vargas the character people most closely associate with her. The publicity department's description of Maria as "The World's Most Beautiful Animal" became the tagline applied to Ava as well, solidifying her image as a sensual movie goddess in the minds of the cinema-going public.

After a whirlwind publicity tour during which Ava and David Hanna visited several far-flung capitals of the world to promote the film, *Contessa* premiered in the fall of 1954. Like *Pandora and the Flying Dutchman*, *Contessa* was popular with the European art-house set. Also like *Pandora*, the film divided critics. Philip K. Scheuer of the *LA Times* praised Ava for her "good and sometimes better" performance. He thought the overall film "fascinating" and deemed it "a must for the adult, sophisticated moviegoer." In New York, Bosley Crowther didn't like anything about the film aside from Jack Cardiff's camera work. The characters were "so bitter and disagreeable that they put the teeth on edge." Ava, he said, failed to give Maria Vargas "plausibility and appeal," although he admitted she was good in "one or two moments." Reviewing the film in 1965 for her anthology *Kiss Kiss, Bang Bang*, Pauline Kael called *Contessa* a "trash masterpiece. . . . It's hard to believe that Mankiewicz ever spent an hour in Hollywood; the alternative supposition is that he spent too many hours there."

Ava may have felt lonely while filming *Contessa*, but she was hardly alone. David Hanna was her near-constant companion, making sure there were no PR mishaps that needed damage control. Bappie was flown to Rome to keep her company. There was also a new man in her life in the form of Spain's preeminent bullfighter, Luis Miguel Dominguín. The two met in Madrid at a holiday party thrown by Ava's friend Doreen Grant shortly after Ava finished filming *Mogambo*. Dominguín was dating someone else at the time, but the attraction between Ava and him was immediate. After the unwelcome publicity of her brief affair with Mario Cabré four years earlier, Ava might have been wary of matadors. Like Cabré, Dominguín was dark, handsome, and spoke little English. Unlike her former lover, however, Dominguín felt no need to use Ava to boost his own career.

from top: Ava poses in the fashion of *The Barefoot Contessa*'s Maria Vargas for *Paris Match*. • By 1955, Ava's image as one of the most beautiful women in films was firmly solidified.

opposite: Ava waves to the press at the New York premiere of *The Barefoot Contessa*.

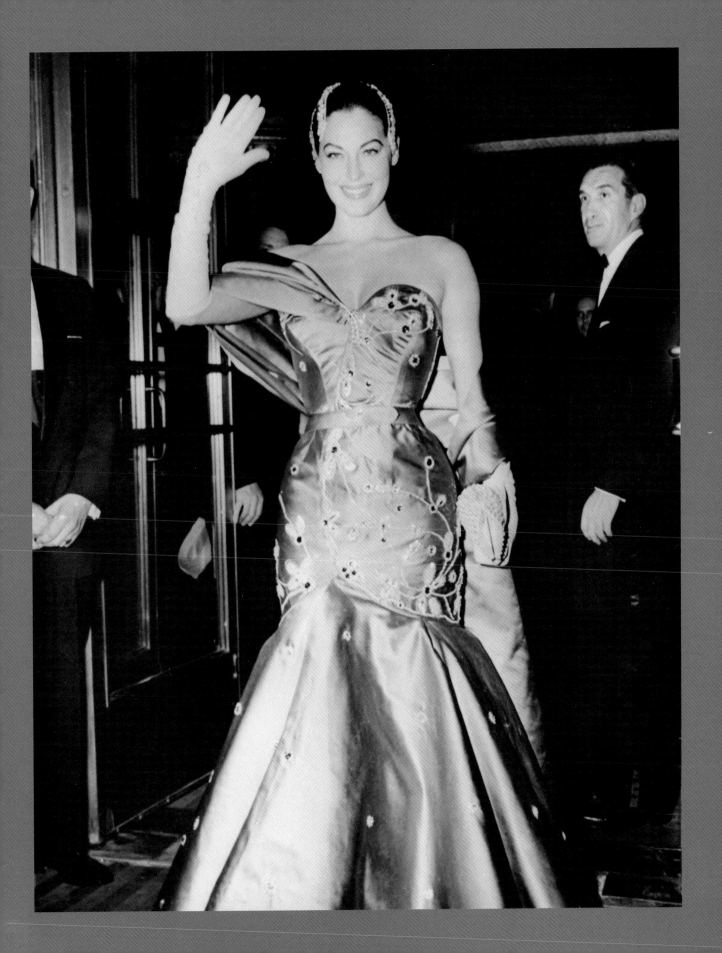

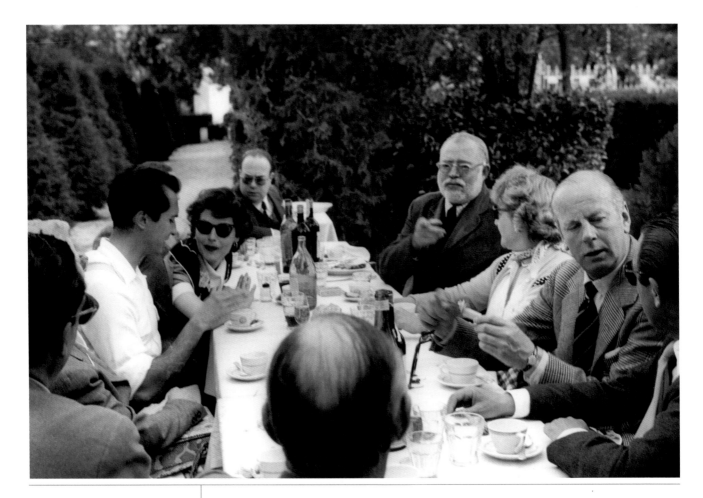

Ava met author Ernest Hemingway through the Spanish bullfighter Luis Miguel Domínguín. She is pictured here at lunch with Domínguín (on her right), Hemingway, her sister Bappie, and unidentified acquaintances, ca. 1954.

opposite: On December 22, 1954, Ava was invited onto the pitch at the Olympic Stadium in Rome to meet the captains of the two Italian football teams competing in an afternoon match.

They frequented the bars and flamenco clubs of Madrid and were photographed ringside at the bullfights on Sundays while Domínguín recovered from a near-fatal goring. Both shared a biting sense of humor.

It was through Domínguín that Ava met Ernest Hemingway. "Papa," as his friends called him, was passionate about bullfighting and used Domínguín and his brother Antonio Ordóñez (also a famous bullfighter) as subjects for his 1959 nonfiction book *Death in the Afternoon*. Hemingway fell for Ava's sensuality and ribald sense of adventure. In *The Making of Ernest Hemingway*, author Hans-Peter Rodenberg writes of Papa inviting Ava to Finca Vigía in Cuba and ordering his staff not to drain the pool after he observed her skinny-dipping in it. Papa told the American poet Harvey Breit that Ava had "two sides to her personality. She could be sweet, attractive, witty, and good fun. She also had a sharp tongue and could be an absolute devil. She suffered from a sense of inferiority and reacted violently to anyone who joked about her." He took an active interest in her affair with Domínguín, pressing the young bullfighter for details about their sex life, which led Domínguín to tell him, "One doesn't ask a man such questions." For her part, Ava considered Papa an older friend and admired his intellect and position as one of the great writers of the twentieth century. And he was good company.

For much of 1954 Dominguín followed Ava around the world, their stormy relationship whipping up headlines from Madrid to Mexico. Gossip writers speculated that the torero, four years younger than the object of his ardor, would become the fourth Mr. Ava Gardner, once her divorce from Frank was final. But the divorce didn't happen. Ava saw no future with Dominguín. It was passionate and fun, but it wasn't love.

"He was much too young," Ava said of Dominguín. "He was a very young twenty-eight or twenty-nine, and I can't be completely foolish about love. It's not that I want maturity by years, but even if I fell in love with a man who was twenty-five years old, I wouldn't marry him. I don't want to be heartbroken when I am forty-five." Looking back years later, Dominguín described his passion for Ava as the "most beautiful and most fierce I ever had. I had a very fierce wolf in a cage."

Dominguín married the Italian actress Lucia Bosè in 1955 and saw Ava intermittently over the years in a friendly capacity. She often enjoyed lunch and drinks in the company of Luis Miguel and his famous friends at his bull-breeding ranch outside

Madrid. David Niven Jr. acted as Ava's agent in the mid-1960s and recalls with good humor being dragged along to one such luncheon that included both Dominguín and Ordóñez. At one point Dominguín asked Niven if he had ever fought a bull.

> I said, "I'm English, we play cricket." And Ava said, "Oh, come on, David. You've run with the bulls twice in Pamplona; you should fight a bull." So now she says, "Yes, Luis Miguel, David would be perfect. Look, he's young, he's brave, he's fearless. He'd be perfect. Of course he can fight a bull!" She's doing everything to instill this. Ordóñez, who is sitting opposite Ava, says, "Of course you can fight a bull, David! Luis Miguel and I can fight a bull, you can fight a bull, too!" So after a lot of—I can't remember what sort of ghastly after-lunch brandies we were drinking, but I said, "All right, I'll do it."

Dominguín, Ordóñez, and Ava led Niven to the ranch's private bullring. "Ava is giggling like a schoolgirl. She's absolutely loving it. Luis Miguel went into the bullring, and out came a young bull looking like a stubby German shepherd with little horns. It's not exactly scary. Luis Miguel did his thing with his big red cape with a few different bulls and then said, 'There you go, David. Can't you do that?' And Ava said, 'Of course he can! Go on, David!'"

It was a comic scene. The small bull charged at Niven, lifting him in the air twice while the two matadors and Ava screamed, "Olé! Olé! Olé!" "Especially Ava," Niven remembered, "who you could hear all the way back in Beverly Hills."

Ava poses with geishas and with Japanese actress Kikiko Tenno in Tokyo during *The Barefoot Contessa* world promotional tour.

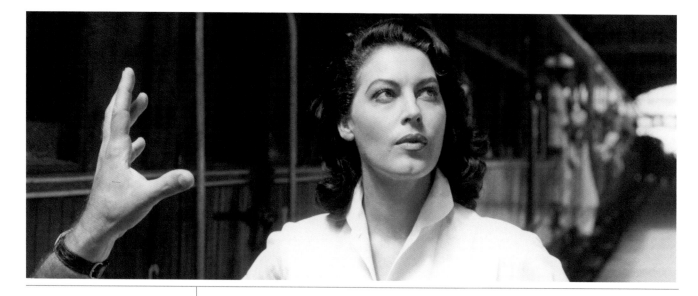

George Cukor (off-camera, left) directs Ava in *Bhowani Junction*.

opposite: George Hoyningen-Huene took some of the most beautiful photographs of Ava for the George Cukor film *Bhowani Junction*.

O F ALL THE DIRECTORS AVA HAD WORKED WITH SO FAR, none seemed to make as much of a positive impact on her as George Cukor. By 1954, Cukor was one of the most respected filmmakers in the business. His filmography, like Ava's, spanned various genres, and his sensitive handling of actors—particularly females—earned him a reputation as a "woman's director." By building trust with his actors, Cukor had been able to coax memorable performances out of big names like Greta Garbo, Katharine Hepburn, Spencer Tracy, Norma Shearer, and Judy Garland. After years of working with directors who offered little to no encouragement regarding her acting abilities, Ava at that point in her career needed exactly the kind of mentorship Cukor could provide.

The film that brought them together was *Bhowani Junction,* based on John Masters's novel of the same title. Looking to display "more realism in films," MGM paid $100,000 for the rights and slated it as their blockbuster film of 1956. In a continuation of playing characters of different ethnicities, Ava was cast as Victoria Jones, an Anglo-Indian woman whose struggles with identity and the love of three men play out against the backdrop of India's fight for independence from British rule. Great care was taken by the production company to ensure that the portrayal of Victoria was accurate, down to the costumes. Jean Dodd, an Anglo-Indian and former Women's Army Corps (WAC) member who served in Delhi, provided consultations and loaned Cukor and Ava one of her photo albums from her time in the service. It was suggested that Ava spend a week in a WAC camp to get a better feel for her character, and a voice coach was brought in to help with her English accent. With the exception of Stewart Granger, who was already courting stardom, the rest of the principal cast was rounded out with up-and-coming actors from British studios, including Bill Travers and Francis Matthews.

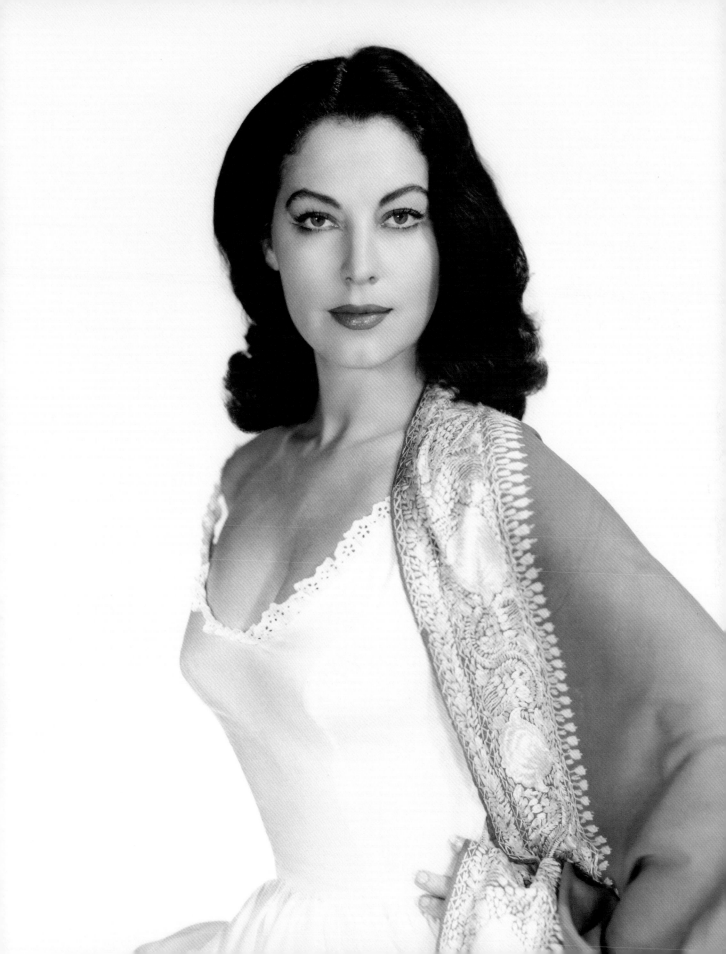

From the beginning, *Bhowani Junction* proved to be a film produced on compromise. Cukor and producer Pandro S. Berman's original plans to film on location in India were thwarted when the Indian government initially refused to support the project based on fears of misrepresentation. Then, as the *New York Times* reported, "The Indian tax collectors said that in addition to several other taxes, M-G-M would have to pay 12 per cent of the net world profit on the picture, a proposal that was considered ridiculous—even by Internal Revenue men back home." When the Pakistani government offered to largely waive taxes, Berman and Cukor moved the production to the ancient Punjab capital city of Lahore.

Conditions were less than ideal. The cast had to deal with throngs of excited onlookers who were unused to seeing Western film stars in their city. Ava and Granger were put up at Faletti's Hotel. According to the *New York Times*, "During the first week after the arrival of Ava Gardner and Stewart Granger . . . there were more Moslem bobby-soxers around Faletti's than ever booed the police at the Paramount or the Roxy in New York." With outdoor temperatures reaching above 110 degrees Fahrenheit in the spring and no air conditioners available, the shoot was grueling. Heat stroke and dysentery were two very real dangers, and Ava caught a mean case of the latter. Bats, bugs, and wild dogs also hovered around the set and hostel at night, making a good night's sleep difficult to achieve. Ava found playing Victoria not only physically but emotionally exhausting. She opted not to use an understudy or body double. "She did everything herself," Cukor told journalists, "no matter how dangerous or strenuous—the kidnapping, the riots. She was black-and-blue most of the time, and Ava loathed physical violence."

"The director's function, among other things, is to get [actors] out of themselves," Cukor explained in an interview with Richard Schickel. "But it's a very fine point, about how to handle actors. Some actors, you've got to give them their head. And some actors, you've got to know what they are likely to do when they are off the beam. And you guard them from that and also you have to watch them and see what they can contribute out of their own gift." Cukor's ethos was especially helpful for Ava in one of the film's tensest scenes, in which Victoria fights off and kills a racist white English lieutenant (Lionel Jeffries) who attempts to rape her. As played by Ava, Victoria's emotional roller coaster is palpable and wholly believable. Her natural gift for pathos was on full display, and the psychological impact of the scene stuck with her long after the film ended.

After finishing with the exterior shots in Pakistan in early May 1955, the cast and crew went to England, where further work was done around Portsmouth and interiors were shot at Elstree Studios on the outskirts of London. Ava and Cukor remained good friends, forming a trio with the film's color specialist George Hoyningen-Huene. ("George H. H.," as Ava referred to him, was also a famous fashion photographer. He took what are some of the best publicity portraits of any film Ava ever made.)

opposite, from top:
Ava learns a traditional dance in Lahore while Stewart Granger looks on. • As preparation for her role as Victoria Jones in *Bhowani Junction*, Ava spent a day with the Women's Auxiliary Corps at Huron Camp in Surrey, England.

In August, after filming wrapped and all that was left was editing and other postproduction concerns, Cukor wrote to Ava at the Hilton Hotel in Madrid: "My Dearest Ava: For the past two weeks—from early morning until late at night—you've been ever-present with me. Not in person, alas, but in Projection Room Number One. (Projection Room Number One is comfortably air-conditioned, but for some mysterious reason, from time to time we have been shunted into Projection Room Number Eight. This is small, stuffy, has a smell very reminiscent to the spot where you stood, over the gutter [an open sewer in Lahore], waiting to make your entrance—'member?—as if you could ever forget that!)"

Cukor was pleased with what he saw in the rushes. "We should all be very, very happy about it. As for you, your performance 'holds up' wonderfully. No matter how often I re-run this bit or that, I'm never bored with it. In fact the more I see it, the more depth, dignity and feeling I find in it." It is difficult to gauge how much credence Ava put in Cukor's compliments. There is no response to this letter in the director's papers at the Margaret Herrick Library. In all likelihood she dismissed his words offhandedly. "She interferes with herself," Cukor told the journalist and artist Richard Overstreet. "She's extremely intelligent. A fatalistic woman. A creature of great fascination . . . and desperation. An extraordinary beauty. You know, she doesn't think a hell of a lot about herself as an actress. And that's too bad." Cukor had favored Trevor Howard over Stewart Granger for the role of Colonel Savage, believing Howard would have made the entire film better. But when the director looked back on the experience as a whole, he credited "working [with Ava] as one of the most harmonious, deeply satisfying and exciting experiences I've ever had."

Unfortunately, *Bhowani Junction* did not turn out as Ava and her director had hoped. Due to censorship concerns, MGM ordered the film to be recut, thereby eliminating some crucial scenes that helped to explain Victoria's motivations concerning the men in her life. The studio's publicity department also heavily played on Ava's pervading image as a sex goddess in the film's marketing material, with posters showing her in low-cut clothing despite the cultural and religious conservatism embodied by her character and the erotic moments having been cut from the actual film. Preview audiences reacted tepidly to the finished product and, on the whole, so did critics.

The British film magazine *ABC Film Review* featured Ava on the cover of their November 1956 edition to promote *Bhowani Junction*.

opposite: Ava gave one of her best dramatic performances as Victoria Jones in *Bhowani Junction*.

"She's extremely intelligent. A fatalistic woman. A creature of great fascination . . . and desperation. An extraordinary beauty.

—GEORGE CUKOR

In December 1955, Ava purchased a house in La Moraleja, a northeastern suburb of Madrid. She called it La Bruja (the witch). "Madrid fits me like a glove," Ava said. Her friend Bunny Bruce described the house as having "2 acres of land & a swimming pool, & the garden is in the process of being made." Ava would never again take up residence in the United States. It was a major but risky step toward her

A glamorous-looking Ava in 1957.

need for independence. It was also the final symbolic act of her separation from Frank. After six and a half years, three of which they had largely spent in separate locations, their divorce was granted in Mexico on July 5, 1957. She was free now from painful marriages—from the phony hypocrisy of Hollywood. If she wanted to spend all night dancing flamenco in gypsy dens and drinking and having a good time, there was no one to stop her. She knew little to no Spanish, but it didn't seem to matter. Nightlife was a universal language.

But there was still work to be done: two more years to fulfill on her MGM contract. In 1956 she flew to Rome to star opposite Stewart Granger and David Niven in the romantic comedy *The Little Hut*. The most notable aspects of the film are Christian Dior's costumes and the fact that it is based on a Nancy Mitford play about two men stranded on a desert island with a beautiful woman. During filming, as a bit of publicity, the English magazine *Picture Post* asked Ava who she would choose to be stranded on an island with. Her choices reflected her interest in culture and the arts, as well as her sense of humor: "Adlai Stevenson, Ernest Hemingway, Yul Brynner, Robert Graves, Tennessee Williams, Salvador Dali, and Alberto, the bartender from Beachcomber's Bar in Hollywood." The men she chose as hypothetical ideal companions appeared more than happy to join Ava: "I'm flattered. Where is this island?" responded Stevenson. Beachcomber Alberto said, "Packing bags and libations. Where is the island? Impatient!!" The most amusing reply came from Hemingway: "If Mr. Stevenson became President I would naturally make a supreme patriotic effort to return him to his exhausting duties. We would

from top: Henry Brittingham-Brett (David Niven) juggles coconuts in an effort to impress his lover, Susan (Ava), in *The Little Hut.* • Susan Ashlow (Ava) and her husband Philip (Stewart Granger) are expecting in *The Little Hut.* • Director Mark Robson (right) rehearses a scene with Niven, Granger, and Ava for *The Little Hut.*

keep the others for amusement value only, and do away with them if they attempted to change their status. Yul Brynner is reportedly an extremely dangerous man, so he would probably be the first to go. Ask Ava the approximate position of the island and my expected time of arrival."

Off-set, Ava struck up a romance with Italian comedian Walter Chiari, who'd had a small role in *The Barefoot Contessa*. During *The Little Hut*, he trailed Ava like a lap dog, often sprawling out in her trailer during press calls. They would spend much of the next three years together, with Chiari making long-distance trips to visit Ava on film sets. One location he tagged along to was Mexico, where Ava went in the spring of 1957 to star in her third Hemingway adaptation, the semiautobiographical *The Sun Also Rises*, produced by Twentieth Century Fox. Published in 1926, *Sun* was Papa's first literary success and has since become an American classic. The film rights had been floating around Hollywood for thirty years, changing hands several times but never getting off the ground on account of certain plot points and character traits. At the book's heart is the world-weary Lady Brett Ashley, a woman who is unapologetically sexually liberated and becomes involved with several men in order to snuff out her lingering feelings for an impotent soldier she met while working as a nurse in Italy during the Great War. What's more, she doesn't get punished for her libidinous

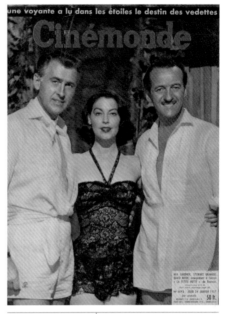

above: Ava, Stewart Granger, and David Niven pose for the cover of the French film magazine *Cinémonde* to promote *The Little Hut* (1957).

left: Ava and Walter Chiari are snapped by paparazzi while leaving a restaurant in Florence on New Year's Eve, 1956.

opposite, clockwise from top left: A striking publicity portrait of Ava wearing a creation by Christian Dior for *The Little Hut*. • Couturier Christian Dior fits Ava for an outfit in his Paris salon. Dior designed the costumes Ava wore in the 1957 film *The Little Hut*. • David Niven's wife, Hjordis, visits the set of *The Little Hut*, Rome, 1956.

from left: Ava leaves the famous Lido cabaret club on the Champs-Élysées in Paris. Walter Chiari can be seen in the middle background. The French press reported that they were playing "hide and seek" in the City of Love.
• March 21, 1957: Ava and her new flame, the Italian comedian and actor Walter Chiari, attend a cocktail party in Rome at the salon of the fashion designers Sorelle Fontana. Their affair lasted for a couple of years, during which the love-sick Italian followed her around the globe. Ava would eventually end the affair during the making of *On the Beach.*

opposite: Wardrobe test for *The Sun Also Rises.* Ava was dressed by Micol Fontana (right, in hat) for the film. Tyrone Power can be seen in the background.

desires. In short, Brett was considered too risqué for Hollywood. Ava was perfect for the role.

Sun was filmed at Mexico City's Churubusco Studios and reunited Ava with her *Snows of Kilimanjaro* director, Henry King. Rounding out the cast were Tyrone Power as Brett's impotent love, Jake Barnes; Errol Flynn as Mike Campbell; and Audrey Hepburn's husband, Mel Ferrer, as Jake's foil, Robert Cohn. Power and Flynn were two former top stars who were nearing the end of their lives; both would be dead of heart attacks within two years of making *Sun.*

Unfortunately, what might have been an entertaining collaboration between a group of Hollywood legends was not such a happy occasion, at least on Ava's part. Ava was less than enthusiastic about Peter Viertel's script, though she and the screen-writer spent quite a bit of time together when cameras weren't rolling. It didn't seem to her that it was possible to bring Hemingway's iconic story to the screen without losing some of its essence in translation. And although she had enjoyed working with Henry King in 1952, her feelings had since changed. According to a letter she wrote George Cukor on March 25, 1957, shortly before arriving in Mexico, she felt sure King would be of no help to her.

Nor was Ava enthusiastic about journalists coming on set and dogging her for details about her personal life in the wake of her divorce from Frank. She agreed to do her share of interviews as necessary for the film's publicity but resented head-lines that painted her as an unhappy and lonely woman, a loser at love who couldn't hold down a marriage. How could she focus on creating her own narrative of her

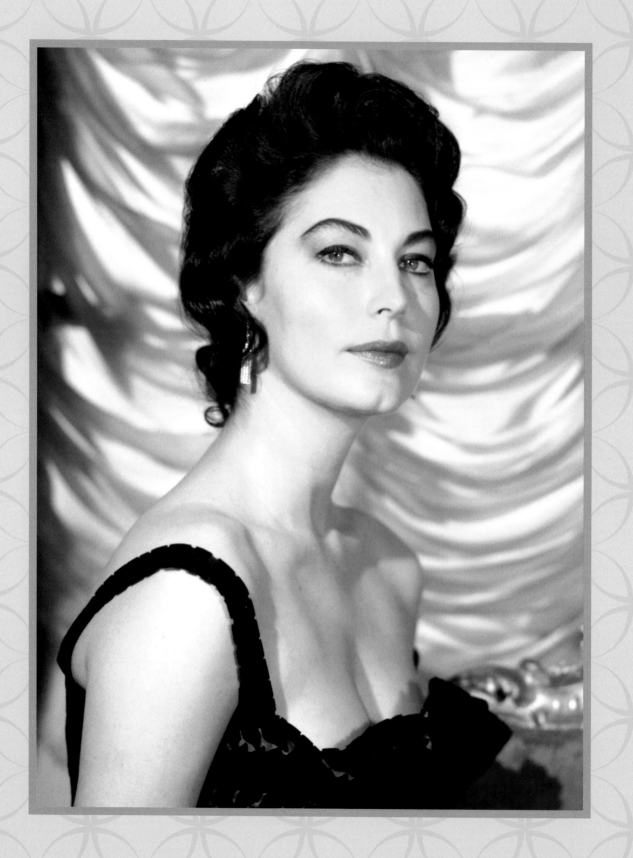

future when the international press was hell-bent on doing it for her? In a moment of frustrated candor, Ava said to journalist Liza Wilson, "Why do you writers insist that I'm tortured, tormented, frustrated—not to mention moody, unhappy, and lonely? I live the way I like to live wherever I happen to be and very few people can say that truthfully. I suggest that you don't cry for me."

Tensions on the set of *Sun* ran high, according to an in-depth report published in *Esquire* magazine. Writer Helen Lawrenson observed that "everyone connected with the picture seemed curiously imbued with the essential spirit of the book itself, so much so that at times, both on and off the set, it almost appeared as if they were really living it instead of acting it. . . ." When it came to Ava, her jaded attitude toward fame and her wariness of the ever-present press affected her work. If a photographer tried to take an unauthorized picture, she had him thrown off the set and spent the rest of the day sulking. Lawrenson described her as "the unknown quantity from day to day." Would she show up to the set on time? Would she be difficult to work with? Her behavior became unpredictable and her mood irascible. Things weren't helped any by producer Darryl Zanuck hovering around and trying to do Henry King's work for him.

opposite: Publicity portrait for *The Sun Also Rises.*

below from left: Ava and Micol Fontana of Sorelle Fontana fashion designers shop for bags in Mexico while on location filming *The Sun Also Rises,* 1957. • Ava and Mel Ferrer rehearse dance steps for *The Sun Also Rises.* Ferrer's wife, Audrey Hepburn, came to visit on the set and struck up a friendly relationship with Ava. The two enjoyed going on shopping excursions.

"If anyone should be frustrated about the picture I'm making now it's Ernest Hemingway," Ava said in an attempt to deflect attention away from herself. "Poor Papa. He gave the book to his first wife as part of the divorce settlement and doesn't get a penny out of the five-million-dollar production." When Hemingway saw a preview of the film in New York, he *was* frustrated with the final product. The *Los Angeles Times* reported that he walked out of the screening after twenty-five minutes with the opinion that Zanuck had turned his story into "Zanuck's splashy Cook's tour of Europe's lost-generation bistros, bullfights, and more bistros. . . . It's all pretty disappointing, and that's being gracious." Errol Flynn was the best thing about the film, "I guess." Mexico, he said, was no substitute for the authenticity of Pamplona, where much of the story takes place. Given the prickly natures of both Hemingway and Zanuck, it is not surprising that the press reported a feud. Zanuck fired back that Hemingway's remarks might harm the film's chances before actual critics had a chance to weigh in. As for Mexico, he said, they had no choice. Hemingway had insisted on Ava playing Brett, and to accommodate Ava's schedule they had to "postpone the schedule from September to February." Did Hemingway expect them to film in the snow? Furthermore, said Zanuck, 60 percent of the dialogue in the film was taken straight from the pages of Hemingway's novel. "If the picture doesn't satisfy Hemingway he should read the book again . . . because then the book won't satisfy him."

Hemingway was known for his sparse and blunt writing style, which didn't appeal to all readers. With such bare dialogue it was left up to the actors to convey the underlying disillusionment and pent-up emotions that flow between the lines of his story. Despite mixed reviews for both Ava and the film as a whole, a reassessment reveals qualities in Ava's performance that have largely been overlooked. Befitting Brett's repressed feelings toward Jake, Ava is largely subdued. Yet in the moments when Brett's passion seeps out of the cracks in her otherwise cool facade, she goes wild. No scene better exemplifies the duality of Ava's characterization than the one in which Jake takes Brett to a club early in the film. After she professes her love for him in the car ride over and tells him that she's going to marry someone else, Jake decides to leave her with Robert Cohn and an infatuated French aristocrat. Jake walks out into the night, and Brett breaks into an uninhibited Charleston, as if his abandonment means nothing to her. We find out otherwise when Jake and Cohn converse outside the club and Jake calls Brett "a drunk and a drifter." The camera cuts back to the club, where Brett is standing in the doorway, having overheard the entire conversation. The shot lasts mere seconds, but the look of hurt that flashes across Ava's face provides a fleeting glimpse into Brett's inner turmoil that speaks louder than any dialogue. It was rare that Ava got credit for revealing psychological depth in the characters she played. At times such revelations indeed seem to appear out of the blue. Unexpected but welcome, they challenge Ava's own insistence that she knew nothing about acting.

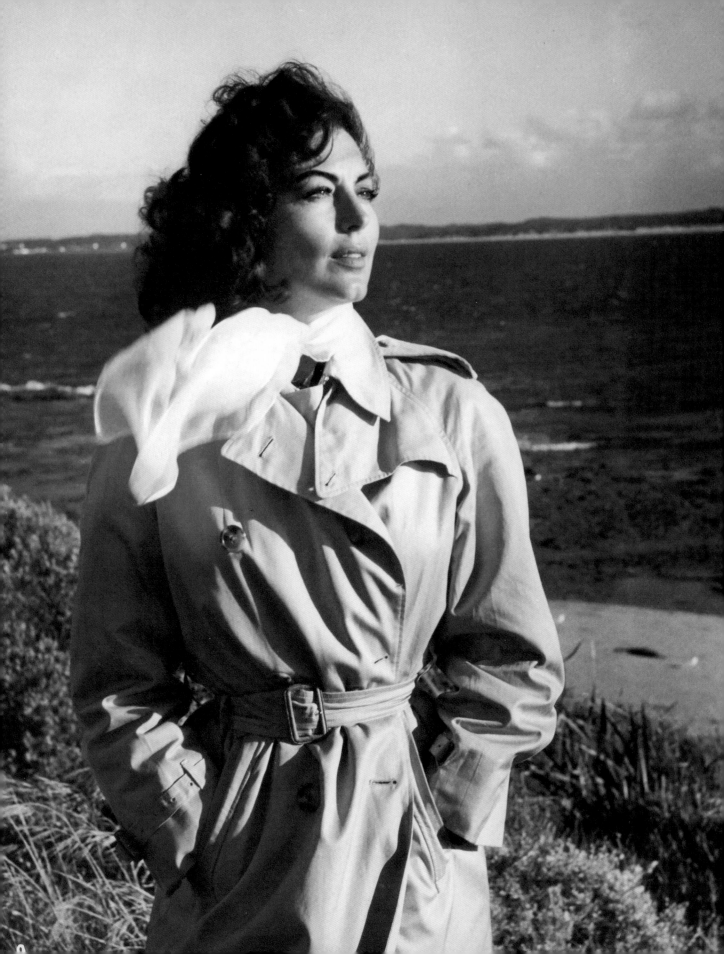

CHAPTER EIGHT:

Independence

AVA RETURNED TO SPAIN IN THE FALL OF 1957, DESPONDENT and unsure about the future. She had one last picture remaining on her MGM contract, and she had been passing on offers for months, dreading the transition she sensed was upon her. She had always felt imprisoned by the studio, always saying how much she wanted to quit. But now, with the prospect of freedom on the horizon, she became terrified. She had never held another job; the studio had been her home, for better or worse, for the past sixteen years. She was also aware that she was approaching an age when actresses found it increasingly difficult to remain on top of their game, especially actresses who depended as heavily on their glamorous image as Ava did. She never believed she had talent—that had not changed. Would anyone really want to hire her had she not been beautiful? And even if they did, actresses renowned for their craft, such as Bette Davis, were also struggling to get parts after the age of forty.

Ava was still considered one of the most beautiful women in the world, and the aura of mysterious glamour was still part of her international image. But it was time to decide in which direction to go, time to make some plans for the future. Ava had never put much thought into her career, but she did believe that making a significant amount of money would ensure her long-term security, at least financially. She knew that freelance stars were receiving salaries far exceeding what the studio was paying her, despite the fact that she was one of its greatest box-office draws.

Before she was able to fulfill her final commitment to MGM, fate dealt her another cruel blow, one that would only contribute to her feelings of insecurity. One day, with Walter Chiari and Bappie, she went to a bull ranch belonging to a friend she had met through Hemingway. Encouraged by her host, and with her courage boosted significantly by alcohol, Ava decided to have a go at fighting a young bull while on horseback. What at first seemed like a fun idea almost immediately turned disastrous, as minutes into her ride Ava was thrown off the horse, falling to the ground and hitting her cheek on the graveled surface. Initially more scared than hurt, Ava was quickly

opposite: Moira watches from the mainland as Dwight, the man she loves, sails away in his submarine in Stanley Kramer's *On the Beach.*

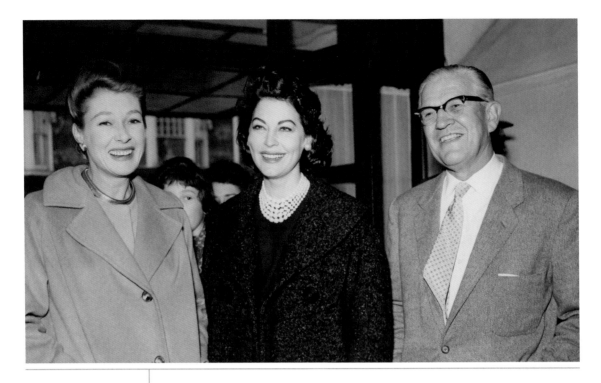

The miracle worker: Ava accompanies Dr. Archibald McIndoe and his wife to a charity benefit at the Queen Victoria Hospital in East Grinstead, England. Ava was eternally grateful to McIndoe for literally saving her face after her bullfighting accident.

carried out of the ring and attended to by Bappie, who was horrified and angry at her sister for being so careless. By that evening, Ava's right cheek had become swollen and bruised, and the situation did not improve over the next few days.

Ava knew of a doctor in England who had a reputation for being something of a miracle worker, performing reconstructive work on hundreds of wounded war veterans, with unbelievably successful results. Wasting no time, and armored with a silk scarf and dark glasses, Ava boarded a flight to London. Archibald McIndoe was the kind of man who reminded Ava of her father, and she immediately trusted him. After carefully examining the lump on her cheek, McIndoe suggested that any form of surgical intrusion would likely leave a permanent scar, or, worse still, alter the contours of her face. His advice was to wait patiently for her face to heal naturally, a process that would take a few months. Ava returned to Spain, where she followed McIndoe's advice. A few weeks later, she reluctantly agreed to see a New York plastic surgeon based on a recommendation from Frank. The doctor, who was planning to build a new clinic in Texas, suggested that a procedure to surgically remove the lump would be the best option. The fee he requested was $1 million. Ava was furious and regretted disregarding Dr. McIndoe's advice. She returned to Madrid without having undergone the procedure and continued to use a vapor-massage device given to her by David Hanna. Eventually her face healed completely, save for a tiny, barely visible scar that would remain on her right cheek for the rest of her life as a permanent reminder of a careless afternoon.

THE MOVIE AVA FINALLY SETTLED ON AFTER NEARLY TWO years away from the screen would not be the most memorable venture of her career; it certainly lacked the artistic quality that her swan song for MGM ought to have possessed. Initially, *The Naked Maja* sounded like a good idea. The story of the alleged affair between Francisco Goya and the famously beautiful and volatile Duchess of Alba seemed custom-made for Ava, and indeed it was. The project was first conceived by Albert Lewin, the visionary director of *Pandora and the Flying Dutchman*. The part of Alba had the same air of mystery and glamour as the role of Pandora, and it held the potential for another stunning performance from Ava. However, by the time Ava signed her contract for the film, Lewin had been forced out of the deal, his idea taken over by new writers, who gradually stripped away all of the project's originality and lyrical beauty.

Yet another obstacle was the fact that the Alba family, still a powerful force in Spain, disliked the idea of filming the seedy tale involving their famous ancestor, and in the end the production was forced to relocate to Rome's Cinecittà Studios. Ava arrived in the Eternal City in January 1958, still terrified of the cameras, fearing that the accident had stolen her looks forever. Titanus, the Italian company producing the film (MGM held the international distribution rights), presented Ava with a script hastily put together in the weeks preceding her arrival. She hated it, declining to start work until major changes had been made. With no leading man and no screenplay, the production was postponed.

Ava took up residence in a beautiful penthouse apartment in an old palazzo at number 9 Piazza di Spagna, around the corner from the iconic Spanish Steps. The apartment had a large terrace with a breathtaking view of the city's ancient skyline. Ava loved to take long evening walks through the narrow, cobbled streets, or take her corgi, Rags, for a walk in the Villa Borghese gardens nearby. The injury to her face had made her more reclusive, more distrustful of everyone around her. If she had indeed lost her looks, as she believed she had, sooner or later everyone would turn against her.

Late at night she would sit on her terrace, looking at the magnificent city before her, quietly sipping a drink, listening to Frank's records. Her life during those lonely months resembled the plot of Tennessee Williams's *The Roman Spring of Mrs. Stone*, a tragic tale of celebrity and lost youth in Rome. Ironically, a couple of years later Ava would be considered to star in the adaptation of the Williams novella, with the part eventually going to Vivien Leigh.

She was forced back to life when filming finally started at Cinecittà later that spring. The part of Goya was given to a strikingly handsome Method actor from New York, Tony Franciosa. It was an odd casting choice, as Franciosa, with his distinctive New York accent and contemporary manner, seemed utterly out of place in the period piece, despite immersing himself completely in the part of the Spanish painter. The screenplay was still far from perfect and was updated daily by everyone,

including Ava, Franciosa, and David Hanna. If Ava still harbored fears about the way she looked, she needn't have worried. She looked stunning in the costumes designed by Maria Baroni, and she was beautifully photographed by the young Italian cinematographer Giuseppe Rotunno, who would go on to work on many notable productions, both in Italy and in Hollywood. The scar on her face was barely visible, and to anyone unaware of the accident it simply appeared as a tiny, rather charming dimple.

The work on the film progressed slowly and offered Ava little satisfaction. Franciosa, who had believed that the part of Goya would do for his career what playing Vincent van Gogh in *Lust for Life* had done for Kirk Douglas two years earlier, was also disappointed, quickly realizing that *Maja* would not be of comparable quality. Some weeks into the filming, whether out of boredom or genuine attraction, Ava set out to seduce her married costar. She was still dating Walter Chiari, who regularly flew to Rome to see her, but their relationship had become a drag to Ava. She wanted to end it, but Chiari desperately clung to the idea that the two of them had a future together. Now, bored and despondent, after weeks of seclusion in her Piazza di Spagna apartment, she was ready to sample Rome's infamous nightlife, and she wanted to do it on the arm of her handsome leading man.

A happy moment on the set of *The Naked Maja* in Rome, as Ava shares a joke with dialogue director Michael Audley.

opposite: Ava as the Duchess of Alba in *The Naked Maja,* her final film under her long-term contract to MGM.

Rome in the second half of the 1950s was a unique place, where the international set of movie stars, models, and aristocrats mingled nightly in the glamorous *ristorantes* and clubs of the Via Veneto. Away from home and from the guarding eyes of their studios and spouses, the stars were able to really let their hair down. The Italian capital, still recovering from the destruction and poverty of the war years, had suddenly awakened as the rapid Americanization of popular culture pushed the city into a social and economic boom that would culminate in the early 1960s. The fact that a great number of costly American productions were filmed at Rome's Cinecittà no doubt contributed to the cultural revolution that was taking place. Simultaneously, as a reaction to the ever-growing number of international celebrities populating the city, and to the public's insatiable appetite for them, a new breed of photojournalist was born. Growing up on the war-torn streets, these hard-boiled men wasted no opportunity where a good story or picture was concerned. This often meant provoking a situation that would create an explosive story or produce a

shocking photograph. Hollywood actors, used to the nurturing care of the studio publicity departments, were completely unprepared for this invasion of their privacy, and as a result many of them unwittingly revealed their mortality for the first time, on the cobbled Roman sidewalks, in the early hours of the morning.

Ava, as Hollywood's reigning screen goddess, famous for her love life and nocturnal escapades, was the most desired target. Paparazzi haunted her every step, waiting outside her apartment and often following her car into the Roman night. As the summer approached, Ava's romance with Franciosa was a hot topic in gossip columns, and photographs of the two were in extremely high demand. One particularly humid night in August became legendary as the night on which *La Dolce Vita* was born. It was a Friday evening; Via Veneto was buzzing with life, its elegant sidewalk cafés overflowing with people. Word that Ava Gardner would be out with her married costar quickly spread, and every photographer in Rome was there, camera in hand, ready to snap away at a moment's notice.

Tazio Secchiaroli, later to be known as "the greatest of the paparazzi," had been the cause of a famous incident when he spotted the ex-king Farouk of Egypt enjoying the company of his Italian mistress, Irma Capece Minutolo, at an outdoor table at the Café de Paris. Wasting no time, Secchiaroli started taking pictures, and soon, alerted by the bright flashes, others arrived on their scooters, besieging the ex-king's table. Enraged, Farouk charged at Secchiaroli while the delighted photographers continued to document the spectacle. As the former monarch was hastily escorted away by his bodyguards, the frantic whispers and brief, coded calls of Roman dialect signaled the arrival of Ava and Franciosa at the nearby Brick Topo club. According to the Milanese daily *Il Giorno*, "It was once again Tazio Secchiaroli who arrived to set off his flash." The paper reported that "Anthony Franciosa's reaction was the same as Farouk's earlier one: he immediately hurled himself at the photographer, with even more energy and with greater agility." The paper referred to Franciosa as "Ava Gardner's leading man in *The Naked Maja*, and the current leading man in her fickle heart."

The article appeared the following Tuesday along with a similar item in the weekly *L'Espresso* titled "That Terrible Night on Via Veneto." Both caught the attention of Italian director Federico Fellini, who for some time had been contemplating writing a movie based on hedonistic nights in Rome. The articles' tones helped to shape the eventual film, with the figure of the goddess-like visiting movie star becoming a central motif. Anita Ekberg, who eventually starred in *La Dolce Vita* as the divinely glamorous Sylvia, even wore a replica of a dress first designed for Ava by the Fontana sisters. As Lee Server observes in his book *Love Is Nothing*, "To Ava Gardner, the first half of *La Dolce Vita* must have looked like home movies."

The affair with Franciosa came to an abrupt end with the arrival of his estranged wife, Shelley Winters. Winters later claimed that she only found out about her husband's liaison with Ava after flipping through the Roman papers on the morning after her arrival. Winters was acutely aware that she was in competition with one of

opposite: Ava and Tony Franciosa carried their characters' passion offscreen as well.

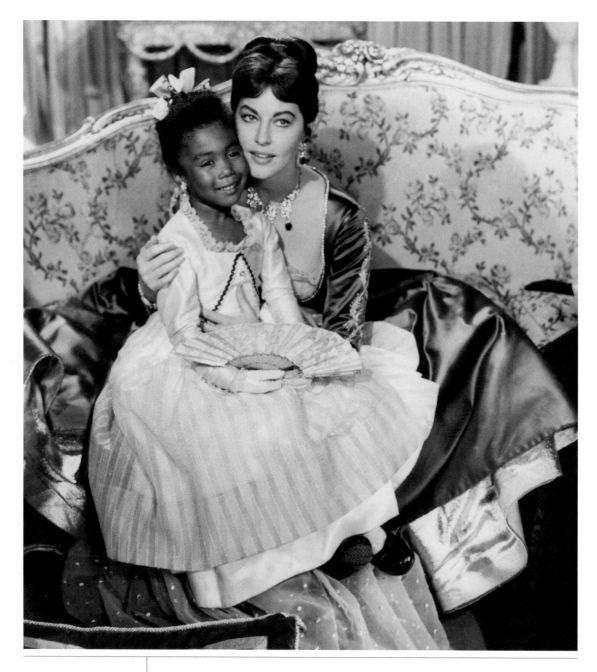

Publicity still for *The Naked Maja.*

the most glamorous women in the world, and that even if the affair meant little more than an erotic adventure to Ava, it had the potential to destroy her already rocky marriage. With a pillow under her dress to simulate pregnancy and earn the sympathy of the crew, Winters arrived at Cinecittà, where filming of *The Naked Maja* was in full swing. She later wrote in her memoirs, "Ava Gardner came out of her dressing room looking like a goddess. Indeed, like the naked Maja. I can still even smell her per-

fume. It was Tabu. She gazed at this religious picture of the pregnant wife squatting on the chair with the husband's arms around her. You could hear a pin drop on the sound stage, where about two hundred workers stood watching."

Winters was determined to shut Ava out of Tony's life by any means, even bad-mouthing her to the press by claiming that Ava's demands compromised the quality of the film, shifting its balance away from the figure of Goya. In her autobiography, she also claimed that "Ava practically destroyed Tony's health and sanity, and she had destroyed the film too." Ava quietly withdrew, and as the filming concluded so did the affair. Even though Shelley Winters won the battle, she could not win the love of Franciosa, who left her less than two years later.

FREED FROM HER MGM CONTRACT, AVA JOINED THE RANKS of independent stars. She was now able to choose her own projects. The transition was made easier by the fact that she was able to begin work almost immediately because her first film as a freelancer had been arranged while she was still in Rome shooting *The Naked Maja*. Nevil Shute's novel *On the Beach* had been a major international best seller that Ava read when it came out in 1957. Almost immediately hailed as one of the most important novels to ever have come out of Australia, the story caught the interest of Stanley Kramer, who was already becoming known as the most socially aware auteur of his generation. The theme of nuclear holocaust was more than timely; with the Cold War approaching its zenith, Kramer felt that it was high time for cinema to document the anxiety and uncertainty experienced by many. Despite an already successful résumé that included *The Pride and the Passion* and *The Defiant Ones,* Kramer struggled to convince United Artists to provide financial backing for a film with such a dark subject matter. No mainstream film up until that point had ended with the extinction of the human race. The box-office potential of such a story was questionable. Kramer, however, believed that the film would strike a chord with audiences, and he expected that it would "cause a world-wide stir."

In order to obtain the high budget needed to realize his ambitious project, Kramer set out to assemble an all-star cast. He later wrote that "the public might not like the subject, but they wouldn't ignore a picture starring Gregory Peck, Ava Gardner, Fred Astaire, and Anthony Perkins." Like many other directors, Kramer had been fascinated by Ava ever since seeing her in *The Killers* more than a decade earlier. He flew to Rome to meet her. Ava, with her usual caginess, didn't understand why he would want her for such an important film. She was, however, deeply moved by the screenplay and soon agreed to star in the film, which was scheduled to begin shooting on location in Australia in early 1959.

Years later Kramer wrote, "Ava Gardner, God bless her, was a wonderful person, a fine actress, and one of the most beautiful women I have ever seen, but in 1959 she gave me an Australian public relations nightmare." Ava had always been mistrustful

Between takes on the set of *On the Beach*.

opposite: Stanley Kramer (seated) directs a scene with Ava and Gregory Peck.

"Ava was never the kind of actress who would complain about her working conditions. She took it like a trouper and we just kept plugging away despite everything, until we got the scene."

—GREGORY PECK

of the press. After her bad experiences with the paparazzi in Rome, she hoped for more privacy and seclusion in Australia. This, however, was not to be, as the press went wild for the entire company of *On the Beach*, the first major Hollywood film to be made down under, and Ava became the main point of their interest.

When she arrived in Melbourne in January she was greeted by a vast crowd of reporters and photographers. Kramer remembered that she was terrified. Although things went well at first, the press, hungry for a more explosive story, quickly began fabricating quotes and provoking situations, a familiar game that Ava detested. Ava's supposed statement that Australia was the perfect place to make a movie about the end of the world became part of local folklore, and although she denied ever saying it, she became widely associated with having a derogatory attitude about her host country. The situation was made more difficult by the working conditions. The sweltering heat of the Australian summer and colonies of flies at times invading the set made it virtually impossible to shoot. Ava took it in stride. She was always on time, knew her lines, and, in contrast with the way she was being portrayed by the press, was friendly and considerate to her colleagues. Gregory Peck remembered that "Ava was never, never the kind of actress who would complain about her working conditions. She took it like a trouper and we just kept plugging away despite everything until we got the scene."

On the Beach was the third film she made with Peck, with whom she shared a special kinship and understanding. Once again, trusting Peck and being appreciated by the director, Ava was able to open herself up and give an outstanding performance. There was a new maturity and sensitivity in her acting that added an extra dimension of meaning to her scenes. It was easy for her colleagues to see that Ava found truth in many of the lines she delivered. In one scene, a drunken Moira visits her old-time admirer, Julian (Fred Astaire), to declare, "There've been men. Lots of men. And every time one fell out there was always a replacement. Not one of them meant anything to me. I can't pretend anymore, Julian. I'm afraid. I have nobody."

Like Robert Siodmak and George Cukor before him, Kramer gently encouraged Ava to draw upon her own experiences in order to give life to her character. It was not easy

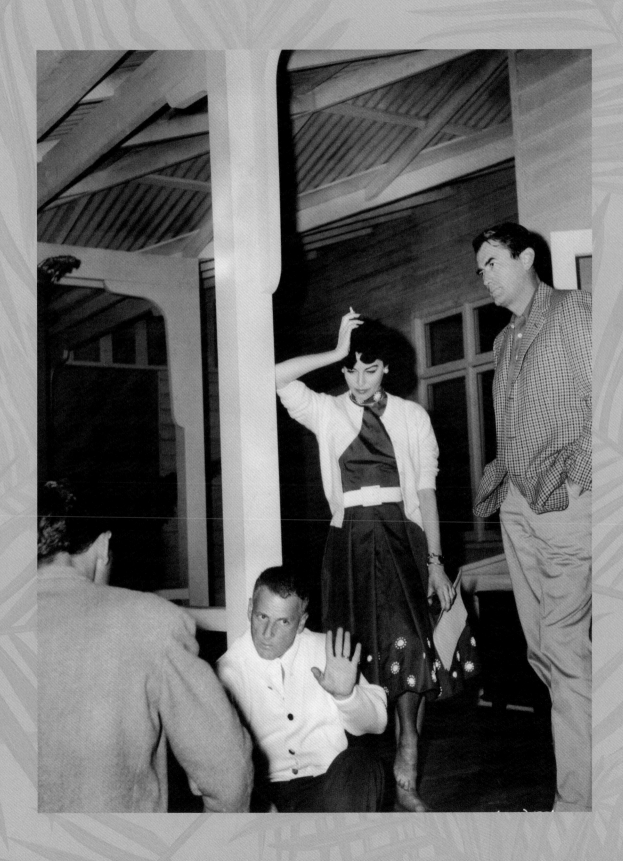

for Ava to bare her soul before the camera. She, like many people, feared a close examination of her feelings. But when she trusted and liked a director, she was unable to refuse him anything—that was one of Ava's defining traits as an actress.

After the release of *On the Beach*, Kramer said in an interview, "When she's really with it, the things actresses usually worry about—makeup, hair, clothes—mean nothing to her. She's avid to grasp every nuance of her next scene. Her projection really is extraordinary. Swiftly she can go from softness, to pathos, to violence."

The intelligence, sensitivity, and keen focus with which Ava approached *On the Beach* likely had a lot to do with the fact that it was the first film she made on her own terms. Not only did she trust Kramer; she also believed that the film would contribute a valid argument in an important sociopolitical discussion. It was an intellectual piece in which her acting mattered far more than who designed her costumes or how well she was lit. In fact, Kramer encouraged her to wear as little makeup as possible, and Ava followed his request. She asked that Giuseppe Rotunno be hired as the film's cinematographer, an inspired choice that resulted in some of the most hauntingly beautiful imagery of all Ava's films. Ava's personal favorite scene was the final one, in which the doomed lovers kiss for the last time, with the setting sun glimmering between their faces. The stunning sequence is followed by Ava standing on the cliff and looking into the sea, bidding farewell to her lover and to humanity, with an enigmatic smile rivaling Garbo's legendary close-up in *Queen Christina*.

The film's premiere on December 17, 1959, was a grand event with an unprecedented simultaneous opening in eighteen different theaters across all continents (even in Antarctica). The global opening was designed to highlight the gravity and universality of the film's message, but it was also how United Artists tried to build up excitement and create extra publicity, as they still feared that the expensive production would prove a box-office failure. Ava attended the premiere in Rome, where she was working on her next film, *The Angel Wore Red*. Her costars appeared in different cities—the Gregory Pecks at a closely guarded gala in Moscow (the film would not be released theatrically in the Soviet Union), while Anthony Perkins and Fred Astaire, together with Stanley Kramer, represented the film at a glitzy premiere in Hollywood.

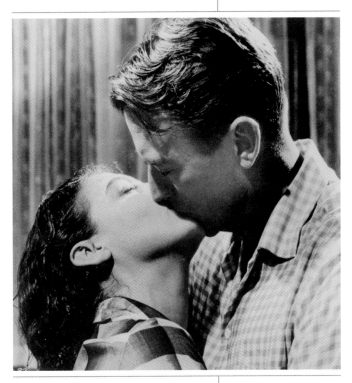

Ava and Gregory Peck as Moira and Dwight in *On the Beach*.

opposite: These behind-the-scenes snapshots from *On the Beach* show Ava, Gregory Peck, and director Stanley Kramer preparing for an emotional scene.

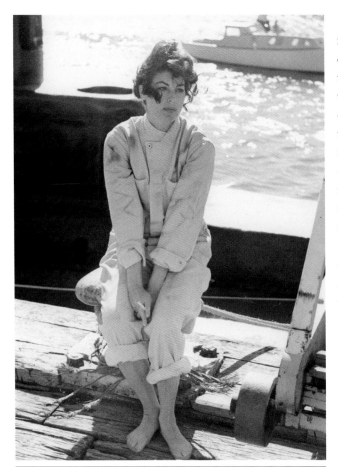

Ava had a miserable time in Australia, mostly due to the hostility of the press. She did, nevertheless, manage to create one of her most accomplished performances.

opposite: Ava was a great admirer of cinematographer Giuseppe Rotunno. The scenes he shot of her and Gregory Peck in *On the Beach* were among her favorites.

Reception of *On the Beach* was mainly positive. Almost all critics agreed that the film was one of the most important motion pictures of the decade, with its moving and realistic portrayal of what could easily have been the reality of the time. The film's impact echoed as far as the highest echelons of the political establishment, with members of President Eisenhower's cabinet trying to discredit its value out of fear that the message it conveyed might raise questions regarding the US government's nuclear activities.

As for Ava's performance, most critics agreed that it was one of her greatest acting achievements. Even reviewers who disliked the film praised Ava. *Variety*, for instance, questioned the film's believability, but it also declared the cast "uniformly excellent" and said that "Peck and Gardner make a good romantic team." Bosley Crowther of the *New York Times*, known for his sharp and often derogatory reviews of Ava's films, praised the actress by stating that in playing the "worldly" Moira she managed to be "remarkably revealing of the pathos of a wasted life." For her performance Ava was nominated for a BAFTA award as best actress. There was even talk of an Oscar nomination, but in the end the Academy would almost completely omit *On the Beach*, save for two nominations for best score and editing.

With the release of *On the Beach*, Ava entered a new phase in her life, both professionally and personally, although perhaps without being fully aware of it. In her screen life she would never again go back to playing the glamour-puss of her MGM years. Playing Moira opened the door to new opportunities, at the same time forever leaving behind the romantic, dark heroines that had made her a global superstar.

Although her reviews were glowing, many critics noticed physical and emotional changes in Ava, an evolution of style as well as the merciless signs of passing time. *Newsweek* proclaimed that "Ava Gardner [has] never looked worse or been more effective," a backhanded compliment that hurt Ava deeply. She became more distrustful of those closest to her, especially when, in 1960, David Hanna published an intimate account of his time in Ava's employment. Although far from unflattering, *Ava: A Portrait of a Star* was filled with personal details and a careful analysis of her personality, something she found particularly intrusive. Rene Jordan remembered Ava's

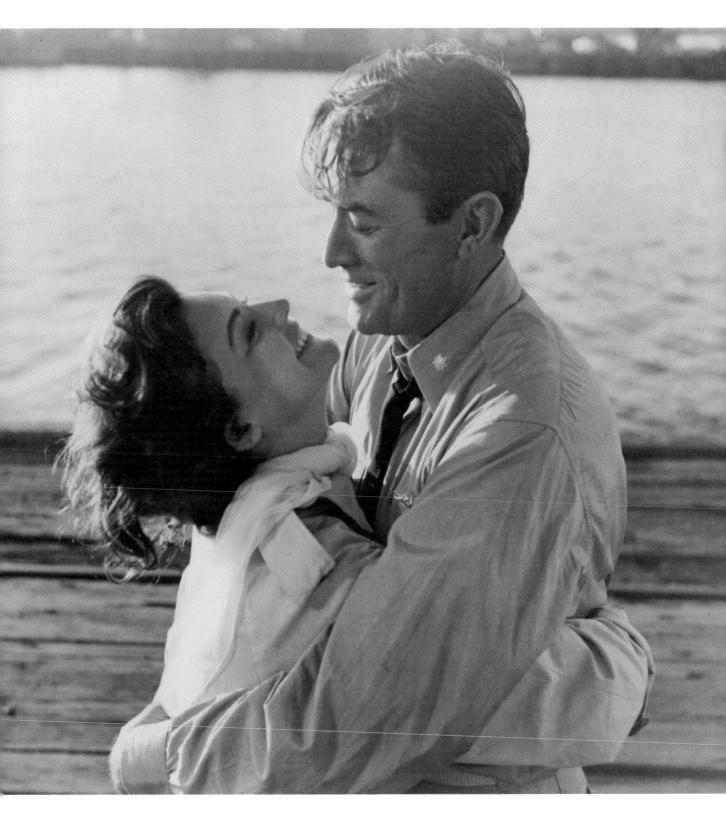

The Swedish magazine *Såningsmannen* featured Ava in a scene from *On the Beach* on its January 9, 1960, cover.

reaction when she first read the book: "There's David, my secretary, my friend. I trusted him. He worked for me for years. His book was probably the most factually correct of all of them, but what the hell!" She saw Hanna's book as a definite betrayal of her trust, and she never spoke to him again.

She was determined to re-create her career, to play more challenging roles in a diverse range of films. After Kramer and *On the Beach*, however, the great parts just failed to come. She finally settled on a story that sounded promising, in which she was to play a prostitute in love with a defrocked priest during the Spanish Civil War, once again to be shot in Rome. There had been some talk about casting Frank in the part of the priest, as well as Montgomery Clift, but eventually the part went to Dirk Bogarde. *The Angel Wore Red* was a disappointment to everyone concerned; however, it did mark the beginning of a close friendship between Ava and Dirk, one that was to last for the rest of her life.

Dirk was warm and sensitive, well-read and sharply intelligent, and he seemed to fulfill Ava's need for a new kind of companionship. Ever since divorcing Artie, Ava had been an avid reader, interested in music and art, but it was only after the end of her contract with MGM that she finally found the time to really nurture the more intellectual side of her life. Parties and nightly escapades didn't seem to fill the void anymore. She began to face up to her own feelings and longings. It was during the shooting of *On the Beach* that she finally realized there was no future in her relationship with Walter Chiari. In a moment of loneliness, she telephoned him from Melbourne. She missed him; would he come to see her? Chiari rushed halfway around the world only to find that Ava's mood had changed; not only did she not miss him, she decided she would never miss him again.

Back in Rome, Ava vowed not to repeat the wild nights of the year before. She was focusing on the part, wanting to prove to her critics that *On the Beach* was not just a fluke, that she really could act and didn't need a glamorous frame to carry a film. Bogarde admired Ava's professionalism and was mesmerized by her beauty. Years later he would write, "Ava and I loved each other instantly." Ava trusted Dirk. She knew of his homosexuality, despite the fact that he was as fiercely private as she was, and she knew he wouldn't try to seduce her. He didn't need to use her for publicity, and she felt she could trust him with her secrets.

In the years ahead, as Ava became more and more reclusive, Dirk would remain one of her dearest and closest friends, someone she could, and often did, depend on for advice and comfort. Home movies shot by Dirk's longtime partner, Tony Forwood, show Ava playing with their beloved corgis during her visits to their Buckinghamshire estate. Tony was also present on the set of *The Angel Wore Red*, where, with his 35mm camera, he caught rare glimpses of Ava and Dirk relaxing between takes.

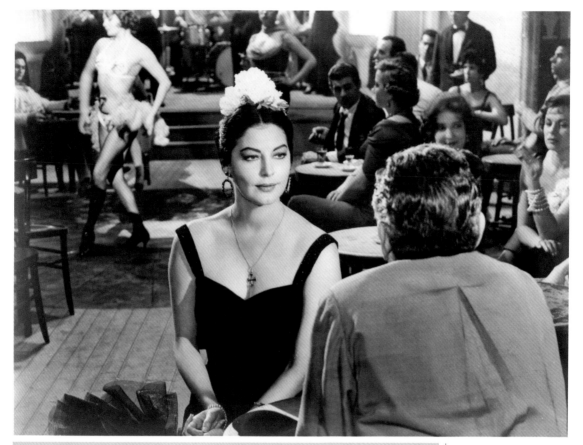

from top: Ava had high hopes for her part in *The Angel Wore Red,* but the end result was a disappointment to everyone concerned.
• Lobby card for *The Angel Wore Red.*

Ava and Dirk Bogarde in the ill-fated *The Angel Wore Red* (1960).

The Angel Wore Red was written and directed by the legendary Hollywood veteran Nunnally Johnson, who had written such classics as *The Grapes of Wrath*, *The Woman in the Window*, and *How to Marry a Millionaire*. Everyone involved had high hopes for the picture, and Ava especially approached the part of Soledad, a vulnerable country-girl-turned-prostitute, with great enthusiasm. Many years later Dirk wrote about the film, "We shot for verite . . . she wore no make-up, one awful old dress, it was good. After three weeks MGM saw the first set of rushes, had hysterics, ordered the whole three weeks to be reshot with Ava dressed by Valentina, shoes by Ferragamo, makeup ta ta ta ta. We all gave in and did as we were told and the film was a disaster."

It wasn't the kind of direction Ava was hoping for when she'd left MGM two years earlier. She found herself at a crossroads in her career at a time when cinema was rapidly changing and entering a very different mode of production. A young generation of actors was appearing, making the glamour of old Hollywood suddenly seem stale and irrelevant. Disenchanted, for a time Ava did not seek new film roles. She returned to Spain, where she decided to sell La Bruja. The quiet and isolated suburb from five years earlier was quickly becoming overcrowded with new developments, and the curious eyes of new neighbors bothered her. Ava could no longer find the cozy feeling of belonging she experienced when she had first arrived in Spain.

She took an apartment in Madrid, at 8 Calle del Arce, where her downstairs neighbor turned out to be the exiled ex-dictator of Argentina, Juan Perón. There was no neighborly friendship between the two. Perón often complained about Ava's nocturnal lifestyle. She regularly played her favorite records—Sinatra, Callas, or flamenco—into the early hours of the morning, causing the angry politician to lose sleep. She also gave parties that were attended by a wide assortment of characters, from famous writers, artists, and movie stars, to gypsies and jazz musicians whom she met on her nightly escapades. She was drinking heavily again, going to bed at dawn and waking up in the afternoon.

Those months in Madrid weren't all parties. Ava was enjoying decorating her new place, trading the flamboyant style of La Bruja for more conservative, classic interiors. Her changing taste was indicative of other changes that were happening in her life. Ava took more time to read, and correspondence became increasingly important to her. Aside from Dirk Bogarde, other meaningful friendships entered her life, and she made sure to maintain them. There were still great movie parts to come, too, although her next film would not be one of them.

Ava and Aristotle Onassis engage in a conversation over dinner at the Bal de la Rose in Monte Carlo, February 1960. The international event was hosted by Ava's good friends Princess Grace and Prince Rainier of Monaco. (Rainier is seated to Ava's left.)

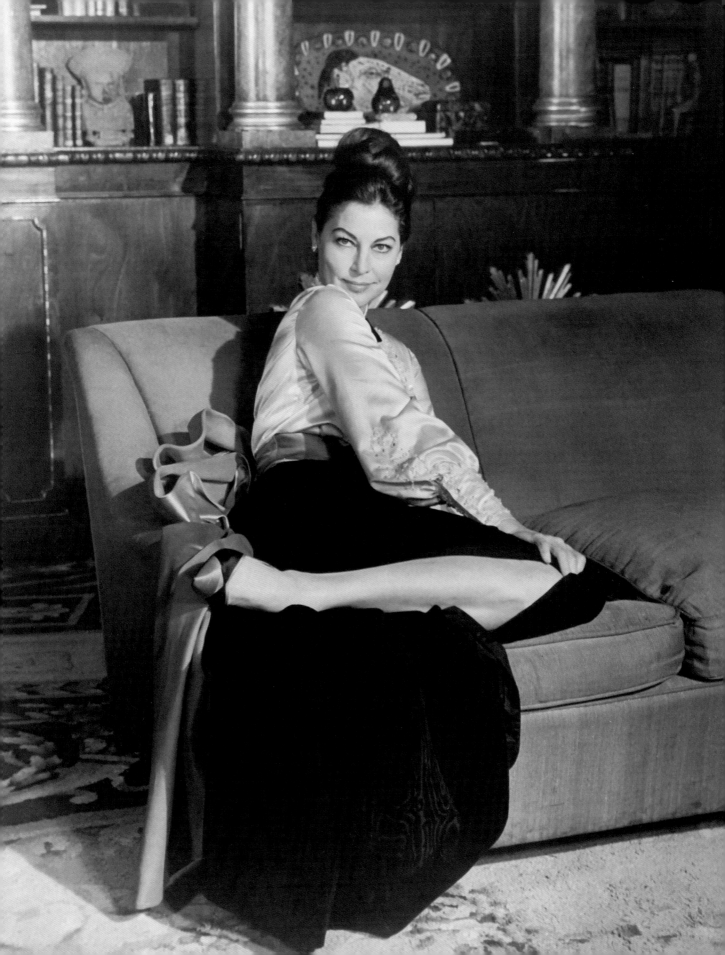

CHAPTER **NINE**:

Maturity

N THE SUMMER OF 1961, ERNEST HEMINGWAY COMMITTED suicide. The news devastated Ava. He had been a constant presence in her life for the past decade. Although there were years when she did not see him, they had always corresponded; his guidance and wisdom were sources of strength. The visits she made to his Cuban home and the time she spent with him in Spain were among her most treasured memories. She identified with his literary creations, but more importantly she felt a unique bond with the man himself. They had much in common, both having grown up in small-town America and having restlessly traveled the world in search of fulfillment and self-expression. The last years of Hemingway's life were marred by physical illness and clinical depression, a fact that was not widely known at the time. To Ava, Papa's death signaled the end of an era. The careless, hedonistic fiesta had come to an abrupt end.

Ava's other friendships with figures from outside the film world continued to flourish. Her lack of formal education continuously bothered her, and it was through association with writers and artists that she was able to get the intellectual validation she needed. She distanced herself from many of her Hollywood friends; talks of who got the latest part and how much money they were being paid for it always bored her. Arlene Dahl, a girlfriend from the MGM days, remembered, "She hated parties. She hated premieres. She loved to stay home, study her lines, and read. She reminded me of Marilyn Monroe, the way she tried to educate herself. She bought a lot of Russian novels, which she couldn't get through. She read poems by Robert Frost and Lord Byron. She played a lot of operas by Puccini, and Spanish flamenco records."

From the time she moved to Spain, Ava counted Spanish Civil War veteran Ricardo Sicre and his wife, Betty Lussier, the American ex-pat who had trailblazed her way to becoming one of the first female pilots in the British Army, among her closest friends. They had a house outside Madrid where they became central figures in the international set, counting Hemingway, Adlai Stevenson, and Robert Graves among their circle. When Ava first moved to La Bruja, the Sicres were her neighbors

opposite: Ava posing in her Madrid apartment during the shooting of *55 Days at Peking.*

and soon introduced her into Spanish society. Ava was also happy to be a part of the Sicres' family life, often volunteering to babysit their four sons, who adored her.

It was at a party at the Sicres' home when Ava first met Robert Graves. She had no idea who he was, and he had only a vague notion of the extent of her fame. Graves was nearly thirty years Ava's senior, happily married, and there was never any hint of a romantic involvement. They did, however, strike up a warm friendship. Ava was immediately taken by his intellect and wealth of worldly experience, rivaled only by Hemingway's. Graves found her to be good company. He was renowned as one of the great poets of the First World War and, later, as an important classical scholar and a central figure of the literary establishment. After that first meeting in Madrid, Ava sent Graves and his wife, Beryl, a huge bouquet of red roses, with a note expressing her appreciation of their friendship.

Graves lived in the picturesque village of Deia, on the remote coast of Majorca. In an article titled "A Toast to Ava Gardner," published in the *New Yorker* in 1958, Graves remembered Ava's first visit to the island. According to the author, Betty Sicre arranged the trip for Ava, who needed to escape from the "exhausting social life of Madrid," and to consult Graves "about how to finish her random education by a crash-course in English poetry." The word of Ava's arrival in Palma quickly spread, and although the holiday didn't turn out to be as private and uninterrupted as Ava had hoped, it was still a magical time. Being involved in the Graveses' family life gave Ava a sense of belonging and brought back comfortable memories of her early childhood, memories she had always clung to for strength. Graves's son, William, remembers Ava telling him, "in her pleasant South Carolina [*sic*] drawl, about her childhood on the tobacco farm." She spent evenings talking to Graves about poetry. "Poems are like people," he told her. "There aren't that many authentic ones around." She, in turn, opened up about her own demons. Graves remembered that when telling the group about "her legendary self which towers above her," she admitted that she "had never outgrown her Hard-Shell Baptist conditioning on that North Carolina farm, with the eye of a wonderful father always on her; and still felt uncomfortably moral in most film studios; it isn't what she does that has created her sultry reputation, but what she says. Sometimes she just can't control her tongue."

Over the years that followed, Graves dedicated several poems to Ava, including one titled "Not to Sleep." She would return to Deia, and Graves would visit her in Madrid. They would also maintain a correspondence, with Ava keeping him informed about her professional choices, something he particularly enjoyed. His

Ava could often be found ringside at the bullfights in Madrid.

opposite, from top:
Ava arriving in Palma de Majorca, Spain, to visit with Robert Graves and his family for the first time, 1956. Also pictured are author Harry Mathews and French sculptor and painter Niki de Saint Phalle. • Ava returned to Deia throughout the years. Her friendship with Graves was one of the most treasured relationships of her life. Courtesy of the Robert Graves Estate.

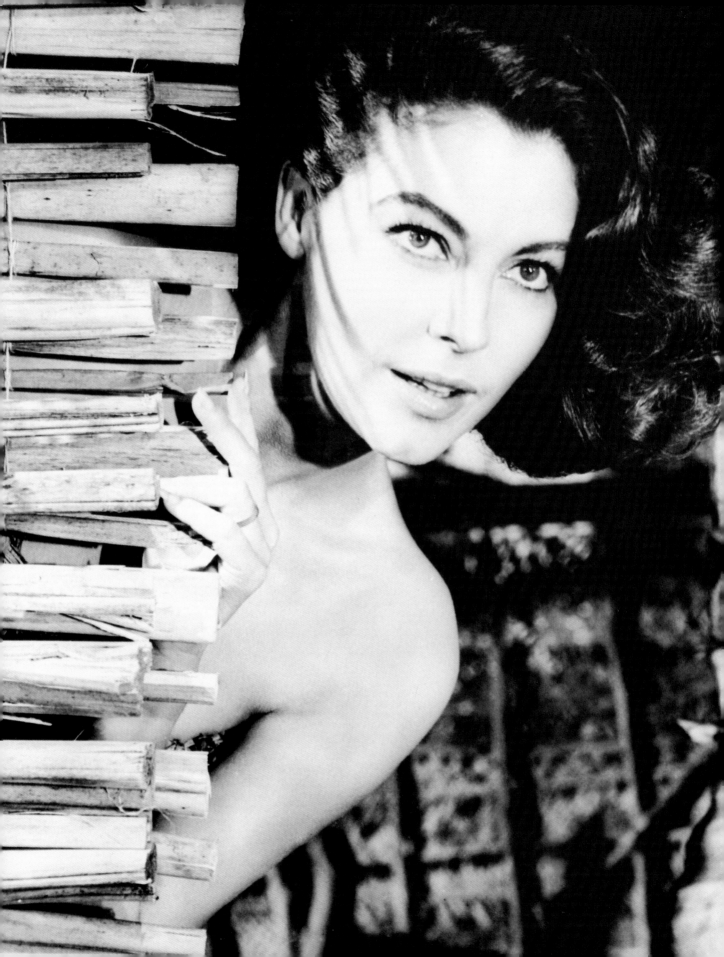

personal letters reveal his active involvement in Ava's film career, including suggestions about parts and directors. Graves always maintained a deeply affectionate tone when he mentioned Ava to his other friends. One of the favorite topics of conversation between Ava and Graves was choosing the perfect company in the event of being stranded on a deserted island. In a note to a friend, Graves wrote, "Quick-witted, courageous, resilient, loyal, talented Ava, . . . who never shows off or bores, and always looks her best, is on the list of ten women with whom I'd choose to be shipwrecked. I'd be proud to bake her Sheppard's pie [sic] and grill her prawns (neither of which she can ever get enough of), and leave the problem of drinks to her favorite bar-man. Hemingway would be usefully employed fishing and shooting, and make no trouble."

In the early 1960s, during the self-imposed hiatus in her acting career, Ava traveled a great deal. She accompanied Graves to England, where he gave his final lecture at Oxford University, and to a series of literary parties, where she met some of the brightest intellectual figures of the time, including J. R. R. Tolkien. It was also around then that she became acquainted with Henry Miller, another writer who would become an important figure in her life. She first read Miller's novels during her marriage to Artie and had been fascinated by him ever since. Upon learning that George Cukor knew Ava, Miller insisted on arranging a meeting. "My admiration for Ava is, I want you to know, utterly genuine and sincere," Miller wrote to Cukor on February 3, 1964. Both writer and movie star fell under each other's spell. Over the years they exchanged a number of letters and notes, several of which are now housed in the Henry Miller Papers at UCLA. Miller was fond of sending Ava gifts, including paintings and books, which she treasured. Ava's letters often express her admiration for Miller's prose. She also inquired about the movie version of his infamous erotic novel, *Tropic of Cancer*, filmed in France in 1965, and even admitted to having stolen one of his novels from her ex-husband.

above: From the Frank Sinatra family scrapbooks: Ava entertaining an unknown friend in Madrid, ca. 1960. Courtesy of the Sinatra Family Archive.

opposite: Robert Graves believed this line of his poem perfectly described the Ava he knew: "She is wild and innocent, pledged to love through all disaster." (Photo taken on the set of *The Little Hut.*)

Miller was so fascinated by Ava that he placed a large photograph of her in the entrance hall of his Ocampo Drive house in Los Angeles. Like Hemingway and Graves, Miller admired her free spirit and her desire for knowledge—about both herself and the world around her. Barbara Kraft, Miller's friend and biographer, recalls the impression Ava left on Miller during one of her visits: "When the lady came to visit in the flesh, Henry overheard her chauffeur asking, as they left, where she wanted to go. According to Miller, she responded, 'Anywhere. Just anywhere.' Henry found that a remarkable answer."

below: Portrait taken by George Hoyningen-Huene to promote *55 Days at Peking.*

opposite: Ava and Charlton Heston were all smiles for the camera on the set of *55 Days at Peking*. In reality, no love was lost between the two stars.

AVA RETURNED TO WORK IN THE SUMMER OF 1962 TO appear in a big-budget epic titled *55 Days at Peking*. It was not to be a happy experience. Initially, Ava was encouraged because the film was to be shot outside Madrid, where Samuel Bronston, the film's ambitious producer, built an enormous set, carefully re-creating the Peking of 1900, the year of the Boxer Rebellion. Ava was cast to play the beautiful and mysterious Baroness Ivanoff, an exiled aristocrat with a troubled past. The part sounded interesting on paper, but as was the case with *The Naked Maja*, the project would not live up to expectations.

Charlton Heston, after winning an Oscar for *Ben-Hur* in 1959, was considered the king of the epic genre and was part of *55 Days at Peking* from the moment of its inception. Convinced that Ava was entirely wrong for the film, Heston was dead set against casting her. An entry from his diary in May 1962 reads, "Nick [Nicholas Ray, the director] phoned from Spain with disturbing news: It seems they want to use Ava Gardner. I'd better get my ass over there next week and find out what the hell is happening."

Despite Heston's best efforts to have another actress cast, Bronston and Ray were adamant that the already uncertain box-office future of the chaotic film, which still had no complete script, would benefit immensely from Ava's star power. Ava was cast in June and hosted a cocktail party at her Madrid apartment to celebrate the start of production. Although Heston noted in his diary that "cocktails at Ava Gardner's went surprisingly well," the mood during filming was sour from the beginning. Ava was furious to find an incomplete script and her part underdeveloped. She

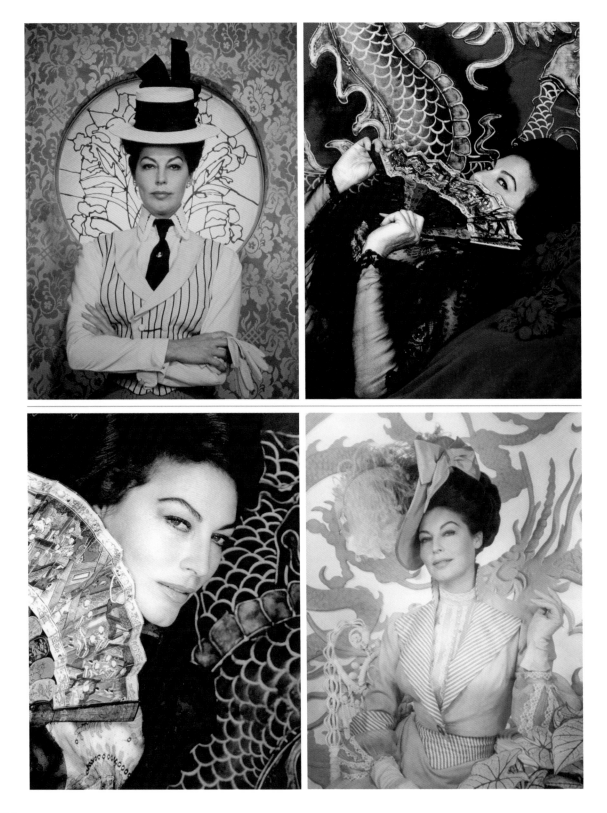

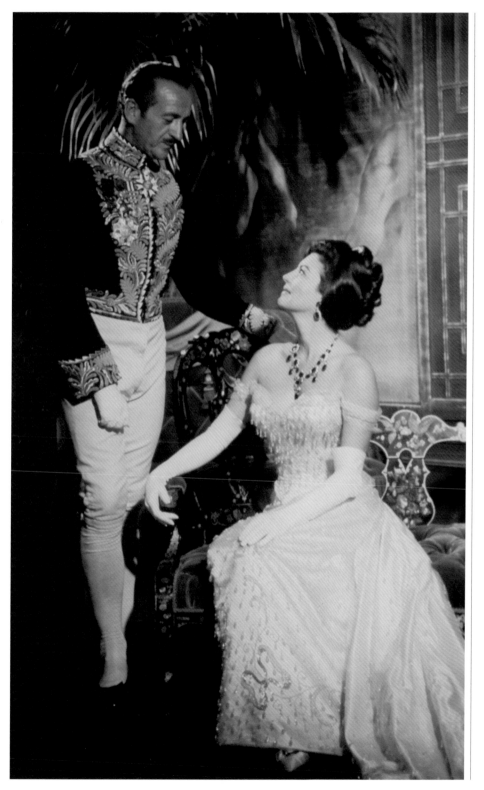

For *55 Days at Peking*, Ava reunited with her friend David Niven.

opposite: Despite these beautiful publicity portraits by Russian-born George Hoyningen-Huene for *55 Days at Peking*, audiences stayed away from cinemas, and the historical epic was a financial flop.

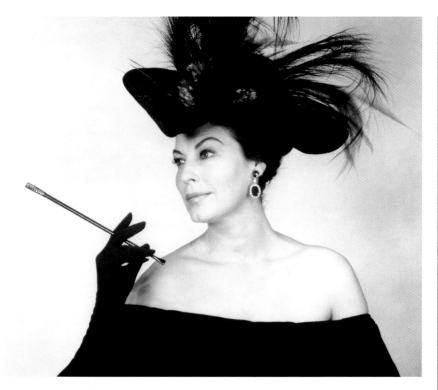

considered the dialogue second-rate. Heston, despite his own reservations regarding the screenplay, turned against Ava. And although the cast also included Ava's old friend David Niven, and Nicholas Ray took special care to accommodate her on the set, it was a difficult few months. For the first time in her career, Ava's professionalism was failing; she arrived late to the set, struggled to remember her lines, and was uneasy about the way she was being photographed.

Midway through the production, Ray suffered a heart attack. Andrew Marton and Guy Green stepped in as directors, with close supervision from Bronston. Heston noted that Ava reacted to the news with "guilty energy," seemingly suggesting that, in his view, Ava's behavior may have contributed to Ray's ill health. In reality, Ray, used to working on small-budget art films, was out of his depth and unable to cope with the demands of a production of *Peking*'s scale. He later recalled writers working overnight on scenes that were to be shot the following day, a situation that couldn't have been easy for either him or his actors.

Ava found it impossible to construct a cogent character out of the hastily assembled bits of dialogue, and she had little support from her leading man. She also felt intimidated by the vast armies of extras, many of whom were summoned to the set at the last moment, engaged straight from Chinese restaurants and laundries across Spain, as the producers struggled to find ample numbers of professional extras needed for the big crowd scenes. She resented the fact that the extras took photos of her, and she often stormed off the set, refusing to return until the offender was found

and the film roll confiscated. To Heston, Ava's behavior was erratic and unprofessional. He was relieved when she finished her scenes at the end of September. Overall, *55 Days at Peking* was an experience that Ava was eager to forget. After shooting the final scene, she told Rene Jordan, "Jesus, Rene. I've spoken lots of crazy closing dialogue in my time, but nothing like this."

While filming *Peking*, Ava agreed to work with British journalist Mike Tomkies on what was to be her first printed interview in two years. After he interviewed Ava for a total of fifteen hours, Tomkies's impression was that of a woman who was "fascinating, troubled, and disturbingly honest." "I was never ambitious for stardom," Ava told him. "It just came to me. If this turns out to be my last film, it will not worry me personally." As for her private life, as ever, Ava resented intrusive questions, although she confessed, "I am very conscious that, as a woman I have not entirely fulfilled myself. After all, I have no husband and no children, and those are really the two reasons a woman has for being." Despite all this, Ava insisted that she was not the "sad, pathetic figure" portrayed in the press. "My God," she said, "if I was as sad and lonely as I have been made out to be, I would go and blow my brains out."

Ava turned forty in December 1962. She told friends it didn't bother her, that she actually preferred herself now compared to the way she was years before. "Physical beauty doesn't matter that much to me. What is real beauty anyway? I like myself more now than I did a few years ago. This will make no sense to most people." Despite the facade of confidence, she was growing concerned about the sorts of roles she was being offered. As she was still a major star, there was no shortage of directors and producers who were eager to work with her, but the parts were starting to reflect the sensitive areas of her life. The dismal time she had during the making of *55 Days at Peking* no doubt contributed to her turning down several important roles, including the female lead in *The Pink Panther* and that of Alexandra Del Lago, a faded movie star, in an adaptation of Tennessee Williams's *Sweet Bird of Youth*.

She was reluctant to go back before the cameras but was finally persuaded to accept a supporting role in the political thriller *Seven Days in May*. The cast included two of her male costars from *The Killers*, Burt Lancaster and Edmond O'Brien, although Ava appeared in scenes with neither actor. (O'Brien considered Ava something of a lucky charm, having won an Oscar costarring with her in *The Barefoot Contessa*, and receiving his second nomination for *Seven Days in May*.) The film marked the first time Ava had worked in Hollywood in more than a decade, and she could not help noticing how much the town and the industry had changed. Once again, she played an aging party girl with a romantic past. Although the part could have easily become a self-parody and a stereotypical representation of a "woman of a certain age," Ava brought to it

> *"I was never ambitious for stardom, it just came to me. If this turns out to be my last film, it will not worry me personally."*
>
> —AVA GARDNER

a kind of heartbreaking sensitivity and her own particular brand of earthy glamour that elevated Eleanor Holbrook from a secondary character to a major presence that looms over the entire picture.

As with *55 Days at Peking*, the production of *Seven Days in May* did not run smoothly. Ava was nervous and mistrustful. She disliked working with Kirk Douglas, and she found the director, John Frankenheimer, to be of little help. In his book *The Ragman's Son*, Douglas remembers Frankenheimer being terrified of working with Lancaster but ending up having problems with Ava instead: "She gets a few drinks in her, and then I have to go in there and she chews my ass off. She complains about what's going on. Nobody is doing anything right." Part of the problem was the stark, black and white cinematography, with numerous close-ups, which Ava found highly unflattering. She felt vulnerable and exposed, playing a secondary role in a "man's picture," getting little support or understanding from the crew. It was the first time in nearly two decades that she wasn't the star of the film, and although she was still being given the full star treatment (along with a lucrative salary), her confidence was low. She was glad to finish shooting, and despite some glowing reviews she preferred not to see the film. She returned to Madrid disenchanted, once again planning to stay away from movie sets indefinitely. But the respite wouldn't last long.

John Huston and his writing partner, Anthony Veiller—the duo who nearly two decades earlier had written the screenplay for *The Killers*—were working on an adaptation of *The Night of the Iguana*, the latest Broadway hit from Tennessee Williams. In the years since he'd first met Ava, Huston had become one of the most renowned directors in Hollywood, although, like Ava, he hadn't lived or worked in Los Angeles in years. His signature style became closely associated with films shot in difficult locations. Huston didn't believe in fabricating reality; he strived to capture the truth, to subject his actors to the kind of conditions that would transform them into the characters they played. Williams's play, set in an isolated hotel on the Mexican coast, fit that bill perfectly. Huston dedicated himself fully to realizing his vision of the story. The first draft of the screenplay was written by Gavin Lambert, who had previously written the screen treatment for Williams's only novel, *The Roman Spring of Mrs. Stone*. Huston, however, was not happy with Lambert's efforts, and he set out

Ava as Eleanor Holbrook in the 1964 political thriller, *Seven Days in May.*

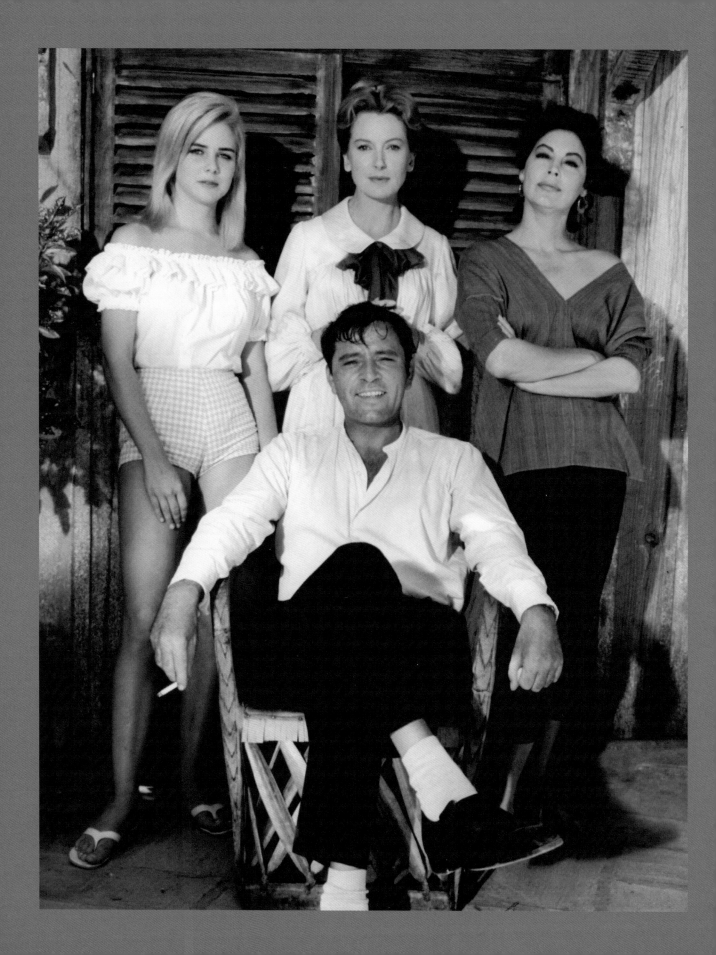

to do a complete rewrite. Huston and Veiller worked closely with Williams, a moody and often difficult genius whose own demons and addictions mirrored the struggles faced by his characters.

Huston wanted to shift the balance of the original play, making the film more hopeful and its ending more optimistic. He also had a slightly different vision for the way he wanted to present the main characters, particularly in the case of Maxine Faulk, the earthy, love-hungry hotelier. In the Broadway production, Maxine had been played by the great Bette Davis. Her performance was brash and loud with desperate, unappealing sexuality, all delivered in an aggressive voice. According to writer and Williams's friend James Grissom, the playwright hated Davis's interpretation. Huston thoroughly agreed. The director saw Maxine as tough but vulnerable, sexy and funny, hardened by life but essentially a golden-hearted romantic. From the very beginning Huston had envisaged Ava as Maxine, although other actresses, including Geraldine Page and Melina Mercouri, were also considered. Rene Jordan remembered that Williams was initially unsure about casting Ava but was quickly persuaded by Huston's enthusiasm for her. Ever since their first meeting, many years earlier, at a party thrown to celebrate the completion of *The Killers*, Huston had been fascinated by Ava. Despite the fact that during the same party Ava had turned down his rather violent attempts at seduction, he remembered her with great fondness and was now convinced that he needed her in *The Night of the Iguana*.

Ava agreed to host Huston and producer Ray Stark in Spain. During the three days and nights they spent in Madrid, she was the perfect, if overly lively hostess. Treating the two to a unique, mostly nocturnal tour of the city, she made sure they visited all her favorite flamenco bars, most of which were not found in any tourist guide. Although they never mentioned the film, Maxine, or Tennessee Williams, by the end of the three days Huston, bone-tired beyond belief, was more convinced than ever that Ava was the only possible choice for the role.

from left: With Richard Burton, rehearsing a scene on the set of *The Night of the Iguana.* • Ava as Maxine Faulk in *The Night of the Iguana.* Many believed that it was Ava's finest performance.

Years later, Huston told his biographer Lawrence Grobel, "I knew damn well that Ava was going to do it. She did too—but she wanted to be courted." It was more than a matter of being courted; to Ava, Tennessee Williams meant serious, thought-provoking drama. The majority of actors appearing in the film versions of *The Glass Menagerie*, *A Streetcar Named Desire*, *Cat on a Hot Tin Roof*, and *Baby Doll* were trained artists, products of the Actors Studio or the British theater. These were the kinds of parts that won Oscars. Ava simply didn't believe she belonged in that category.

Initially, Tennessee Williams was prone to agree with her. Rene Jordan remembered Williams telling Huston that Ava was too beautiful to play Maxine. In time, however, he would completely alter his assessment, becoming one of Ava's great admirers. Like Hemingway, Graves, and Miller before him, Williams was taken with Ava's complete lack of pretension. During his visit to the set of *Iguana*, he observed her at work: impulsive, insecure, wonderful. They became friends, and although they would never get the chance to become very close, their affection for one another endured through the years. Williams told author James Grissom, "You want a friend? You can't do better than Ava Gardner. Good Lord, do not ask her a question, any question, unless you want the unvarnished, peppery truth. She will level you with honesty, kindness, appreciation, open and pure love. If you deserve it, of course. Do not get on her bad side. It takes a lot to get there, but don't get there. In the name of God—or anything."

Ava later said of Williams, "God, I adored him."

Ava arrived in Mexico City in September 1963, ready for makeup, hair, and costume tests. In the film, she was to look natural—no Hollywood glamour, no Fontana gowns, no make-believe. Sydney Guilaroff styled her hair into a simple ponytail. Her two costumes in the film consisted of a loose, light-brown poncho blouse with toreador pants, and a simple figure-hugging summer dress for the final scene. With the tests completed within a few days, Ava, along with her costars, made her way to the remote coastal town of Puerto Vallarta, where cast and crew settled in for the length of filming.

Because *The Night of the Iguana* was a character-driven piece with pages of dialogue and little conventional Hollywood action, Huston and Stark knew that casting was of vital importance. The troupe of actors they assembled was truly impressive, with Richard Burton as the tormented Reverend T. Lawrence Shannon, Deborah Kerr as ethereal artist Hannah Jelkes, and Sue Lyon, having maximized her star turn in *Lolita*, playing promiscuous teenager Charlotte. Though the tempestuous climate, the wilderness of the tropical forest, and the basic living conditions in town were a great shock to all, within days everyone settled in nicely, and the natural beauty of the location inspired them to create.

Ava and Richard Burton in *The Night of the Iguana* (1964). Ava believed that Burton's talent made her own performance better.

Huston built the set from scratch, constructing a small hotel on a remote hill overlooking the ocean and the tiny fishing village of Mismaloya, a few miles south of Puerto Vallarta. Ava and Rene stayed in a rented villa called Casa de la Luna (the Moon House), while Deborah Kerr and her husband, Peter Viertel, stayed in a villa nearby. At the time, Burton and Elizabeth Taylor were in the midst of *le scandale*. The press followed them to Mexico, sensing a big story, particularly with Ava Gardner on the scene. In reality, as Deborah Kerr observed in her filming diary, though Ava "adored Burton," there was no romantic drama between the stars. Ava and Elizabeth had been friends from the time they were MGM's reigning queens in the early fifties, and although Ava did find Burton magnetically attractive, she was not about to get into a contest with Taylor. She later remembered Elizabeth as "marvelous because she's very good with the press, she's fearless. So she did a lot of that which would have fallen on my shoulders. I've never been very good with the press because I'm frightened of them."

Despite the fact that Elizabeth and Burton took a lot of the publicity away from Ava, fabricated stories about her still managed to appear in the press almost daily. "I am revolted by the mass of moronic muck that is printed every day, everywhere, in almost every newspaper and magazine," wrote Deborah Kerr. "Ava was very upset, and rightly so, about the ludicrous report in the press that she was to marry Emilio Fernández, a Mexican movie director. Needless to say there wasn't a *word* of truth in it."

The hype surrounding the film was so great that Huston, wanting to defuse the strained atmosphere, offered each of his stars, as well as Elizabeth Taylor, a golden revolver, along with five bullets inscribed with the names of all the actors. The gag was received with shocked amusement, Ava in particular finding it hilarious. If Huston harbored any fear that the larger-than-life personalities he'd brought together would clash in the heat of the rain forest, he needn't have worried. From the very beginning, the atmosphere on the set was one of friendliness and respect.

On the first day in Mismaloya, Huston organized a round-the-table reading of the entire script, giving all the actors the chance to get the feel for their parts and their costars. Ava was terrified at the prospect, still expecting to be found out as a fraud. Deborah Kerr noted in her diary, "Ava warm and friendly but very nervous." Huston was aware that Ava would require the gentlest and most encouraging direction in order to give the performance he knew she was capable of. She never had a technique to rely on—no acting tricks or studied method—she was purely a natural actress, reacting to her costar in the moment and relying on the director to give her the support she needed.

Maxine was in many ways the most difficult part she'd ever played, a complex woman with a rich backstory and a very real, multifaceted emotional life. Ava's true talent lay in her ability to spontaneously bare her soul before the camera, something she could do only when comfortable in her working environment and able to put her trust in her director. Being away from the constraining artificiality of a studio,

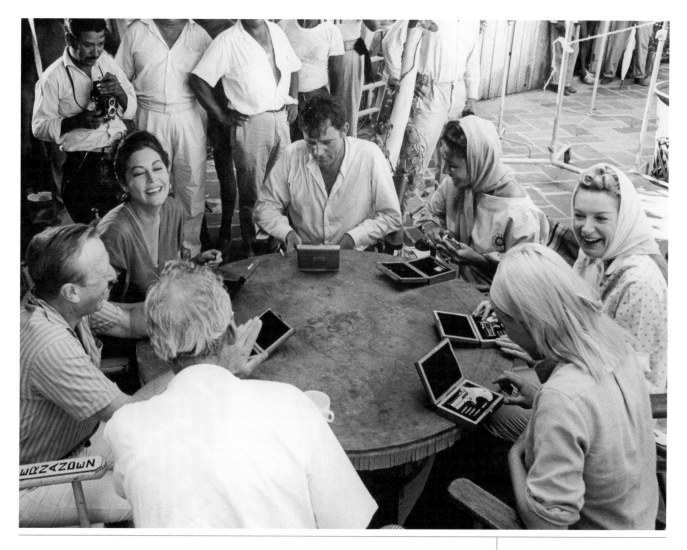

surrounded by people whom she liked and trusted, she was able to open herself up and truly dedicate herself to the work. Deborah Kerr, who had acted with Ava fifteen years earlier in *The Hucksters*, was very impressed by her costar and quickly became a good friend. Early on in the shoot, Ava told Deborah and her husband "how happy she was, how much she enjoyed working. For the first time in her life she was really enjoying the business of acting." Burton also proved to be a gracious and considerate costar, making Ava feel at ease and, as she told Deborah, "making everyone else act well," being so good himself.

The results were transformative. Even in the early stages of the production, it was clear to everyone that, far from being inadequate, Ava's performance was a standout. "John and I were discussing Ava today," Deborah noted in her diary on November 5. "How completely different she will appear to the public in this part; they have never seen Ava like this—funny [and] rich and warm and human, as well as beautiful. The part is marvelous for her and she's making it even better." After shooting the scene in the kitchen, in which Maxine talks about her late husband and about her need to

John Huston gifts the cast of *The Night of the Iguana* with golden revolvers and bullets inscribed with the names of all the stars. Ava found the gimmick brilliant.

satisfy her biological urges by having one-night stands with young beach boys, Deborah noted, "She was good! It was really touching and had extraordinary spontaneity."

It wasn't easy for Ava to reveal so much of herself. Scenes such as the one in which Maxine takes a moonlight swim with her two young Mexican lovers were particularly difficult, and Ava was only able to do them because of Huston's unconditional support and dedication. "John is unique," she told Larry Grobel years later. "I relied completely on him. There was no doubt in my mind. He had my complete trust."

When not on call, the company took advantage of the wonders of the as yet unspoiled Mexican coastline. Most mornings Ava commuted to work by waterskiing behind a speedboat. On her afternoons off she would pick a secluded beach, where she'd sunbathe and read, sipping gin cocktails. There were several makeshift bars built at Mismaloya especially for the company, and alcohol flowed liberally at all hours. Ava and Burton led the way when it came to drinking around the clock. The rest of the company, including Huston, happily followed their example. But the merriment ceased on November 22, when news of President Kennedy's assassination reached the set. As did so many around the world, Ava remembered that day clearly: "We were on our way home for lunch and you have never seen so many drunks sober up so quickly. It was like a total black curtain came down. It was a dreadful time. Everyone was in tears. Even the Mexican kids. I met Kennedy once and he was so charming. We lost a great president."

Ava stayed behind after filming concluded to enjoy a few more weeks of sunshine and the beach, but the ghosts of loneliness crept in just as they had in Madrid. She went back to Los Angeles to visit Bappie and see some old friends, and to celebrate her forty-first birthday.

Expectations for *The Night of the Iguana* were high, particularly concerning Ava's performance. Shortly before the film's release in 1964, John Huston said in an interview, "For my money Ava's performance in this film is the greatest thing she has done on the screen so far. People are going to talk about it." And they did. In the end, Ava received some of the best notices of her career. *Life* called her performance "a revelation," stating that she "all but runs away with the picture." *Newsweek* proclaimed that "a great woman played a great woman," while the *New Yorker* declared her "absolutely splendid." Despite an overwhelming amount of praise, culminating in Golden Globe and BAFTA nominations, she was once again denied an Oscar nomination. Many were angered at the omission, including Tennessee Williams, who told James Grissom he thought Ava "had been robbed."

Ava's turn as Maxine Faulk may have been overlooked by her peers at the Academy of Motion Picture Arts and Sciences, but it arguably remains her most notable performance. *The Night of the Iguana* lives on as one of the best screen adaptations of a Williams play. And its filming changed the Mexican landscape. Puerto Vallarta has since become a premiere resort town, and to the north the ruins of Maxine's hotel still stand on the hill above Mismaloya.

opposite, from top:
Maxine and her cabana boys meet her old friend, Reverend T. Lawrence Shannon (Burton), on the steps of her hotel.
• Ava photographed candidly on set in Mismaloya, Mexico.

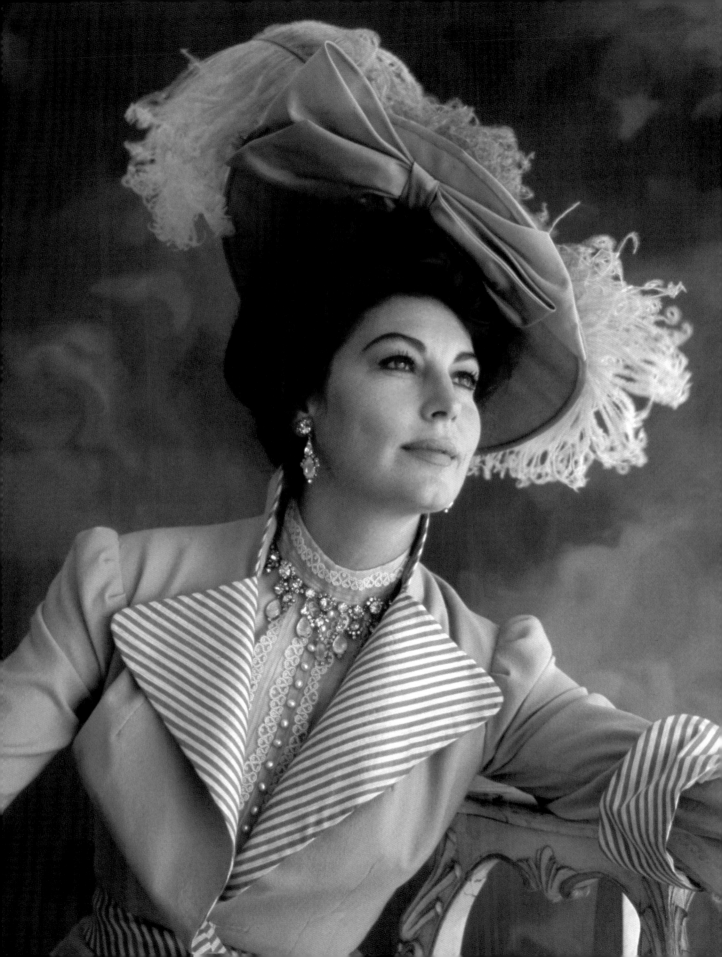

CHAPTER TEN:

Character Actress

N O ONE WAS SURPRISED WHEN THE BEAUTIFUL LEADING lady fell for her leading man—the story was as old as movies themselves. This time, however, it wasn't a romantic affair or a wild and erotic episode, but rather, in Ava's own words, "a dark and ugly" chapter in her life.

The film was *The Bible*, producer Dino De Laurentiis's ambitious epic, which was to depict the first twenty-two chapters of the Book of Genesis. Initially, each segment was to be helmed by a different director, but in the end John Huston was entrusted with directing the entire picture—as well as being the narrator, the voice of God, and playing the part of Noah. Huston wanted Ava to play Sarah, the barren wife of Abraham, who miraculously gives birth to Isaac at the age of 90. Ava was reluctant to accept; it was the role of a true biblical matriarch, the Mother of Nations, who died at age 127. She later told Larry Grobel, "I didn't want to do it. The script John gave me had all these archaic words in it. 'I want thee to go forth.' 'Thou art blah blah blah.' What the hell was that? I wasn't the right gal for that. But John being John just used that soothing voice of his and convinced me to go along."

It was certainly not the kind of part Ava wanted to follow Maxine with, but she could not say no to Huston, who she now regarded as her favorite director, a close friend, and something of a father figure. In the summer of 1965 she traveled to Rome, where production on *The Bible* had already been underway for months. Huston was delighted to see his favorite leading lady and was excited to introduce her to his Abraham. George C. Scott was a Broadway veteran with a string of successful film appearances under his belt. He was a powerful presence, on-screen and off, and was the perfect embodiment of the biblical hero he was set to portray. Ava was instantly attracted to the tough, bulky-looking actor, whom she found intelligent and interesting, and who instantly paid her the kind of attention she couldn't help but feel flattered by. They started going out to dinner; they talked acting, books, theater. Ava once again saw a glimmer of hope for a successful relationship. Scott in turn became intoxicated with her. It was certainly a familiar pattern. She was beautiful, wild, impulsive, caring. What was not familiar, however, was the violence, the physical abuse that quickly manifested itself.

opposite: Ava as British actress Lillie Langtry in *The Life and Times of Judge Roy Bean* (1972).

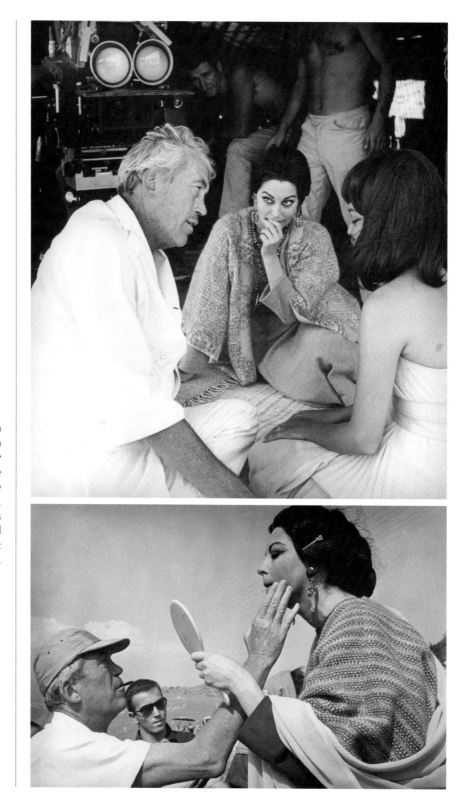

from top: John Huston directs his actors on the set of *The Bible*. • Despite the nightmare she endured during the making of *The Bible*, under John Huston's direction Ava created another great performance.

Scott was an alcoholic. One evening, after the company moved south for location work, staying in a little town called Avezzano, he invited Ava for dinner at a small, intimate restaurant. They drank, talked, and later walked over to Scott's hotel, where the atmosphere suddenly changed dramatically. Ava recalled later in her conversations with Larry Grobel, "I don't remember what we said that got him so enraged, but I saw how he changed, how his eyes narrowed and reddened, how his jaw clenched. When I got up to leave, he leaped up and threw a punch, he hit me in the face." It was a total shock to Ava. She was no stranger to fights and tempestuous arguments. Things had gotten pretty bad with Artie and with Frank, but she had never before feared for her life. "I was trapped in that room as he beat me for God knows how long, until I managed to escape."

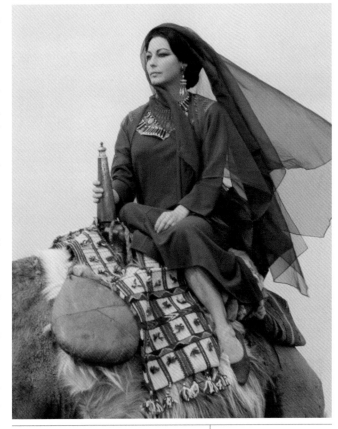

As Sarah in *The Bible*.

Everyone on the set was outraged. Costar Peter O'Toole wanted to beat Scott up. Huston hired bodyguards to protect her. Rene Jordan begged Ava to keep away from him. No one could understand why Ava kept going back to the actor, why she continued to see him, dine with him, and subject herself to further abuse. She later told Grobel, "Don't ask me why I was having dinner with him, but that's the way it was with me. I was always ready to forgive. I felt sorry for him."

Scott was apologetic and remorseful. He begged for forgiveness and for Ava to marry him, despite the fact that he was already married to actress Colleen Dewhurst. The affair, and the abuse, continued throughout the shoot, although Ava knew that she needed to get out. She wanted nothing more than to finish the film, to end the nightmare. Miraculously, despite the hell she was going through behind the scenes, once again under Huston's careful and nurturing direction, she turned out a great performance. "That was the magic of the man," Ava later said.

Although as far as Ava was concerned the affair with Scott was over along with the filming, he didn't quite see things in the same light. The terrifying, life-threating nightmare continued from Italy to London, where Scott managed to find Ava and Rene at the Savoy Hotel, beating Ava up savagely and threatening to kill Rene with a broken-edged bottle. Although both managed to escape through a bathroom window, the terror wasn't over. Scott was arrested and Ava was banned from the Savoy, which

had been her favorite London hotel for years. Upon Rene's insistence, they flew back to the States. Scott followed, begging for forgiveness and inviting Ava to spend a weekend at his Connecticut home. To Rene's utter disbelief, Ava accepted. "Miss G, you are mad! He will never leave you alone! He might kill you!" Just as Rene predicted, the visit ended in disaster, with Ava again brutally attacked by Scott. She was rescued by Sinatra's men. Rene, in a moment of panic, had telephoned Frank and given him the scoop. Frank wasted no time: "Don't worry Rene, I'll take care of it."

The final confrontation occurred some weeks later, in California. Ava and Rene were staying in their usual bungalow at the Beverly Hills Hotel when Scott, drunk and enraged, appeared by the pool. Alerted by Rene, Bappie arrived with her husband, along with a doctor, arranged by Frank, and two other men for protection. At Frank's request, Dr. Jack Moshein admitted Ava to the hospital under a false name and later

As Sarah in *The Bible*.

sent the bill to Sinatra. Her injuries included a broken clavicle. As Dr. Moshein put it to his son Rob, Scott "had beaten the shit out of her." Rob Moshein remembers how "Ava was so grateful and became instant friends with Dad."

The episode at the Beverly Hills Hotel was to be Ava's last, horrific encounter with Scott. When questioned about that time in his life, years later Scott would say, "I never talk about Ava. Don't ask me anything about her."

THE DISASTROUS AFFAIR WITH GEORGE C. SCOTT WAS the last straw for Ava. She was fed up with the men, the crazy life, the Spanish fiesta. She knew that changes had to be made, that the pace of her life had to slow down. After the release of *The Bible*, she told a journalist, "I'm sorry I spent twenty-five years making films. I wish now I had the things most important to a woman—a good marriage, children, a better education." Although in Ava's mind it may have been too late to accomplish those things, it wasn't too late to move. She'd fallen in love with London the first time she'd visited the city, while making *Pandora* in 1951. Now she was finally ready to make it her home. She sublet an apartment in Park Lane, in the heart of Mayfair. For the next year or so, with the help of Rene, she would travel back and forth between London and Madrid, moving all the treasures she'd amassed during the years in Spain. (Eventually, she replaced most of her extravagant furniture items with mellower pieces.) She avoided men, with the exception of a few, telling Rene, "I've had my share of marriages, and if I ever got married again it would be a re-marriage." Rene knew she meant Sinatra. He was a steady presence in her life again, albeit from afar, and the years they had spent apart created an idealized, romantic vision in her mind. They didn't see each other very often, but Ava knew she could count on him for anything. They telephoned each other frequently, often spending hours reminiscing about the old days. Their relationship cooled slightly during Frank's brief marriage to Mia Farrow, with Ava quoted as saying, "I always knew Frank would wind up in bed with a little boy."

Ava loved London. She cherished her privacy and the kindness and politeness of the British, who left her alone, rarely bothering her for autographs or pictures. She enjoyed the city's diverse and rich cultural scene, with world-famous museums, theaters, restaurants, and jazz clubs. She was happy to relax, and the experience of making *The Bible* made any suggestions of returning to a film set fill her with dread.

In 1967 Mike Nichols approached her about playing the part of Mrs. Robinson in *The Graduate*. It was the kind of movie that could have transitioned Ava's star persona to appeal to a younger generation, to make her glamour appear more relevant. Nichols represented the American New Wave, a revolutionary movement in cinema, which, despite having its roots in the studio era, stood in direct contrast to

from left: In *Mayerling,* Ava played Omar Sharif's mother, despite being a mere decade older than the Egyptian-born actor. The two maintained a warm friendship, and Sharif continued to express affection for Ava until his death. • Ava and Catherine Deneuve in Terence Young's *Mayerling.*

it. With the fall of the studio system, filmmakers were free to explore new and daring themes, such as sexual liberation and gratuitous violence, that had previously been forbidden under the rules of the Production Code. Ava was intrigued by the screenplay and wrote to George Cukor to ask his opinion. She felt uncomfortable at the prospect of portraying what would be described today as a cougar; she especially objected to scenes of nudity and lovemaking with the young Benjamin Braddock. She went as far as meeting Nichols, whom she liked very much, but eventually the deal fell through. Some years later, she would express regret at not having done *The Graduate* as well as some other meaty roles she turned down in the 1960s.

Instead of the seductive Mrs. Robinson, Ava returned to the screen as the legendary Empress Elisabeth of Austria, better known the world over as Sisi, in Terence Young's lavish production of *Mayerling.* In the film she was paired with her old-time costar James Mason, who had played the Flying Dutchman to her enchanted Pandora all those years before. This time, they were merely a couple of glamorous supporting players, relics of the lost era of Hollywood splendor. The romantic leads were Omar Sharif and Catherine Deneuve, both of whom symbolized the youthful beauty of the Swinging Sixties.

Ava played Sharif's mother, despite a mere decade between them. She was charmed by her handsome costar, who was gallant and respectful, and while there was undeniable chemistry between them, there was no romance. The film was

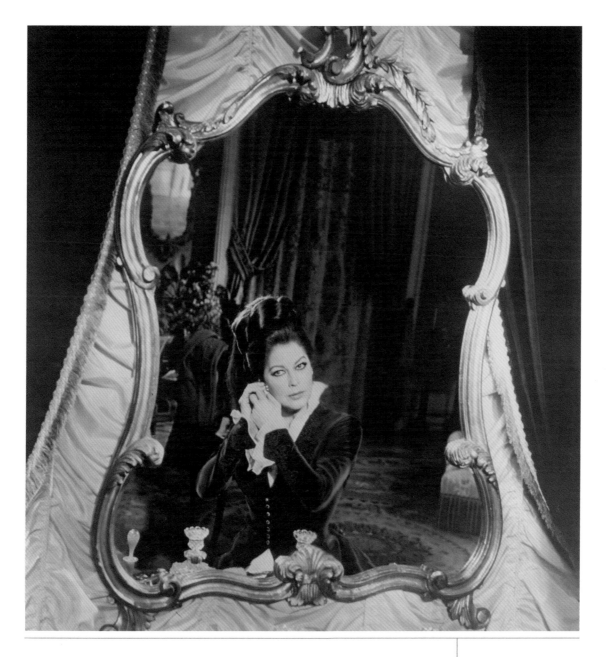

As Empress Elisabeth in *Mayerling*.

shot on location in Austria and Italy, as well as in Paris, and Ava had a good time, mostly courtesy of Sharif, who was more than happy to guide her around the most extravagant nightspots in Vienna and Paris. "We struck up a rather ambiguous, highly pleasurable camaraderie, bordering on romance," Sharif remembered. "I became her friend. Someone who showed her affection, took her out, showered her with attention." To Ava, after the violent nightmare she'd endured during the making of *The Bible*, Sharif's chivalrous manner was like a soothing tonic. She was

clockwise from top: London, February 25, 1969: Ava greets Queen Elizabeth the Queen Mother at the Odeon Leicester Square for the royal film premiere of *The Prime of Miss Jean Brodie.* • Ava photographed in the 1970s. • Not wanting to stop and pose for photographers, Ava took the hand of an airline official at London Heathrow as she boarded a plane for New York on September 27, 1970.

still battling the old demons, still drinking heavily, still wrestling with loneliness. "Ava is a lonely person," Sharif noted in his memoirs. "She has known glory, wealth, but never love in the way she understood it: total giving shared in passion."

In her acting, she continued to excel, despite displaying her usual self-deprecation. Her roles were now endowed with tender, world-weary maturity, the same kind of authenticity that had wowed both critics and audiences in *The Night of the Iguana*. Sharif would remember, "On the set Ava Gardner the actress forgot Ava Gardner the woman. She would take charge of the part with extraordinary self-assurance." *Mayerling* was poorly received upon its release. Of Ava's performance, however, Howard Thompson of the *New York Times* wrote, "The surprise of the picture is Ava Gardner as the enigmatic Empress of Austria. With an uncertain smile and husky voice, this beautiful lady is the most beguiling character in the movie."

By the late 1960s, the majority of Ava's contemporaries from the studio days were struggling with their screen careers; some moved to television, others to Las Vegas, and many abandoned the business altogether. Ava's relative lack of vanity in regard to the physical aspects of aging, combined with the natural quality of her acting, enabled her to continue working in movies well beyond the usual screen-life expectancy for love goddesses. Despite her turning down some important parts, offers continued to come in, although not nearly as frantically as before. Ava kept declaring each of the films she made during the 1960s as her last, but somehow she always came back. Whether it was solely for the money, as she liked stating, or perhaps because work gave her a sense of stability and satisfaction beyond what she liked to admit, Ava Gardner entered her fourth decade of moviemaking. She had come a long way from the shy Southern girl whose silent screen test Al Altman had shipped off to Hollywood back in 1941.

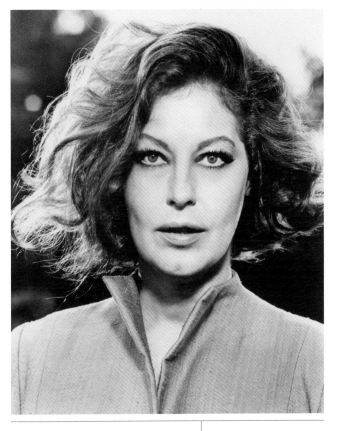

Ava as the hauntingly beautiful Michaela Cazaret, the devil's widow, in *Tam-Lin* (1970).

"On the set Ava Gardner the actress forgot Ava Gardner the woman. She would take charge of the part with extraordinary self-assurance."

—OMAR SHARIF

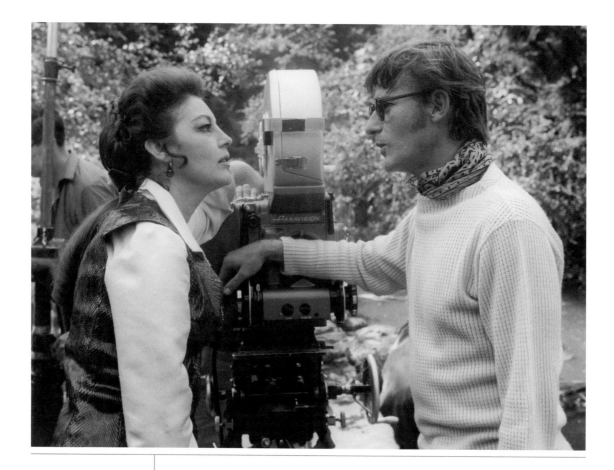

Ava with her old friend and first-time director, Roddy McDowall, behind the scenes on the set of *Tam-Lin*.

NO SOONER HAD AVA SETTLED BACK INTO HER COMFORTABLE new life in London when she was once more approached by an admiring director who wanted her in his movie. This time it was Roddy McDowall, a former MGM child star and later a notable character actor about to direct his first feature film. McDowall remembered Ava from the early 1940s, when she had signed his autograph book as "Mrs. Mickey Rooney." McDowall was an extravagant art collector and an avid movie lover, with an extensive knowledge of all aspects of cinema history. He was also famously a loving and generous friend. Lauren Bacall said of him, "Roddy had the greatest gift for friendship of anyone I have ever known. He paid attention—more than attention—to his hundreds of friends he had made worldwide. And we each felt that we were the closest, and in a way I suppose we each were."

Ava was no exception. From the very beginning she adored Roddy, and she quickly agreed to star in *The Ballad of Tam-Lin*. This bizarrely enchanting tale was based on an old Scottish legend concerning the Queen of the Fairies, who sends any man who falls for her to his doom. Set at the dawn of the Swinging Sixties, the film

tells the story of a modern-day queen, a rich and glamorous patroness with a coven of young and beautiful protégés who lead an empty, hedonistic existence. Ava agreed to do it not only as a favor to McDowall; she also hoped that the part would bring her the kind of attention she'd missed out on when turning down *The Graduate*.

Her youthful love interest in the film was played by the dashing Ian McShane, and the supporting cast included a string of young, up-and-coming British talents. One of them was a model who was making her big-screen debut. In the years ahead, Joanna Lumley would become one of Britain's most iconic actresses, and more than forty years later she still vividly recalls the making of *Tam-Lin*. "Ava was glorious," she says. "The first scene we had with her went on forever. She was late, and there was talk that she had several glasses of champagne on hand. She got her words wrong many times, but we thought she was the bee's knees and couldn't believe that she would ever be nervous. I admired her easy way of *being* when the cameras turned. She made the part her own, the words as though she had thought of them herself."

Ava, the "Big A," with Joanna Lumley, Michael Billiard-Leake, and Kiffer Weisselberg on the set of *Tam-Lin* in Scotland.

from top: Joanna Lumley said of Ava in *Tam-Lin,* "Did she fancy [Ian] McShane? Probably. We all did and she was first in line." • Still from a cut scene in *Tam-Lin.*

Being on location in Scotland and working with Roddy and the cheerful troupe of young actors brought Ava great joy. Lumley remembers:

> Roddy was a sweetheart and knew all the actor's fears and worries. [Ava] adored us; we called her "Big A," and she loved having us around when she was shooting and we weren't. She might not have remembered all our names, but she would call us "hon" in her lovely drawl, and we would have walked through fire for her. Rumors of her occasional behavioral lapses only made us more devoted. Did she fancy McShane? Probably; we all did and she was first in line. He was the dark Spanish type that we knew she loved, very able and talented and funny. She loved laughing. She was a darling diva.

Later, when the company returned to London, upon hearing that Lumley was throwing a party in her humble West London flat, Ava insisted on coming along. She loved feeling part of the group, and, as ever, didn't let her legendary status get in the way. Joanna remembers her astonishment upon seeing Ava, "Green eyes flashing, ready to join the party. Her little waist in her Spanish dress; the heavy, sweet, ravishing smell of her scent; Reggie, her manservant, bringing up the rear as she climbed up to the top floor, carrying a basket of every known drink; her mixing everything in a huge jug and calling it Mommy's Mixture, which we all had to drink. Most of all I remember her leaning over my baby son's cot, stroking his head as he slept, and saying, 'Little baby' so tenderly."

Although *Tam-Lin* was a highly original and at times beautifully inspired film, due to the financial difficulties of its production company, it would not be released for a number of years. And when it finally reached the screens in limited release in 1972, it received next to no attention. Both Ava and Roddy McDowall were deeply disappointed. McDowall never directed another picture.

Ava was now leading a quiet life in London, only occasionally returning to work. In 1972 she once more agreed to work for John Huston, appearing in a cameo role as the legendary beauty Lillie Langtry in his film *The Life and Times of Judge Roy Bean*. Ava went to shoot her one scene on location in Tucson, Arizona. Victoria Principal, the female lead, making her screen debut, remembered Ava's arrival: "She didn't walk into the room, she came in like a cat. I had never seen a woman move like that, or have that kind of presence, before or since. I've never seen a woman electrify a room sexually like she did."

Judge Roy Bean was Ava's last film for Huston, but it wasn't the end of their friendship. A decade later, Ava traveled to Los Angeles to be by Huston's side as he received the American Film Institute's Lifetime Achievement Award. Anjelica Huston, John's daughter and by then a star in her own right, remembered Ava that evening: "Ava Gardner, in a rare appearance, had come in from London. I was bowled over by how radiant she was. Ava's beauty just jumped out at you; her eyes glittered and her skin

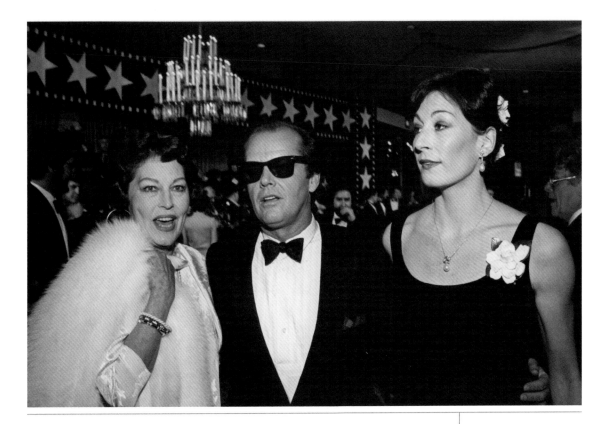

glowed. She was wrapped in white fur, seated next to Dad like a snow leopard in a diamond necklace." Events like that were rare occasions during which Ava was able to revisit the past, to reconnect with old friends she hadn't seen in many years. At the AFI evening she chatted with Robert Mitchum, whom she'd had a crush on during the shooting of *My Forbidden Past* in 1949. She caught up with Lauren Bacall, a warm and friendly survivor of the early Rat Pack days. "At the end of the evening, on our way out of the ballroom Jack [Nicholson] and I joined Ava for the walk down the red carpet," remembers Anjelica Huston. "She had been living in Europe for a long time, and the local press was overjoyed to see her. The flashbulbs were popping and the paparazzi were shouting her name exuberantly. Ava just glided between us with that million-dollar smile, uttering a stream of profanities."

In London, she bought an apartment at 34 Ennismore Gardens, an elegant square in the heart of Knightsbridge just a short walk from Hyde Park, the Royal Albert Hall, and Harrods. Her spacious first-floor apartment had huge, floor-to-ceiling windows overlooking the beautiful gardens. The place suited her perfectly, and save for short trips abroad Ava would remain there for the rest of her life. Rene Jordan had by now moved back to the States, where she got married, and although the bond between them never loosened, with Rene often visiting London and continuing to accompany Ava to her movie sets, for a time Ava lived alone. One of her comforts

At the American Film Institute gala celebrating her favorite director, John Huston. Ava walked the red carpet with Anjelica Huston and Jack Nicholson.

opposite: Ava as British actress Lillie Langtry in *The Life and Times of Judge Roy Bean* (1972).

had always been the company of her dogs. Her love for corgis stretched back all the way to the early 1950s, when Frank gifted her with a puppy she later named Rags. In London, it was Cara who was her dear companion, and after Cara's death in 1980 she was followed by Morgan. Paparazzi would sometimes snap a photo of the legendary star, disguised by dark glasses and an unglamorous outfit, walking her dog in Hyde Park or in the gardens near her home.

In time, Ava hired another housekeeper, who quickly became a loyal and loving companion. When she first started working at 34 Ennismore Gardens, Carmen Vargas had no idea that the elegant American lady was famous. She remained blissfully unaware of the fact until one day Ava mentioned work. "What kind of job do you do?" asked Carmen. Ava was greatly amused. "Carmen, for heaven's sake," she laughed, "don't you know I'm a lousy movie star?"

Ava meticulously furnished her new apartment, selecting rare antiques from shops and auction houses around Europe. She favored pieces that evoked the flavors of the Orient, as well as some exquisite examples of Italian and French furniture.

Artist Michael Garady, together with his partner, the late pianist Peter Feuchtwanger, became Ava's neighbor and close friend. "Ava really liked the English way of life; she loved London," Michael recalls. "Her place was like a palace. Ava loved it, and Carmen took great care of it. Morgan was like a king, with his name engraved on all his possessions, and although he wasn't the friendliest of dogs, Ava adored him." Ava instantly loved Feuchtwanger and would often drop by their top-floor apartment, asking Peter to play the piano. "'Play something Spanish,' she'd say," Feuchtwanger remembered. "I'd say, 'Ava, I can't really play flamenco on the piano. Wouldn't you prefer to hear some Schubert?' She loved classical music, although she didn't know much about it. But she was very sensitive to beauty, to art."

She would often take Michael and Peter to concerts at the Albert Hall or the nearby Wigmore Hall. Michael recalls with fondness how "she hated being recognized; she wasn't comfortable with fame. She was really quite ordinary, very real. I think that's what was so extraordinary about her. Of course she had that beauty, which had the power to bring a crowded room to a standstill, but she was essentially very shy. She liked chatting to strangers, to regular people on the park bench, particularly if they had dogs. I think some people in the neighborhood started buying dogs just so they could talk to her. I remember one day she said, 'Michael, let's go shopping together.' We went to Harrods, and everyone stood still, staring at us. It was very strange. I thought, how does she deal with it all the time? I said, 'Ava, can we go now? Everyone is staring at us.' 'Don't be silly, honey, they are looking at someone else.'"

She also happily entertained old friends, who stopped by while visiting London. Robert Graves's son William remembers visiting Ava at Ennismore Gardens. To Graves's surprise, she kept most of her prized possessions, including correspondence with his father, in a shoe box. Michael Garady recalls the time his friend Tennessee Williams came to London. "It was before we moved to number 34, and we

still lived in our little flat in the Mews. Tennessee said, 'I hear that Ava lives around the corner, let's pay her a visit.' We rang the bell, and Ava, with a fake British accent, answered, 'Miss Gardner isn't home, this is Mrs. Baker.' Tennessee called up, 'I'd recognize that sweet drawl anywhere. Ava, this is Tennessee, open up!' They loved each other."

She still carefully cultivated her friendships. She kept up her correspondence, including with Graves and Henry Miller, as well as with some of her old Hollywood friends. Not having lived in Hollywood in more than two decades, she had become an iconic figure, synonymous with the glory and the glamour of the studio era. In January 1974 she took part in the grand premiere of *That's Entertainment!*, produced to commemorate the fiftieth anniversary of the establishment of MGM. Hosts Liza Minnelli and Sammy Davis Jr. called out the legendary names, who one by one made their great entrance onto the stage. When Sammy Davis announced, "Ladies and gentlemen, Miss Ava Gardner," a torrent of excitement flashed through the room. The applause intensified, as the audience, the cameramen, and the other notables turned their heads to see the most legendary beauty of them all take the stage. Ava was overwhelmed by the reception as she gracefully took her place, extending a friendly embrace to

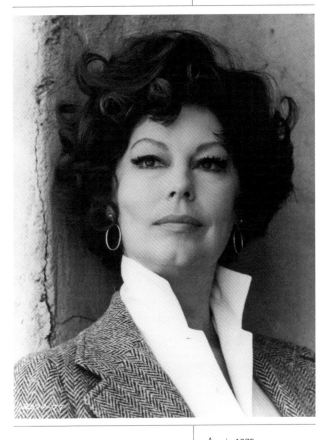

Ava in 1975.

Charlton Heston, with whom she'd shared a less than cordial working relationship while making *55 Days at Peking* more than a decade earlier.

Her friendship with Grace Kelly, by now in her third decade as Her Serene Highness, the Princess of Monaco, had survived all the years since they had worked together on *Mogambo*. Ava had attended Grace's wedding to Prince Rainier in 1956. She was a frequent guest at the many elegant galas Grace organized in Monaco, and in 1978 she joined Frank, his new wife (Barbara Marx), Gregory Peck, Cary Grant, and other Golden Age luminaries from Grace's Hollywood past at the wedding of Princess Caroline. If Ava was hurt by Frank's recent marriage, she didn't let it show. She merrily danced the night away with Peck. They had aged, but that night, as if by the power of some magic spell, they were able to go back in time.

Her connection with Gregory Peck remained particularly significant. He was a very special friend, someone who knew and understood her, and for whom she always had the greatest affection. Toward the end of Ava's life, in 1989, Peck appeared on

Terry Wogan's TV chat show. When asked by the famous host to single out one among the many legendary ladies he had worked with during his outstanding career, Peck answered, "I would like to say that there is a lady in London, with whom I made three pictures, and I've loved her for a good many years. In a way, we are what we call down South kissin' cousins. I mean to say we're both small-town folks to start with. I love her dearly, and she may be listening tonight. It's Ava Gardner."

She also kept in close touch with Dirk Bogarde, who, in addition to his acting, was now enjoying a successful writing career. They were reunited on the screen in 1975, when they appeared in the spy thriller *Permission to Kill*. After completing the location shoot in Austria, Dirk wrote to his friend the English film critic Dilys Powell:

> *Ava G was in fine form. She really is the last of the Great Stars. And it shows. Her work on the screen may not be up to the standards of, say, Garbo . . . or Ethel Barrymore! But none the less she is, by God, THERE! And is still incredibly beautiful . . . really a face of quite glorious planes, and eyes so green that the lakes were dimmed by her. Enough of that. But she was splendid to work with. It was almost like the Old Days of the Cinema and so old-fashioned, my dear, that it is almost classical today!*

opposite from top:
Ava was reunited with her dear friend Dirk Bogarde in the 1975 spy drama *Permission to Kill*. • Ava and Charlton Heston as the bickering married couple in *Earthquake*. • Ava and Monica Lewis were MGM girlfriends in the 1950s. They reunited years later for the disaster extravaganza *Earthquake* (1974).

Although Ava was reluctant to leave the safe haven of her London apartment, she continued to work sporadically. After *Tam-Lin* her parts became smaller, a string of supporting roles that contributed her star name to a number of otherwise undistinguished productions. She was financially comfortable enough not to work at all but found it hard to refuse the star salaries she was offered. In 1974 she appeared in *Earthquake*, one of the big-budget disaster films so popular in the 1970s. There wasn't much of a part in it for Ava. She played a sadly underwritten caricature of Martha from *Who's Afraid of Virginia Woolf?*, a bitter, drunken, pill-popping wife to Charlton Heston's grumpy but heroic husband. The reviews for the film were poor, with Pauline Kael concisely summing it up for the *New Yorker*: "Ava Gardner's name lifts *Earthquake* out of the Universal action-picture category. She was just another old star hired to beef up the movie's star power." Despite that, *Earthquake* was a sensational box-office hit and would become one of the highest-grossing films of the decade.

A year later, Ava traveled to Russia to appear in George Cukor's fantasy *The Blue Bird*. It was to be the first major coproduction between the United States and USSR, and hopes were high. Ava was excited to be working with Cukor again, although during production their relationship went sour for unclear reasons. Months later, back in London, Ava caught *Pat and Mike*, one of Cukor's old classics, on a late show on television. Rene Jordan remembered Ava screaming with laughter and later insisting on sending George a telegram. She ended it by saying, "They don't make 'em like that no more." The next day Cukor responded, "They don't make 'em like you no more dearest Ava."

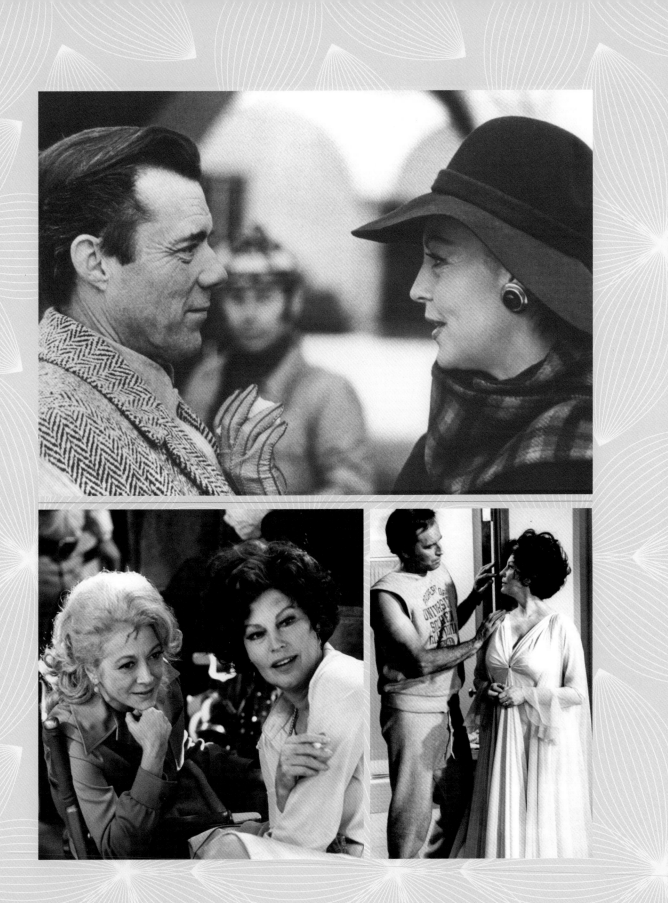

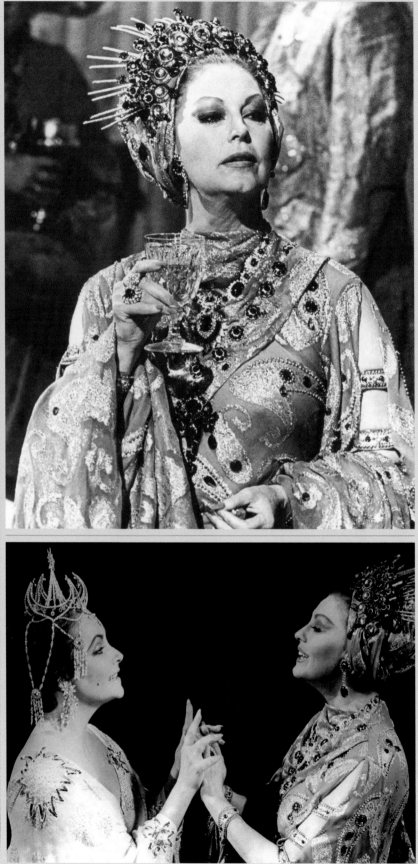

The Blue Bird brought together Ava and Elizabeth Taylor, who had known each other for years but had never worked together. In addition, the cast included Jane Fonda and Cicely Tyson. Despite the distinguished ensemble, the production was a disaster. Endless weeks in the Russian cold made nearly everyone ill, and with food rationing and lack of sufficient heating, the conditions were less than agreeable. On top of that, some of the best scenes between Ava and Elizabeth were later cut out of the finished movie. In the end, what should have been a stunning and magical film, bringing together some of the great actresses of the time, felt like a confused, cheap-looking television movie.

Ava appeared in only three more movies in the 1970s. Her parts were small but showy, highlighting her matured glamour and alluding to her past glories. In 1976, she made a true star entrance in *The Cassandra Crossing*, in which, draped in fur, she arrives at the train station, emerging from a cloud of steam. The film

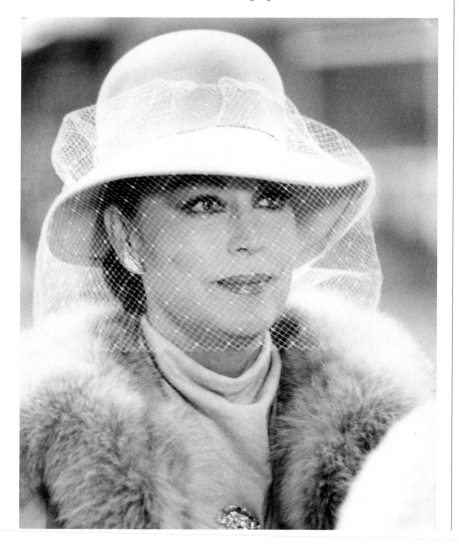

As Nicole Dressler in the star-studded action film *The Cassandra Crossing* (1976). Sophia Loren, Martin Sheen, Burt Lancaster, and Richard Harris also appeared in the cast.

opposite, clockwise from left: When Ava returned to London after a visit to Los Angeles in August 1976, her dog Cara acted as a bodyguard. • Ava as Luxury in *The Blue Bird*. • Ava and Elizabeth Taylor: *The Blue Bird* was an unworthy film for the pairing of these two grande dames.

Cristina Raines as Alison Parker and Ava as Miss Logan, a landlord with a dark secret, in *The Sentinel* (1977).

was another disaster thriller, this time set on a luxurious train carrying a terrorist infected with a deadly virus. Once again the cast was impressive, with Ava, Sophia Loren, Burt Lancaster, Richard Harris, Martin Sheen, and Lee Strasberg. The film was shot at Cinecittà, which allowed Ava to enjoy the pleasures of Rome, one of her favorite cities. The following year she traveled to New York to appear in a cameo role as the sinister and glamorous estate agent in *The Sentinel*. It was an odd horror movie, borrowing heavily from *Rosemary's Baby*, *The Omen*, and *The Exorcist*, but sadly not sharing their quality.

from top: Ava as the sinister estate agent in *The Sentinel*, with costar Cristina Raines. • Ava pictured with friend and neighbor Charles Gray, after a Peggy Lee concert at the London Palladium, 1977.

In 1981, Ava was persuaded to travel to Mexico to appear in the independent British production *Priest of Love*, a biopic of the author D. H. Lawrence and his wife, Frieda. Ava was intrigued by the pair of British theater actors who played the lead roles, Ian McKellen and Janet Suzman, both of whom she'd seen onstage in London. She played Lawrence's patroness, Mabel Dodge Luhan, and although shooting on location was often difficult, Sir Ian McKellen remembers Ava as being "unfailingly friendly and supportive. I suspect her energies were flagging somewhat, although she never complained about the inadequacies of her trailer when we filmed in her beloved Mexico. I was particularly impressed that, away from work, she dressed with no intent to draw attention to herself, and her trademark glossy hairstyle relaxed into an everyday wispiness."

The film attracted little attention, yet critics praised Ava. *People* noted that "Ava brings a beauty and pathos to her role," while the *Saturday Review* declared Ava "enjoyable in her mature beauty and brusque humor." It was a fitting if understated tribute, made more poignant by the fact that it was to be the last cinematically released film for which Ava received wide critical notice.

The following year she appeared with Anthony Quinn in the low-budget drama *Regina Roma*, in which she gave a powerful performance despite the poor quality of the material. The film was to be the last big-screen appearance of Ava Gardner.

> " *I was particularly impressed that, away from work, she dressed with no intent to draw attention to herself, and her trademark glossy hairstyle relaxed into an everyday wispiness.* "
>
> —SIR IAN MCKELLEN

opposite: Ava in her final theatrically released film, *Priest of Love* (1981).

from left: Ava in the low-budget disaster film *City on Fire* (1979). • Ava played the scheming Agrippina in five episodes of the TV miniseries *A.D.* (1985). The show also starred Anthony Andrews and Colleen Dewhurst.

EPILOGUE:

Returning Home

THE LOSS OF FRIENDS WAS PAINFUL. IN 1982 GRACE KELLY died. Ava was devastated. Gracie had been one of her dearest friends and someone who was always there, a constant presence. In 1985, Robert Graves died in his hillside cottage in Deia, a place that Ava loved so much. She attended his memorial service in London and the reception thrown in Graves's memory at the Royal Academy in Piccadilly. And in 1987 her dear friend and favorite director, John Huston, passed away after a long and painful illness.

Although the press liked to portray her as a recluse, in reality Ava's London years were filled with close friendships. The fact that she never had children of her own made her even more generous and gracious toward others. Tina Sinatra recalls a particular visit to Ennismore Gardens:

> She was very maternal and a great friend. I went to visit her with Robert Wagner, and I was astounded to see the collection of photographs she had of all of us kids. I know my sister came to adore her. Ava was always reflective when we were together. She was very sensitive to her time with dad, very connected to it. She would say, "God, what we went through. All we had to do is be a little smarter about it. Thank God he is still in my life." She really got on with him very well; they never lost touch. I can't even count the number of times I would walk into Dad's Palm Springs office and he would say [to the person on the phone], "Tina just walked in," and he would hand me the phone, and it was Ava. It happened all the time.

opposite: Ava dances with her secretary and friend, Jack Fixa, in her flat at 34 Ennismore Gardens, Kensington, London, ca. late 1970s.

William Graves also remembers Ava telling him that Frank would call her several times a week. As Ava ventured out of her London flat less and less often, the telephone became an important connection with the outside world. She called friends from the old days, some of whom, like Lana Turner, she hadn't spoken to in years. There were also new friends. Michael Garady and Peter Feuchtwanger were always

there for her, as was actor Charles Gray, who also lived in the neighborhood. Spoli Mills was another close friend. Ava had known Spoli since her husband, Paul Mills, worked as a publicity man on *Bhowani Junction*, but it wasn't until she moved to London that the two became close.

There was still occasional work to be done. In the mid-1980s Ava was persuaded to appear in a number of television movies, and she also guest-starred in seven episodes of the highly popular soap opera *Knots Landing*. Ava's costar Constance McCashin still vividly recalls Ava's time on the set:

> *The producers really wanted her. She was playing this very upscale, meticulously groomed, older but still kind of sexy lady, who had tremendous influence over her son. I played her daughter-in-law. I think she found it difficult to be so mean to me, because she was so kind in real life. She didn't act like a star; she didn't act like a diva. One day I had a big fight with my son. I remember slamming the door so hard that it cracked. I felt really guilty about it and arrived on the set in floods of tears. That evening the telephone rang. I remember my husband picking up and turning to me with disbelief: "It's Ava Gardner!" She just wanted to make sure that I was all right, that all was well again. That's just the kind of person she was.*

Ava found the fast pace of television life daunting, and she missed London, so she decided not to stay in California any longer than needed for the shoot.

In 1986 Ava reunited with her dear friend Omar Sharif for the television movie *Harem*. Aside from a pilot titled *Maggie* filmed later that year, *Harem* was to be her last screen appearance. Ava and Sharif still shared a close friendship, and years later he would remember her as his favorite leading lady and "the most beautiful woman" he had ever known.

Further prospects of work became impossible as Ava's health dramatically deteriorated. Throughout 1986 she felt unwell; she was coughing and losing weight. In October she flew to Los Angeles, where she was admitted to the hospital with pneumonia. While recuperating at Saint John's Hospital in Santa Monica, Ava suffered a stroke. It was a terrifying experience; the entire left side of her body was paralyzed, and she couldn't speak. Weeks would pass before she was able to get out of bed and sit in a chair. Her speech slowly returned, although the left side of her face drooped, and she still couldn't move her left arm. Numerous friends visited her in the hospital, including Frank. Rene Jordan wrote, "Every time I came back to see her she had made some improvement. Soon she could move her left leg again and start to walk by herself, though it was a slightly stumbling walk. Her face and mouth recovered almost completely, but from now on it was always slightly puffed from the cortisone she needed to take."

clockwise from top left: Ava photographed with her good friend Dirk Bogarde at Foyles bookstore in London, 1984. The event was a luncheon held in Bogarde's honor, possibly to promote his novel, *West of Sunset*, which was published that year. • Pictured with Shirley Bassey at the London Palladium for the opening night of *La Cage aux Folles*, 1986. • Pictured with her friend Lena Horne backstage at London's Adelphi Theatre, where Lena performed in 1984. • Ava photographed at London's Heathrow Airport on November 1, 1985.

After she was released from the hospital in late November, Ava wanted to fly back to England. Bappie insisted she stay, but Ava was adamant. Her home was in London; that's where she had her friends, her beloved apartment, and Morgan. She spent 1987 recovering. Paparazzi would sometimes snap photos of the star exercising in Hyde Park. She tried to go back to swimming, which she had always loved, and she saw a physiotherapist a few times a week. Michael Garady remembers, "After the stroke she always wore this big silk shawl over her shoulder, so you couldn't even tell that her arm was out. She was a great actress, on the screen and in life. I knew she suffered, but she didn't let on. She was a trouper. But I know that those last years were very difficult. She would come up for lunch, and sometimes she needed help with her food. She would say, 'Oh, this is so embarrassing.' But she was very brave. She kept on the brave face."

Because going back to work was impossible for the time being, Ava was finally persuaded to write her autobiography. She had always resisted doing so, saying her life was not for sale. Now, after the stroke, she was more prone to being sentimental. She remembered people and events with fondness, the negative aspects dimmed by time. For the next year and a half, she worked with a few different ghostwriters, recalling her life, sorting through photographs and letters, and calling old friends. Peter Evans, the first writer to work with Ava, captured her at her most candid. Ava disliked just how honest she had been, especially after having too much to drink, and she decided to terminate the deal. (Evans's account was eventually published as *The Secret Conversations* in 2013.) Other writers were sent to work in Evans's place; however, in the end the finished autobiography, *Ava: My Story*, would not appear until after Ava's death. "Ava didn't want that book," says Tina Sinatra of *My Story*. "There was a lot wrong in it. It's a pity. She wrote notes and letters to me for many years, and she had a great voice as a writer. It's a shame she didn't get the chance to write her own book."

Ava spent a lot of time reading and watching old movies on television. Some of her own films she saw for the first time since they had premiered years earlier. On Christmas Eve 1989, she celebrated her sixty-seventh birthday with Carmen and a few close friends. She felt unwell. Her lung problems had returned, and she lacked the energy to get out of bed. Some days later she gave Carmen a hefty package. In the event that something should happen to her, she wanted Carmen to promise she would destroy it without opening it or showing it to anyone. Carmen suspected they were letters and her personal writings, but in keeping with Ava's wishes she never opened the package to find out.

Late in the evening of January 24, a heavy storm hit London. The winds blew so strong that the leafless trees in Ennismore Gardens were leaning to the ground. Throughout the night, across Britain, trees were downed as one of the most powerful windstorms on record approached from the Atlantic. Michael Garady recalls, "I remember that morning, after the storm had started, Carmen came to the door. It was quite early in the morning. She said, 'Miss Gardner is gone, but she got her wish. She had champagne and a cigarette.'"

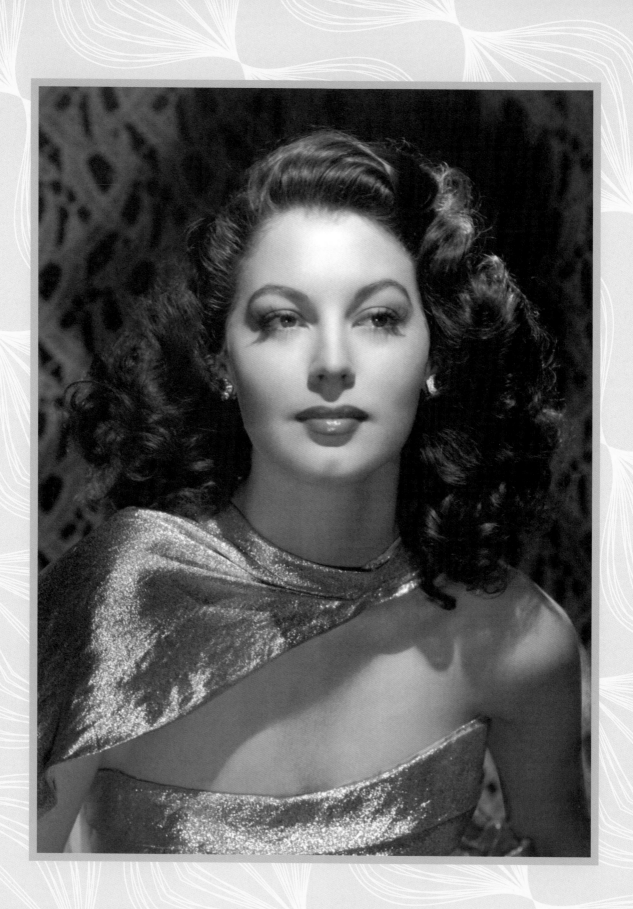

VA'S DEATH ON JANUARY 25, 1990, FROM BRONCHIAL
pneumonia and systemic lupus erythematosus, was a great shock to her
friends. Although she had been ill for some time, her energy and strength
had made her seem invincible. Tributes flooded in from around the world.
Mickey Rooney, who had fallen under her spell so many years
before, was greatly moved: "My heart is broken with the loss
of my first love. The beauty and magic of Ava Gardner will
forever be in our hearts." Burt Lancaster, who'd acted oppo-
site Ava in the film that had launched both their careers more
than forty years earlier, reflected from his Los Angeles home,
"She was a wonderful lady, a wonderful lady. . . ."

Gregory Peck released a moving tribute to his great
friend: "My wife and I are sad today, but also proud of our
friend Ava. After the great years of her career, she retired
from the limelight, settled quietly in London, and lived
her life like the lady she was. She did not compromise. She
did nothing that lowered her standards as an actress or a
lady. Now Ava is returning to her home in North Carolina.
Her journey, as adventurous, glamorous and exciting as it
was, did not change her. She was always a country girl, and
remained so until the end."

Frank was devastated. She had been the great love of his
life, his ideal woman, the one whom he had once possessed
and lost but never let out from under his skin. A simple
statement released on his behalf read, "Ava was a great lady,
and her loss is very painful." His true feelings were too per-
sonal to share with the world. "He never got over it," says Tina Sinatra.

Obituaries, tributes, lengthy articles, radio podcasts, and television specials
appeared all over the world. Most of them remembered her glamorous image, her
legendary beauty, and her tumultuous love life. *Cosmopolitan* noted, "For contempo-
rary women, Ava Gardner is a fascinating—and very relevant—example of a fiercely
independent female, who always lived according to her own tenets."

It's sad to note how dismissive the majority of the press was of Ava's talent and
her legacy as a screen actress. As fate would have it, Barbara Stanwyck, another great
leading lady from the Golden Age of Hollywood and Ava's one-time love rival, had
died just days earlier. Many press articles chose to compare the two, with Stanwyck
often emerging as a "great actress" while Ava remained a glamorous movie star rather
than a serious actress, a glorious face "framed and frozen into iconography." A few
journalists who knew Ava personally and who were more expertly familiar with her
work noted this unfair and one-dimensional assessment. Liz Smith, for instance,
wrote in her column, "Thank heaven she had been made immortal on film, so that we

The memorial urn in
London's Ennismore
Gardens was dedicated
to Ava after her death
in 1990 by her house-
keeper, Carmen, and
dog, Morgan.

opposite: "No one could
craft a lovelier vase, hunk
of crystal, painting, or
diamond than what God
did with Ava Gardner."
—Elizabeth Taylor, in an
interview with author
James Grissom. Photo
by Clarence Sinclair Bull,
early 1940s.

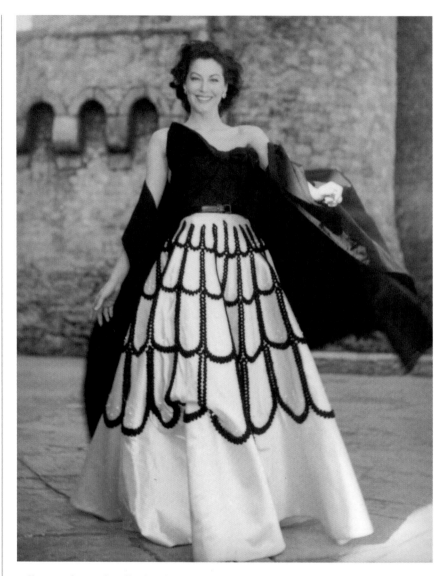

"She was a great, great broad." —Howard Keel, in an interview with Rex Reed. Photo by Norman Parkinson, 1953.

will never forget Ava Gardner's sultry, sensuous look, her down-to-earth persona, her husky manner of speaking, and her vastly underrated talents as an actress."

Ava's London home was sold, and the majority of her possessions auctioned off at Sotheby's. Carmen, who had been Ava's faithful companion to the very end, went to live and work at Gregory Peck's Hollywood home. Morgan went along with her. Before she departed London, Carmen arranged for an opulent memorial urn to be placed in the private gardens of the square Ava came to love so much. The simple plate reads, "In loving memory of Ava Gardner 1922–1990, Carmen and Morgan."

In accordance with her wishes, Ava was buried alongside her parents in Smithfield, North Carolina. Her funeral was a private affair—no big Hollywood names, no fuss.

She had returned home at last.

BIBLIOGRAPHY

BOOKS

Aaker, Everett. *George Raft: The Films*. USA: Macfarland, 2013.

Altman, Diana. *Hollywood East: Louis B. Mayer and the Origins of the Studio System*. United States: Citadel Press, 1994.

Bacall, Lauren. *By Myself and Then Some*. New York: HarperCollins, 2005.

Basinger, Jeanine. *The Star Machine*. United Kingdom: Knopf Doubleday Publishing Group, 2007.

Birnes, William and Richard Lertzman. *The Life and Times of Mickey Rooney*. New York, London, Toronto, Sydney, New Delhi: Gallery Books, 2015.

Bogarde, Dirk. *Ever, Dirk: The Bogarde Letters*. Edited by John Coldstream. London: Weidenfeld & Nicolson, 2008.

Bowyer, Justin. *Conversations with Jack Cardiff: Art, Light and Direction in Cinema*. United Kingdom: Batsford, 2003.

Brown, Peter Harry. *The MGM Girls: Behind the Velvet Curtain*. United States: St. Martin's Press, 1983.

Cabré, Mario. "You Don't Understand Me," in Gilbert L. Gigliotti, ed., Ava Gardner: Touches of Venus (Washington, DC: Entasis Press, 2010), 6–7.

Cannon, Doris Rollins. *Grabtown Girl: Ava Gardner's North Carolina Childhood and Her Enduring Ties to Home*. United States: Down Home Press, 2001.

Carroll, Andrew. *Here Is Where: Discovering America's Great Forgotten History*. New York: Crown Publishing Group, Division of Random House, 2013.

Crane, Cheryl and Cindy De La Hoz. *Lana Turner: The Memories, the Myths, the Movies*. United States: Running Press Book Publishers, 2008.

Crist, Judith. "D. H. Lawrence Brought to Life." Saturday Review, October 1981.

Douglas, Kirk. *The Ragman's Son*. USA: Simon & Schuster, 1988.

Duncan, Paul and Jurgen Muller, eds. Film Noir: 100 All-Time Favorites (Cologne, Germany: Taschen, 2014).

Emmett Long, Robert, ed. *George Cukor: Interviews*. Jackson: University Press of Mississippi, 2001.

Evans, Peter and Ava Gardner. *Ava Gardner: The Secret Conversations*. New York, US: Simon & Schuster (US & UK), 2013.

Eyman, Scott. *Lion of Hollywood: The Life and Legend of Louis B. Mayer*. Great Britain: Robson Books, 2005.

Fordin, Hugh. *The Movies' Greatest Musicals: Produced in Hollywood USA by the Freed Unit*. United Kingdom: Frederick Ungar, 1984.

Fowler, Karin J. *Ava Gardner: A Bio-Bibliography*. New York: Greenwood Press, 1990.

Friedrich, Otto. *City of Nets: A Portrait of Hollywood in the 1940's*. New York: HarperCollins Publishers, 1986.

Gardner, Ava. *Ava: My Story*. Paperback ed. New York: Bantam, 1992.

Gigliotti, Gilbert L., ed. *Ava Gardner: Touches of Venus*. Washington DC: Entasis Press, 2010.

Granger, Farley and Robert Calhoun. *Include Me out: My Life from Goldwyn to Broadway*. United States: St. Martin's Press, 2007.

Grobel, Lawrence. *Conversations with Ava Gardner*. USA: CreateSpace, 2014.

Grobel, Lawrence. *The Hustons*. United Kingdom: Prentice Hall & IBD, 1989.

Guilaroff, Sydney and Cathy Griffin. *Crowning Glory: Reflections of Hollywood's Favorite Confidant*. Santa Monica, CA: General Publishing Group, 1996.

Hall, Fred. *Dialogues in Swing: Intimate Conversations with the Stars of the Big Band Era*. Ventura, CA: Pathfinder Publishing, 1989.

Hanna, David. *Ava: Portrait of a Star*. London: Hamilton & Company, 1962.

Heston, Charlton and Hollis Alpert. *The Actor's Life: Journals, 1956-1976*. USA: E.P. Dutton, 1978.

Huston, Anjelica. *Watch Me: A Memoir*. United States: Simon & Schuster, 2014.

Jordan, Mearene. *Living with Miss G.* North Carolina: Ava Gardner Museum, 2012.

Kael, Pauline. *Kiss Kiss, Bang Bang*. Boston, Toronto: Little, Brown and Co., 1965.

Kashner, Sam and Jennifer MacNair. *The Bad and the Beautiful: A Chronicle of Hollywood in the Fifties*. United States: W. W. Norton & Co., 2002.

Kobal, John. *People Will Talk*. United States: Alfred A. Knopf, 1985.

Kobal, John. *The Art of the Great Hollywood Portrait Photographers* (London: Pavilion, 1988).

Kramer, Stanley. *A Mad, Mad, Mad, Mad World: A Life in Hollywood: A Life in Hollywood / Stanley Kramer with Thomas H. Coffey*. United States: Harcourt Brace International, 1998.

Kyrou, Ado. Amour, érotisme et cinéma (Paris: Eric Losfeld, 1966).

Lambert, Gavin and Robert Trachtenberg. *On Cukor*. United States: Rizzoli International Publications, 2000.

Lertzman, Richard and William Birnes. The Life and Times of Mickey Rooney (New York, London: Gallery Books).

Lumley, Joanna. *Absolutely: A Memoir*. London: Weidenfeld & Nicolson, 2011.

Martin, Pete. *Hollywood Without Makeup*. New York: J.B. Lippincott, 1948.

Meyers, Jeffrey. *Hemingway: A Biography* (London: Paladin Books, 1985).

Morgan, David T. *Murder Along the Cape Fear: A North Carolina Town in the Twentieth Century*. Macon, GA: Mercer University Press, 2005.

Mormorio, Diego and Tazio Secchiaroli. *Tazio Secchiaroli: Greatest of the Paparazzi*. New York: Harry N. Abrams, 1999.

National Legion of Decency, ed. *Motion Pictures Classified by National Legion of Decency*. New York: National Legion of Decency, 1959.

Parish, James Robert and Ronald L. Bowers. *The MGM Stock Company: The Golden Era*. London: Ian Allan Ltd, 1973.

Rodenberg Hans-Peter. *The Making of Ernest Hemingway: Celebrity, Photojournalism and the Emergence of the Modern Lifestyle Media* (Münster, Germany: LIT Verlag, 2014).

Schickel, Richard and Frank Capra. *The Men Who Made the Movies: Interviews with Frank Capra, George Cukor, Howard Hawks, Alfred Hitchcock, Vincente Minnelli, King Vidor, Raoul Walsh, and William A. Wellman*. United States: Atheneum, 1975.

Server, Lee. *Ava Gardner: "Love is nothing."* New York: St. Martin's Press, 2006.

Shariff, Omar. *The Eternal Male*. United States: Doubleday Books, 1977.

Sinatra, Nancy. *Frank Sinatra: An American Legend*. USA: General Publishing Group, 1995.

Sinatra, Tina and Jeff Coplon. *My Father's Daughter: A Memoir*. United States: Berkley Publishing Corporation, U.S., 2004.

Sinden, Donald. *A Touch of the Memours*. United Kingdom: Hodder & Stoughton, 1982.

Spoto, Donald. *The Kindness of Strangers: The Life of Tennessee Williams*. New York: Da Capo Press, 1997.

Taraborrelli, J. Randall. *Sinatra: The Man Behind the Myth*. United Kingdom: Mainstream Publishing, 1997.

Turner, Lana. *Lana: The Lady, the Legend, the Truth*. United States: Pocket Books, 1983.

Weaver, Tom. *Poverty Row Horrors! Monogram, PRC and Republic Horror Films of the Forties*. North Carolina and London: McFarland, 1993.

Wilson, Earl. *Hot Times: True Tales of Hollywood and Broadway*. United States: McGraw-Hill Contemporary, 1984.

Winters, Shelley. *Shelley II: The Middle of My Century*. USA: Pocket Books, 1990.

Wiseman, Thomas. *The Seven Deadly Sins of Hollywood*. London: Oldbourne Press, 1957.

ARTICLES AND ONLINE SOURCES

"Actress Ava Gardner Dies." *Newport News Daily Press*, January 26, 1990.

"Ava Ban Lifted." *Aberdeen Evening Express*, September 14, 1954.

"Ava Gardner Declares Public Image Not Real." *Sarasota Journal*, October 5, 1966.

"Ava Gardner Ill with Dysentery," *New York Times*, November 25, 1952.

"Ava Gardner Is Dead at 67; Often Played Femme Fatale." Obituaries, *New York Times*, January 26, 1990.

"Ava Gardner: Venus de Hollywood." *Nostalgia Illustrated 2*, no. 004 (1975).

"Bullfighter Rival of Sinatra Quite Sure of Ava's Love," *Los Angeles Times*, May 14, 1950.

Burns, Sally. "Tragic Triangle." *Modern Screen*, September 1950.

Callahan. John P. "Bivouac at 'Bhowani.'" *New York Times*, May 15, 1955.

Callahan, Richard. Review of *On the Beach*. *Life*, July 10, 1964.

Charles, Arthur L. "What Now, Frankie Boy?" *Modern Screen* January 1951.

"Coming and Going," *Film Daily*, July 31, 1941.

Crowther, Bosley. Review of *The Killers*. *New York Times*, August 29, 1946.

Crowther, Bosley. "'Mogambo,' with Ava Gardner and Clark Gable, Presented at Radio City Music Hall." *New York Times*, October 2, 1953.

Crowther, Bosley. Review of *Show Boat*. *New York Times*, July 20, 1951.

Crowther, Bosley. Review of *Whistle Stop*. *New York Times*, March 18, 1946.

"Delayed Rights Held Here for Mrs. Gardner." *Smithfield Herald*, May 25, 1943.

"Domínguín Y Ava Gardner: Una Relación Tormentosa Y Apasionada." *20 Minutos*. June 5, 2016. http://www.20minutos.es/noticia/370166/0/dominguin/mujeres/ava/.

Epstein, Edward Z. "All About Ava." *Cosmopolitan*, February 1990.

"Famous Inventor Knew Ava as a Girl." *Deseret News*, April 9, 1951.

Fieschi, Jacques. "La femme-idée." Cinématographe, no. 40, 1978.

Flint, Peter B. "Ava Gardner Is Dead at 67; Often Played Femme Fatale," *New York Times*, January 26, 1990.

Graves, Robert. "A Toast to Ava Gardner," *New Yorker*, April 26, 1958.

Grobel, Lawrence. "Twilight of the Goddess," *Movieline*, May 1990.

Grant, Jack D. Review of *She Went to the Races*. *Hollywood Reporter*, October 17, 1945.

Grissom, James. "Ava Gardner: The Gal from Grabtown," interview with Tennessee Williams, 1982. http://jamesgrissom.blogspot. co.uk/2013/03/ava-gardner-gal-from-grabtown.html (accessed March 9, 2016).

Havers, Richard. "Why Frank Sinatra Will Always Be the Voice." *The Telegraph* (Telegraph.co.uk), April 13, 2012. http://www.telegraph.co.uk/culture/tvandradio/the-voice/9200058/Why-Frank-Sinatra-will-always-be-The-Voice.html.

Henaghan, Jim. Review of *Whistle Stop*. *Hollywood Reporter*, January 7, 1946.

"Hollywood Mourns the Loss of Ava Gardner." *Lawrence Journal*, January 26, 1990.

Hyams, Joe. "Ava Gardner: In Search of Love." *LOOK*, December 11, 1956.

Jamison, Barbara Berch. "You Can't See the Jungle for the Stars." *New York Times*, October 19, 1952.

Kael, Pauline. "The Current Cinema." *New Yorker*, December 2, 1974.

Kerr, Deborah. "The Days and Nights of the Iguana," *Esquire*, May 1964.

Kraft, Barbara. "Henry Miller: The Last Days." *Hudson Review*, vol. XLVI, no. 3 (1993).

Kramer, Stanley. "The Many Moods of Ava." *American Weekly*, January 24, 1960.

La Barre, Harriet. "Ava in Pakistan." *Cosmopolitan*, March 2, 1956.

Lawrenson, Helen. "Shooting 'The Sun' with Ava." *Esquire*, October 1957.

Lavin, Cheryl. "Love and Marriage: His Romances Were Marked by Rocky Times—and Really Big Rocks." *Chicago Tribune*, May 17, 1998.

"Letters Show Another Side to Grace Kelly," *Independent-World* (Independent), March 10, 1994.

MacPherson, Virginia. "Ava in Best Film," *LA Herald-Express*, February 13, 1952.

Murphy, Kathleen. "Farewell My Lovelies." *Film Comment*, March 1990.

"New Feature Films: On the Beach." *Newsweek*, December 21, 1959.

Nicholson, David. "Actress Ava Gardner Dies." *Newport News Daily Press*, January 26, 1990.

O'Hara, John. "The Author's Name Is Hemingway." *New York Times*, September 10, 1950.

Oliver, Edith. "The Current Cinema." *New Yorker*, August 15, 1964.

"On an Island with Ava." *Picture Post*, October 22, 1956.

Parsons, Louella. Review of *Pandora and the Flying Dutchman*. *Cosmopolitan*, July 1951.

"Picks and Pans: Screen." *People*, November 16, 1981.

"Railcrash Scene from Bhowani Junction." *Portsmouth Evening News*, June 9, 1955.

Reddy, Thomas. "Ava Gardner Again to Seek Career." *Los Angeles Examiner*, April 24, 1944.

Reed, Rex. "Ava, What a Dame!" *Talk*, January 2000.

Review of *On the Beach*. *Variety*, January 1, 1960.

Review of *Whistle Stop*. *Variety*, January 9, 1946.

Rhode Island History Society, "Saga of Herodias (Long) Hicks-Gardner-Porter," Rhode Island History, vol. 2, no. 3, July 1952. http://mv.ancestry.com/viewer/e0b92473-894b-417a-9420-141e4dd42dbb/7500877/-965105504 (accessed October 7, 2015).

Sanders, Walter. "Metro-Goldwyn-Mayer: Louis B. Mayer Bosses the Biggest Movie-Making Machine." *Life*, September 27, 1943.

Schallert, Edwin. "Director Lauds Ava for Work in 'Contessa'." *Los Angeles Times*, October 24, 1954.

Schallert, Edwin. "Jean Harlow Comedy a Hit at Two Theaters." *Los Angeles Times*, October 22, 1932.

Schallert, Edwin. Review of Pandora and the Flying Dutchman. *Los Angeles Times*, January 11, 1952.

Schallert, Edwin. Review of *Show Boat*. *Los Angeles Times*, July 18, 1951.

Schallert, Edwin. Review of *Whistle Stop*. *Los Angeles Times*, January 7, 1946.

Scheuer, Philip K. Review of *The Barefoot Contessa*. *Los Angeles Times*, November 5, 1954.

Scott, John L. "Little Ava Goes Back to Learnin'." *Los Angeles Times*, June 30, 1946.

Smith, Liz. "Thanks to Film, Ava Gardner Will Be Immortal." January 26, 1990. Publication unknown, Ava Gardner clippings files, Margaret Herrick Library, Academy of Motion Pictures Arts and Sciences.

Taylor, Elizabeth. Interview with author James Grissom, 1991. Private collection.

Thompson, Howard. "Screen: Opulence of Austria-Hungary: New 'Mayerling' Opens at the Music Hall," *New York Times*, February 14, 1969.

Tomkies, Mike. "Ava Gardner, Hollywood's Runaway Queen." Publication unknown, Ava Gardner clippings files, Academy of Motion Picture Arts and Sciences, Los Angeles, CA.

"Two Heavyweights: Burton and Gardner Meet." *Stage and Cinema*, August 1964.

United States Federal Census, District 5, Edgecombe, North Carolina, 1830. http://interactive.ancestry.com/8058/4409548_00557/196946?backurl=http://person.ancestry.com/tree/47904042/person/12830722712/facts/citation/120018948518/edit/ record (accessed October 7, 2015).

United States Federal Census, Wilson, North Carolina, 1860. http://interactive.ancestry.com/7667/423752 4_00411/38936013?backurl=http://person.ancestry.com/tree/47904042/person/12830722712/facts/citation/120018943577/ edit/record (accessed October 7, 2015).

Untitled. March 9, 1944, Ava Gardner clippings files, Academy of Motion Picture Arts and Sciences, Los Angeles, CA.

Untitled. *The State*, January 23, 1954.

Vallance, Tom. "Obituary: Sydney Guilaroff." Obituaries, *The Independent*, May 30, 1997. http://www.independent.co.uk/news/obituaries/obituary-sydney-guilaroff-1264351.html.

"WHO'S Un-American?," Variety, October 29, 1947.

Wilson, Earl. "Ava Boiling Mad over Harsh Letters from Sinatra Fans." *Los Angeles Daily News*, March 25, 1950.

Wilson, Liza. "Ava Gardner, reputedly the unhappiest of movie stars, says—'Don't cry over me'." Cincinnati Enquirer, September 8, 1957.

MANUSCRIPTS

George Cukor Papers, Margaret Herrick Library, Beverly Hills.

Arthur Freed Collection, Cinematic Arts Library, University of Southern California, Los Angeles.

James Grissom Papers, private collection, New York.

Robert Graves Papers, St John's College, Oxford University, England.

Gladys Hall Papers, Margaret Herrick Library, Beverly Hills.

Ernest Hemingway Papers, John F. Kennedy Presidential Library, Boston.

Hedda Hopper Papers, Margaret Herrick Library, Beverly Hills.

Joseph Mankiewicz Papers, Margaret Herrick Library, Beverly Hills.

Henry Miller Papers, University of California, Los Angeles.

Gregory Peck Papers, Margaret Herrick Library, Beverly Hills.

DOCUMENTARIES

Crazy About the Movies: Ava Gardner (Robert Guenette, 1992).

La noche que no acaba: Ava Gardner (Isaki Lacuesta, 2010).

Moviedrome: The Killers, (Mark Cousins, November 3, 2014).

Presentación en España de su película Disparadme (2009)

Sinatra: All of Nothing at All (Alex Gibney, 2015).

Wogan (BBC, episode aired September 25, 1989)

INTERVIEWS

Diana Altman, September 2014

Peter Feuchtwanger, May 2016

Michael Garady, May 2016

William Graves, June 2016

James Grissom, August 2015

Joanna Lumley, September 2015

Constance McCashin, May 2016

Sir Ian McKellen, November 2015

Rob Moshein, February 2016

David Niven, Jr., May 2015

Tina Sinatra, July 2015

Thomas Wiseman, September 2015

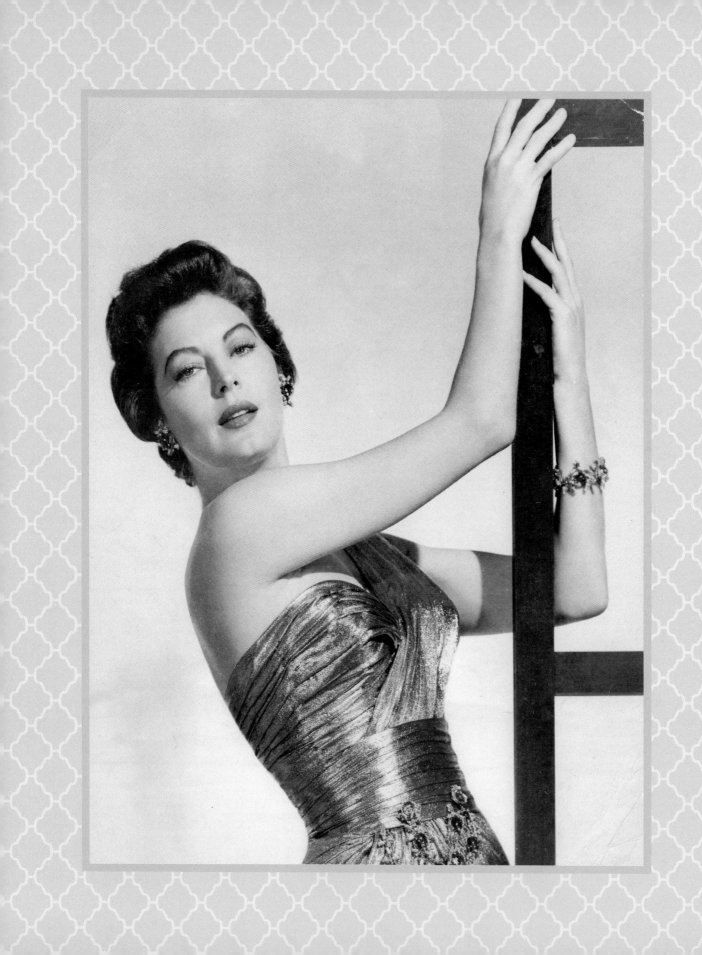

CHAPTER NOTES

INTRODUCTION

"When I think of her": James Grissom, "Ava Gardner: The Gal from Grabtown," interview with Tennessee Williams, 1982. http://jamesgrissom.blogspot .co.uk/2013/03/ava-gardner-gal-from-grabtown. html (accessed March 9, 2016).

"I was never really an actress": Ava Gardner, quoted in "Ava Gardner Is Dead at 67; Often Played Femme Fatale," by Peter B. Flint, *New York Times*, January 26, 1990.

"It's too bad that the silent pictures": Letter from George Cukor to Ava Gardner, January 14, 1970, George Cukor Papers, folio 763, Academy of Motion Picture Arts and Sciences, Los Angeles, CA.

"As an actress, she was": Gregory Peck, tribute to Ava Gardner sent to publicist Monroe Friedman, January 25, 1990, Gregory Peck Papers, folio 1366, Academy of Motion Picture Arts and Sciences, Los Angeles, CA.

CHAPTER ONE:
DAUGHTER OF THE SOUTH

"I can tell you that in the fifties": Thomas Wiseman, interview with authors, September 1, 2015.

At the top of the incline stood the film's lead actress: Thomas Wiseman, *The Seven Deadly Sins of Hollywood* (London: Oldbourne Press, 1957), 68–69.

"the Aphrodite of the atom-age": Ibid.

"I don't enjoy making films": Ibid.

"Perhaps we're not so interesting": Ibid.

Ava Lavinia Gardner, a self-proclaimed: Peter Evans and Ava Gardner, *Ava Gardner: The Secret Conversations* (New York: Simon and Schuster, 2013), 36.

There they were seized: Rhode Island History Society, "Saga of Herodias (Long) Hicks-Gardner-Porter," *Rhode Island History*, vol. 2, no. 3, July 1952. http://mv .ancestry.com/viewer/e0b92473-894b-417a-9420- 141e4dd42dbb/7500877/-965105504 (accessed October 7, 2015).

The 1830 North Carolina census: United States Federal Census, District 5, Edgecombe, North Carolina, 1830. http:// interactive.ancestry.com/8058/4409548_00557/19694 6?backurl=http://person.ancestry.com/tree/47904042/ person/12830722712/facts/citation/120018948518/edit/ record (accessed October 7, 2015).

His son David helped with labor: United States Federal Census, Wilson, North Carolina, 1860. http://interactive .ancestry.com/7667/4237524_00411/38936013? backurl=http://person.ancestry.com/tree/47904042/ person/12830722712/facts/citation/120018943577/ edit/record (accessed October 7, 2015).

According to former Wilson County journalist: Doris Rollins Cannon, *Grabtown Girl: Ava Gardner's North Carolina Childhood and Her Enduring Ties to Home* (North Carolina: Down Home Press, 2001), 18–19.

Lawrence Grobel recalls Ava: Lawrence Grobel, *Conversations with Ava Gardner* (United States: CreateSpace, 2014), 61.

"She was a lively kid": *The State*, January 23, 1954, reprinted in *Our State* magazine, May 2006.

It read, in part: Andrew Carroll, *Here Is Where: Discovering America's Great Forgotten History* (New York: Three Rivers Press, 2013), 213.

It is unclear whether Ava: "Famous Inventor Knew Ava as a Girl," *Deseret News*, April 9, 1951.

"I remember one time she climbed": Lee Server, *Ava Gardner: Love Is Nothing* (London: Bloomsbury, 2006), 20.

"We were nothing if not game": Ava Gardner, *Ava: My Story* (New York: Bantam, 1990), 13.

Blacks were to be respected: Evans and Gardner, *The Secret Conversations*, 45–46.

"sexed to the limit": Edwin Schallert, "Jean Harlow Comedy a Hit at Two Theaters," *Los Angeles Times*, October 22, 1932.

When Gable came up for the part: Gardner, *My Story*, 26.

Ava "was a rather shy person": "Actress Ava Gardner Dies," *Newport News Daily Press*, January 26, 1990.

"We used to walk to Newport News": Ibid.

"I'm taking French": Letter from Ava Gardner to Clara Whitely, June 4, 1936, quoted in Cannon, *Grabtown Girl*, 42.

CHAPTER TWO:
NEW YORK

"You are so pretty": Lee Server, *Ava Gardner: Love Is Nothing* (London: Bloomsbury, 2006), 39–40.

but Ace maintained that it: Ibid.

He did not have a date: Ibid., 41–42.

"My name is Barney Duhan": Ibid.

Decades later Alberta remembered: Doris Rollins Cannon, *Grabtown Girl: Ava Gardner's North Carolina Childhood and Her Enduring Ties to Home* (North Carolina: Down Home Press, 2001), 66.

"Most of them were just pretty": Diana Altman, *Hollywood East: Louis B. Mayer and the Origins of the Studio System* (New York: Citadel Press, 1994), 220.

"Ava Gardner, MGM's latest eighteen-year-old": "Coming and Going," *Film Daily*, July 31, 1941.

CHAPTER THREE:
THE MGM STARLET

"I love to cook": Undated notes for article, Gladys Hall Papers, folio 198, Academy of Motion Picture Arts and Sciences, Los Angeles, CA.

"Life magazine called it": Walter Sanders, "Metro-Goldwyn-Mayer: Louis B. Mayer Bosses the Biggest Movie-Making Machine," *Life*, September 27, 1943.

"In periods of peak production": Scott Eyman, *Lion of Hollywood: The Life and Legend of Louis B. Mayer* (New York: Simon and Schuster, 2012), 1.

Sitting behind "a white-leather-sided": Ibid., 5.

He preferred his employees to: Ibid., 7.

"The idea of a star being born": Jeanine Basinger, *The Star Machine* (New York: Vintage, 2007), 11.

"I worked very hard": "Ava Gardner Notes," undated, Gladys Hall Papers, folio 198, Academy of Motion Picture Arts and Sciences, Los Angeles, CA.

In a conversation with Lee Server: Lee Server, *Ava Gardner: Love Is Nothing* (London: Bloomsbury, 2006), 52.

Fortunately, the "brainless producer": Ibid.

"With one glance I was swept": Sydney Guilaroff, *Crowning Glory: Reflections of Hollywood's Favorite Confidant* (Santa Monica: General Publishing Group, 1996), 171.

But they did become close: Ibid.

"you know, sort of a suffering look": John Kobal, *The Art of the Great Hollywood Portrait Photographers* (London: Pavilion, 1988), 257–258.

"For instance," Willinger later said: Ibid.

Ava commented on Eric Carpenter's: Pete Martin, *Hollywood Without Makeup* (Philadelphia: J. B. Lippincott, 1948), 37.

"I spent a lot of time doing publicity stunts": Lawrence Grobel, "Twilight of the Goddess," *Movieline*, May 1990.

"He would have had a beautiful": Joe Hyams, "Ava Gardner: In Search of Love," *Look*, December 11, 1956.

"Mickey was obsessed": Richard Lertzman and William Birnes, *The Life and Times of Mickey Rooney* (New York, London: Gallery Books), 176.

"After the first date": Ibid., 177.

"I called him the 'All-American Nothing'": Guilaroff, *Crowning Glory*, 175.

"I was lousing up his career": Hyams, "Ava Gardner: In Search of Love."

"Ava feared that living": Lertzman and Birnes, *The Life and Times of Mickey Rooney*, 177.

"I thought I had found": Hyams, "Ava Gardner: In Search of Love."

"the sort of film that makes": Tom Weaver, *Poverty Row Horrors!: Monogram, PRC and Republic Horror Films of the Forties* (Jefferson, NC: McFarland, 1993), 199–120.

"I've got to say it was a thrill": Ava Gardner, *Ava: My Story* (New York: Bantam, 1990), 65.

"one of the most promising": Untitled article, March 9, 1944, Ava Gardner clippings files, Academy of Motion Picture Arts and Sciences, Los Angeles, CA.

"Gardner was cast in the second lead": Basinger, *The Star Machine*, 9.

"It's not much": Ibid.

"It will be a long time": Thomas Reddy, "Ava Gardner Again to Seek Career," *Los Angeles Examiner*, April 23, 1944.

She would later admit: Gardner, *My Story*, 98.

"MGM has a great bet": Jack D. Grant, review of *She Went to the Races*, *Hollywood Reporter*, October 17, 1945.

"Suggestive dialogue, sequences": "Whistle Stop," *Motion Pictures Classified by National Legion of Decency* (New York: National Legion of Decency, 1959), 264.

"Nebenzal . . . saw latent talent in": Martin, *Hollywood Without Makeup*, 42.

"flavor, consistency, reason": Bosley Crowther, review of *Whistle Stop*, *New York Times*, March 18, 1946.

"Miss Gardner displays her best": Review of *Whistle Stop*, *Variety*, January 9, 1946.

"fills her assignment creditably": Edwin Schallert, review of *Whistle Stop*, *Los Angeles Times*, January 7, 1946.

"The plot substituted for the wanton": Jim Henaghan, review of *Whistle Stop*, *Hollywood Reporter*, January 7, 1946.

"Yordan said that both Raft": Everett Aaker, *George Raft: The Films* (Jefferson, NC: McFarland, 2013), 119.

CHAPTER FOUR:
THE FEMME FATALE

With characteristic patience: Ava Gardner, *Ava: My Story* (New York: Bantam, 1990), 86.

"Marrying Ava was purely": Artie Shaw, interviewed for the documentary *Crazy About the Movies: Ava Gardner*, directed by Robert Guenette, 1992.

"Ava had a wonderful mind": Sydney Guilaroff, interviewed for the documentary *Crazy About the Movies*, Guenette.

"intelligent, intellectual male": Gardner, *My Story*, 88.

"Of course, my home studio, MGM": John L. Scott, "Little Ava Goes Back to Learnin'," *Los Angeles Times*, June 30, 1946.

"I was hoping she would be able": Pete Martin, *Hollywood Without Makeup* (Philadelphia: J. B. Lippincott, 1948), 42.

"didn't do enough to help": Gardner, *My Story*, 23.

"Of all [Lana's] friends, I think Ava": Cheryl Crane and Cindy De la Hoz, *Lana: The Memories, the Myths, the Movies* (Philadelphia: Running Press, 2008), 171.

"sultry and sardonic": Bosley Crowther, review of *The Killers*, *New York Times*, August 29, 1946.

"Robert Siodmak does wonders": Quoted in Paul Duncan and Jurgen Muller, eds., *Film Noir: 100 All-Time Favorites* (Cologne, Germany: Taschen, 2014), 213.

"Imagine that: late night": Mark Cousins, *Moviedrome: The Killers*, YouTube, November 3, 2014. www.youtube.com/watch?v=9FzhLEXcdvw.

"They've been after me": Martin, *Hollywood Without Makeup*, 44.

"She didn't object to": Mearene Jordan, *Living with Miss G* (Smithfield, NC: Ava Gardner Museum, 2012), 23.

"was quick to recognize": Ibid.

MGM finally got the message: Gardner, *My Story*, 114.

"magical little interlude": Ibid., 119.

CHAPTER FIVE:
MRS. SINATRA

"worn velveteen": Richard Havers, "Why Frank Sinatra Will Always Be the Voice," *Telegraph*, April 13, 2012. www.telegraph.co.uk/culture/tvandradio/the-voice/9200058/Why-Frank-Sinatra-will-always-be-The-Voice.html (accessed April 12, 2016).

Ava first met Frank in 1943: Ava Gardner, *Ava: My Story* (New York, Bantam: 1990), 122.

"I looked at her and said": *Sinatra: All or Nothing at All*, documentary directed by Alex Gibney, 2015.

"If he arrived on a plane in": Notes mentioning Jack Keller, undated, Hedda Hopper Papers, folio 1892, Academy of Motion Picture Arts and Sciences, Los Angeles, CA.

"on the skids": Fan letters to Hedda Hopper, 1946, Hedda Hopper Papers, folio 2961 (Frank Sinatra), Academy of Motion Pictures Arts and Sciences, Los Angeles, CA.

"They were together one night": *Sinatra: All or Nothing at All*, Gibney.

"What I remember most": Tina Sinatra, interview with authors, July 10, 2015.

"We, the undersigned, as American citizens": "WHO'S Un-American?," *Variety*, October 29, 1947.

"great fun to work with": Jack Cardiff, interviewed for the documentary *La noche que no acaba: Ava Gardner*, directed by Isaki Lacuesta, 2010.

"[Lewin] thought Ava was": Justin Bowyer, *Conversations with Jack Cardiff: Art, Light, and Direction in Cinema* (London: Batsford, 2003), 108.

"One day I had to say to him": Gardner, *My Story*, 156.

"a very pleasant film": Bowyer, *Conversations with Jack Cardiff*, 109.

surrealist photographer Man Ray: Sam Kashner and Jennifer MacNair, *The Bad and the Beautiful: Hollywood in the Fifties* (New York: W.W. Norton, 2003), 160.

"Eroticism is the whole climate": Richard Schickel and Frank Capra, *The Men Who Made the Movies* (New York: Atheneum, 1975), 181.

"When we got back to England": Bowyer, *Conversations with Jack Cardiff*, 108.

"The centuries hammer into the rocks": Mario Cabré, "You Don't Understand Me," in Gilbert L. Gigliotti, ed., *Ava Gardner: Touches of Venus* (Washington, DC: Entasis Press, 2010), 6–7.

"pain in the ass": Gardner, *My Story*, 157.

Ava and Frank "were combustible": Tina Sinatra, interview with authors, July 10, 2015.

"After Sinatra's visit": "Bullfighter Rival of Sinatra Quite Sure of Ava's Love," *Los Angeles Times*, May 14, 1950.

"He was having a really bad time": Fred Hall, *Dialogues in Swing: Intimate Conversations with the Stars of the Big Band Era* (Ventura, CA: Pathfinder Publishing, 1989), 166.

"We understand that you are planning": Hugh Fordin, *The Movies' Greatest Musicals: Produced in Hollywood USA by the Freed Unit* (New York: Frederick Ungar, 1984), 334.

According to Hugh Fordin: Ibid.

"You couldn't pass Lena off": John Kobal, *People Will Talk* (New York: Alfred A. Knopf, 1985), 652.

"there wasn't much enthusiasm": Fordin, *The Movies' Greatest Musicals*, 334.

"Kathryn Grayson was right": Kobal, *People Will Talk*, 652.

"Freed gives this exchange": Ibid.

"pale, thin, and tentative": Fordin, *The Movies' Greatest Musicals*, 338.

"Boy could she sing!": Rex Reed, "Ava, What a Dame!," *Talk*, December 1999–January 2000.

"Ava had really astonishing": Ibid.

"You couldn't help but": Ibid.

"Mr. Mayer sent around": Ibid.

"Ava Gardner terrific": Report from Howard Strickling detailing audience comments from the first preview of *Show Boat* at the Bay Theater in Pacific Palisades, March 22, 1951. Arthur Freed Collection ("Show Boat"), box 56/folder 2, Cinematic Arts Library, University of Southern California, Los Angeles, CA.

"Ava Gardner splendid": Ibid.

"haunting and moving": Bosley Crowther, review of *Show Boat*, *New York Times*, July 20, 1951.

"Miss Gardner comes definitely to": Edwin Schallert, review of *Show Boat*, *Los Angeles Times*, July 18, 1951.

"the greatest screen performance": Virginia MacPherson, "Ava in Best Film," *LA Herald-Express*, February 13, 1952.

"the most ravishing 'femme fatale'": Louella Parsons, review of *Pandora and the Flying Dutchman*, *Cosmopolitan*, July 1951.

"has succeeded in elevating": Edwin Schallert, review of *Pandora and the Flying Dutchman*, *Los Angeles Times*, January 11, 1952.

"Pandora is the only resolutely": Ado Kyrou, *Amour, Érotisme et Cinéma* (Paris: Eric Losfeld, 1966), 238–239.

"Only Ava Gardner could portray": Jacques Fieschi, "La femme-idée," *Cinématographe*, no. 40, 1978.

"The year 1950 will go": Arthur L. Charles, "What Now, Frankie Boy?," *Modern Screen*, January 1951.

"[Ava and Frank] are the most disgusting": Letter from Marie Miller to Hedda Hopper, August 7, 1951, Hedda Hopper Papers, folio 2961, Academy of Motion Picture Arts and Sciences, Los Angeles, CA.

"I have always watched": Letter from Mrs. C. Cassidy to Hedda Hopper, February 10, 1950, Hedda Hopper Papers, folio 2961, Academy of Motion Picture Arts and Sciences, Los Angeles, CA.

"I'm being vilified": Earl Wilson, "Ava Boiling Mad over Harsh Letters from Sinatra Fans," *Los Angeles Daily News*, March 25, 1950.

"*Ava was . . . ahead of her time*": Farley Granger and Robert Calhoun, *Include Me Out: My Life from Goldwyn to Broadway* (New York: St. Martin's Press, 2007), 113.

"*It was a nightmare time*": Peter Evans and Ava Gardner, *Ava Gardner: The Secret Conversations* (New York: Simon and Schuster, 2013), 179.

"*Dad had met his match*": Tina Sinatra and Jeff Coplon, *My Father's Daughter: A Memoir* (New York: Simon and Schuster, 2000), 24.

CHAPTER SIX:
INTERNATIONAL STARDOM

"*since the death of Shakespeare*": John O'Hara, "The Author's Name Is Hemingway," *New York Times*, September 10, 1950.

Cynthia was the first part: Ava Gardner, *Ava: My Story* (New York: Bantam, 1990), 167.

"*a gentleman of the old school*": Mearene Jordan, *Living with Miss G* (Smithfield, NC: Ava Gardner Museum, 2012), 70.

"*she did things in Kilimanjaro*": Gregory Peck in Gardner, *My Story*, 243.

"*No one with your talent*": Randy J. Taraborrelli, *Sinatra: The Man Behind the Myth* (Edinburgh: Mainstream Publishing, 1998), 193.

Tina Sinatra remembers: Tina Sinatra, interview with authors, July 10, 2015.

"*Since yesterday there's been*": Newswire caption on verso of Associated Press photograph, October 1952.

"*Battling Sinatras*": Taraborrelli, *The Man Behind the Myth*, 173.

"*You know who should play*": Tina Sinatra, interview with authors, July 10, 2015.

"*sassy, tough-talking playgirl*": Gardner, *My Story*, 181.

"*get a good sun tan*": Donald Sinden, *A Touch of the Memoirs* (London: Futura, 1983), 202.

"*My name is Donald Sinden*": Ibid., 207.

"*He could be the meanest*": Lee Server, *Ava Gardner: Love Is Nothing* (London: Bloomsbury, 2006), 254.

"*You are damn good*": Gardner, *My Story*, 183.

"*had to pay a flying visit*": Sinden, *A Touch of the Memoirs*, 214.

"*Ava Gardner was receiving*": "Ava Gardner Ill with Dysentery," *New York Times*, November 25, 1952.

"*largest safari camp ever*": Barbara Berch Jamison, "You Can't See the Jungle for the Stars," *New York Times*, October 19, 1952.

"*Ava and I are now great*": "Letters Show Another Side to Grace Kelly," *Independent-World* (*Independent*), March 10, 1994.

"*He never got over it*": Taraborrelli, *The Man Behind the Myth*, 207.

"*They were too much alike*": Tina Sinatra, interview with authors, July 10, 2015.

"*amusingly bewitching*": Bosley Crowther, "'Mogambo,' with Ava Gardner and Clark Gable, Presented at Radio City Music Hall," *New York Times*, October 2, 1953.

CHAPTER SEVEN:
WOMAN OF THE WORLD

Another actress who lobbied: Letter from Bert Allenberg to Joseph Mankiewicz, July 20, 1953, Joseph Mankiewicz Papers, folio 45 (William Morris Agency correspondence re: *The Barefoot Contessa*), Academy of Motion Picture Arts and Sciences, Los Angeles, CA.

"*MGM's no great shakes now*": Quoted in James Robert Parish and Ronald L. Bowers, *The MGM Stock Company: The Golden Era* (London: Ian Alan, 1973), 242.

"*I received your wire*": Letter from Allenberg to Mankiewicz, June 26, 1953.

"*get the hell out of town*": Letter from Allenberg to Mankiewicz, October 27, 1953.

"*Ava has now become so violently*": Letter from Allenberg to Mankiewicz, October 30, 1953.

"*When Nick got here*": Letter from Allenberg to Mankiewicz, November 17, 1953.

Apparently she was "quite disturbed": Cable from Allenberg to Mankiewicz, December 8, 1953, Joseph Mankiewicz Papers, folio 41 (*The Barefoot Contessa* Production Files), Margaret Herrick Library.

"*Although outwardly cordial and polite*": David Hanna, *Ava: A Portrait of a Star* (New York: G. P. Putnam and Sons, 1960), 60–61.

As she sat on the edge: Ava Gardner, *Ava: My Story* (New York: Bantam, 1990), 197.

Mankiewicz would later sing: Edwin Schallert, "Director Lauds Ava for Work in 'Contessa,'" *Los Angeles Times*, October 24, 1954.

"a complete bust": Peter Evans and Ava Gardner, *Ava Gardner: The Secret Conversations* (New York: Simon and Schuster, 2013), 234–235.

"Exactly where do living expenses": Letter from Mankiewicz to Allenberg, December 15, 1953.

"There are 625 lire to the dollar": Ibid.

"She had pulled a similar stunt": Ibid.

"good and sometimes better": Philip K. Scheuer, review of *The Barefoot Contessa*, *Los Angeles Times*, November 5, 1954.

"so bitter and disagreeable": Bosley Crowther, review of *The Barefoot Contessa*, *New York Times*, September 30, 1954.

"trash masterpiece": Pauline Kael, *Kiss Kiss, Bang Bang* (Boston: Little, Brown and Co., 1965), 235.

In The Making of Ernest Hemingway: Hans-Peter Rodenberg, *The Making of Ernest Hemingway: Celebrity, Photojournalism and the Emergence of the Modern Lifestyle Media* (Münster, Germany: LIT Verlag, 2014), 145.

"two sides to her personality": Jeffrey Meyers, *Hemingway: A Biography* (London: Paladin Books, 1985), 525.

He took an active interest: Ibid.

"He was much too young": Joe Hyams, "Ava Gardner: In Search of Love," *Look*, December 11, 1956.

"most beautiful and most fierce": "Dominguín y Ava Gardner: Una relación tormentosa y apasionada," *20 Minutos*, June 5, 2016.

I said, "I'm English, we play cricket": David Niven Jr., interview with authors, May 18, 2015.

"The Indian tax collectors": John P. Callahan, "Bivouac at 'Bhowani,'" *New York Times*, May 15, 1955.

"During the first week after": Ibid.

"She did everything herself": Harriet La Barre, "Ava in Pakistan," *Cosmopolitan*, March 2, 1956.

"The director's function": Quoted in Richard Schickel, *The Men Who Made the Movies* (New York: Atheneum, 1975) 171–172.

"My Dearest Ava": Letter from George Cukor to Ava Gardner, August 20, 1955, George Cukor Papers, folio 25 *(Bhowani Junction)*, Academy of Motion Picture Arts and Sciences, Los Angeles, CA.

"We should all be very": Ibid.

"She interferes with herself": Robert Emmet Long, ed., *George Cukor: Interviews* (Jackson: University Press of Mississippi, 2001), 46.

"working [with Ava] as one": Letter from Cukor to Gardner, August 20, 1955.

"Madrid fits me like a glove": Liza Wilson, "Ava Gardner," *Cincinnati Enquirer*, September 8, 1957.

"2 acres of land & a swimming pool": Letter from Bunny Bruce to George Cukor, undated, George Cukor Papers, folio 726 (Ava Gardner general correspondence), Academy of Motion Picture Arts and Sciences, Los Angeles, CA.

"Adlai Stevenson, Ernest Hemingway": "On an Island with Ava," *Picture Post*, October 22, 1956.

"Why do you writers insist": Wilson, "Ava Gardner."

"everyone connected with the picture": Helen Lawrenson, "Shooting 'The Sun' with Ava," *Esquire*, October 1957.

"If anyone should be frustrated": Liza Wilson, "Ava Gardner, reputedly the unhappiest of movie stars, says – 'Don't cry over me'," *Cincinnati Enquirer*, September 8, 1957.

"Zanuck's splashy Cook's tour": Art Buchwald, "The Great Feud of Mr. Hemingway and Mr. Zanuck," *Los Angeles Times*, November 29, 1957.

CHAPTER EIGHT:
INDEPENDENCE

"It was once again Tazio Secchiaroli": Quoted in Diego Mormorio et al., *Tazio Secchiaroli: Greatest of the Paparazzi* (New York: Harry N. Abrams, 1999), 23.

"To Ava Gardner, the first half": Lee Server, *Ava Gardner: Love Is Nothing* (London: Bloomsbury, 2006), 362.

"Ava Gardner came out": Shelley Winters, *Shelley II: The Middle of My Century* (New York: Simon and Schuster, 1989), 244.

"Ava practically destroyed": Ibid., 251.

"cause a world-wide stir": Stanley Kramer and Thomas Coffey, *A Mad, Mad, Mad, Mad World: A Life in Hollywood* (London: Aurum Press, 1998), 155–156.

"The public might not like": Ibid., 155.

"Ava Gardner, God bless her": Ibid., 157.

"Ava was never, never": Gregory Peck in Ava Gardner, *Ava: My Story* (New York: Bantam, 1990), 245.

"When she's really with it": Stanley Kramer, "The Many Moods of Ava," *American Weekly*, January 24, 1960.

"uniformly excellent": Review of *On the Beach*, *Variety*, January 1, 1960.

"worldly" Moira: Bosley Crowther, review of *On the Beach*, *New York Times*, December 19, 1959.

"Ava Gardner has never looked worse": "New Feature Films: On the Beach," *Newsweek*, December 21, 1959.

"There's David": Mearene Jordan, *Living with Miss G* (Smithfield, NC: Ava Gardner Museum, 2012), 169.

"Ava and I loved each other": Dirk Bogarde, *Ever, Dirk: The Bogarde Letters*, ed. John Coldstream (London: Weidenfeld & Nicolson, 2008), 387.

"We shot for verite": Ibid.

CHAPTER NINE:
MATURITY

"She hated parties": Rex Reed, "Ava: What a Dame!," *Talk*, December 1, 2000.

"exhausting social life": Robert Graves, "A Toast to Ava Gardner," *New Yorker*, April 26, 1958.

"in her pleasant": William Graves, interview with authors, June 2015.

"Poems are like people": Graves, "A Toast to Ava Gardner."

"her legendary self": Ibid.

"Quick-witted, courageous": Robert Graves, typescript for contribution to article "On an Island with Ava," published in *Picture Post*, October 22, 1956. Robert Graves Papers, St. John's College, Oxford University.

"My admiration for Ava": Letter from Henry Miller to George Cukor, February 3, 1964, George Cukor Papers, folio 838, Academy of Motion Picture Arts and Sciences, Los Angeles, CA.

"When the lady came to visit": Barbara Kraft, "Henry Miller: The Last Days," *Hudson Review*, vol. XLVI, no. 3 (1993).

"Nick phoned from Spain": Charlton Heston, *The Actor's Life Journals 1956–1976* (New York: Pocket Books, 1979), 143.

"cocktails at Ava Gardner's": Ibid., 147.

"guilty energy": Ibid., 152.

"Jesus, Rene": Mearene Jordan, *Living with Miss G* (Smithfield, NC: Ava Gardner Museum, 2012), 173.

"fascinating, troubled, and disturbingly honest": Mike Tomkies, "Ava Gardner, Hollywood's Runaway Queen," publication unknown, Ava Gardner clippings files, Academy of Motion Picture Arts and Sciences, Los Angeles, CA.

"Physical beauty doesn't matter": Ibid.

"She gets a few drinks in her": Kirk Douglas, *The Ragman's Son: An Autobiography* (London: Pan Books, 1989), 323.

"According to writer and Williams's friend": James Grissom, interview with authors, August 2015.

"I knew damn well that Ava": Quoted in Lawrence Grobel, *The Hustons: The Life and Times of a Hollywood Dynasty* (London: Bloomsbury Publishing, 1990), 530.

"You want a friend?": Tennessee Williams, 1982 interview with James Grissom, in "Ava Gardner: The Gal from Grabtown," James Grissom's personal blog, March 14, 2013. http://jamesgrissom.blogspot.co.uk/2013/03/ava-gardner-gal-from-grabtown.html (accessed April 4, 2016).

"God, I adored him": Lawrence Grobel, *Conversations with Ava Gardner* (United States: Createspace, 2014), 24.

though Ava "adored Burton": Deborah Kerr, "The Days and Nights of the Iguana," *Esquire*, May 1964.

"marvelous because she's": Grobel, *Conversations with Ava Gardner*, 18.

"I am revolted by": Kerr, "The Days and Nights of the Iguana."

"Ava warm and friendly": Ibid.

"how happy she was": Ibid.

"John and I were discussing": Ibid.

"She was good!": Ibid.

"John is unique": Grobel, *Conversations with Ava Gardner*, 21.

"We were on our way home for lunch": Ibid., 23.

"For my money": "Two Heavyweights: Burton and Gardner Meet," *Stage and Cinema*, August 1964.

"a revelation": Richard Callahan, *Life*, July 10, 1964.

"A great woman played": "New Feature Films," *Newsweek*, July 1964.

"absolutely splendid": Edith Oliver, "The Current Cinema," *New Yorker*, August 15, 1964.

he thought Ava "had been robbed": James Grissom, interview with authors, August 2015.

CHAPTER TEN:
CHARACTER ACTRESS

"dark and ugly": Lawrence Grobel, *Conversations with Ava Gardner* (United States: Createspace, 2014), 28–35 passim.

"I didn't want to do it": Ibid.

"I don't remember what we said": Ibid.

"Don't ask me why": Ibid.

"That was the magic": Ibid.

"Miss G, you are mad!": Mearene Jordan, *Living with Miss G* (Smithfield, NC: Ava Gardner Museum, 2012), 219.

Scott "had beaten": Rob Moshein, interview with authors, February 2016.

"I never talk about Ava": Grobel, *Conversations with Ava Gardner*, 35.

"I'm sorry I spent": "Ava Gardner Declares Public Image Not Real," *Sarasota Journal*, October 5, 1966.

"I've had my share of": Jordan, *Living with Miss G*, 227.

"I always knew Frank": Cheryl Lavin, "Love and Marriage: His Romances Were Marked by Rocky Times—and Really Big Rocks," *Chicago Tribune*, May 17, 1998.

"We struck up": Omar Sharif, *The Eternal Male* (New York: Doubleday, 1977), 152.

"Ava is a lonely person": Ibid.

"On the set Ava Gardner": Ibid.

"The surprise of the picture": Howard Thompson, "Screen: Opulence of Austria-Hungary: New 'Mayerling' Opens at the Music Hall," *New York Times*, February 14, 1969.

Whether it was solely: Ava Gardner, *Ava: My Story* (New York: Bantam, 1990), 189.

"Mrs. Mickey Rooney": Roddy McDowall, quoted in Gardner, *My Story*, 261.

"Roddy had the greatest gift for friendship:" Lauren Bacall, *By Myself and Then Some* (New York: Headline Hardbacks, 2005), 447.

Joanna Lumley said of Ava: Joanna Lumley, interview with authors, November 2015.

"Ava was glorious": Joanna Lumley, interview with authors, November 2015.

Roddy was a sweetheart: Ibid.

Ava, "Green eyes flashing": Ibid.

"She didn't walk into the room": Quoted in Lawrence Grobel, *The Hustons: The Life and Times of a Hollywood Dynasty* (London: Bloomsbury, 1990), 645.

"Ava Gardner, in a rare appearance": Anjelica Huston, *Watch Me: A Memoir* (New York: Simon and Schuster, 2014), 139.

"At the end of the evening": Ibid.

"What kind of job do you do?": Lee Server, *Ava Gardner: Love Is Nothing* (London: Bloomsbury, 2006), 465.

"Ava really liked the English way": Michael Garady and Peter Feuchtwanger, interview with authors, May 2016.

"she hated being recognized": Ibid.

"To Graves's surprise": William Graves, interview with authors, June 2015.

"It was before we moved to number 34": Michael Garady and Peter Feuchtwanger, interview with authors, May 2016.

"I would like to say that": Gregory Peck, interview with Terry Wogan, *Wogan*, BBC, September 25, 1989. Available at: https://www.youtube.com/watch?v=CYBWHONgm-j8&t=679s.

"Ava G was in fine form": Dirk Bogarde, *Ever, Dirk: The Bogarde Letters*, ed. John Coldstream (London: Weidenfeld & Nicolson, 2008), 108.

"Ava Gardner's name lifts": Pauline Kael, "The Current Cinema," *New Yorker*, December 2, 1974.

"They don't make 'em like you no more": Telegram from George Cukor to Ava Gardner, April 19, 1976, George Cukor papers, folio 763, Academy of Motion Picture Arts and Sciences, Los Angeles, CA.

"unfailingly friendly and supportive": Sir Ian McKellen, interview with authors, November 2015.

"Ava brings a beauty and pathos": "Picks and Pans: Screen," People, November 16, 1981.

"enjoyable in her mature beauty": Judith Crist, "D.H. Lawrence Brought to Life," Saturday Review, October 1981.

EPILOGUE:
RETURNING HOME

"She was very maternal": Tina Sinatra, interview with authors, July 2015.

"The producers really wanted her": Constance McCashin, interview with authors, May 2016.

"The most beautiful woman": Omar Sharif, interviewed in 2009, Presentación en España de su película Disparadme. Available at: https://www.youtube.com/watch?v=En1DrKu-oP7E&t=158s (Accessed August 2016).

"Every time I came back to see her": Mearene Jordan, Living with Miss G (Smithfield, NC: Ava Gardner Museum, 2012), 245.

"After the stroke she always": Michael Garady, interview with authors, May 2016.

"Ava didn't want that book": Tina Sinatra, interview with authors, July 2015.

"I remember that morning, after the storm": Michael Garady, interview with authors, May 2016.

"My heart is broken": Quoted in "Ava Gardner Is Dead at 67; Often Played Femme Fatale," Obituaries, New York Times, January 26, 1990.

"She was a wonderful lady": Quoted in "Hollywood Mourns the Loss of Ava Gardner," Lawrence Journal, January 26, 1990.

"My wife and I are sad today": Gregory Peck, tribute to Ava Gardner sent to publicist Monroe Friedman, January 25, 1990, Gregory Peck papers, folio 1366, Academy of Motion Picture Arts and Sciences, Los Angeles, CA.

"Ava was a great lady": Quoted in "Hollywood Mourns the Loss of Ava Gardner," Lawrence Journal, January 26, 1990.

"He never got over it": Tina Sinatra, interview with authors, July 2015.

"For contemporary women": Edward Z. Epstein, "All About Ava," Cosmopolitan, February 1990.

"Framed and frozen into iconography": Kathleen Murphy, "Farewell My Lovelies," Film Comment, March 1990.

"Thank heaven she had been made immortal": Liz Smith, "Thanks to Film, Ava Gardner Will Be Immortal," January 26, 1990. Publication unknown, Ava Gardner clippings files, Margaret Herrick Library, Academy of Motion Pictures Arts and Sciences.

"No one could craft a lovelier": Elizabeth Taylor, interview with author James Grissom, 1991. Private collection.

"She was a great, great broad": Rex Reed, "Ava What a Dame!" Talk, December–January 2000.

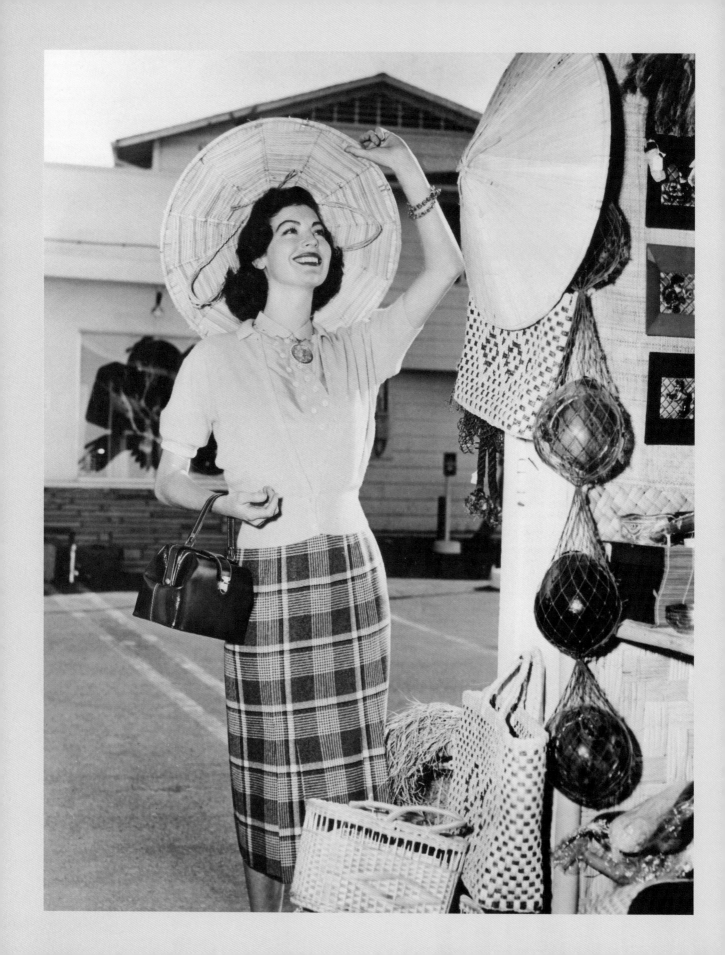

PHOTO CREDITS

opposite: Shopping for clothing at the Olvera Street Market in downtown Los Angeles, August 1958.

ACKNOWLEDGMENTS

As with any major project, *Ava: A Life in Movies* can truly be called a team effort. We owe a debt of gratitude to many people for their assistance with interviews, photographs, research, and many other facets of assembling this book.

To Joanna Lumley, the late Peter Feuchtwanger, Michael Garady, William Graves, Constance McCashin, Sir Ian McKellen, Rob Moshein, David Niven, Jr., and Tina Sinatra, thank you for sharing your personal memories of Ava with us. Your stories have enriched the book and your kindness and patience have enriched our lives.

Thanks are also owed to Stacey Behlmer, Jenny Romero, and Matt Severson at the Academy of Motion Pictures Arts and Sciences Margaret Herrick Library; to Ned Comstock at the USC Cinema Archive; to the special collections teams at UCLA; to Keith Tew of Barton College, North Carolina; to Stewart Tiley at St. John's College Library, Oxford University, and to the staff of the John F. Kennedy Presidential Library in Boston. Thanks to Elizabeth Smith and Aris Kourkoumelis at the Norman Parkinson Archive; to Amanda Erlinger for allowing us to use some photographs from the Sinatra family albums; to Todd Johnson of the Johnston County Heritage Center, Will Robinson at the Wilson County Public Library, Ian Dunn at the State Archives of North Carolina, and Jillian Wagner at the Newport News Public Library for assistance with photographs and information about Ava's years in and around Smithfield, North Carolina, and Newport News, Virginia. We are also grateful to William Graves for allowing us to publish the photographs of Ava and Robert Graves, and to Diana Altman for the screenshots of Ava from her father's original screen test. Thanks to Lawrence Grobel for kindly allowing us to quote from his books and his conversations with Ava, and to James Grissom for allowing us to quote from his unique interviews with Tennessee Williams and Elizabeth Taylor.

We are also grateful for the assistance and support of Pablo Aharonian, Jonathan Ambar, Lena Backström, Jill Blake, Lucy Bolton, Emma Borneland, Nick Britt, Andrew Budgell, Penny Calder, Carmen Alonso Calleja, Kayla Campana, Simon Crocker at the John Kobal Foundation, Thomas Deehan, Fran DeWysockie, Lewis Dugdale, Angelo Faccio, Alejandro Franks, Marya Gates, Victoria Haddock, Donna Hill, Kari Elizabeth Hobbs, Linda Hough, Ali Humphries, Kinvara Jardine Paterson, Jay Jorgensen, Nina Khan, Jeremy Kinser, Monica Lewis, Kim Luperi, Serge Mafioly, Guillermo Magnone, Howard Mandelbaum at Photofest, Philip Masheter, Francesco Massaccesi, Dale McCarthy, Denise McKinnon-Frew, Thomas Moodie, Geoff Napthine, Juju O'Grady, Jay Patrick, Terence Pepper, Mike Pitt, Danny Reid, Judy Salter, Jason Schneider, Lee Server, Lee Smith, Marissa Vassari, Tony Walsh, Joe Williams, Thomas Wiseman, and Meredith Wold.

Thank you to all the fans and followers of the *Ava Gardner: A Life in Movies* Facebook page. With your love and passion for Ava and her work, you keep her legacy alive, and this book is for you.

Last but certainly not least, we would both like to thank our editor at Running Press, Cindy De La Hoz, for taking this project on and supporting it through thick and thin. And to our mutual agent, Laura Morris, for the encouragement and good faith, as always.

ANTHONY

Special thanks to the people whose support means the world to me, and without whom this book could not have been written. To my mother, for her eternal encouragement and belief in me, through thick and thin. To my partner Tony, for his support and patience in bearing with me through all the ups and downs during the many months in which Ava dominated my life. To my adopted family, my dear friends whose support means so much to me: Olivia Doutney, Ethan Friskney-Adams, Abaigh Wheatley, Amandeep Singh, and Steph Brandhuber. And to Kendra, my co-author and great friend—thank you for this incredible journey.

KENDRA

For my mom, dad, and brother Derek, who have been supportive of my obsession with old movies for many years. To Robbie, my husband and my rock, for lending an ear and advice, and for his constant encouragement. To my friends in the classic film and blogging communities—you know who you are—many thanks for sharing your love for cinema and allowing me to share mine with you. And finally, to Anthony, thank *you* for your friendship and for so many laughs. "Birds of a feather."

INDEX